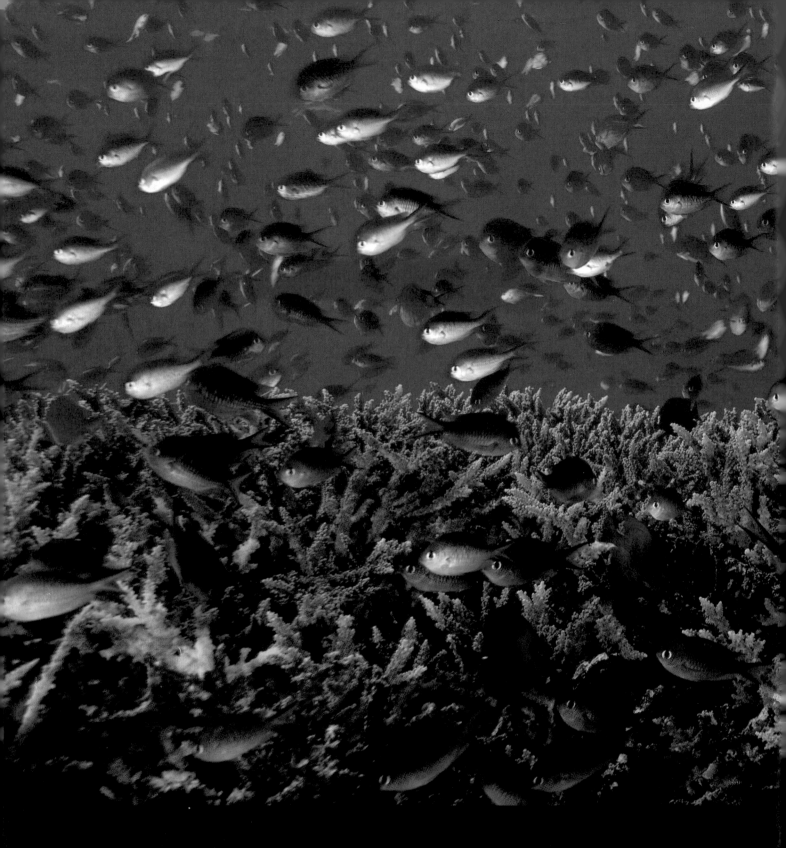

 words and images by

SCUBAZOO

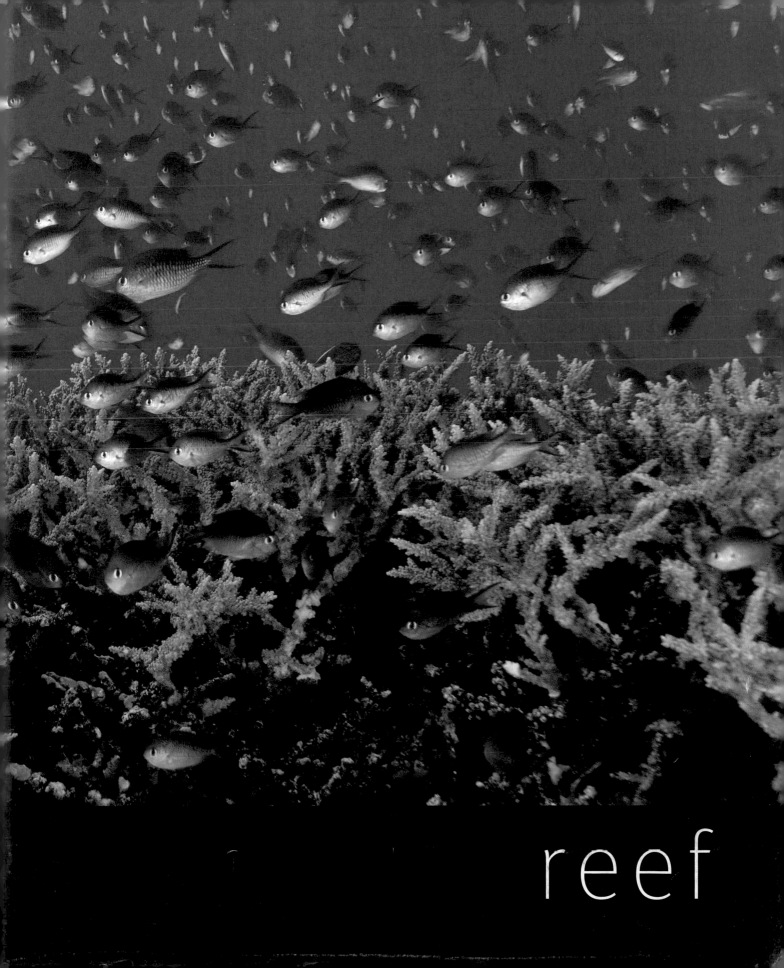

reef

A tiny commensal shrimp (*Dasycaris zanzibarica*) on wire coral. Sabah, Malaysia.

A leafy seadragon
(*Phycodurus eques*).
Kangaroo Island, Australia.

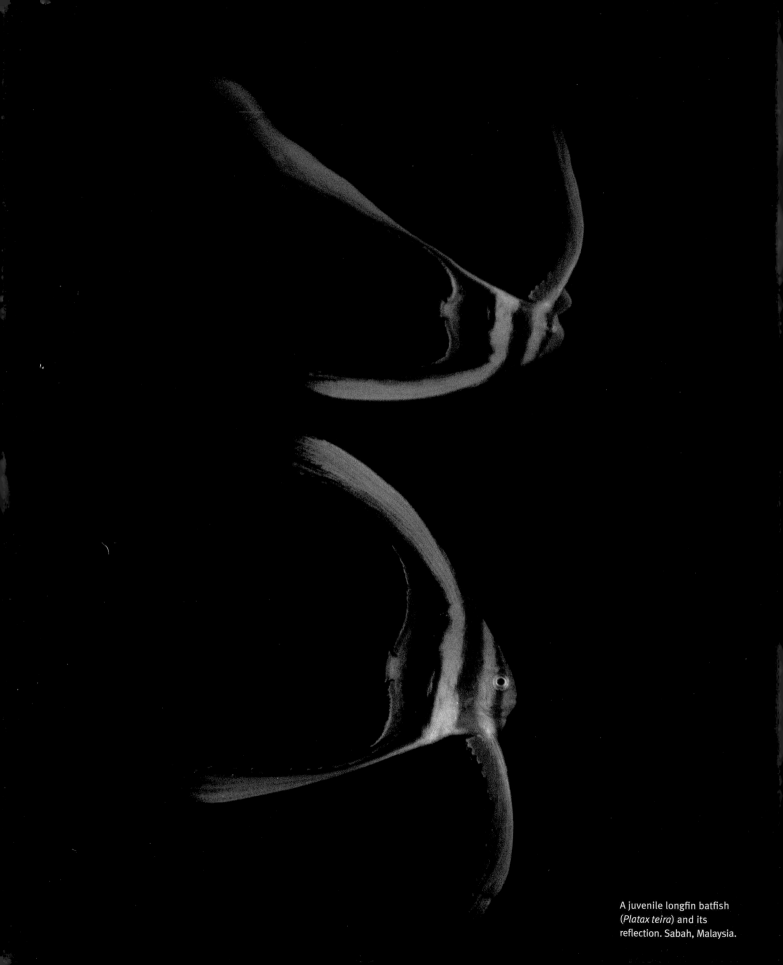

A juvenile longfin batfish
(*Platax teira*) and its
reflection. Sabah, Malaysia.

A sargassum frogfish
(*Histrio histrio*) with its
reflection. Sabah, Malaysia.

A yellowmouth moray eel (*Gymnothorax nudivomer*). Mabul, Sabah, Malaysia.

A commensal shrimp
(*Vir philippinensis*).
Kapalai, Sabah, Malaysia.

A dwarf hawkfish
(*Cirrhitichthys falco*).
Kalimantan, Indonesia.

A Michel's ghost goby (*Pleurosicya micheli*) on hard coral. Sabah, Malaysia.

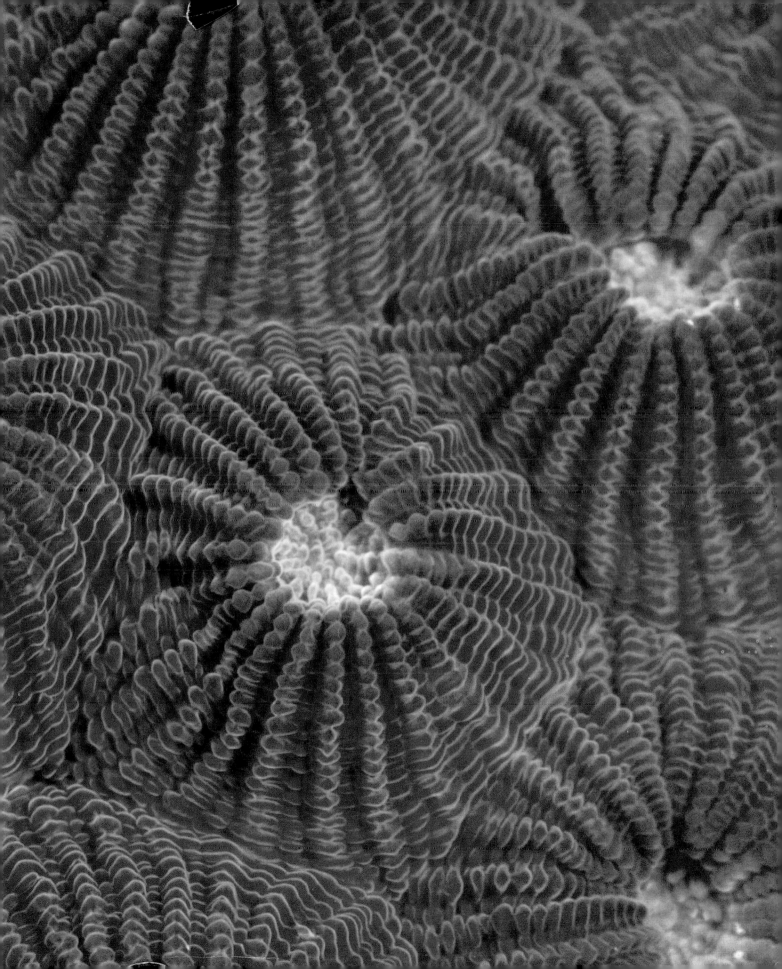

A colony of *Perophora namei* ascidians. Raja Ampat Islands, West Papua, Indonesia.

A ring-eye dwarf goby
(*Trimma benjamini*).
Seraya, Bali, Indonesia.

LONDON, NEW YORK, MELBOURNE,
MUNICH, AND DELHI

PROJECT EDITOR Bob Bridle
PROJECT ART EDITOR Katie Eke
US EDITOR Christine Heilman

MANAGING EDITOR Stephanie Farrow
MANAGING ART EDITOR Lee Griffiths

ART DIRECTOR Bryn Walls
PUBLISHER Jonathan Metcalf

PRODUCTION EDITOR Vania Cunha
PRINT PRODUCTION CONTROLLER Inderjit Bhullar

JACKET DESIGN Duncan Turner

DVD
FILMING BY Scubazoo
EDITING BY Scubazoo/Simon Enderby,
Roger Munns & Jonni Isaacs
MUSIC BY Brollyman

This edition published in 2009 by
DK Publishing
375 Hudson Street
New York, New York 10014
First American Edition, 2007

11 12 13 14 10 9 8 7 6 5 4 3 2 1
RD149—September/2009

Published in Great Britain by Dorling Kindersley
Limited. A catalog record for this book is available from
the Library of Congress

ISBN: 978-0-7566-5575-4

DK books are available at special discounts when
purchased in bulk for sales promotions, premiums,
fund-raising, or educational use. For details, contact: DK
Publishing Special Markets, 375 Hudson Street, New
York, New York 10014 or SpecialSales@dk.com.

Color reproduction by Media Development
Printing Ltd. Printed and bound in China by Hung Hing
Offset Printing Company Ltd

Discover more at
www.dk.com

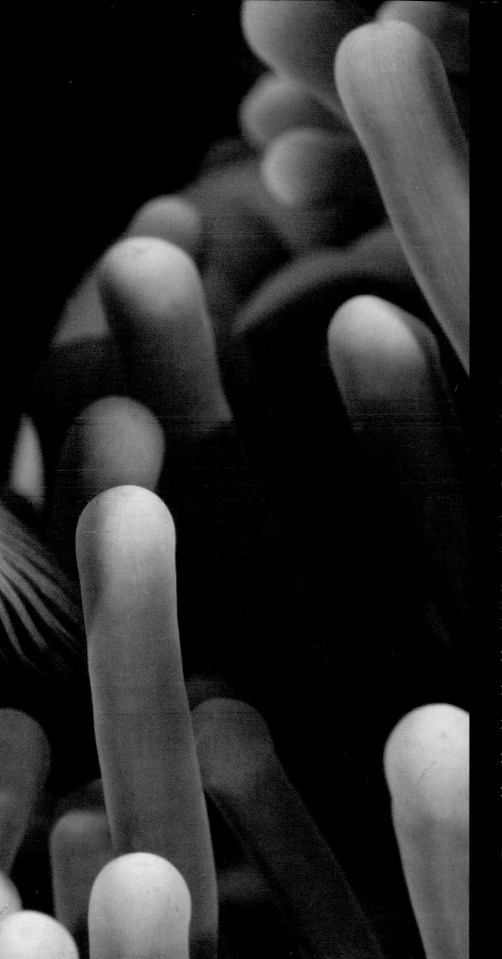

contents

foreword

Like a jeweled belt around the midsection of the planet, coral reefs have adorned clear tropical seas for hundreds of millions of years. For many, these rich, diverse ecosystems, ablaze with life and color, symbolize the essence of the sea. They are also places where human history and the history of life on this planet are now converging, as documented in this beautifully illustrated volume.

When I was a child, half a century ago, most of our coral reefs were intact and brimming with a cross-section of life. Of all the various forms of life on this planet, nearly half can be found within its waters, including all of the major animal groups and many divisions of plants, fungi and microbes—and almost all of these groups are represented in the biodiversity of coral reefs. Today, however, more than half of the reefs worldwide are in serious decline—many have disappeared as a result of human actions, and global warming has added new stresses.

The good news is that about half of the coral reefs wordwide are still in good health. There is a chance now as perhaps never again to reverse the troubling trends of loss and decline. Saving reefs is a global

project and no one person, organization, or country can do it alone. For the Coral Reef Alliance (CORAL), "Working Together to Keep Coral Reefs Alive" is more than just a tagline. For the last ten years, I have been proud to work with this coral reef conservation organization and its partners to provide education, inspiration, and tools to the people who live at the front lines of the efforts to save coral reefs.

Scubazoo's photography is not only striking in its originality and beauty, but also in its ability to provide new insights into the nature of the living ocean. As a reader, the images in this book provide you with a chance to vicariously dive into some of the ocean's finest reefs. I encourage you to join the Coral Reef Alliance, Scubazoo, me, and the thousands of people who care for the ocean and its beautiful reef systems to help make an enduring difference to their fate, and ours. To find out how you can do more, visit www.coral.org/reefbook.

THE CORAL REEF ALLIANCE

Sylvia A. Earle
Explorer in Residence, National Geographic Society
Chairman, Deep Ocean Exploration and Research

Some of my fondest childhood memories come from family summer vacations in the Costa Brava, where, much to my parents' concern, I would disappear for hours on end with my mask, snorkel, and fins looking for octopuses. I spent literally hundreds of hours watching them, long before I ever put on my first scuba tank. I was completely captivated by their soft intelligence and remarkable ability to change color in an instant—an early sign of the "Scubazoo passion"!

I graduated with a zoology degree, and then four years of working in sales finally convinced me to leave the UK and follow my heart. I set off to find the very best scuba diving in the world, 20 years after those first octopus liaisons. My destination was Southeast Asia—home to the most biodiverse seas on Earth. After six months of diving around the Philippines, Thailand, Vietnam, Indonesia, and Malaysia, I discovered a magical island called Sipadan, off Sabah in Borneo. It was there that I fell well and truly in love with the underwater world.

I first started diving with a video camera on a dive boat in Cairns, just off the Great Barrier Reef. I had a dream job—filming divers with the sharks, turtles, and octopuses on the reef—and I realized that underwater filming was what I really wanted to do. This was also when I first met Jason Isley. Like me, Jason had left his comfortable but unfulfilling life as a civil engineer in search of better things. He shared my passion for the natural world and diving, and he was the first like-minded Scubazoo'er to join me in this adventure.

Not even my tales of seeing hundreds of hammerhead sharks or encountering more than 20 turtles on every dive could really prepare Jason for his first dives on Sipadan. However, seeing is believing, and diving off this limestone pinnacle, which rises 2,000 ft (600 m) from the seabed, is a truly staggering experience. It's a unique underwater paradise, and Scubazoo's success is partly due to the incredibly diverse and friendly nature of the marine life on Sipadan's reefs. By diving here, day in, day out, the team has

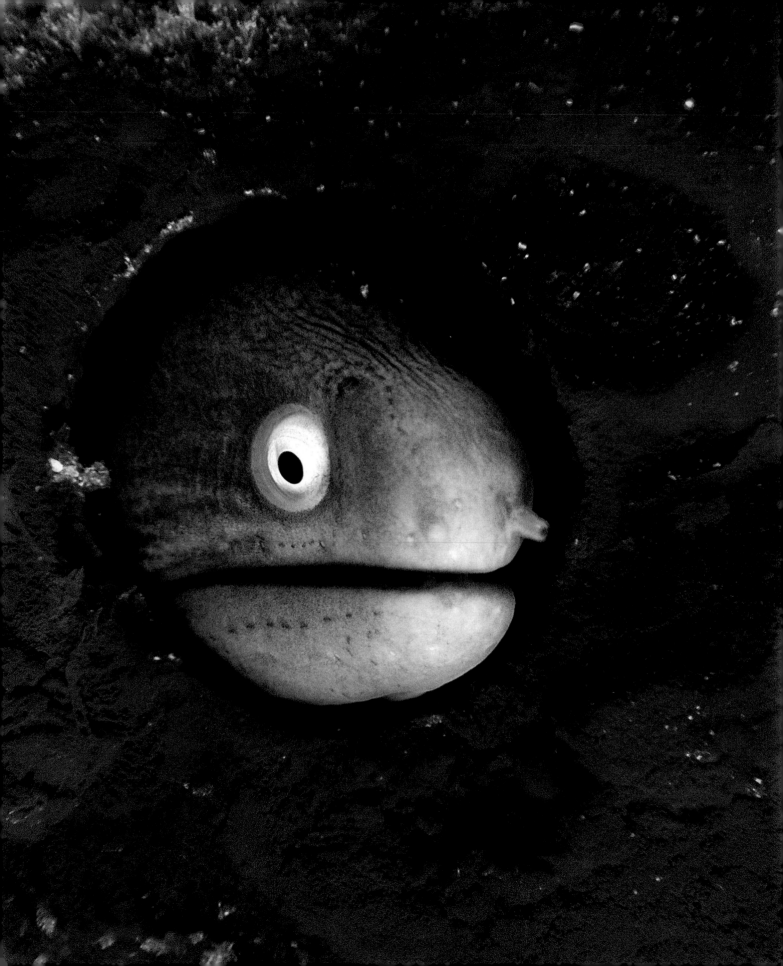

filmed the reef's inhabitants from every possible angle. We've become "naturalist photographers," predicting behavior patterns and taking pictures that reveal so much about how the creatures live. It's Jason's passion for photography that has led to the making of this book. As you turn the pages, many of the stunning photos you see are his from those early days of Sipadan.

The next two Scubazoo'ers—Simon Enderby and Matthew Oldfield—were also in Sabah independently, following their own marine-related passions. Inevitably, they joined us, and news of Scubazoo quickly spread across the international diving and filming industries. A couple of years later, again through a love of Sipadan, Roger Munns was drawn to Scubazoo, and his exceptional talent is clear in his photos here. It's the colorful mix and tremendous talent of this team that has allowed Scubazoo to grow into what it is today.

Jason, Matt, and Roger's stunning photographs provide an intimate portrait of the weird and wonderful creatures that make their home on reefs worldwide—and Matt eloquently describes these animals and the environments they inhabit.

> **" Diving off this limestone pinnacle is a truly staggering experience—it's a unique underwater paradise. "**

There are also some equally driven and promising new talents working their way up the Scubazoo ladder. In particular, both Seok Wun Au Yong and Adam Broadbent have contributed photographs for this book. Finally, our wives—Clare, Mona, and Helle—deserve a specific mention here for their undying love, support... and patience!

Scubazoo's mission is to share our images of the underwater world with as many people as possible. This vast realm is under serious threat as our ever-growing populations destroy the marine environment in pursuit of its many resources. Whether this destruction is to improve the quality of our lives or, for those less fortunate, simply for survival, we have no choice but to find new, sustainable ways of harvesting our oceans before it's too late. We hope that by sharing our pictures in this book we can foster real appreciation for the world's reefs and help communicate the urgent need for their conservation and preservation.

Simon Christopher, Scubazoo founder and CEO

seascapes

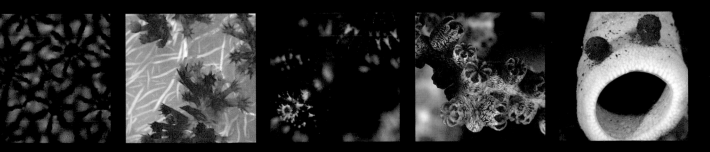

> **The coral reefs explored by Wallace and Darwin and the rocky shores once scoured by early man are still only partially understood.**

In the mid-19th century, Alfred Russel Wallace embarked on a journey of scientific discovery. Sailing through the Malay Archipelago and into Indonesia, he found "one of the most astonishing and beautiful sights I have ever beheld." Beneath the surface of the calm sea, he remarked that "the bottom was absolutely hidden by a continuous series of corals, sponges, actiniae, and other marine productions, of magnificent dimensions, varied forms, and brilliant colors." Wallace marveled at the fish, spotted and banded with color, as they threaded their way between the rocks and corals. "The reality exceeded the most glowing accounts I had ever read of the wonders of a coral sea."

In the same century, Charles Darwin explored the Indian Ocean during his voyages aboard HMS *Beagle*. Despite complaining about the flowery language used by other naturalists, he couldn't help but be enchanted by the coral islands he encountered. "We feel surprise when travelers tell us of the vast dimensions of the Pyramids and other great ruins, but how utterly insignificant are the greatest of these when compared to these mountains of stone accumulated by the agency of various minute and tender animals!"

These men, both deep thinkers and co-founders of the theory of evolution by natural selection, were spellbound by the diversity of

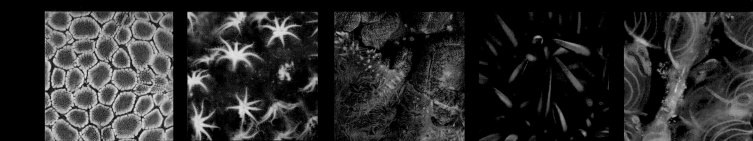

the environments they encountered. Humans have lived alongside reefs for thousands of years, gathering food from temperate and tropical shores, fishing with lines and nets, and even making brief, blurred forays beneath the surface to hunt. Today, tourists flock to white-sand beaches, don masks and snorkels, and let schools of tiny fish nibble their fingers and toes. Yet even now, despite our awe and long association with the marine world, much remains to be discovered. The calm surface through which Wallace and Darwin once peered is the frontier between the known and the unknown. The animals and plants that inhabit the reefs give up their secrets reluctantly.

The reason why the marine world was barely understood until the 20th century is clear—we drown. Most early attempts to support human life underwater involved simple pumps that fed air to helmeted divers, or sealed diving bells with limited supplies of air. Alexander the Great, seeking to fully explore his conquered territories, is said to have traveled to the bottom of the sea in a glass diving bell. Sir Edmund Halley and John Smeaton developed a diving bell with a pump. Siebe Gorman made a commercial success of hard-hat diving equipment. But it wasn't until Rouquayrol and Denayrouze, and later Jacques Cousteau and Emile Gagnan, developed their "self-contained underwater breathing apparatus" (scuba) that people were free to explore the underwater world at will. Without tangling hoses or cumbersome helmets to contend with, scientists, photographers and filmmakers could finally observe and record marine animals in their natural habitat, going about their daily lives.

Reefs are the underwater world of our coastline, of isolated tropical islands and rocky temperate shores. They are the forests of giant seaweed and the sand plains stretching into the unknown. Reefs are beyond the beach where we played as a child and the murky depths that we fish. Reefs are places of discovery and exploration, home to an incredible variety of species, most of which we are only now beginning to fully understand.

seascapes

A school of predominantly female scalefin anthias (*Pseudanthias squamipinnis*) swims above a colorful mix of hard and soft corals—the archetypal coral reef scene. North Male Atoll, Maldives.

CORAL REEFS

For many people, the word "reef" conjures up an image of clear blue water, sun-dappled corals, and myriads of colorful fish. Tropical coral reefs are not only one of the world's most beautiful environments, they are also one of the most diverse. In fact, more species are found on coral reefs than in any other marine environment, possibly more than in any other environment on the planet. Coral reefs are built up from the skeletons of stony corals that only grow in warm, sunlit, shallow water.

Corals require a temperature of at least 65°F (18°C) to thrive and, paradoxically, the tropical and subtropical seas that provide the right temperature conditions are actually very poor in nutrients. To survive, corals have evolved a partnership with a photosynthesizing organism that lives within the tissue of each coral animal. By capturing the energy of the sun, these zooxanthellae provide much of the food necessary for the growth of corals, and explain why coral reefs thrive in sunlit waters.

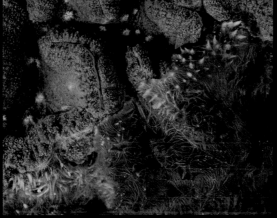
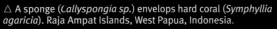

△ A sponge (*Callyspongia sp.*) envelops hard coral (*Symphyllia agaricia*). Raja Ampat Islands, West Papua, Indonesia.

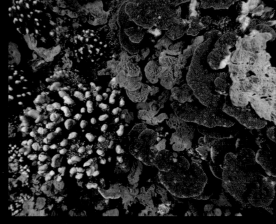

△ Communities of hard and soft corals grow alongside sponges and algae. Mios Befondi, West Papua, Indonesia.

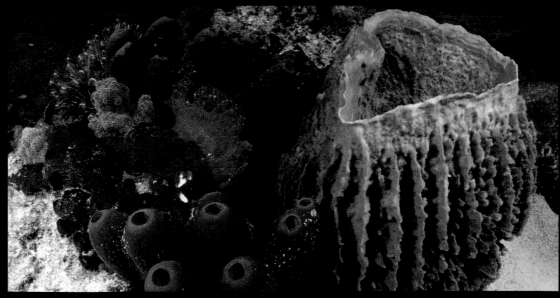

△ A variety of sponges provide shelter for a giant frogfish (*Antennarius commersonii*). Sipadan, Sabah, Malaysia.

During a dive on a coral reef, it is very difficult to get a sense of the scale and structure of the reef as a whole. Only by flying overhead can you appreciate the huge size, or the intricacies of the reef's different formations. However, it is often the remarkable colors that capture my attention—the saturated blues and greens, and the bright bands of white sand, all woven through by the dark patterns of coral and rock.

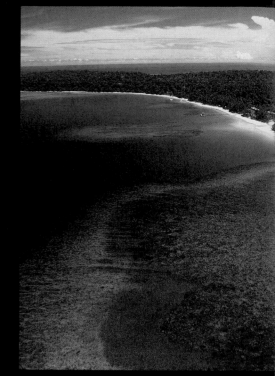

▽▷ Fringing coral reefs form in the shallow, sunlit waters around tropical islands. Only where rivers meet the sea does the water become too cloudy for the growth of corals. Sabah, Malaysia.

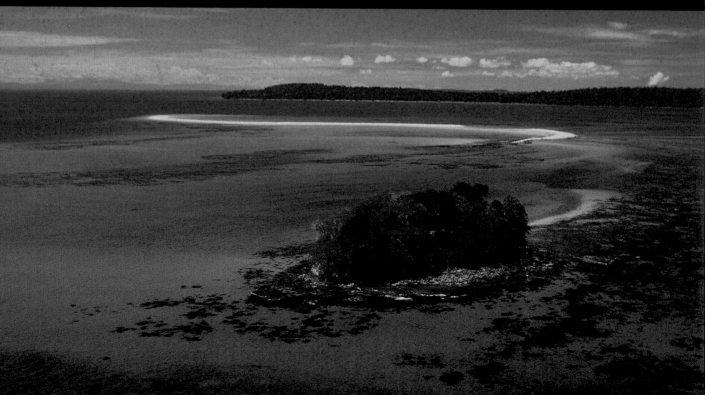

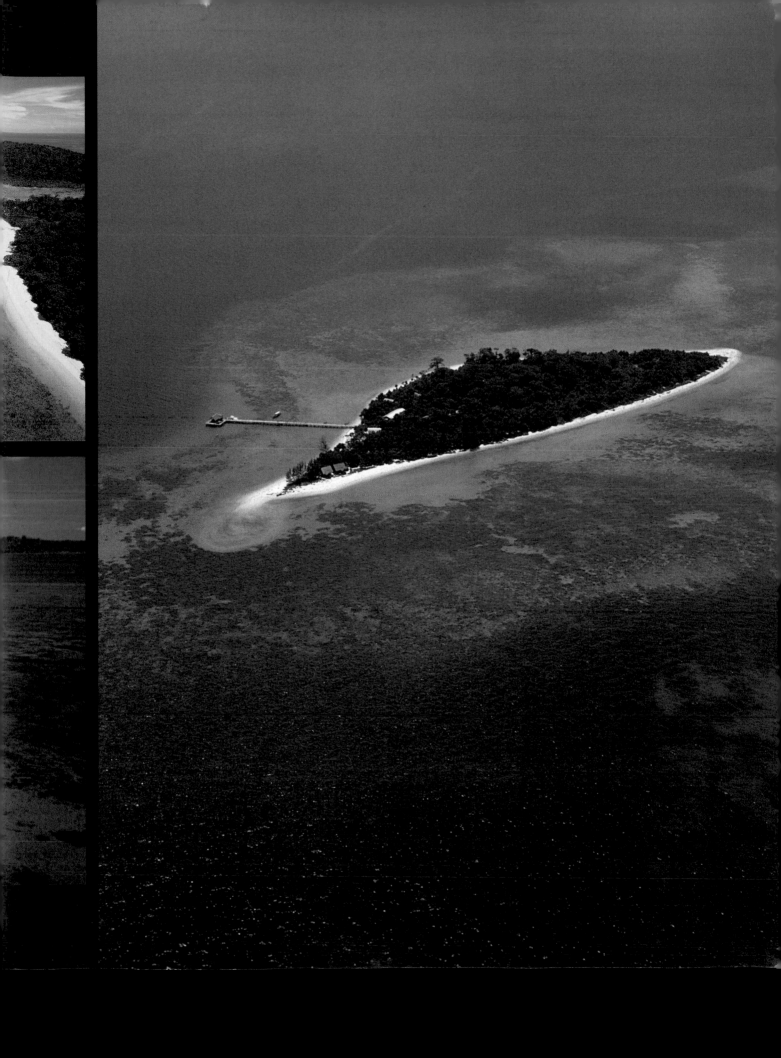

"The colorful polyps of cup corals are a remarkable sight, but their beauty hides a deadly secret—they are designed to kill. Each arm comes laden with a battery of stingers, and if you watch closely, you can see tiny crustaceans being engulfed by the tentacles as they drift too close. After being killed, the food is then delicately pushed into the central mouth to be slowly digested by the ravenous but beautiful coral."

▷ Like all corals, the cup coral (*Tubastraea sp.*) is armed with stinging cells on the tentacles of each polyp, which it uses to capture and kill small animals in the plankton. Unlike many other corals, however, the cup coral does not rely on photosynthesizing partners for its food—instead it extends its tentacles to feed at night when the plankton is at its richest. Raja Ampat Islands, West Papua, Indonesia.

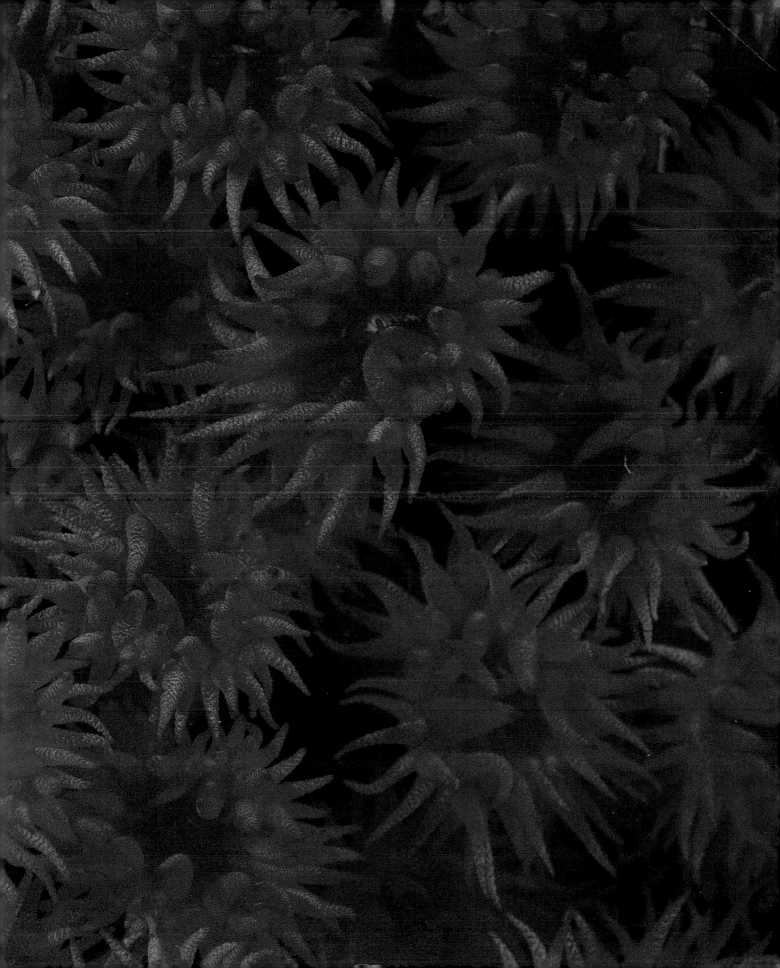

“ I've had some of the most beautiful dives of my life while exploring the deep, vertical walls of atolls around Borneo. On both Layang Layang in the South China Sea and Maratua off East Kalimantan, these dark walls are festooned with an incredible variety of huge fans, whips, and soft corals—it's a colorful jungle of plankton-feeders extending their bodies out into the currents that sweep by these isolated locations. **”**

▷ Plankton-feeders, such as soft corals (*Dendronephthya sp.*) and sea fans (*Melithaea sp.*), orient themselves to maximize the surface area they present to the currents, which greatly increases the amount of food they are able to catch. Maratua, Kalimantan, Indonesia.

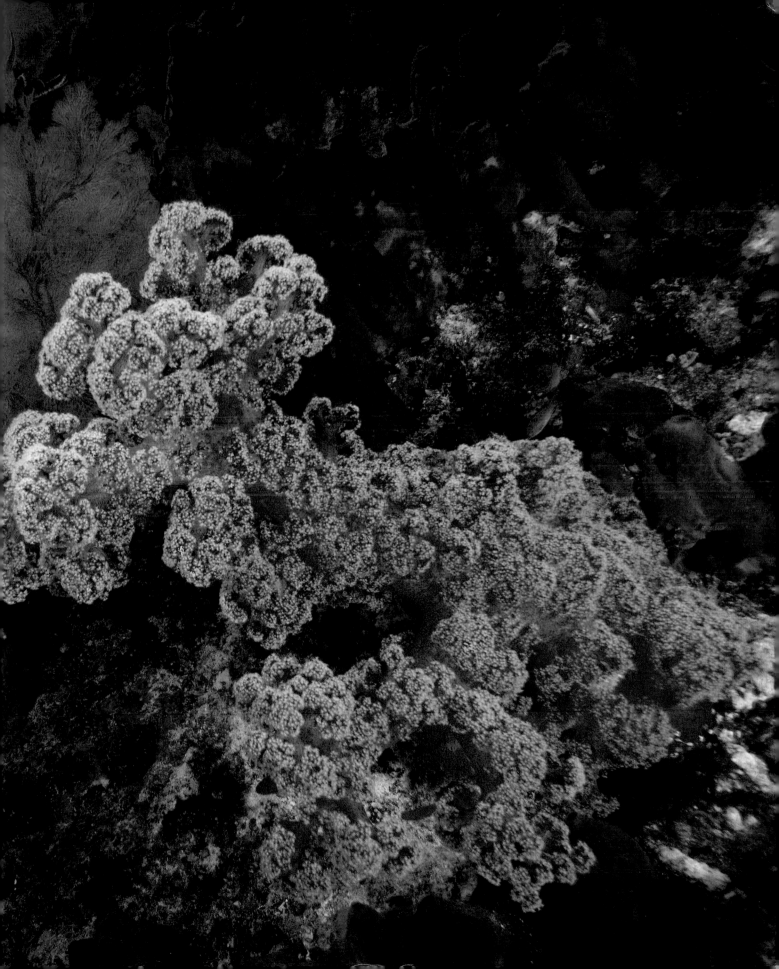

△ A close-up of *Acropora gemmifera* coral.

△ A detail of the sea fan *Muricella sp.*

△ The anal sac of the sea urchin *Echinothrix calamaris*.

△ *Perophora namei* sea squirts or ascidians.

△ A close-up of the sea fan *Acabaria sp.*

△ A detail of the soft coral *Dendronephthya sp.*

△ The mouth of the hard coral *Cynarina lacrymalis*.

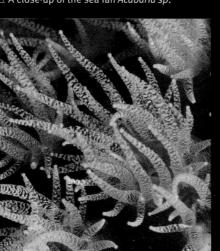
△ The polyps of the hard coral *Turbinaria sp.*

△ The siphon of the giant clam *Tridacna gigas*.

△ The siphon of the clam *Tridacna squamosa*.

△ The polyps of the sea fan *Muricella sp.*

△ A thorny oyster (*Spondylus varians*).

△ A close-up of *Dendronephthya sp.* coral.

> " The reefs of the world hide a remarkable diversity of color and texture. With the use of strobes and a suitable lens, clams reveal electric bands of blues and greens, branching sea fans show off their gardens of delicate polyps, and Christmas-tree worms display their feathery spirals of feeding arms. While the large, charismatic predators that inhabit the reefs or make fleeting visits often take center stage, there is so much happening on a minute scale. In fact, a single boulder or isolated patch of coral can take an entire dive to explore at this intricate level of detail. "

∧ A Christmas-tree worm (*Spirobranchus giganteus*).

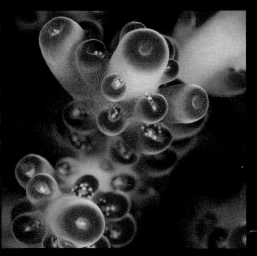

△ A detail of the hard coral *Acropora sp.*

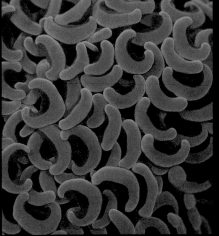

△ The polyps of the hard coral *Euphyllia ancora*.

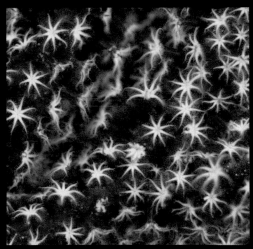

△ The polyps of the sea fan *Melithaea sp.*

The bright feeding tentacles of a tube anemone (*Cerianthus sp.*) are a common sight on coral reefs. Despite their name, these animals are more closely related to black corals than true anemones. Mabul, Sabah, Malaysia.

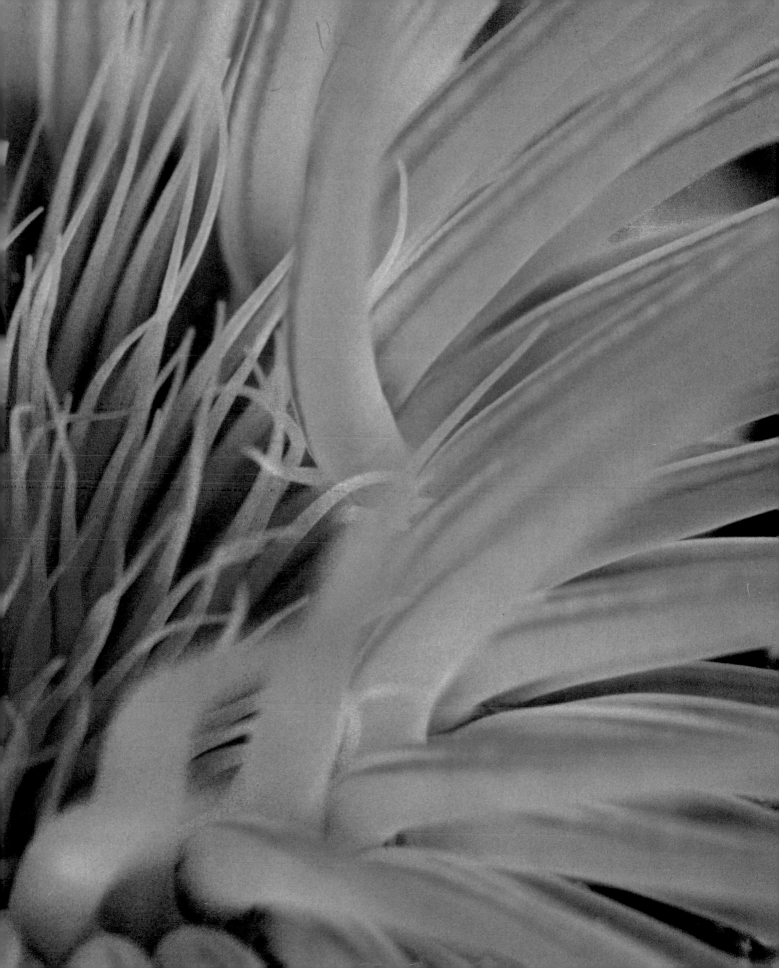

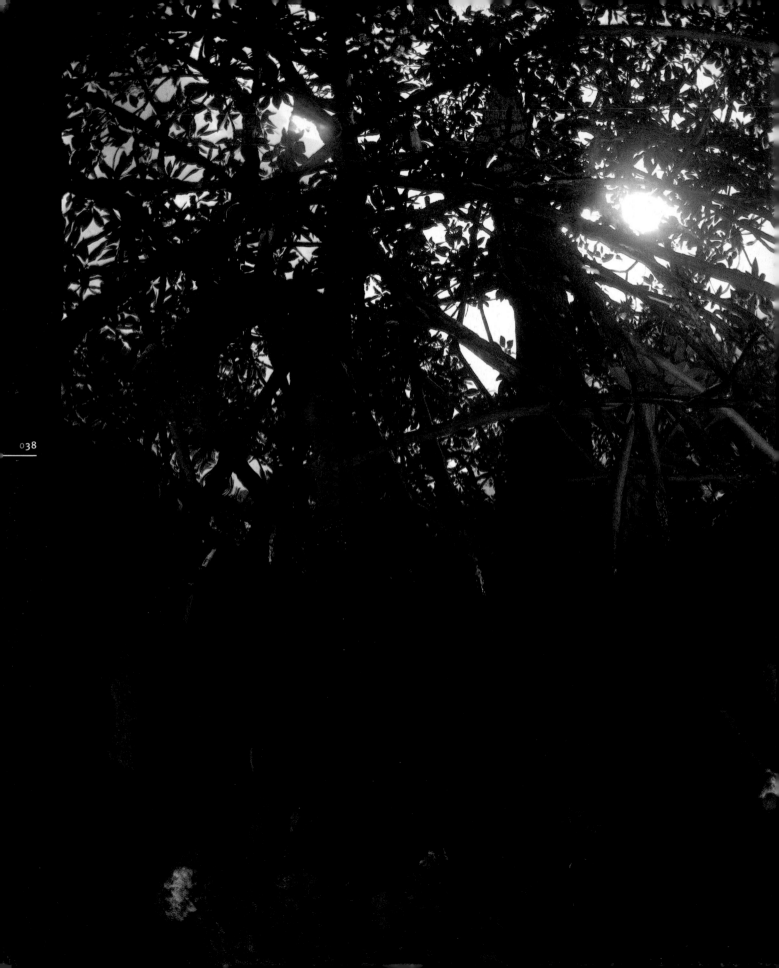

◁ The roots of mangrove trees (*Rhizophora sp.*) help trap sediment, stabilize the shoreline, and provide the perfect shelter for juveniles of many different species of reef fish. Raja Ampat Islands, West Papua, Indonesia.

MANGROVE SWAMPS

Thriving at the frontier between land and sea, mangrove swamps protect the shoreline from erosion and the sea from plumes of sediment washed out by rivers. Mangroves are found on sheltered, muddy shores across the tropics and play host to a unique group of organisms—the roots of these salt-tolerant trees provide shelter for plants and animals found only in this intertidal environment. Complex communities of sponges and encrusting life cover the roots, aiding the swamp's ability to catch sediment. Not only do mangroves prevent sediment from smothering the reef itself, they also help nurture its next generation of inhabitants. The dense network of roots creates dark caverns, which are vital to the inhabitants of nearby seas—many open-ocean and reef-dwelling fish come to the mangroves to spawn. Their young can develop here in safety, hidden and protected from predators by a maze of roots and branches.

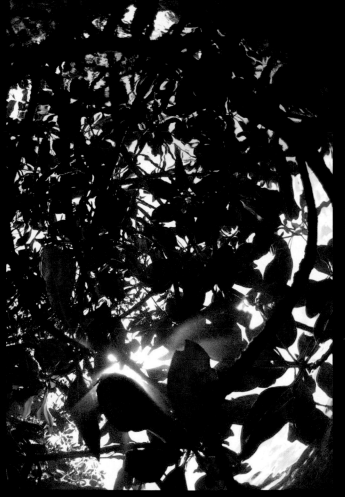

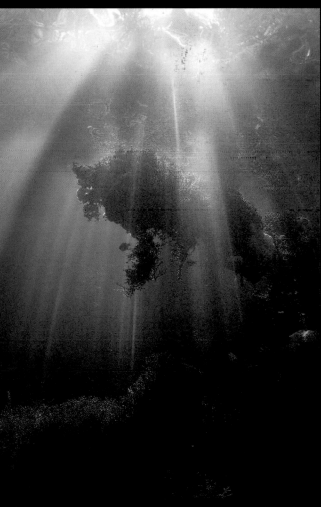

△ The growth patterns of mangrove trees (*Rhizophora sp.*) means that very little sunlight reaches the water beneath. West Papua, Indonesia.

∧ At breaks in the mangroves (*Rhizophora sp.*), rich communities of algae and encrusting life develop. Kakaban, Kalimantan, Indonesia.

△ A mangrove root breaks the surface of the water.
Raja Ampat Islands, West Papua, Indonesia.

△ A mangrove stem growing at the boundary of land and sea.
Raja Ampat Islands, West Papua, Indonesia.

▽ The flower of a mangrove tree slowly drifts with the currents, having finished its task of attracting pollinators. Raja Ampat Islands, West Papua, Indonesia.

In the Raja Ampat Islands, there is a remarkable dive site called "the Passage." Here, a narrow channel—more like a salt-water river than part of the sea—runs through thick mangroves and the tropical rainforest that covers the limestone rock.

The undercut banks are lined with sea fans and huge numbers of sea squirts, and an amazing array of different species can be found from both the mangroves and the reefs A drift dive through the Passage is a must for the underwater photographer. 🔳🔳

▷ Mangrove cardinalfish (*Apogon ceramensis*) take shelter among the sponges and sea squirts that engulf the dense network of mangrove roots. West Papua, Indonesia.

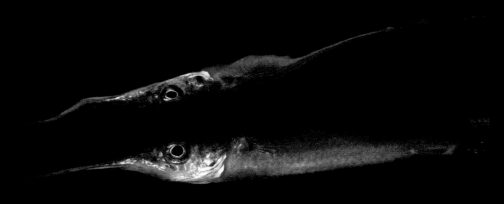

△ The estuarine halfbeak (*Zenarchopterus dispar*) has an elongated lower jaw for feeding at the surface. Raja Ampat Islands, West Papua, Indonesia.

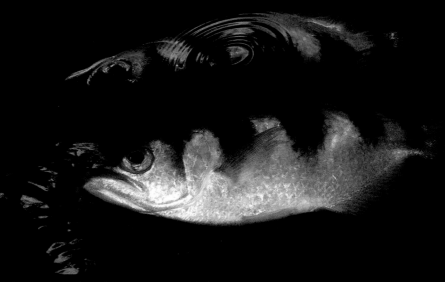

△ The banded archerfish (*Toxotes jaculatrix*) lurks below the surface, from where it can shoot jets of water at insects above the waterline. Raja Ampat Islands, West Papua, Indonesia.

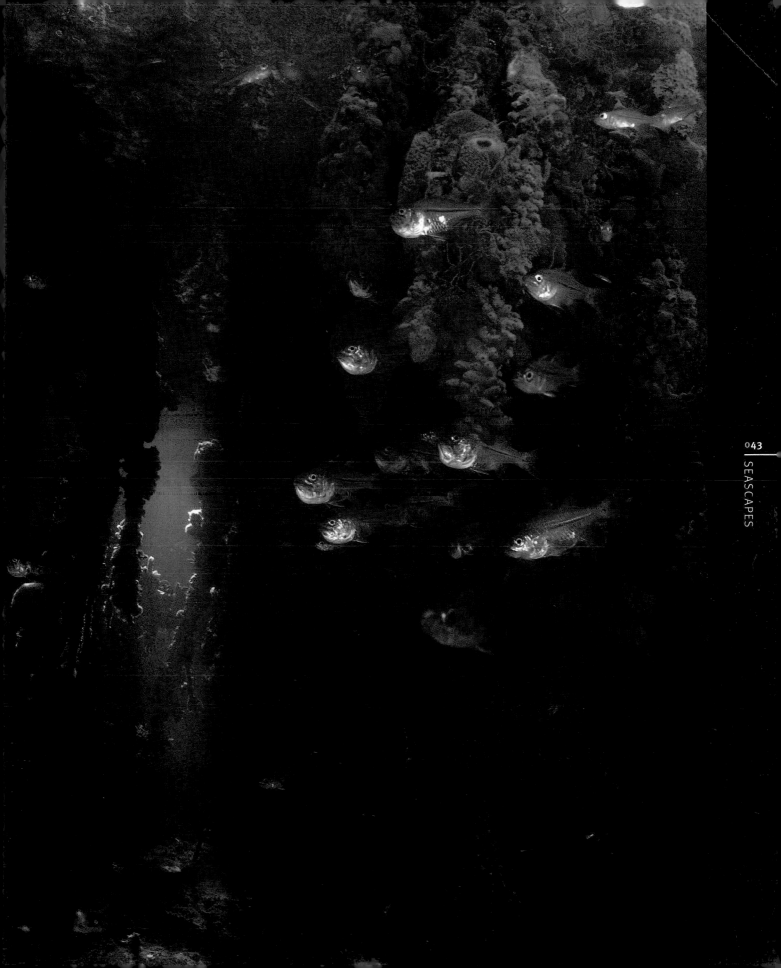

SEAGRASS BEDS

Plants play an important role in the marine environment: coralline algae help build up tropical coral reefs; red seaweeds dominate the deep, rocky coastlines of the world; and in warm, shallow seas with enough light to support their growth, seagrasses can be found in abundance. Seagrasses are the ocean's only flowering plants, and they help stabilize the shifting sands of the seabed, allowing other species to gain a foothold. These grassy plains are also home to a profusion of animal life. Some animal species have evolved perfect camouflage and spend their entire lives in the seagrass, while others use the shelter of the swaying, shadowy beds as a safe haven for their young. Even some of the largest marine animals rely on these plants— both dugong and huge green turtles can be seen grazing the seagrass like herds of marine cattle.

△ Vast plains of seagrass (*Halodule uninervis*) hide a surprising amount of marine life, most of which is highly camouflaged. Manado, Sulawesi, Indonesia.

△ The *Pteraeolidia ianthina* nudibranch uses symbiotic algae to photosynthesize. Manado, Sulawesi, Indonesia.

△ A sea hare (*Stylocheilus striatus*) feeds on algae growing on the seagrass itself. Manado, Sulawesi, Indonesia.

As with all plants, this species of seagrass (*Enhalus acoroides*) needs sunlight to thrive, restricting its growth to shallow areas with clear water. Lembeh Straits, Sulawesi, Indonesia.

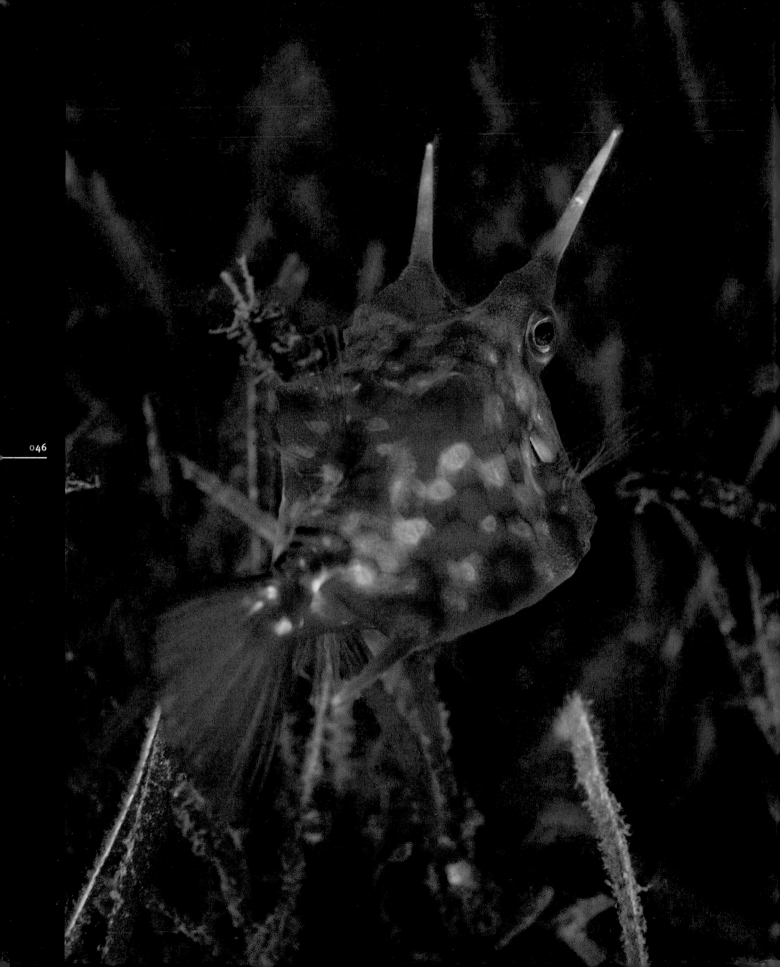

◁ The longhorn cowfish (*Lactoria cornuta*) is well-camouflaged against the seagrass, and also benefits from the protection of its spines and tough coat of armor. Manado, Sulawesi, Indonesia.

△ The strapweed filefish (*Pseudomonacanthus macrurus*) can change its color to match the lighting conditions. Manado, Sulawesi, Indonesia.

△ The marbled parrotfish (*Leptoscarus vaigiensis*) feeds on the seagrass, biting off mouthfuls with its sharp beak. Manado, Sulawesi, Indonesia.

△ A sea cucumber (*Bohadschia koellikeri*) decorates itself with pieces of seagrass for extra camouflage. Manado, Sulawesi, Indonesia.

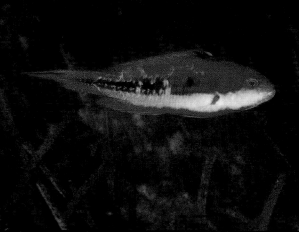

△ The two-spot wrasse (*Oxycheilinus bimaculatus*) lives near coral or rocky outcrops in the seagrass beds. Manado, Sulawesi, Indonesia.

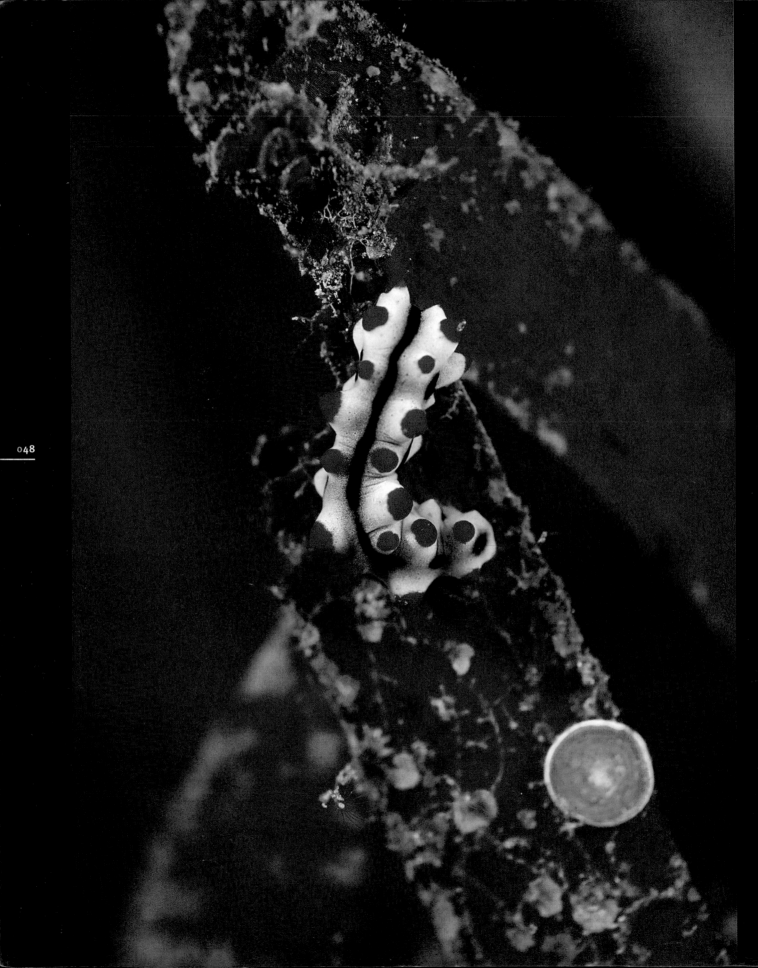

◁ Rather than relying on camouflage, this juvenile sea cucumber (*Bohadschia graeffei*) has evolved a remarkable resemblance to a toxic nudibranch. Manado, Sulawesi, Indonesia.

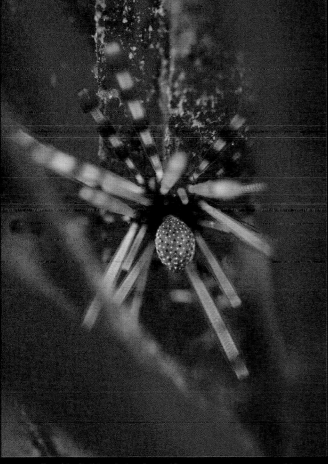

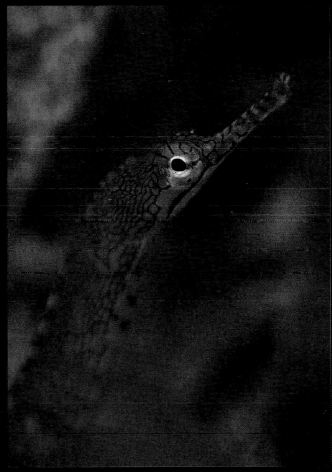

△ A small urchin (*Echinothrix calamaris*) grazes on the algae, safely protected by its array of spines. Manado, Sulawesi, Indonesia.

△ If threatened, the yellow-spotted pipefish (*Corythoichthys polynotatus*) "freezes" and relies on its camouflage. Manado, Sulawesi, Indonesia.

SAND FLATS

Beyond the edge of the reef, where the sand and sediments stretch away into the gloom, the only movement is from drifting algae, rippled by the shifting currents. Appearances, however, can be deceptive. These barren-looking sand plains are in fact home to a remarkable collection of life that is even less studied than the residents of the coral reef. Without any form of shelter, the animals here have evolved bizarre ways to survive on the exposed sands—the secret is to remain undetected or to deter predators from attack. Some animals bury their sinuous bodies in the sand, leaving just their mouths exposed. Others have evolved perfect camouflage, resembling the scattered sponges that manage to survive in the sand. Animals that cannot remain hidden have armed themselves with spines or poisons—grazers, for example, come equipped with toxic body parts, or are marked with false eyespots to confuse their enemies. In a never-ending evolutionary spiral, predators and prey compete with one another for survival, resulting in some of the most stunning marine organisms on the planet.

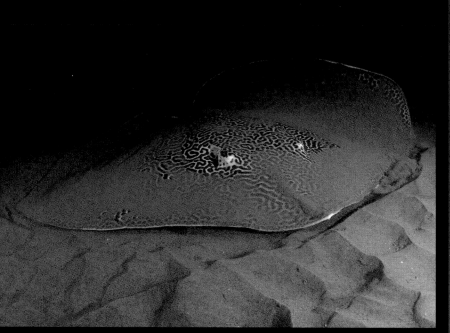

△ The camouflaged patterns of the reticulated ray (*Himantura uarnak*) help it blend in with the dappled sand. Sodwana Bay, South Africa.

▷ A marbled stingray (*Taeniura meyeni*) literally glides over the surface of the sand, using its "wings" to gracefully turn as it hunts for prey. Sodwana Bay, South Africa.

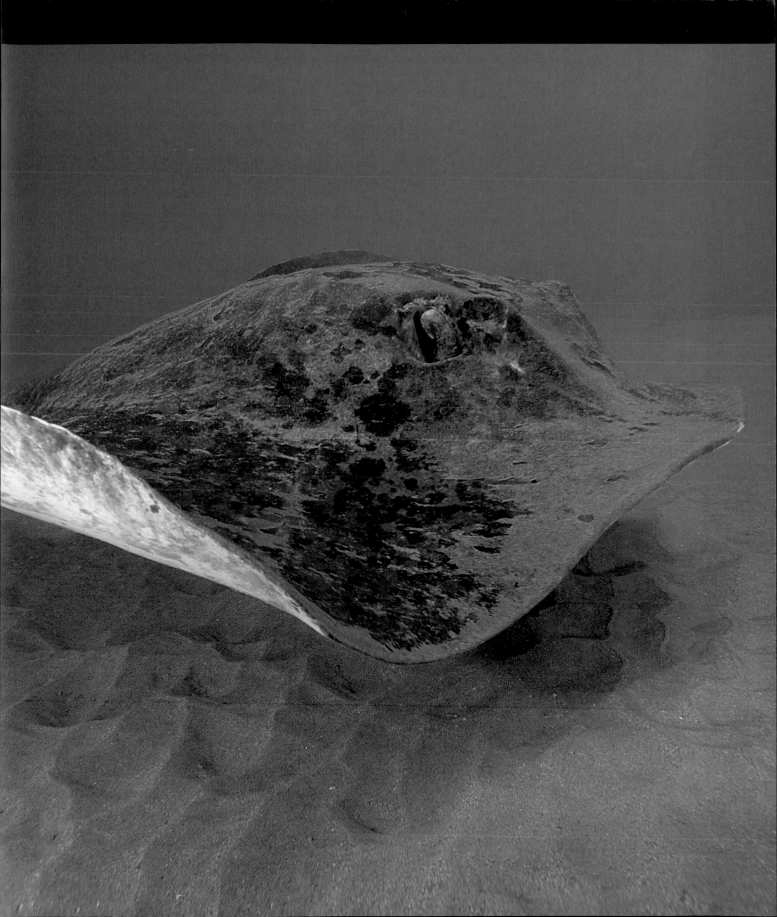

" Diving on the sand plains is like exploring a living laboratory—so many different animals can be seen, each with their own unique ways of surviving in this exposed environment. You can witness incredible camouflage, weird and wonderful ambush predators, octopuses that instantly change their markings, and crabs scuttling across the bottom like miniature tanks. There are very few habitats where so many different strategies for survival can be observed in such a small area. "

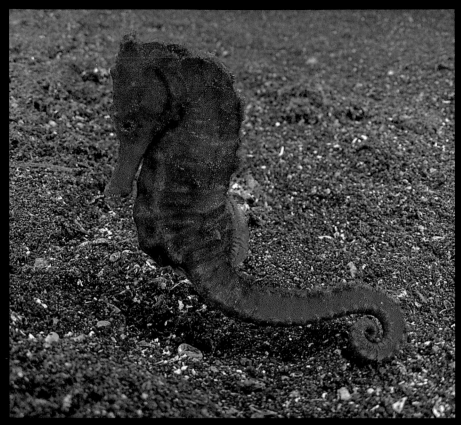

△ The yellow sea horse (*Hippocampus kuda*) protects its body with bony rings, and can hold on to corals and sponges with its near-prehensile tail. Lembeh Straits, Sulawesi, Indonesia.

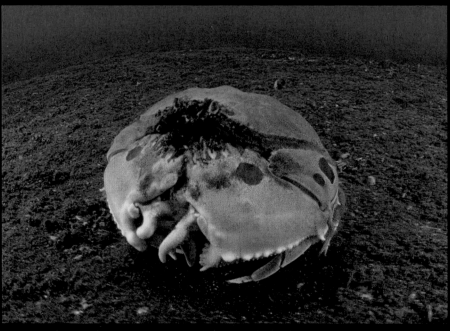

△ A shame-faced crab (*Calappa philargius*) hides behind its heavily armored front arms. If disturbed, it will run off and bury itself in the sand. Lembeh Straits, Sulawesi, Indonesia.

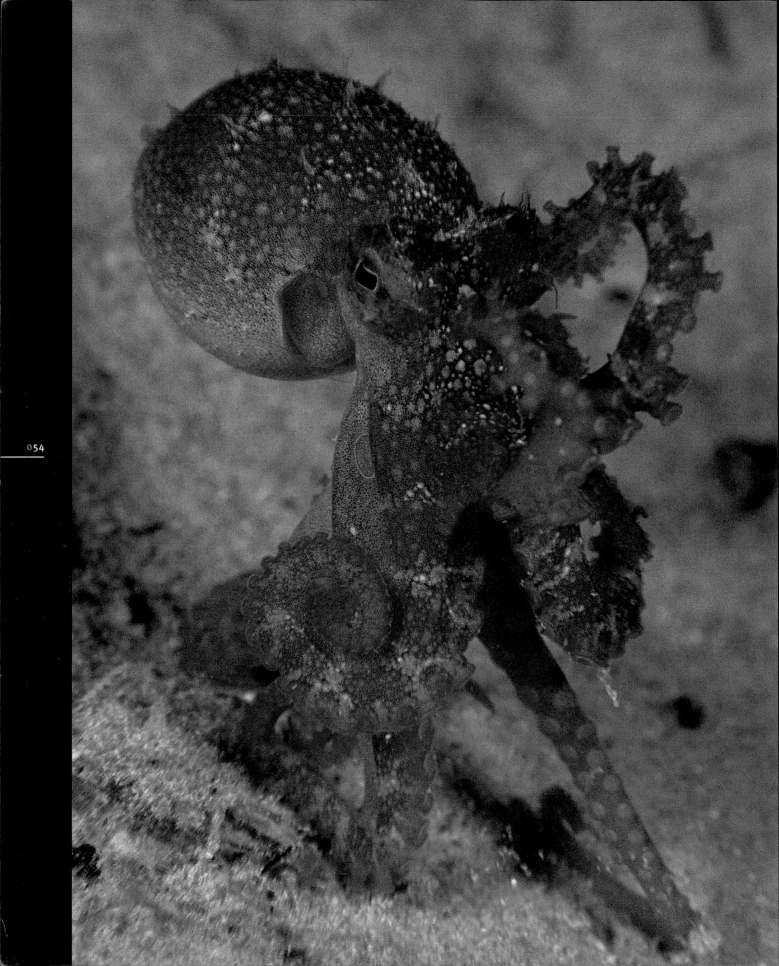

◁ If caught out in the open, the ocellated octopus (*Octopus rex*) will escape to the safety of a suitable hole or hide its body in a coconut shell. Mabul, Sabah, Malaysia.

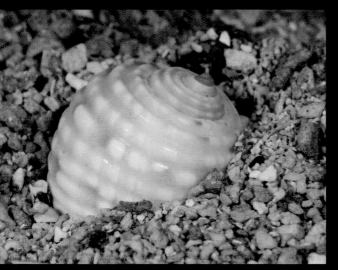

△ An apple snail (*Malea pomum*) buries itself beneath the sand for safety. Manokwari, West Papua, Indonesia.

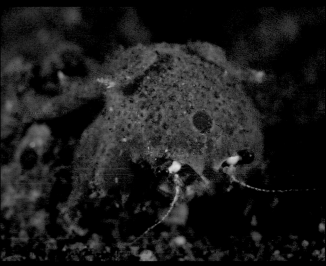

△ Even without its protective cover, this sponge crab (*Cryptodromia sp.*) remains safe by resembling a piece of sponge. Seraya, Bali, Indonesia.

△ A mantis shrimp (*Lysiosquilloides sp.*) hides in its burrow, exposing only its eyes and deadly arms. Seraya, Bali, Indonesia.

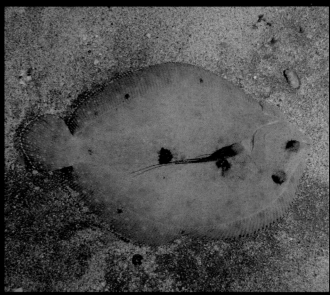

△ A peacock flounder (*Bothus mancus*) uses eyespots—as well as camouflage—to confuse any predators. Sodwana Bay, South Africa.

KELP FORESTS

In cooler waters, beyond the constant conditions of the tropics, the seasons play a more important role beneath the surface of the ocean. Towering forests of kelp thrive on rocky shores where cold, fluctuating currents stimulate bursts of new growth. These seasonal changes impart a different set of evolutionary pressures on the inhabitants of the kelp, but like terrestrial rainforests and tropical seas, these dark forests are filled with many different microhabitats and niches—perfect for evolution to work its ways. As with the coral polyps of the reef, kelp brings the energy of the sun into the marine world. They are some of the world's fastest-growing plants and are the base of a complex chain of life—kelp are eaten by herds of invertebrate grazers and provide nutrients as they disintegrate and rot away after the first storms of winter.

▷ A northern scorpionfish (*Scorpaena cardinalis*) hides among the sea lettuce. For the animals that live in these underwater forests, kelp is both a source of food and a place to hide from predators and prey. Poor Knights Islands, New Zealand.

△ Sea lettuce (*Ulva sp.*) and *Ecklonia radiata* kelp. Poor Knights Islands, New Zealand.

△ Strap kelp (*Lessonia variegata*) is one of the few species able to grow on surge-swept rocks. Poor Knights Islands, New Zealand.

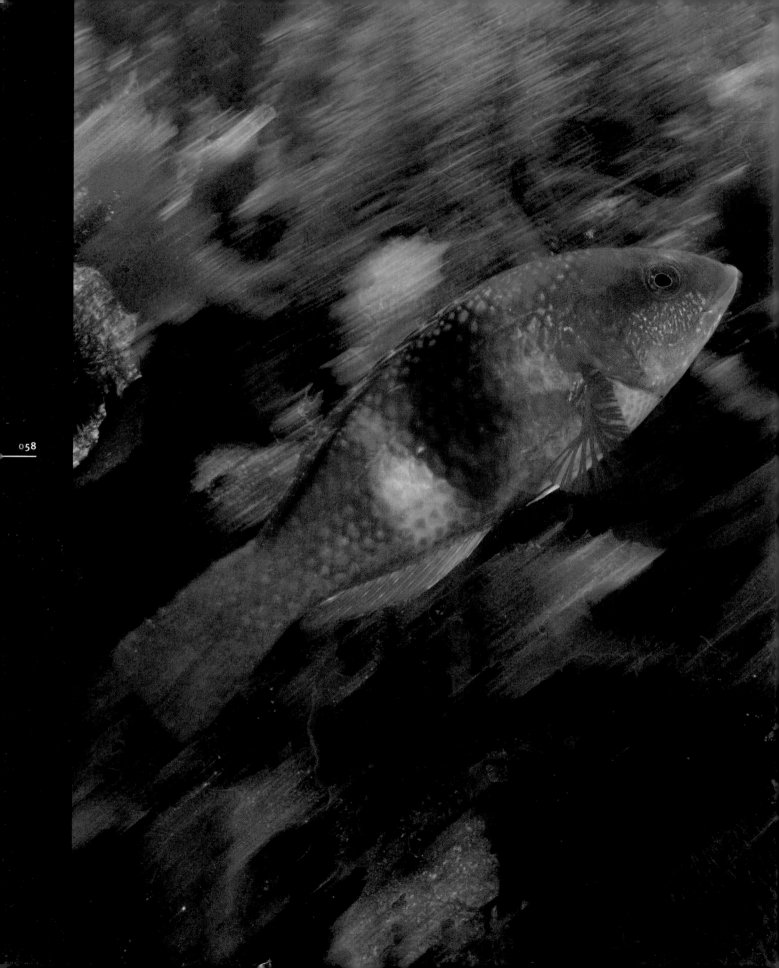

◁ The blue-throated wrasse (*Notolabrus tetricus*) uses its camouflage to blend in with the swaying fronds of the kelp forests. Kangaroo Island, Australia.

△ A pair of old wives (*Enoplosus armatus*) take shelter among short fronds of seaweed. Kangaroo Island, Australia.

△ The Degen's leatherjacket (*Thamnaconus degeni*) has a varied diet that includes the kelp itself. Kangaroo Island, Australia.

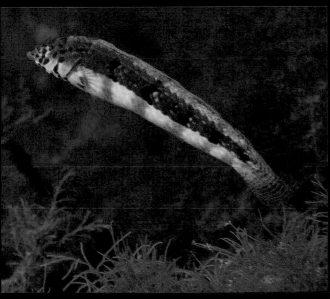

△ During mating or territorial disputes, the pretty polly wrasse (*Dotalabrus aurantiacus*) displays its bright colors. Kangaroo Island, Australia.

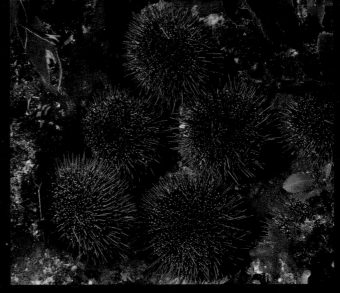

△ Sea urchins (*Evechinus chloroticus*) graze on algae growing on rocks in the kelp forest. Poor Knights Islands, New Zealand.

TEMPERATE REEFS

Light cannot penetrate far in cold waters that are thick with plankton or sediment. Here, colonies of animals, which resemble plants, stretch out their limbs and filter particles of food from the currents. Other animals, stuck firmly to their rocky homes, pump the nutrient-rich water through their bodies to gather both food and oxygen. A huge variety of invertebrate life covers every available surface—from sponges and sea squirts to hydroids and anemones. These animals engage their neighbors in chemical warfare in an attempt to hold on to their small piece of real estate. It is this intense competition for space that has resulted in such a diversity of animals and livelihoods. Sponges, for example, have evolved with a plethora of chemicals in their tissues to deter hungry grazers, and the valleys and ridges of their bodies harbor minute shrimp and squat lobsters that feed on trapped debris. When space is at a premium, evolution provides the mechanism by which different species of animals seek new ways to survive.

▷ In the rich, green waters, filter-feeders flourish. The plumose anemones (*Metridium senile*) found in these waters are the world's tallest. Vancouver Island, British Columbia, Canada.

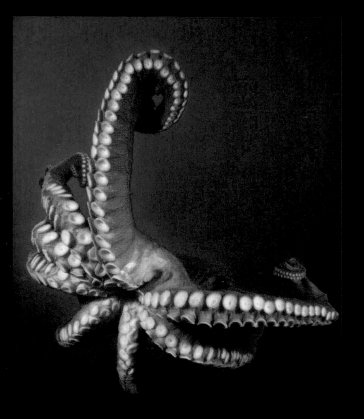

△ A giant pacific octopus (*Enteroctopus dofleini*) spreads its arms to reveal rows of suckers. Vancouver Island, British Columbia, Canada.

△ An orange sea pen (*Ptilosarcus gurneyi*)—as long as an adult human's arm—feeds in the strong currents. Vancouver Island, British Columbia, Canada.

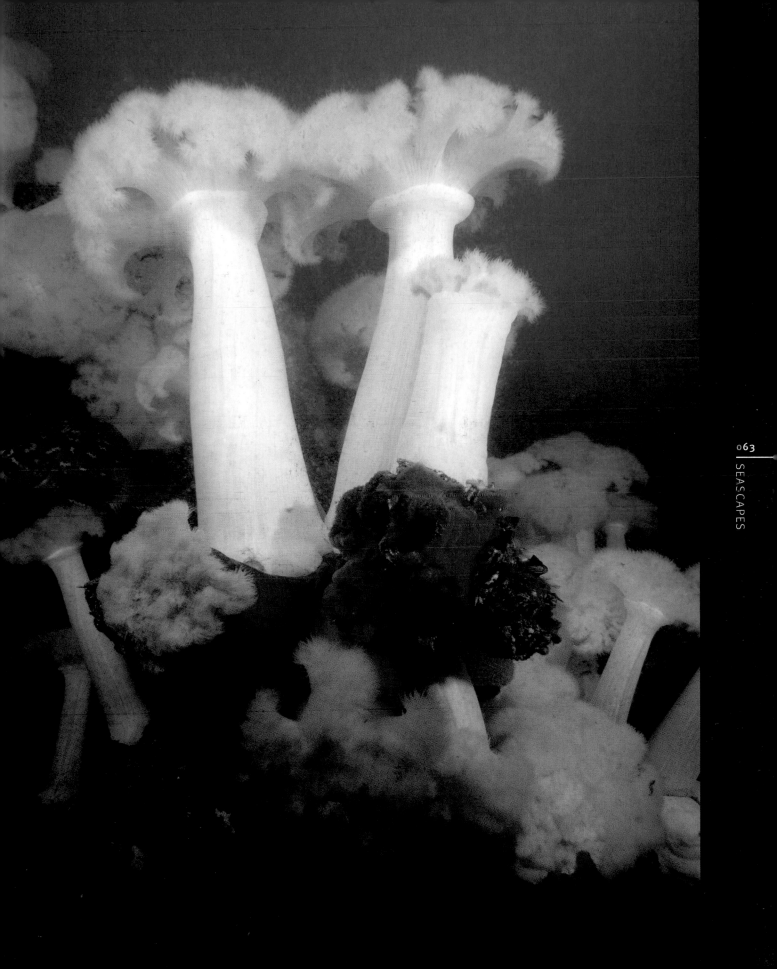

▷ This species of anemone, which is only about ½ in (1 cm) across and has yet to be scientifically classified, hides within the seaweed that clings to the rocks. Kangaroo Island, Australia.

△ A blue-eyed triplefin (*Notoclinops segmentatus*) shows off its bright markings as it shelters in seaweed. Poor Knights Islands, New Zealand.

△ The chiton (*Plaxiphora obtecta*), a type of mollusk, is camouflaged against the exposed rock. Poor Knights Islands, New Zealand.

△ A pair of clown nudibranchs (*Ceratosoma amoena*) line up head-to-tail as they mate. Poor Knights Islands, New Zealand.

△ The bright markings of a juvenile white-barred boxfish (*Anoplocapros lenticularis*) are thought to advertise its toxicity. Kangaroo Island, Australia.

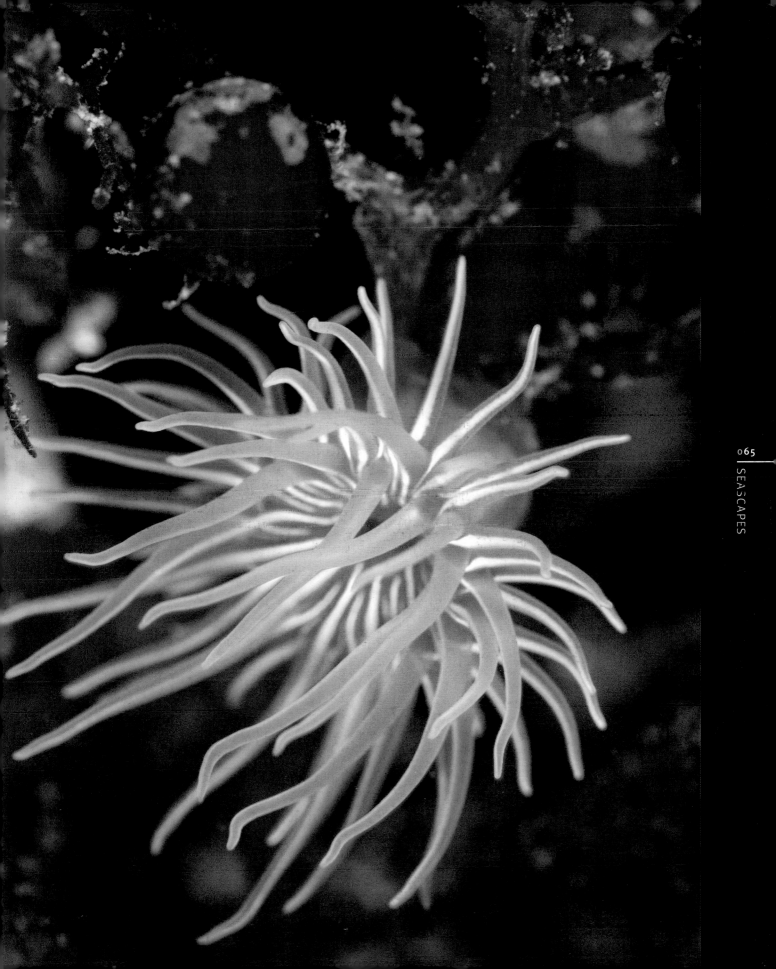

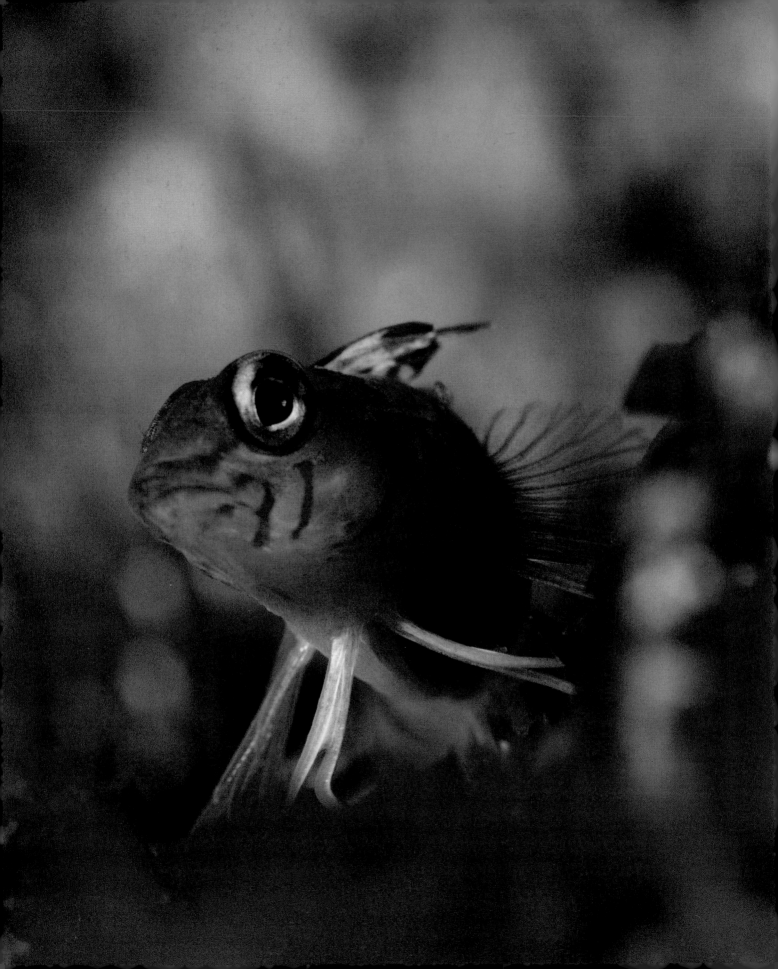

> **"** Most divers see coral reefs as the ultimate underwater destinations, but the cool, rocky shores beyond the tropics offer some equally remarkable experiences. Instead of hard corals, gardens of colorful sponges and anemones decorate the rocks, and the drifting schools of fish are made up of species unrecognizable to the warm-water diver. While these locations have had a very different set of evolutionary pressures, the end result is the same—diversity, from the smallest triplefin to the world's largest octopus. **"**

◁ A male blue-eyed triplefin (*Notoclinops segmentatus*) makes its home on a bed of algae. Poor Knights Islands, New Zealand.

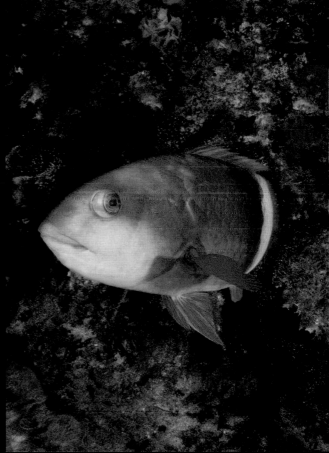

△ The sea spider or pycnogonida (*Stylopallene longicauda*) is related to terrestrial spiders and scorpions. Kangaroo Island, Australia.

△ A male blue-throated wrasse (*Notolabrus tetricus*) shows his bright colors, advertising his sexual maturity. Kangaroo Island, Australia.

ARTIFICIAL REEFS

Humankind has always been intimately involved with the marine world. As a source of food and as a means of transportation, we have exploited the seas and reefs since time immemorial. But we have left our mark—shipwrecks litter the seabed, jetties split the coastline, and oil rigs mark the horizon. These structures, which we often regard as eyesores, may well harbor a huge amount of life beneath the surface. Pier legs and bridge supports, for example, can become homes for colonies of barnacles and sponges. Similarly, a log washed out of a river from a logging camp might create an oasis of life on an otherwise empty silt plain. With the passing of time, the remains of a long-lost ship are likely to accommodate different kinds of passengers. Even our greatest feats of marine engineering become just temporary homes for generations of schooling fish, encrusting corals, and waving sea fans.

▷ A sailfin tang (*Zebrasoma veliferum*), looking for a meal, investigates the eggs that have been laid on the clean, flat surface of an artificial reef. Mabul, Sabah, Malaysia.

△ Orange-lined cardinalfish (*Archamia fucata*) schooling in the shelter of an overgrown plane wreck. Manokwari, West Papua, Indonesia.

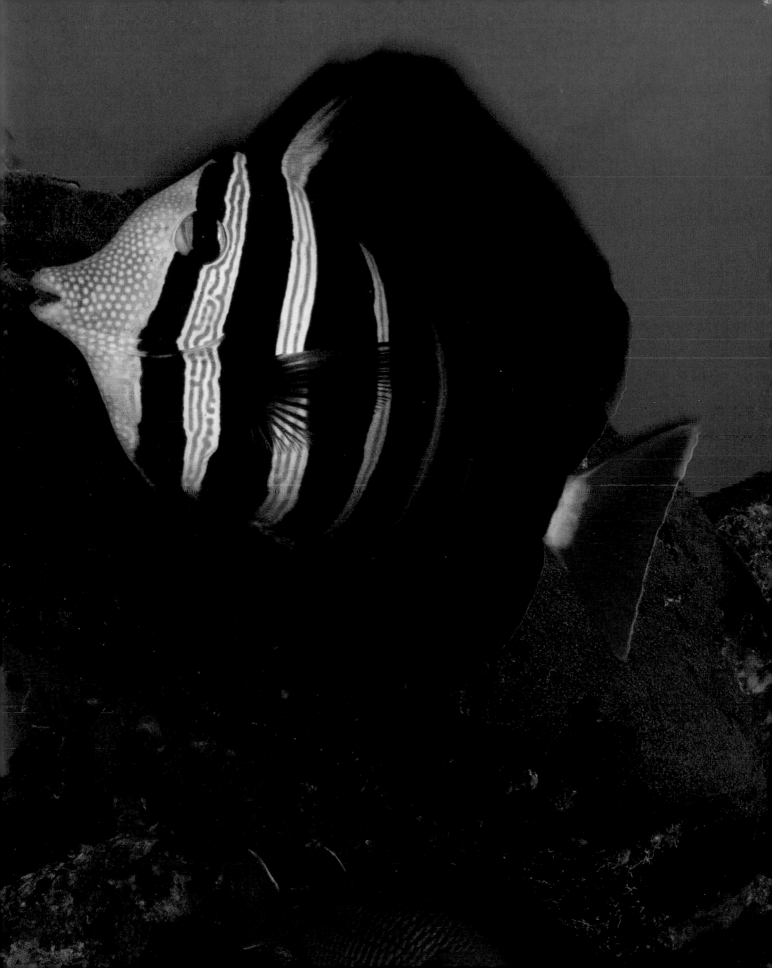

" Whether they have been sunk intentionally, or as a result of storms or war, wrecks are havens of life wherever they are found. In New Zealand, I dived on a decommissioned naval ship—with guns and shell racks still intact—that had been sunk deliberately as a diving attraction. But it is in places like West Papua that I've had the most rewarding dives on wrecks. Intact Catalina bombers are now home to sea fans and crocodilefish, coastal torpedo boats are crewed by schools of tiny fish that shelter in the holds, and tanks lie on the seabed, armed only with venomous scorpionfish. Despite the eerie atmosphere that seems to surround any wreck, the variety of life that can be seen makes diving on these sites an incredible experience. "

▷ The ghostly sight of a Catalina flying boat that lies intact on the seabed just outside Biak Harbor. Biak, West Papua, Indonesia.

△ Equipment still lies in place near the bow rails on the wreck of the HMNZ *Waikato*. Tutukaka, New Zealand.

△ The twin guns of the HMNZ *Waikato* are now choked with encrusting marine life. Tutukaka, New Zealand.

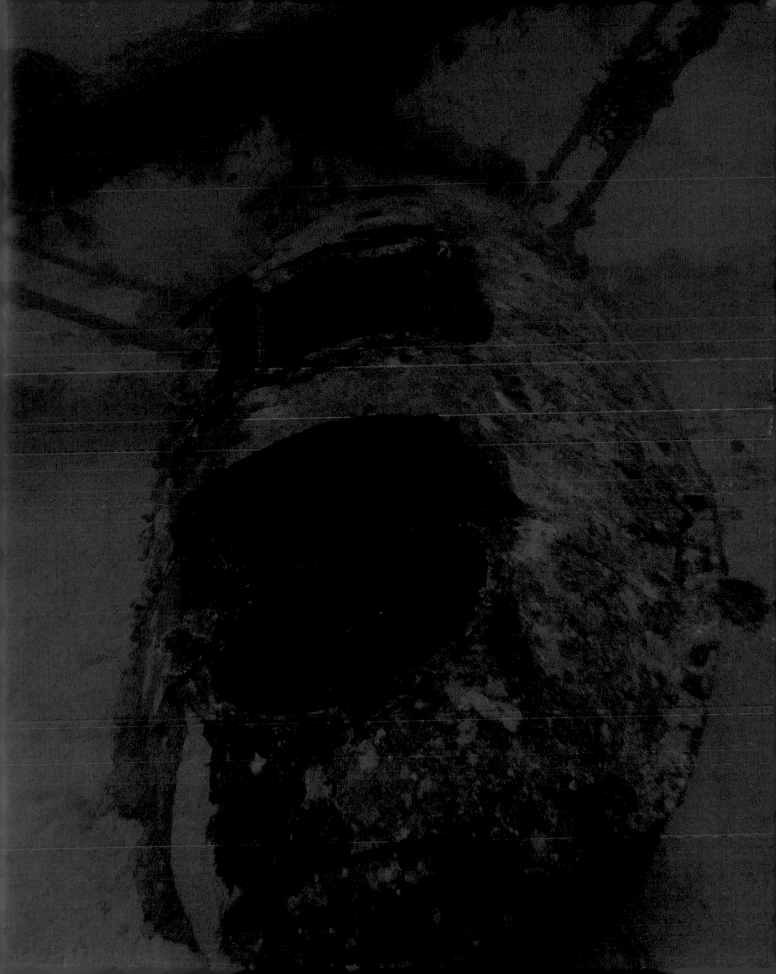

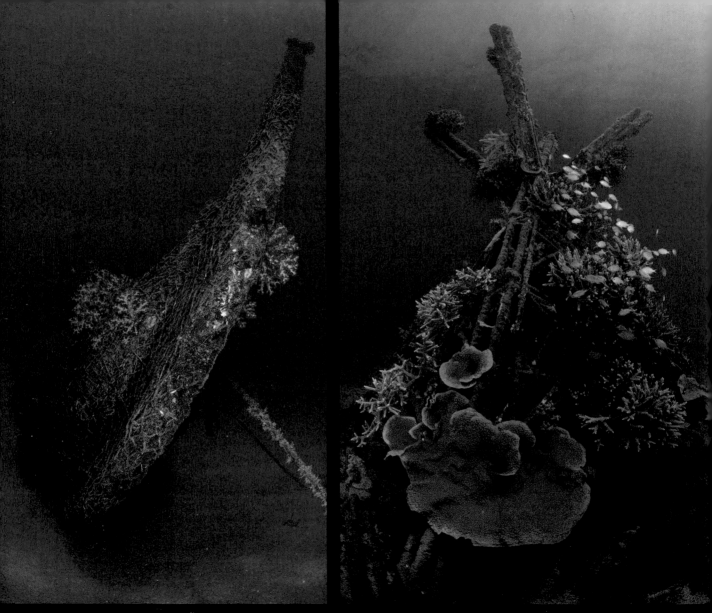

△ An old boat is wrapped in wire mesh to encourage the growth

△ Large plate corals growing on a tower of wire.

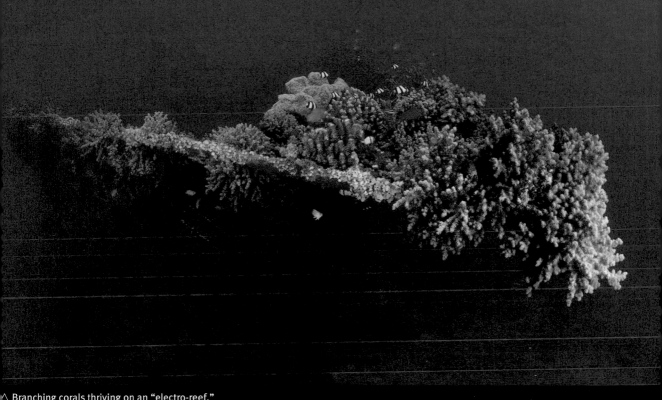

△ Branching corals thriving on an "electro-reef."
Pemuteran Bay, Bali, Indonesia.

△ The growing corals can be carefully removed and cemented onto
damaged parts of the reef. Pemuteran Bay, Bali, Indonesia.

△ Corals that have been left to grow on a wire frame.
Pemuteran Bay, Bali, Indonesia.

diversity

Drop beneath the surface of a calm sea to explore a coral reef, or swim through the mighty columns of a kelp forest, and it is clear that these environments harbor an astonishing diversity of species. A visitor to the marine world is greeted by the sight of hundreds of different types of fish and encrusting life, animals growing on animals, plants growing on plants. From tiny invertebrates hidden among the rocks to some of the largest animals on Earth, our reefs are an incredible example of evolution at work.

But why are these environments so diverse? It has long been thought that the richness of life on coral reefs is a product of the constant conditions in the tropics—warm seas and sunny days—combined with the vast time period over which plant and animal life has evolved. However, recent research shows that destructive typhoons and El Niño effects—the brief, violent events that punctuate otherwise stable conditions—also help to drive evolution forward in more unpredictable ways. Conditions and pressures of yet another kind

are created in cooler waters by the seasonal arrival of food and sunlight. For the inhabitants of temperate rocky shores and kelp forests, life cycles are synchronized with the arrival of nutrient-rich water, with seasonal blooms of algae, or with the mating cycles of their prey. It is the various ways in which animals have evolved to cope with these seasonal changes that has led to the diversity of species we see on the cooler, current-swept reefs.

All life on Earth began in the sea, and representatives from every major group of organisms can still be found underwater. Minute, photosynthesizing algae, and green, red, and brown seaweeds are some of the primary producers, capturing the sun's energy and forming the basis of the entire food chain. Much as in the great terrestrial rainforests of the world, it is the small invertebrate animals that demonstrate the greatest diversity. Worms and crustaceans, sponges and hydroids, featherstars and jellyfish have taken advantage of every conceivable niche—in the kingdom of the reef, invertebrates reign supreme.

> **Home to 90 percent of all marine species, the coastal zones are the richest marine habitats known to humankind.**

Human eyes view the reef on a human scale, unable to discern the stunning diversity of life that exists at a microscopic level. So for us it is the large, colorful animals that are synonymous with the reef—a gallery of different fish species, turtles, and mammals. Animals such as dolphins and whales, which capture our imaginations so acutely, are temporary visitors to the reef, while turtles and sea snakes take up permanent residence. Sharks and rays grab our attention, but it is the bony fish, such as gobies and wrasse, that have had the most evolutionary success, reaching their peak in the diversity of species on tropical reefs. There are, however, threats to this diversity. It is thought that global fish and seafood stocks will collapse within 50 years if current trends continue.

In the remote reaches of West Papua, Indonesia, some of the world's healthiest reefs were recently surveyed. Over 970 species of fish were recorded—including a record-breaking 283 on a single dive at Cape Kri. Also documented were 456 coral and 699 mollusk species. That's more species on a tiny group of islands than in the entire Caribbean Sea. Across the world, places like Cape Kri still exist, perfect examples of the incredible driving forces of evolution.

diversity

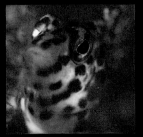

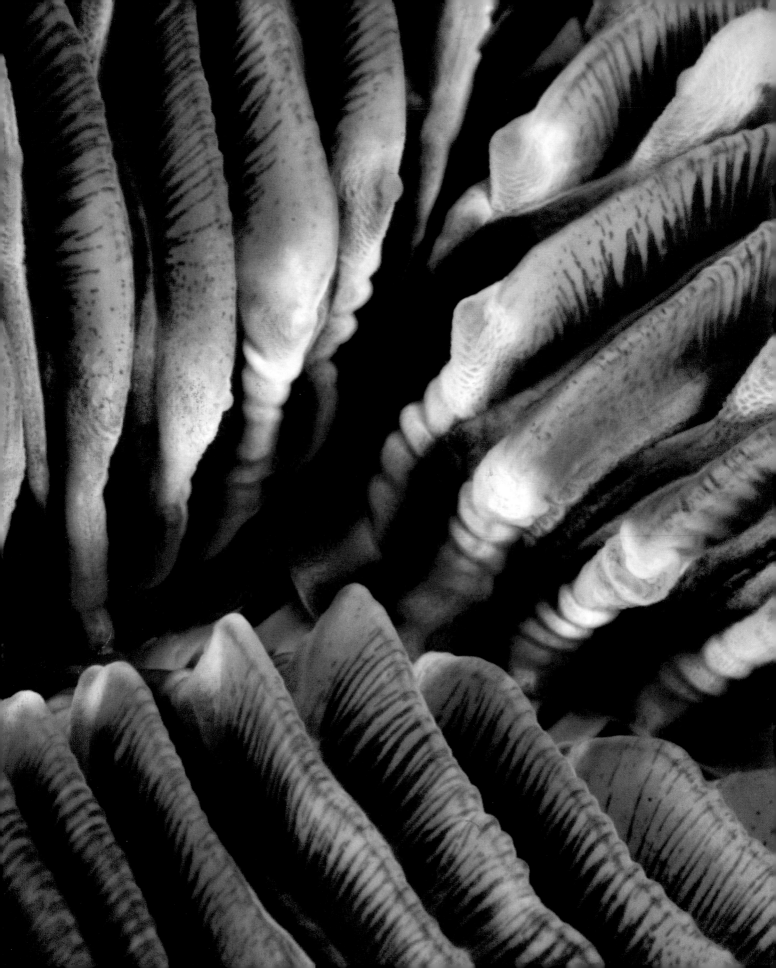

❝ There is so much beautiful detail and color just waiting to be discovered underwater. Sea fans and hard corals—such as this mushroom coral—have a certain symmetry that lends itself perfectly to macrophotography. I spend many of my dives searching the reef for a different composition or new combination of colors. ❞

◁ Unlike most species of coral, mushroom corals (*Fungia scutaria*) consist of a single animal rather than a colony. Each polyp has a central mouth, ringed by the colorful ridges of its limestone skeleton. At night, a crown of tentacles extends into the currents to feed. Raja Ampat Islands, West Papua, Indonesia.

Christmas-tree worms (*Spirobranchus giganteus*) burrow their bodies into hard coral, leaving only their colorful feeding tentacles on display. Raja Ampat Islands, West Papua, Indonesia.

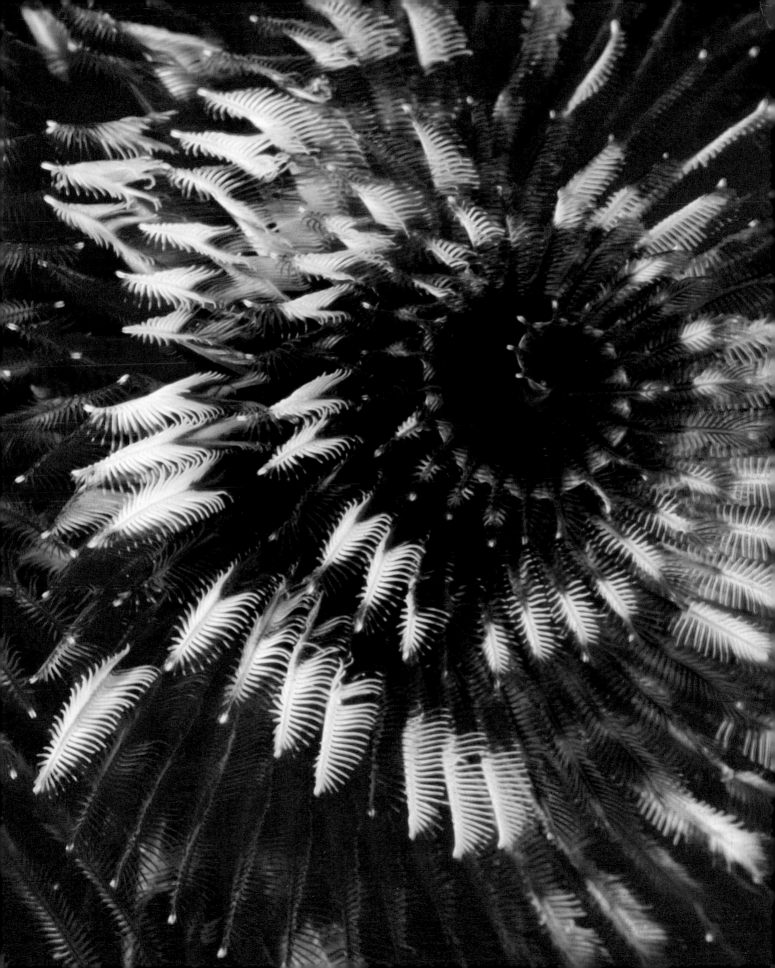

Imperial shrimp *(Periclimenes imperator)* live on a variety of host animals, such as this sea cucumber. They rely on their host's defenses to deter predators. Mabul, Sabah, Malaysia.

"I'd been searching for these animals for a long time and, although I had encountered them on a couple of occasions, I had never managed to capture the image I really wanted. During a dive in the Lembeh Straits in northern Sulawesi, I was shooting nudibranchs when my dive buddy signaled to me to take a look at something he had found. Hidden inside a black coral bush was this deep-sea squat lobster, well camouflaged against its home, and looking like something out of a science-fiction movie with its incredibly long, stiltlike legs."

▷ With a body no bigger than a child's fingernail, this is one of the few species of deep-sea squat lobster (*Chirostylus dolichopus*) that will venture into the shallow waters of tropical reefs. Lembeh Straits, Sulawesi, Indonesia.

A flabellina nudibranch (*Flabellina exoptata*) feeding on hydroids. It uses toxins within the hydroids for its own defenses, storing them in the colorful cerata on its back. Seaventures, Mabul, Malaysia.

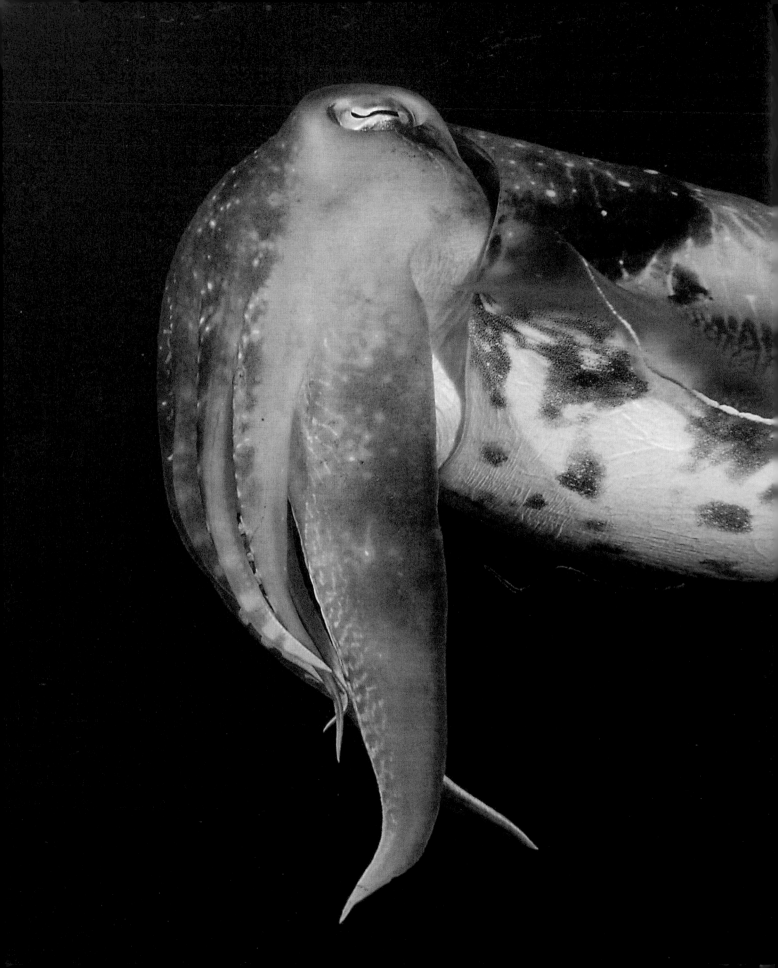

" Sangalaki is probably the only place I have visited where the resident cuttlefish allow divers to follow them as they go about their daily lives. You can watch them mate and lay white clusters of eggs in the hard coral and on rotting palm-tree stumps, but more fascinating is their hunting behavior. Rather than relying on camouflage, these broadclub cuttlefish use a stunning display of fast-moving bands across their bodies, confusing their prey so much that they can approach to within striking distance. "

DIVERSITY

◁ Like most cephalopods, broadclub cuttlefish (*Sepia latimanus*), which are about the size of a small dog, have a complex system of pigment sacs to instantly change the pattern and color of their skin. Sangalaki, Kalimantan, Indonesia.

A wonderpus (*Wonderpus photogenicus*) floats down through the water, looking like a crinoid or young lionfish. Like its relative, the mimic octopus, it has only recently been discovered. Sulawesi, Indonesia.

092

▷ Several decades ago, pygmy sea horses (*Hippocampus bargibanti*) were discovered by accident on a sea fan collected for an aquarium. Barely longer than a grain of rice, these fish have only been located in their natural habitat in the last few years. It is thought that the seven or eight types found so far may well be different species, but all are equally elusive. Mabul, Sabah, Malaysia.

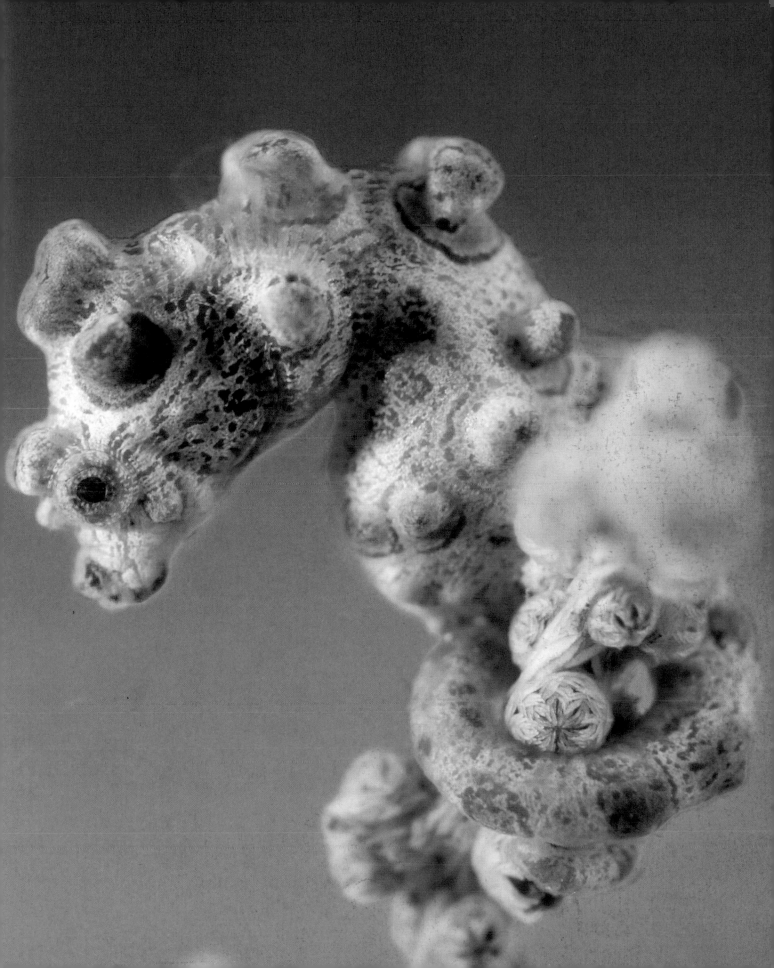

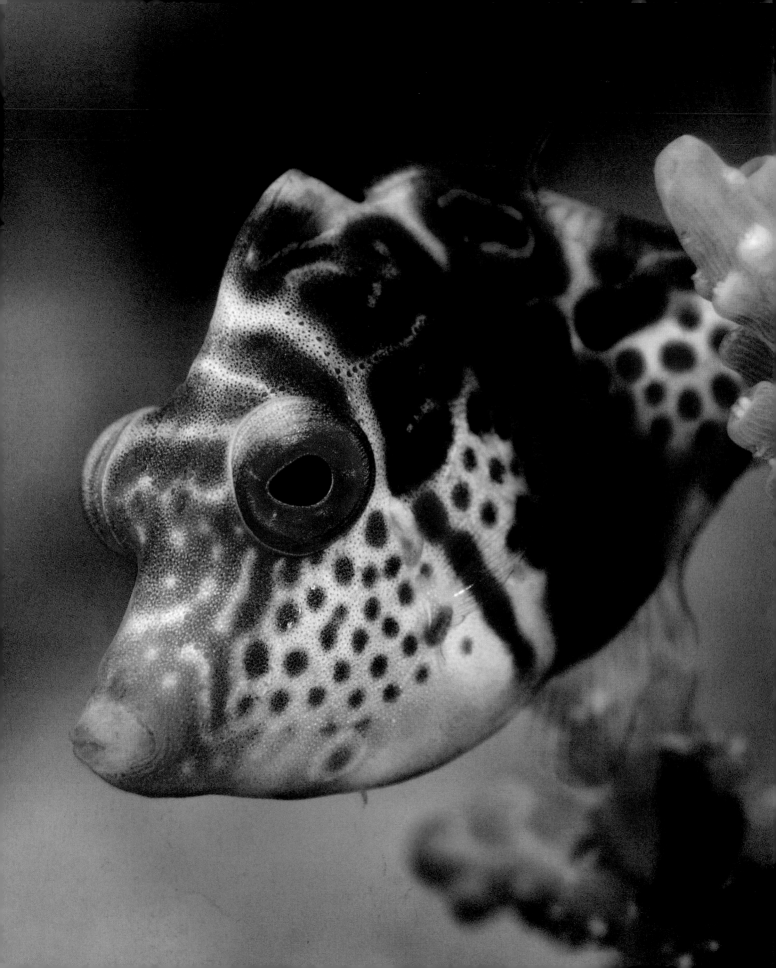

A juvenile mimic filefish (*Paraluteres prionurus*) resembles the toxic saddled toby—a tactic that allows it to warn off predators without having to go to the expense of actually producing any toxins for itself. Abai, Biak, West Papua, Indonesia.

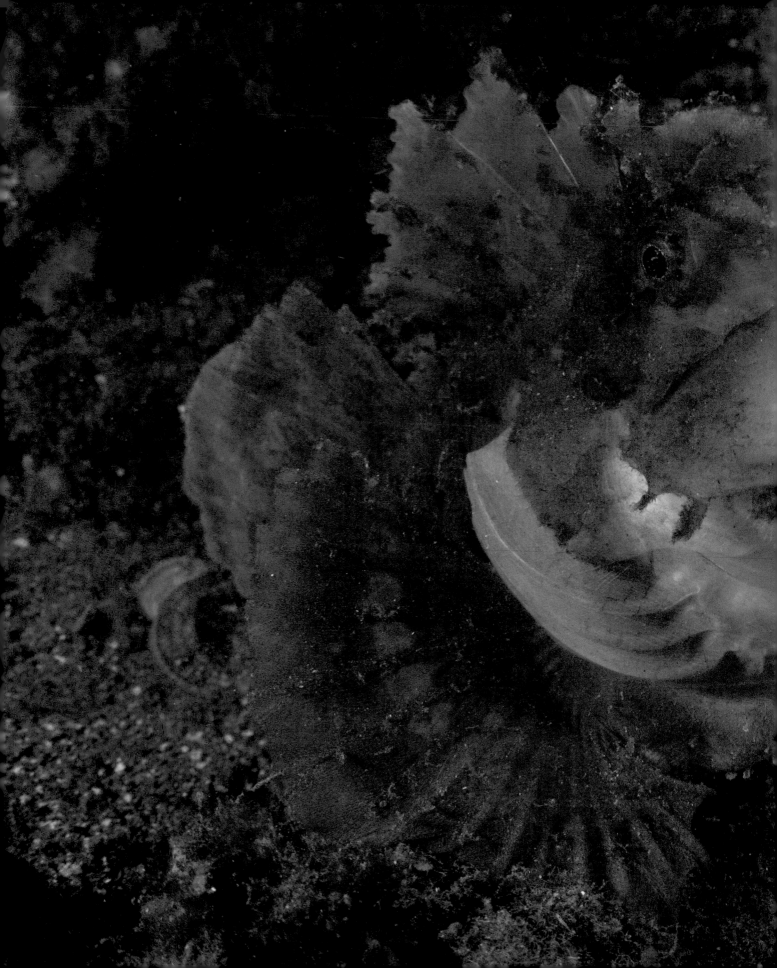

“ These beautiful fish are rare and difficult to track down but, as they don't move around too much, once located they can be visited again and again. I had spent a great deal of time over many dives trying to capture a shot that gave an insight into the animal itself and the environment in which it reigned. After three weeks of shooting, on the last dive of the last day, I went back to this particular fish and finally got what I was looking for, as it stretched out its cavernous jaws in a threat display. ”

◁ Weedy scorpionfish (*Rhinopias frondosa*) are some of the most beautiful fish on tropical reefs, although their stunning colors only show up under the lights of a camera strobe. In natural light, they blend into the background perfectly, relying on camouflage to get close to the small fish that make up their diet. Lembeh Straits, Sulawesi, Indonesia.

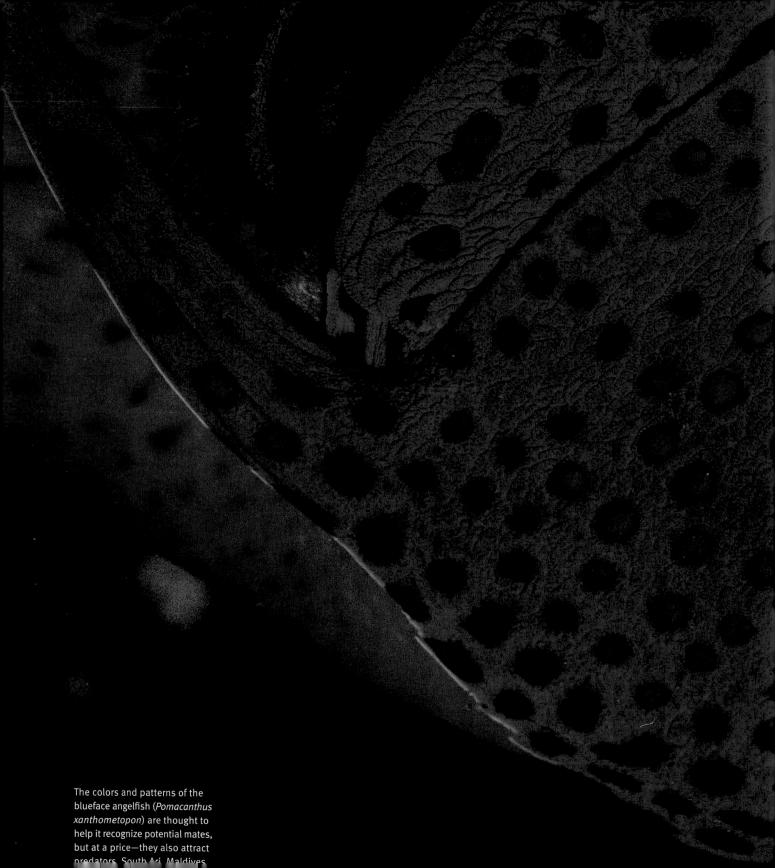

The colors and patterns of the
blueface angelfish (*Pomacanthus
xanthometopon*) are thought to
help it recognize potential mates,
but at a price—they also attract
predators. South Ari, Maldives.

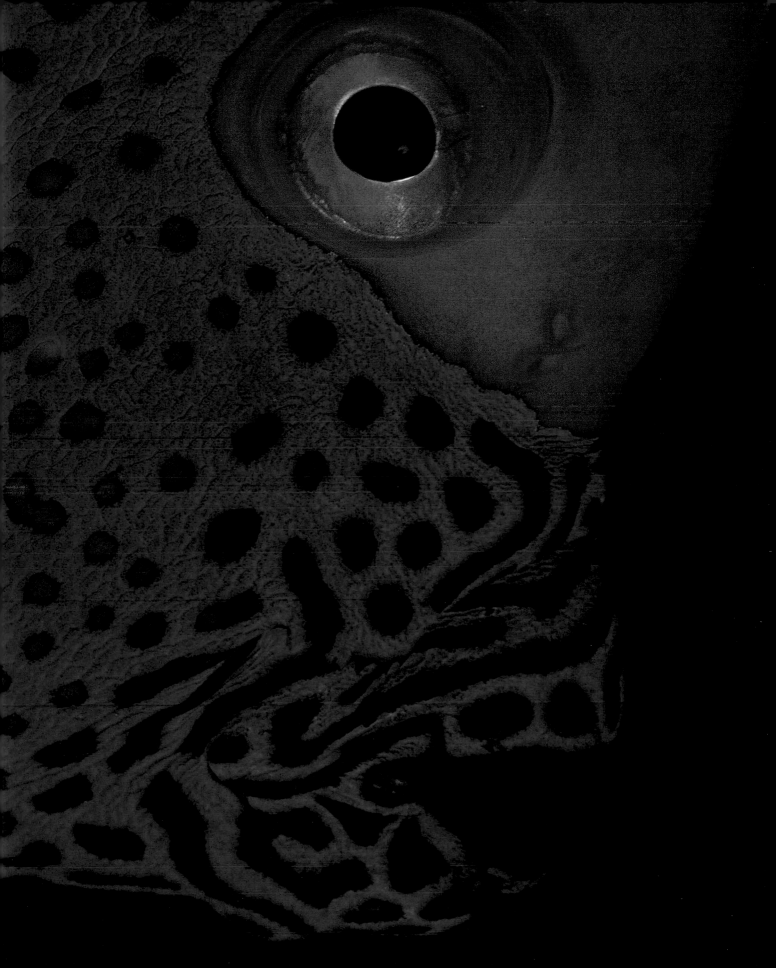

" We'd traveled to South Africa to shoot tiger and grey nurse sharks but, due to horrendous weather, decided to travel on to Sodwana and try our luck on the shallow reefs. The potato bass we found there made it all worthwhile. The huge fish were extremely confident, standing their ground as we approached. They even came right up to us to see what we were shooting, or to stare in seeming fascination at their own reflection in the camera's dome port. "

▷ Giant potato bass (*Epinephelus tukula*) are among the largest of all bony fish, growing to over 6 ft (2 m) in length and 220 lb (100 kg) in weight. They are keystone predators, controlling the populations of smaller fish and crustaceans in the large territories they patrol. They are also very inquisitive, eager to examine any newcomers on their patch of reef. Sodwana Bay, South Africa.

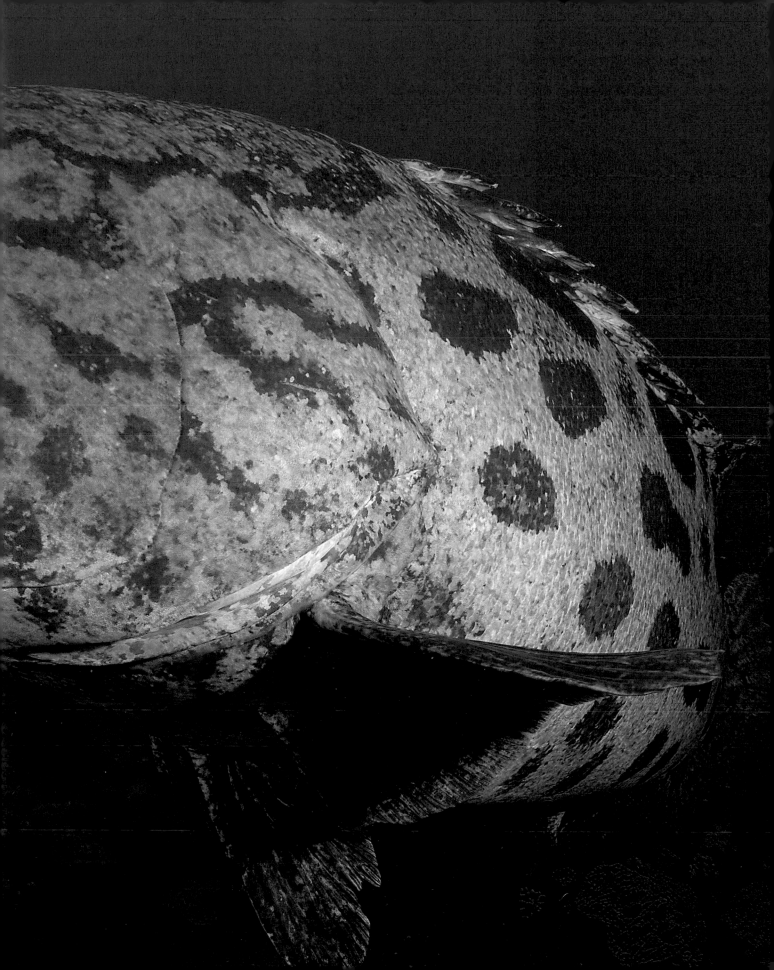

" Despite their fearsome reputation, most moray eels are surprisingly gentle and shy animals. The blackcheek, however, is one of the few species of moray eel that deserves its reputation. On a drift dive in the Maldives, I was forced to grab hold of the bare rock to stop myself from being swept out to sea. Unfortunately, my middle finger slipped into a small hole that was home to a young blackcheek moray—which promptly ripped my nail in half with its razor-like teeth. "

▷ The blackcheek moray eel (*Gymnothorax breedeni*) is found throughout the Indian Ocean and on a few isolated islands in the Pacific Ocean. It is a superbly adapted predator that has extra teeth in the roof of its mouth to help it hold on to struggling fish. Ari Atoll, Maldives.

"" I'd been searching for eagle rays and stingrays around a shallow bay in the Poor Knights Islands for several days, and although I'd seen quite a few, most were very shy and would move off as soon as I approached. However, one particular eagle ray accepted my presence and allowed me to get extremely close to where it lay, half-hidden by the seaweed. It would move off to hunt for food buried in the sand and then settle back down in the same area, giving me the chance to capture what I wanted. ""

▷ New Zealand eagle rays (*Myliobatis tenuicaudatus*) are a common sight along shallow, rocky shores, and even in kelp forests. They feed on crustaceans, digging them out from beneath the sand or pulling them off rocks, before crushing their shells with strong, platelike teeth. Poor Knights Islands, New Zealand.

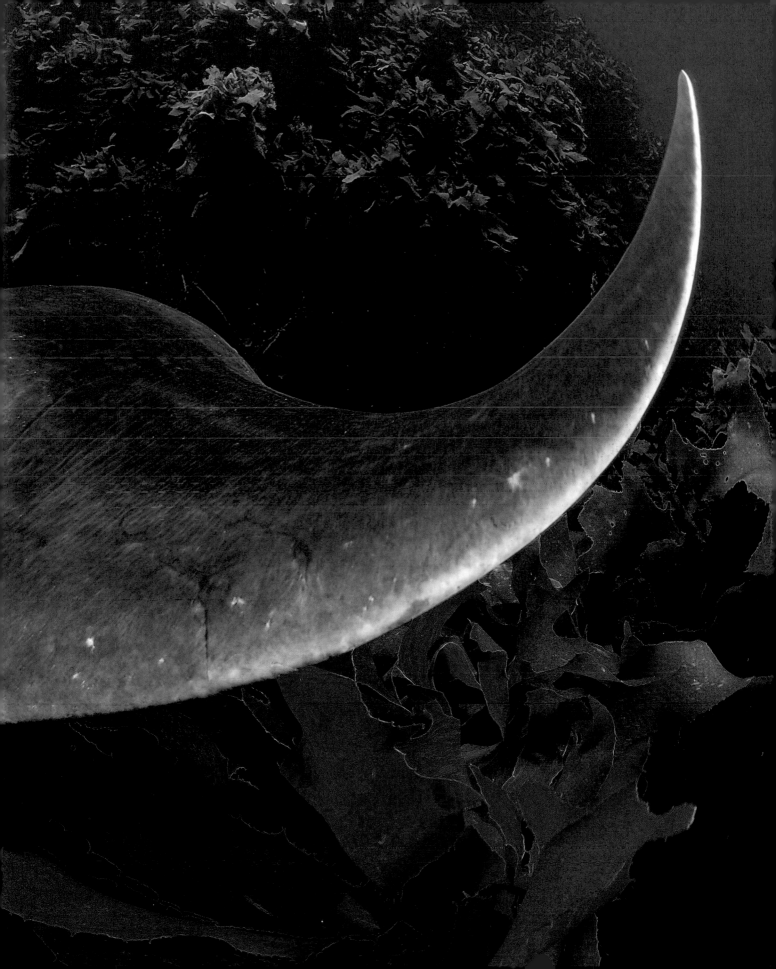

The manta ray (*Manta birostris*) usually follows currents in the open ocean, only coming in to the reefs to feed in current-swept channels or to visit cleaning stations. Raja Ampat Islands, West Papua, Indonesia.

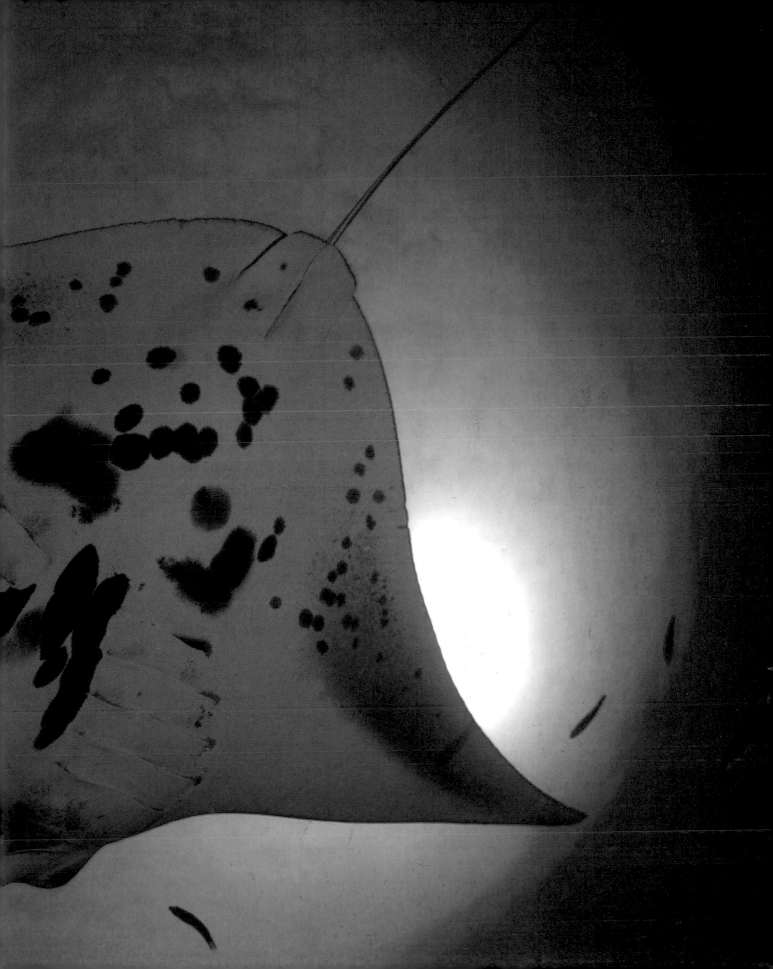

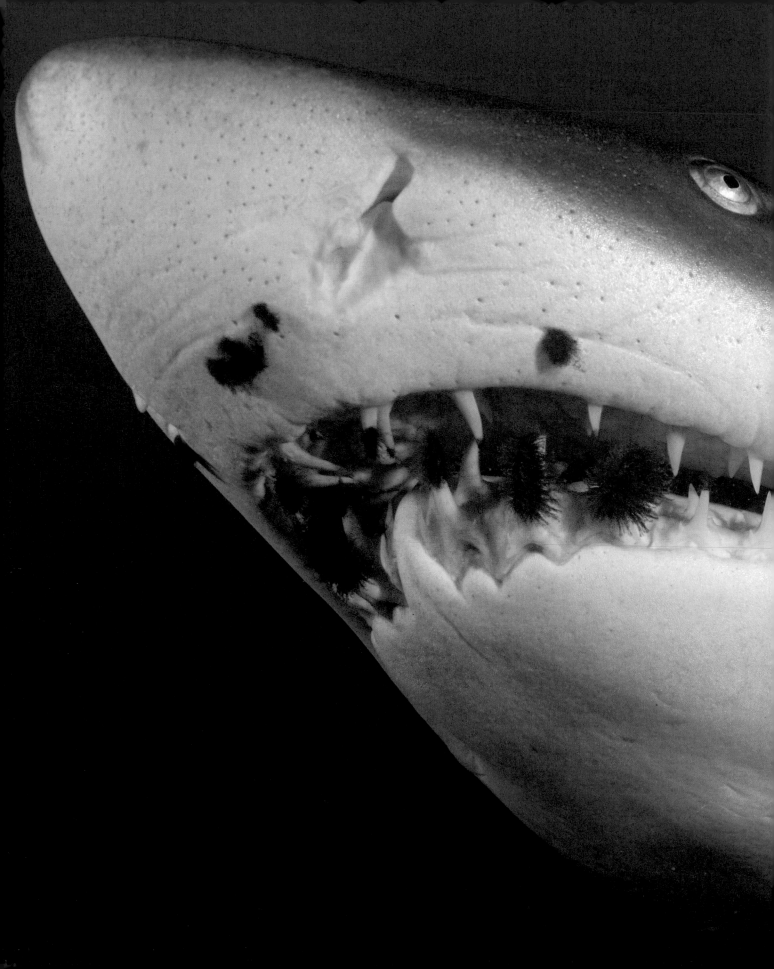

" If there's a saying that sums up the sand-tiger shark, it's "never judge a book by its cover." These fearsome-looking sharks, which always seem to have too many teeth for their mouths, are actually gentle and approachable animals. However, as with any wild animal, it is always best to err on the side of caution when diving with these sharks, giving them the space and respect they deserve. **"**

◁ The sand-tiger shark (*Carcharias taurus*) is common in shallow tropical and subtropical waters. Its remarkable teeth have evolved to help it capture its prey—small fish find it very hard to escape from the mass of spiny teeth. Sodwana Bay, South Africa.

" Aliwal Shoal is well known for its concentrations of dangerous sharks. We'd traveled there to shoot the resident tiger sharks, but it was the blacktips that gave us the most problems. Big groups would suddenly emerge from the murky water, darting at us from below or behind. They seemed to be attracted to the electrical field of my lighting strobes, and kept bumping them with their snouts— not something that I particularly enjoyed! "

▷ The blacktip shark (*Carcharhinus limbatus*) is the hyena of the underwater world, traveling in a pack and showing little fear of other, larger predators. Aliwal Shoal, South Africa.

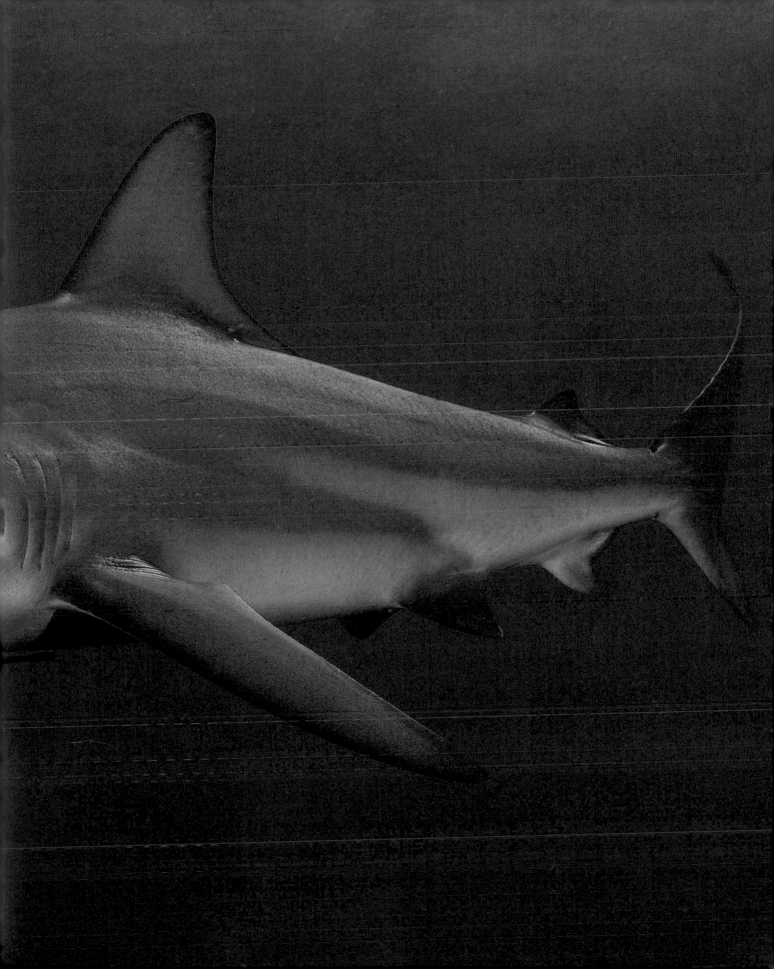

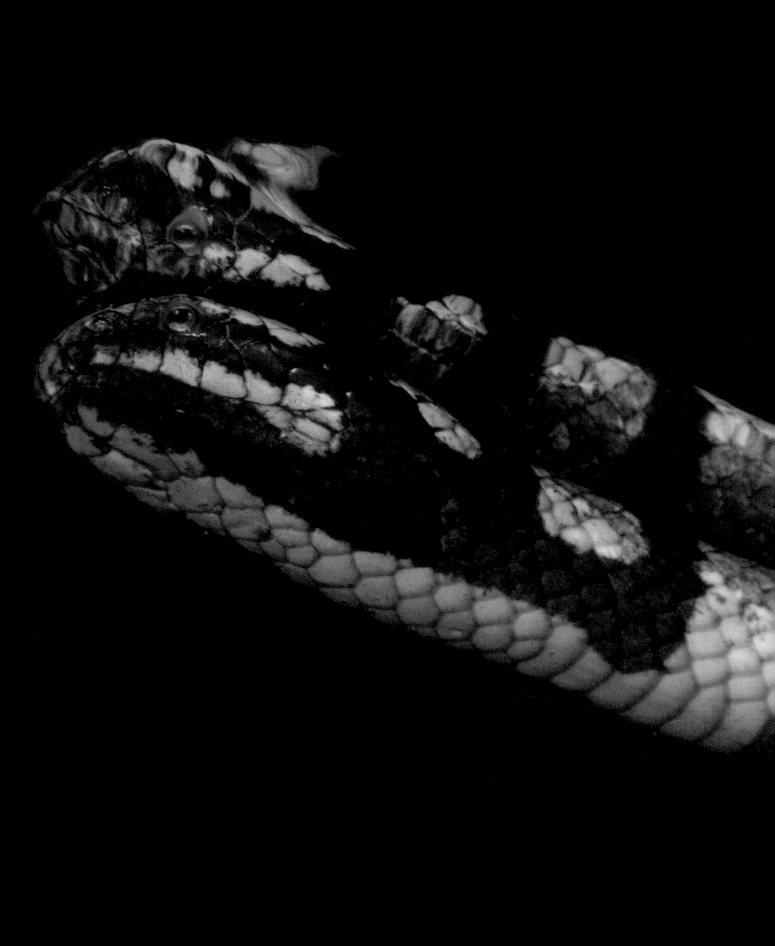

" Despite being one of the most venomous species of animals in the world, sea snakes are far from aggressive. I spotted this old snake several days in a row, sleeping beneath a resort built out over the water on Maratua in Kalimantan. One evening, as I swam in after a sunset dive, I saw her out hunting for small fish. She seemed completely unperturbed as I followed her in the gathering darkness, the still, inky water proving the perfect mirror for her reflection. "

◁ Like all reptiles, the banded sea krait (*Laticauda colubrina*) evolved for a life on land before returning beneath the surface of the ocean once again. Banded sea kraits still retain many of their adaptations for life on land—as well as having to fill their lungs at the surface, they must return to dry land to lay their eggs. Maratua, Kalimantan, Indonesia.

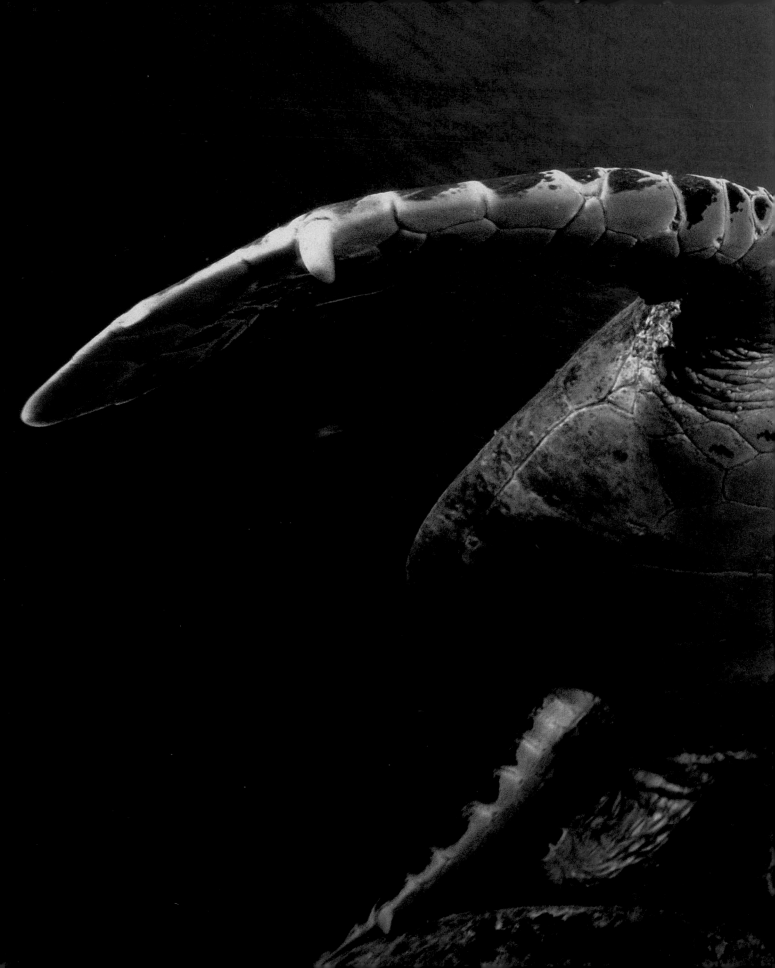

A hawksbill turtle (*Eretmochelys imbricata*) poses on the reef top, giving cleaner fish the chance to eat parasites underneath its body and between the folds of skin around its limbs. Sipadan, Sabah, Malaysia.

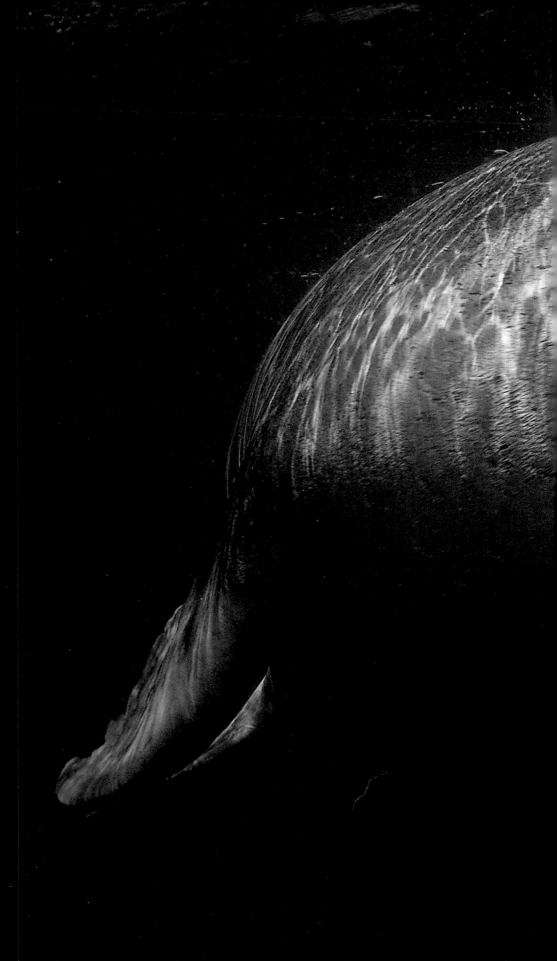

" As part of a recent trip to Australia, I was lucky enough to visit a sea-lion colony on an isolated stretch of rocky shore. After I'd been photographing the colony for some time, I suddenly had the feeling that I was being watched. Turning around, I came face to face with a juvenile male that hovered in front of my face, assessing my potential as a playmate. However, despite the fact that he was still a juvenile—and undeniably cute with his large, dark eyes and friendly expression—I was careful to give him plenty of space and waited for him to approach me. Play is one thing, but sea lions are powerful animals and accomplished predators that deserve plenty of respect. "

▷ The large eyes and whiskers of the Australian sea lion (*Neophoca cinerea*) have evolved to help it feed in the cool, dark waters of its home. Kangaroo Island, Australia.

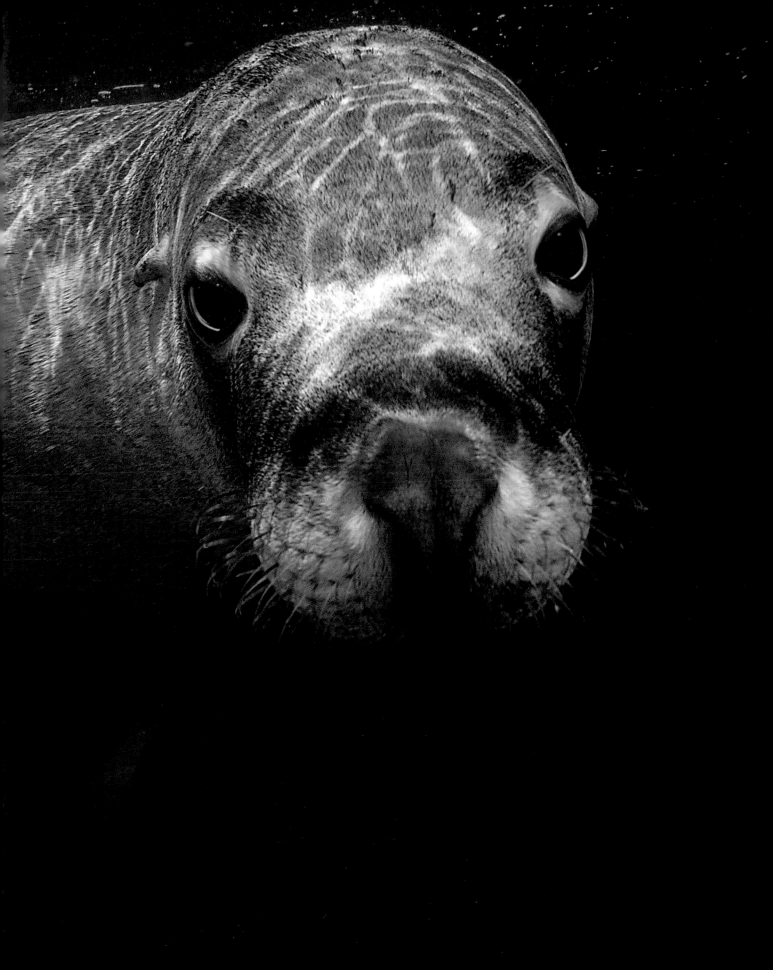

Spinner dolphins (*Stenella longirostris*) are named after their acrobatic displays. They can leap 10 ft (3 m) into the air, twisting their bodies before hitting the surface again. Fernando de Noronha, Brazil.

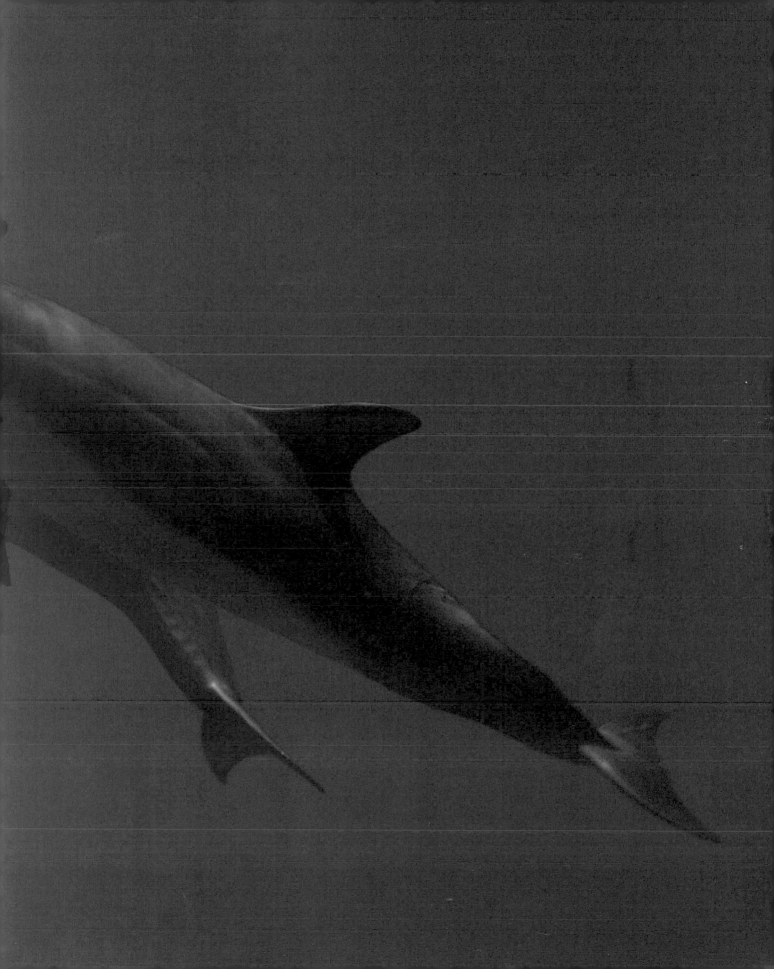

survival

The remarkable diversity of species found in the marine world is the physical manifestation of how organisms have evolved to survive in a world of intense competition. What we see today when we descend beneath the surface is the product of millions of years of competition between each and every plant and animal. This intense rivalry has led to ever more specialized means of survival, and has pushed animals into new relationships with one another. Ultimately, the pressure to adapt has meant that more and more species have evolved, adding to the stunning gallery that once awed Wallace and Darwin.

There are both producers and consumers on the reef. The producers are the plants, corals, and plankton that capture the energy of the sun and convert it into food. To compete for light and space, temperate kelps have evolved remarkable rates of growth—so that they can tower over their competitors and block out the sun. Tropical corals, on the other hand, use chemical warfare to kill off their neighbors, fighting for centuries over inches

of sunlit reef. Corals even recruit minute defenders in the shape of crabs that bite the feet of marauding starfish.

The consumers on the reef are the animals that must eat in order to survive, unable to produce their own food. It is their drive to find food that has led to much of the diversity in the marine world today. Space is at a premium for filter-feeders that fight for access to the richest currents. Grazers of algae or sessile animals must overcome cocktails of toxic chemicals, often going on to use them in their own defense. Predators have to locate their prey and lure them in, surprise them, or chase them down to guarantee a meal. Prey, meanwhile, must remain hidden, escape, or deter their foes from attack. Both are locked in a classic, spiraling arms race of evolution, producing ever more finely detailed camouflage, remarkable senses, wicked arms, or resilient armor.

Some surprising relationships have evolved between species, giving them the edge over their competitors and a better chance of survival. Many

> **In a world of limited space, light, and food, organisms have been forced to adapt in order to survive on the reef.**

are loose, temporary partnerships between hunting fish. Others are more dedicated, from the gobies that defend their partner shrimp so they can both live in safety, to the well-known bond between anemones and their beautiful, live-in partners, anemonefish. As if to illustrate how well-established these relationships are, some fish have evolved to mimic the appearance and behavior patterns of benign cleaner fish, so that they can abuse the trust of other animals.

To survive is one thing, but to thrive, a species must reproduce and populate the reefs with the next generation. Animals must locate a mate and survive to tell the tale, genetic material must be swapped, and eggs must be dispersed in plankton or hidden away for safety. Underwater there is an incredible variety of sexual lifestyles, from asexual reproduction, hermaphrodites, and monogamous pairs, to orgies of mass-spawning, sex changes, and harems of males or females. Eggs are cradled in the jaws of their parents, males carry their partner's eggs, and cannibal fetuses eat their own brethren before they have left their mother's body. On the reef, the drive to seek out light, to find food, and to reproduce means that no lifestyle option has gone untried or unexplored.

survival

Predator

By picking off the weak, old, and diseased, predators control the numbers of their prey and uphold evolution's ruthless laws of survival.

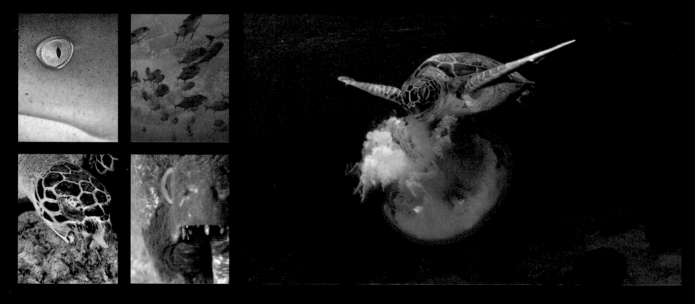

Predators rely on capturing and eating other animals to survive, and there are many ways of eating—and being eaten. Nudibranchs have chemical sensors for tracking down other sea slugs or sessile animals, which they engulf in slow motion. Other invertebrates, such as giant octopuses, use their huge, flexible bodies to smother the reef, probing for crustaceans or small fish with their long arms. Their cousins, the cuttlefish, have spikelike tentacles for spearing prey at blinding speeds, while mantis shrimp have arms equipped with either lethal spines or bulky clubs, which they employ to seize or smash their prey.

The senses are vital for all predators. Sharks, for example, are able to pick up electrical signals from the muscles of animals, even if their quarry is buried beneath the sand. In fact, the bizarre head of the hammerhead shark is thought to increase the sensitivity and accuracy of its electric-field sensory system.

△ A green turtle (*Chelonia mydas*) devours a jellyfish that has drifted close to the reef.
▷ The tiger shark (*Galeocerdo cuvier*) is an apex predator that usually hunts at night.

Many predators actively hunt for prey, while others lie in wait, their bodies camouflaged against the reef. For some, stillness and patience are key, while for others, speed is paramount—frogfish, for example, have the fastest recorded feeding action of any known fish.

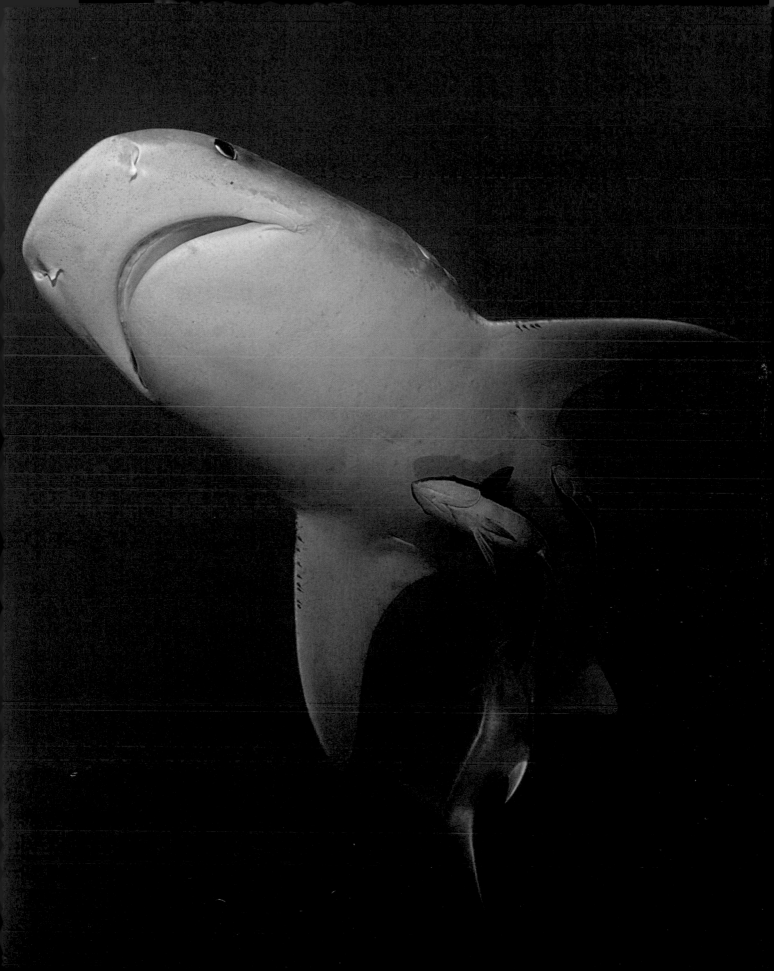

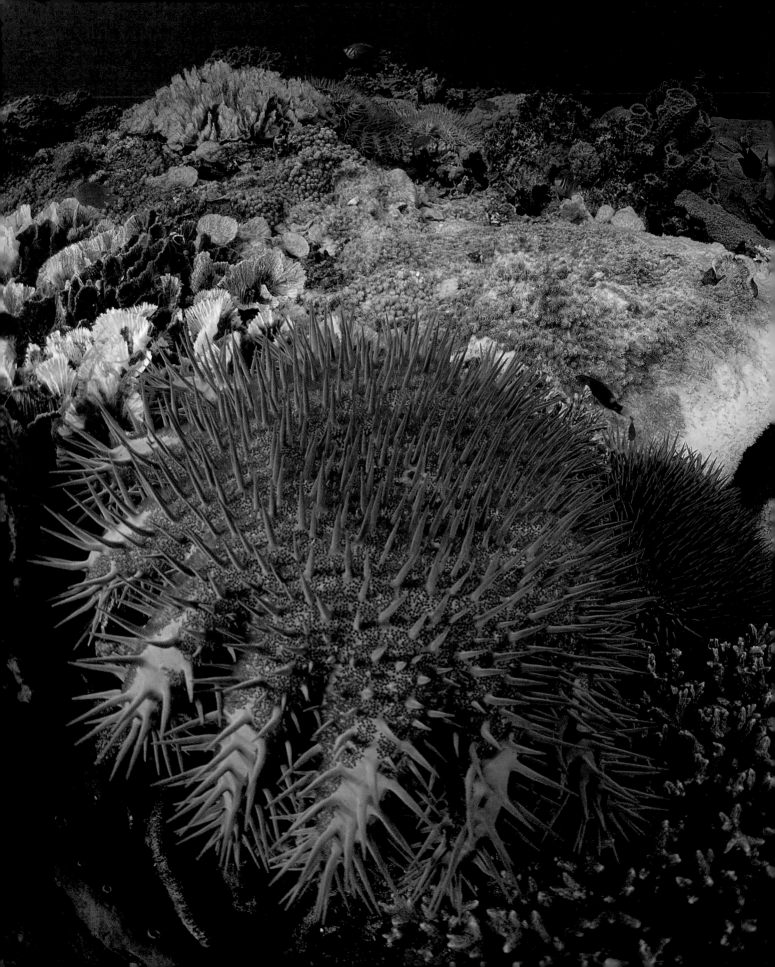

Sponges and corals contribute to the growth of the reef as a whole and also provide nutrients for the many species of animals that feed on them. Triggerfish, for example, have a highly varied diet and will sometimes feed on soft corals while grazing on other animals. Other species have a specialized diet based solely on corals or sponges—the infamous crown-of-thorns starfish is a voracious predator of hard corals and can damage huge areas of tropical reef. It feeds by inverting its stomach onto the live corals and digesting them in situ, leaving a trail of bare white coral skeletons in its wake. Bumphead parrotfish also feed on hard corals, ingesting huge amounts of coral skeleton, which is eventually excreted as sand. In fact, the sand on many tropical beaches has passed through these fish. To combat predation, sponges contain a lethal cocktail of toxins and have a silicaceous skeleton that most animals find indigestible, although the hawksbill turtle is one of the world's only animals that can feed primarily on sponges.

◁ Crown-of-thorns starfish (*Acanthaster planci*) are common on tropical reefs and contribute to the turnover of space and species by clearing away patches on the reef. However, if the predators of the adult starfish, or juveniles floating in the plankton, are removed through overfishing and pollution, they can reach plague proportions, destroying an entire reef system in a matter of months. Sulawesi, Indonesia.

" The atoll of Layang Layang is best-known for offering divers exhilarating encounters with big sharks. However, during a morning dive there I found myself getting very excited about one of the reef's smaller inhabitants. Clown triggerfish are usually very shy animals, swimming away long before you can get to within shooting distance. So I was very surprised when this particular individual seemed completely unperturbed as I approached. I managed to photograph the fish as it plucked at mouthfuls of bright soft coral, behavior I had never witnessed before in this beautiful fish. "

▷ The clown triggerfish (*Balistoides conspicillum*) has a varied diet and is one of the few animals known to feed on soft corals. Layang Layang, Sabah, Malaysia.

▽ The bumphead parrotfish (*Bolbometopon muricatum*) is a large, schooling fish that bites off pieces of both living and dead coral, feeding from dawn until dusk. Sipadan, Sabah, Malaysia.

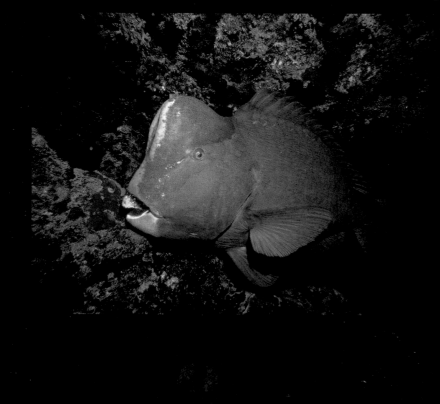

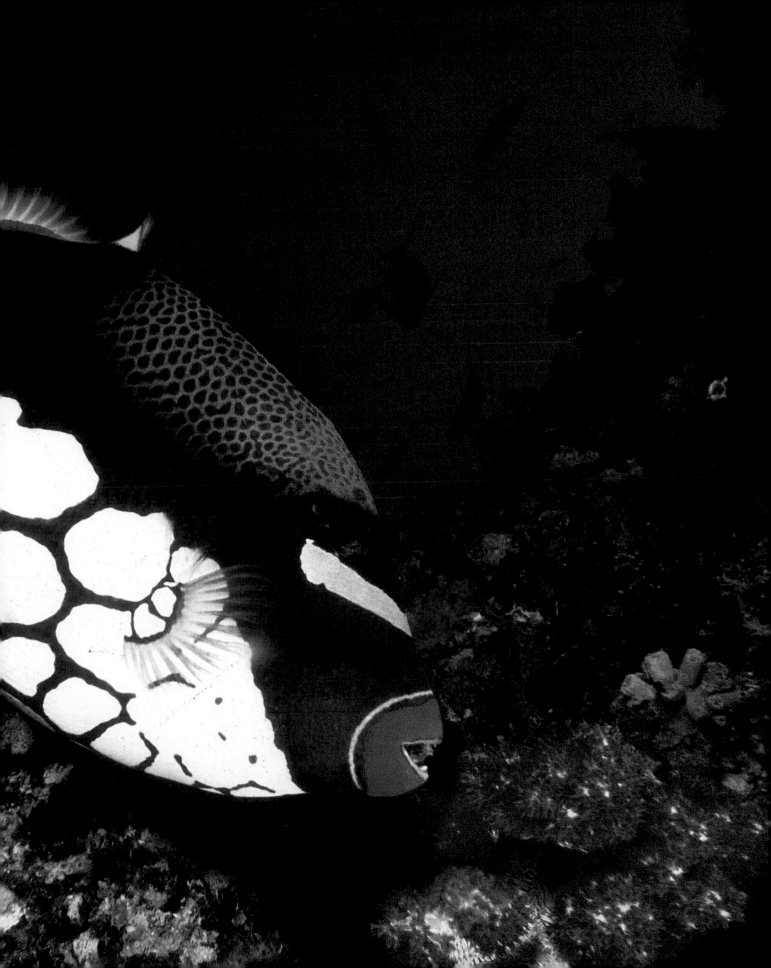

" The last place you'd expect to find a turtle is beneath an old oil platform. However, while out looking for frogfish beneath a rig that has been converted into an artificial reef, I came across a hawksbill turtle busily digging away next to one of the huge metal supports. Among the favorite foods of these turtles are the small encrusting sponges that grow hidden beneath the old broken coral and, once they have ripped up the rubble and started to feed, nothing distracts them from their hunt for these morsels. As a result, I was able to capture a feeding sequence at very close quarters. "

▽▷ This hawksbill turtle (*Eretmochelys imbricata*) uses its front flippers and strong beak to pull small encrusting sponges free of the rock or coral on which they grow. Although the hawksbill doesn't feed exclusively on sponges, they do form a large part of its diet. Mabul, Sabah, Malaysia.

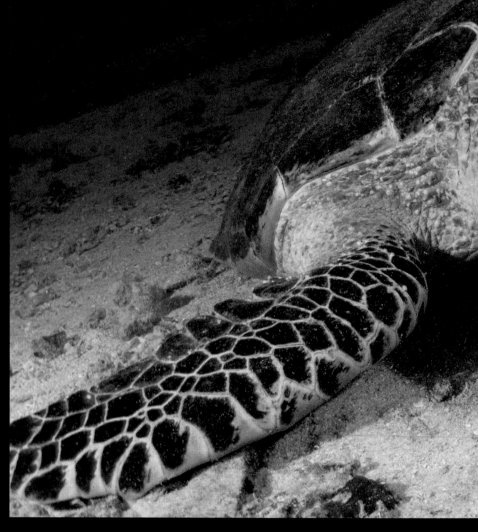

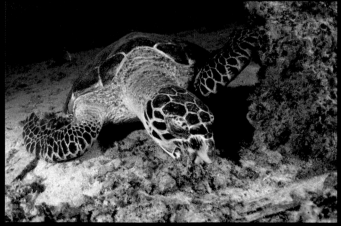

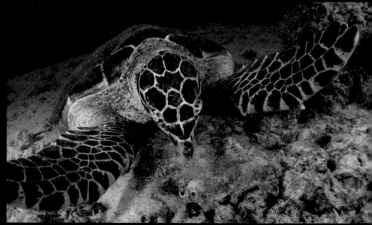

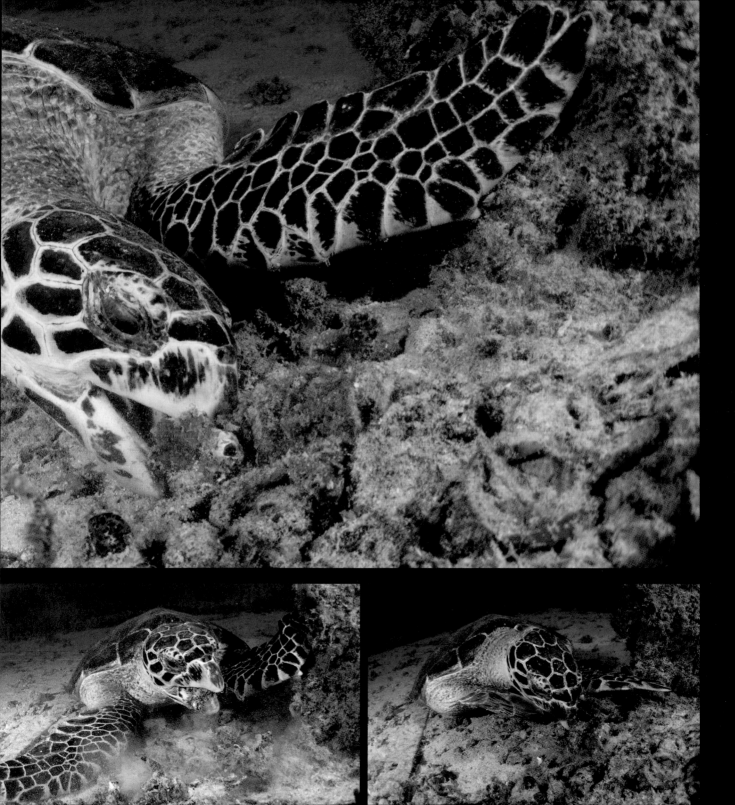

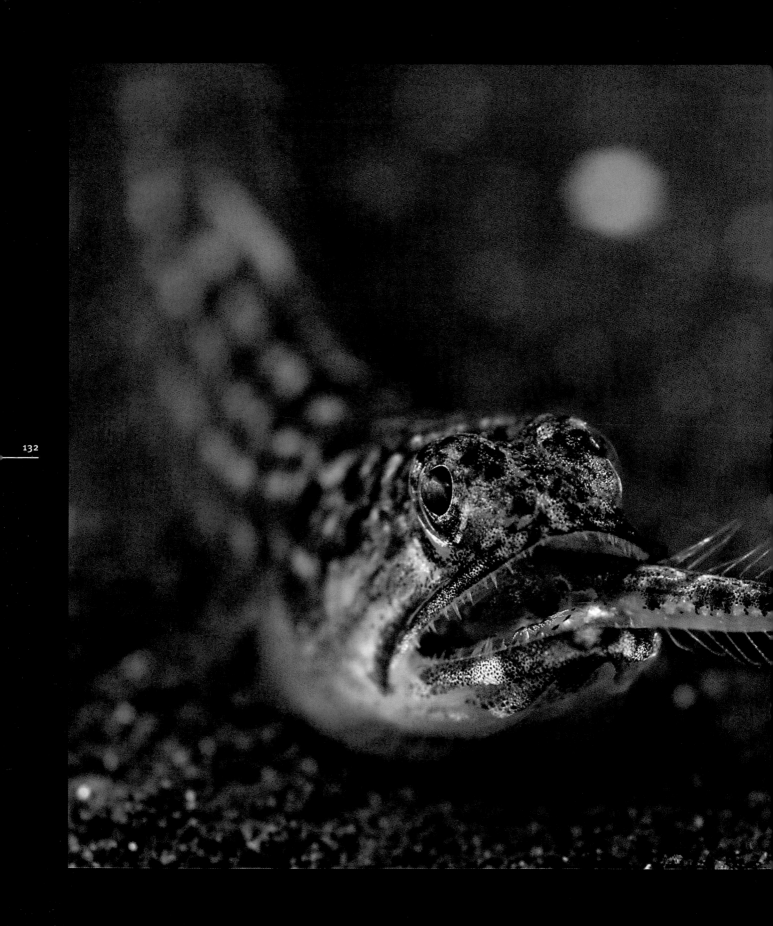

LYING IN WAIT

Ambush predators rely on a combination of camouflage, stealth, speed, and deception to capture their prey. Scorpionfish lie hidden on rocks and corals, waiting for a chance to snatch at their prey, while snakefish and lizardfish actually bury their bodies in the sand, leaving only their vicious mouths exposed. Mantis shrimp have evolved arms like heavy clubs, or ones covered in sharp spines, and prefer to bide their time in permanent burrows dug deep into the sand, waiting for the opportunity to smash hapless crustaceans or strike out at passing fish. The ultimate ambushers on the reef, however, are the frogfish—with perfect camouflage, inviting lures, and the fastest strike of any known marine animal, few fish escape these unusual animals.

◁ After lying in wait, the snakefish (*Trachinocephalus myops*) pounces on a small goby or triplefin. To trick its prey, the snakefish buries its body in the sand, leaving only its head and mouth exposed. Lembeh Straits, Sulawesi, Indonesia.

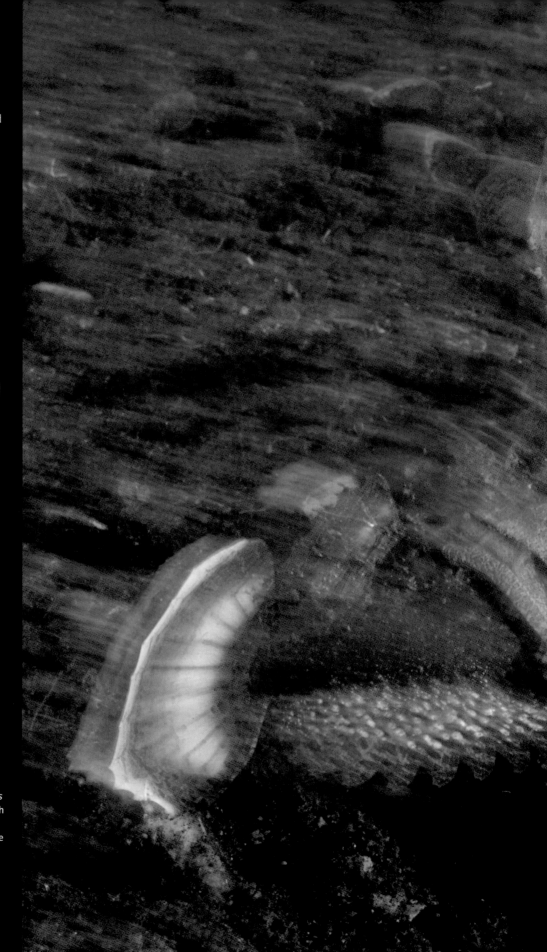

" The shallow Lembeh Straits are perfect for capturing animal behavior. I'd set out to photograph mating fish and had been following a pair of devil scorpionfish for over an hour, watching as the male tried to impress the female by shuffling and vibrating his body. However, he clearly didn't make the grade, as the female promptly struck out at the smaller male as he passed in front of her, swallowing him headfirst. I was lucky enough to shoot a few frames before the male disappeared into the stomach of his cannibalistic partner. In a matter of seconds, he had gone from potential mate to convenient meal. "

▷ The devil scorpionfish (*Inimicus didactylus*) snaps up its prey—which can include members of its own species—in a rapid movement once within striking distance. Lembeh Straits, Sulawesi, Indonesia.

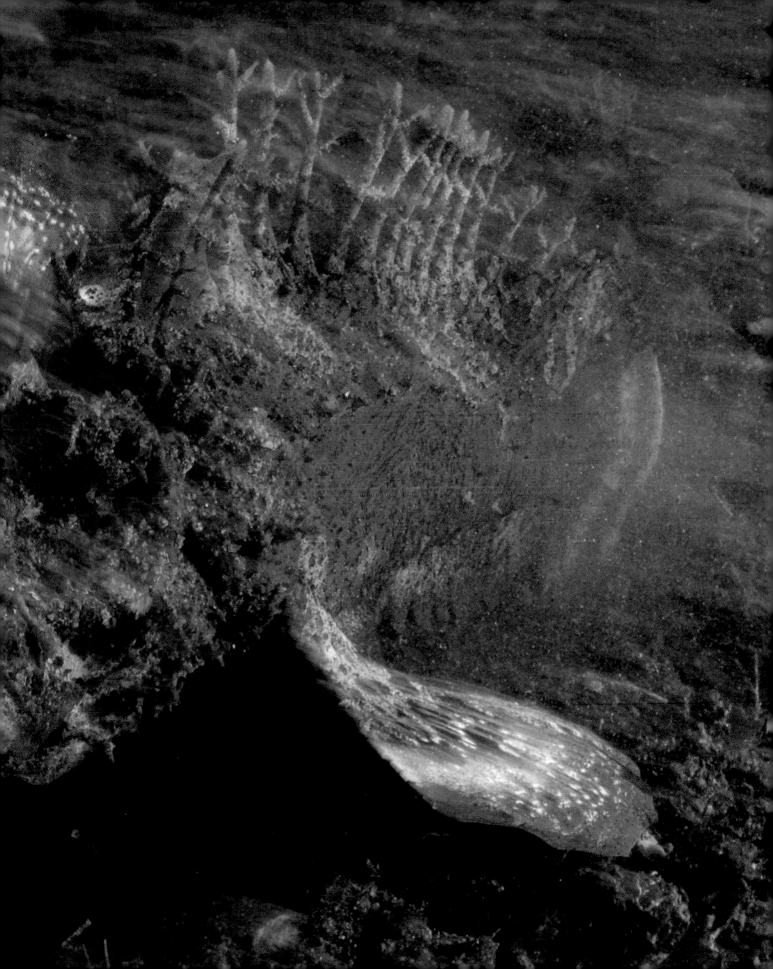

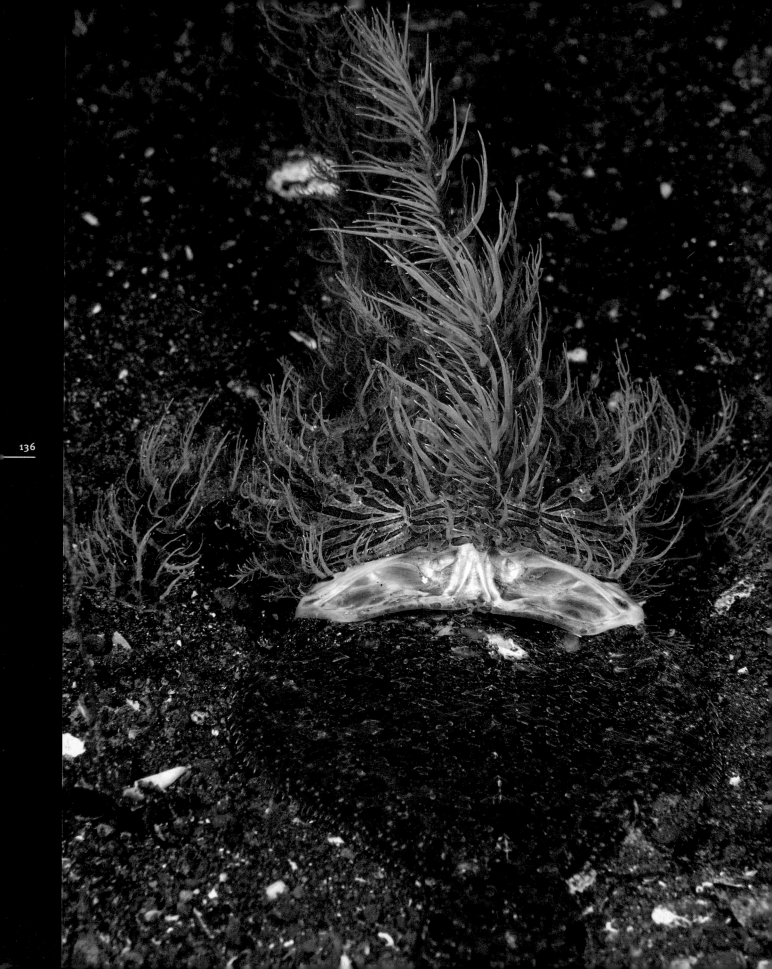

◁ All frogfish (*Antennarius striatus*) are capable of eating prey nearly as large as their own bodies—such as the camouflaged flounder in this picture. Despite the huge jaws and extensible stomach of the hairy frogfish, this flounder simply proved too big and was eventually released, already dead. Lembeh Straits, Sulawesi, Indonesia.

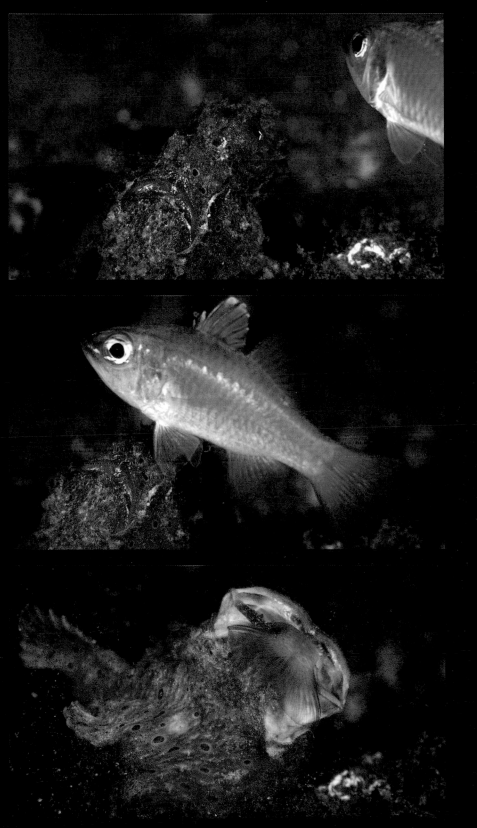

▷ The strike of the painted frogfish (*Antennarius pictus*) is the fastest recorded of any marine animal and may well prove to be one of the fastest in the animal kingdom. Even using fast shutter speeds, the stills camera cannot quite capture the moment of attack, but the skill of this ambush predator is clear to see. Lembeh Straits, Sulawesi, Indonesia.

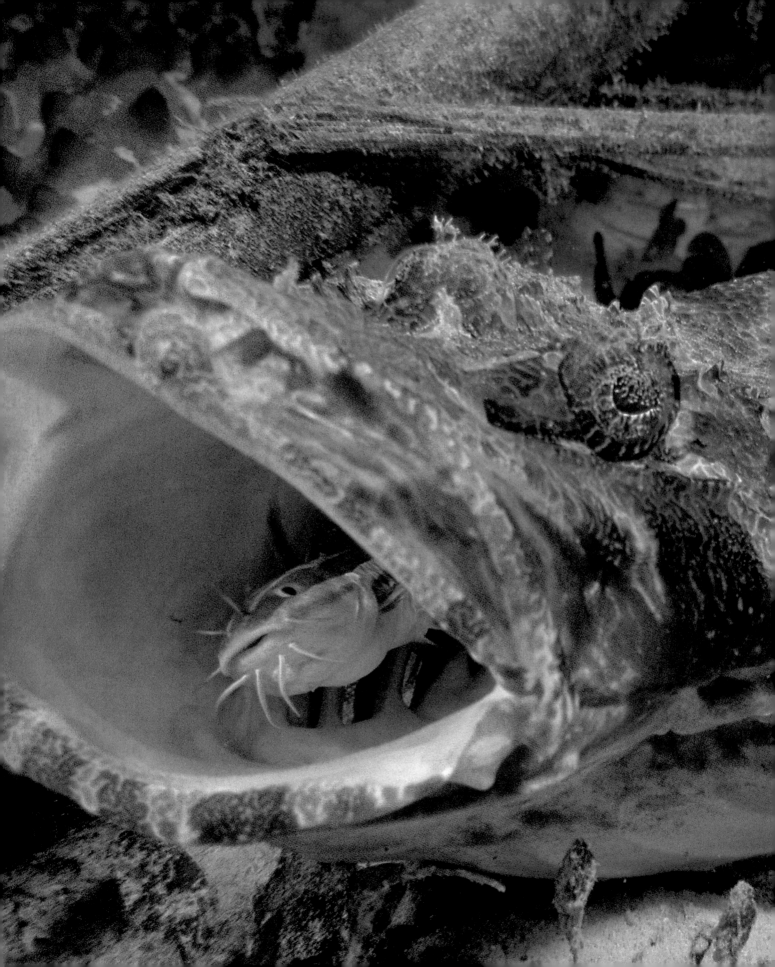

“ I was diving on shallow sand flats off Mabul when, out of the corner of my eye, I caught sight of a crocodilefish striking out at something. Frustrated that I had missed a chance to capture this predator feeding, I swam over and noticed it behaving oddly—puffing up its gill covers and jerking its body on the sand. As I approached, the crocodilefish suddenly stretched open its jaws to reveal a catfish caught in its throat. I managed to take a single shot before the predator "coughed" out its victim, which promptly swam away, apparently unharmed. ”

◁ Crocodilefish (*Cymbacephalus beauforti*) lie in wait for their prey, camouflaged against the seabed. Small fish rarely escape its lightning-fast strike, but may still survive—this striped catfish (*Plotosus lineatus*) has flared open its spiked gill covers and lodged itself in the predator's throat to avoid being swallowed. Mabul, Sabah, Malaysia.

" Mantis shrimp are surprisingly powerful animals and, when photographing big specimens, it's worth taking extra care. They are aggressive and quite territorial creatures, and when presented with a reflection of themselves in the lens port of the camera housing, they can strike out and scratch or even shatter the glass. I've seen lens ports ruined by a single blow from a mantisshrimp, a clear demonstration of their power. "

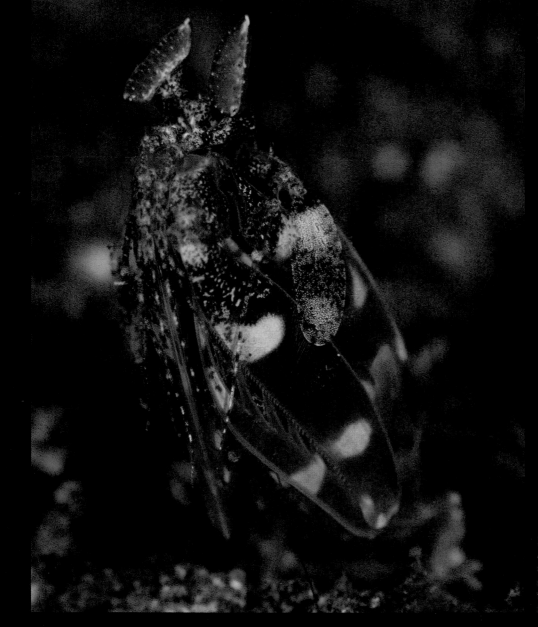

◁ An as-yet-unclassified spearer mantis shrimp (*Lysiosquillina sp.*) rears up, ready to strike. Lembeh Straits, Sulawesi, Indonesia.

▷ A mantis shrimp (*Lysiosquillina maculata*) uses its long, powerful arms to attack—relying on sharp spines or heavy, clublike growths to kill or stun its prey. Lembeh Straits, Sulawesi, Indonesia.

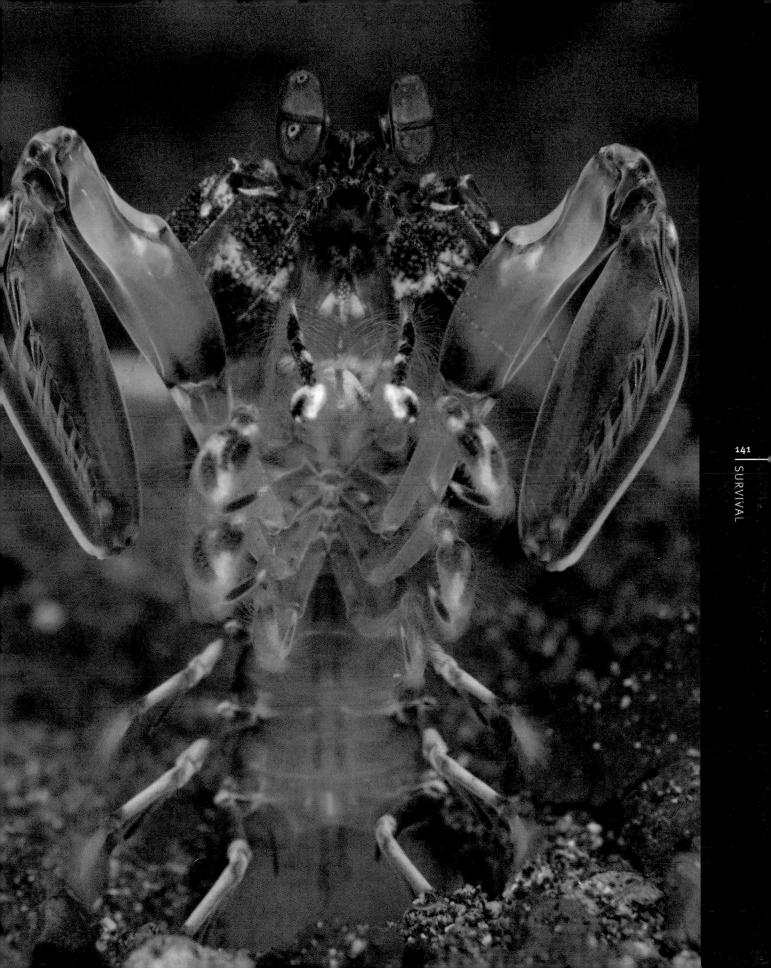

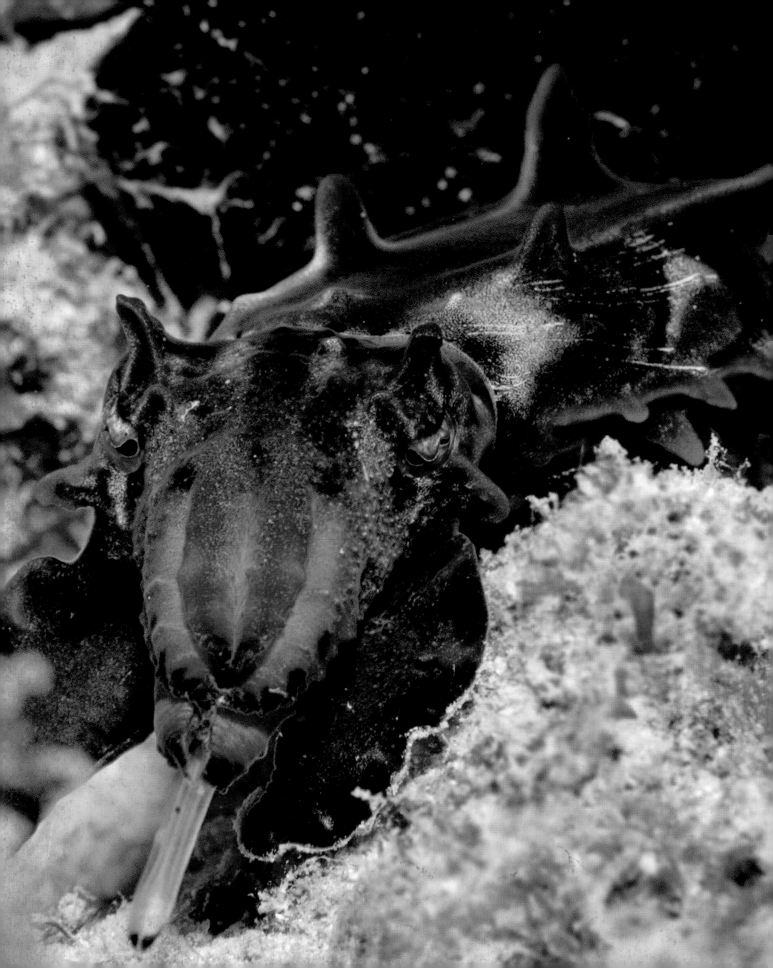

◁▽ The feeding tentacles of the flamboyant cuttlefish (*Metasepia pfefferi*) are tipped with suckers, ensuring that, once seized, their prey has little chance of escape. Kapalai, Sabah, Malaysia.

The flamboyant cuttlefish is one of the most remarkable stalkers on tropical reefs and, despite its small size, is an incredibly lethal predator. Like most cephalopods, the flamboyant disguises itself by using adaptive camouflage, changing its colors and patterns as it moves across the seabed. Rather than swim, the predator "walks" across the bottom on its lower arms and paired flaps of skin under its body—probably so as not to disclose its position to any prey. The flamboyant also has long, extensible feeding arms for striking out at small fish and shrimp. It is the flamboyant's amazing color displays, however, that have earned it the title of ultimate stalker. As it hunts, it often produces a hypnotic, moving display of black and white bands across its body, which confuses its prey and allows the cuttlefish to approach to within striking distance.

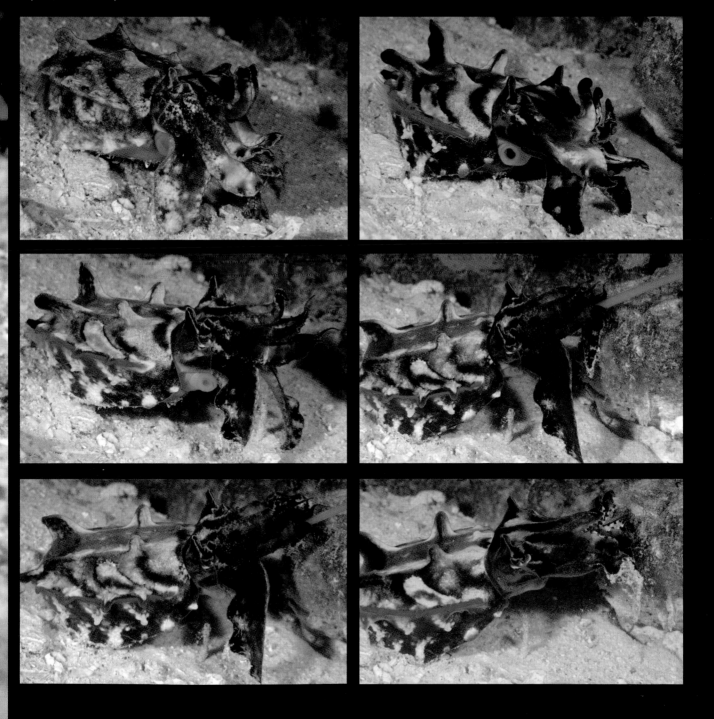

△ Common octopus (*Octopus cyanea*).

△ Crocodilefish (*Cymbacephalus beauforti*).

△ Tasseled wobbegong (*Eucrossorhinus dasypogon*).

△ Broadclub cuttlefish (*Sepia latimanus*).

△ Horny-back cowfish (*Lactoria fornasini*).

△ Flying gurnard (*Dactyloptena orientalis*).

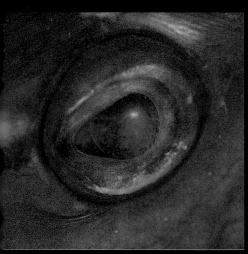

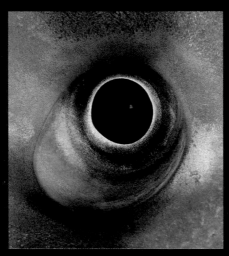

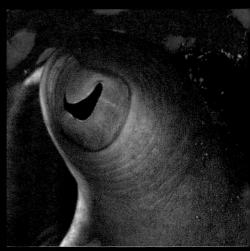

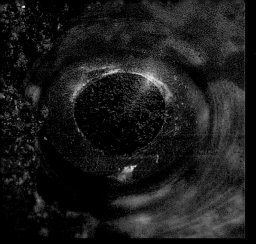
△ Rounded porcupinefish (*Cyclichthys orbicularis*).

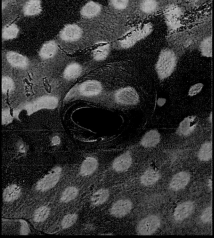
△ Coral grouper (*Cephalopholis miniata*).

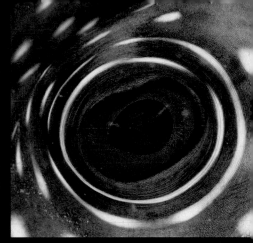
△ White-spotted pufferfish (*Arothron hispidus*).

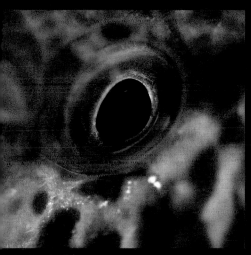
△ Pixy hawkfish (*Cirrhitichthys oxycephalus*).

> A successful photograph gives the viewer a sense of connection with the subject that can only be achieved in one way—eye contact. Capturing the huge range of eyes underwater is a challenge, but it's surprising how much you can learn. Hunters, such as trumpetfish, have elongated retinas so they can accurately judge distances directly in front of their elongated bodies, while the eyes of ambush predators are hidden by flaps and tassels. Even the eyes of prey species are revealing—their large, bulbous eyes give them 180-degree "fish-eye" vision, perfect for spotting approaching predators.

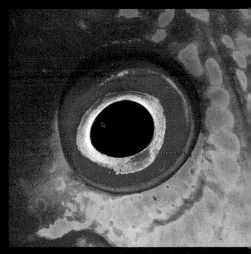
△ Golden damselfish (*Amblyglyphidodon aureus*).

△ Dwarf lionfish (*Dendrochirus brachypterus*).

△ Striped triplefin (*Helcogramma striata*).

△ Ribboned sweetlips (*Plectorhinchus polytaenia*).

GREAT HUNTERS

Predators that actively seek out their prey rely on a variety of techniques to locate and catch their food. Senses such as sight, smell, and taste are crucial, although some hunters employ more unusual senses, such as electroreception. Speed and cooperative behavior are also important factors for predators as diverse as sharks and trevallies. Rays, on the other hand, are more solitary, relying on their own ability to track down prey hidden in the sand. When it comes to jaws and teeth, different types have evolved depending on whether a hunter is a specialist, feeding on a single type of prey, or an opportunist that feeds on virtually anything. Whatever their tactic, however, all hunters have evolved to find and catch their food as efficiently as possible.

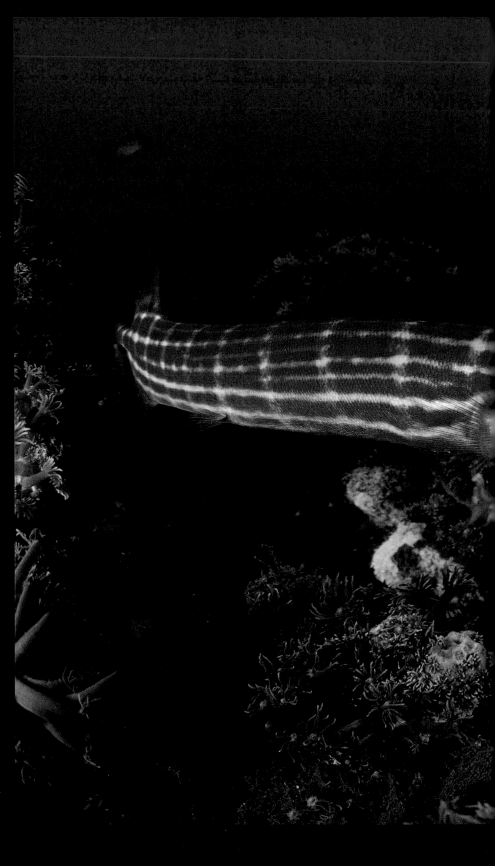

146

△▷ Seen head-on, the long, slender body of the trumpetfish (*Aulostomus chinensis*) appears much shorter than it really is—an illusion that allows it to drift close to its prey as it hunts among the corals. Lembeh Straits, Sulawesi, Indonesia.

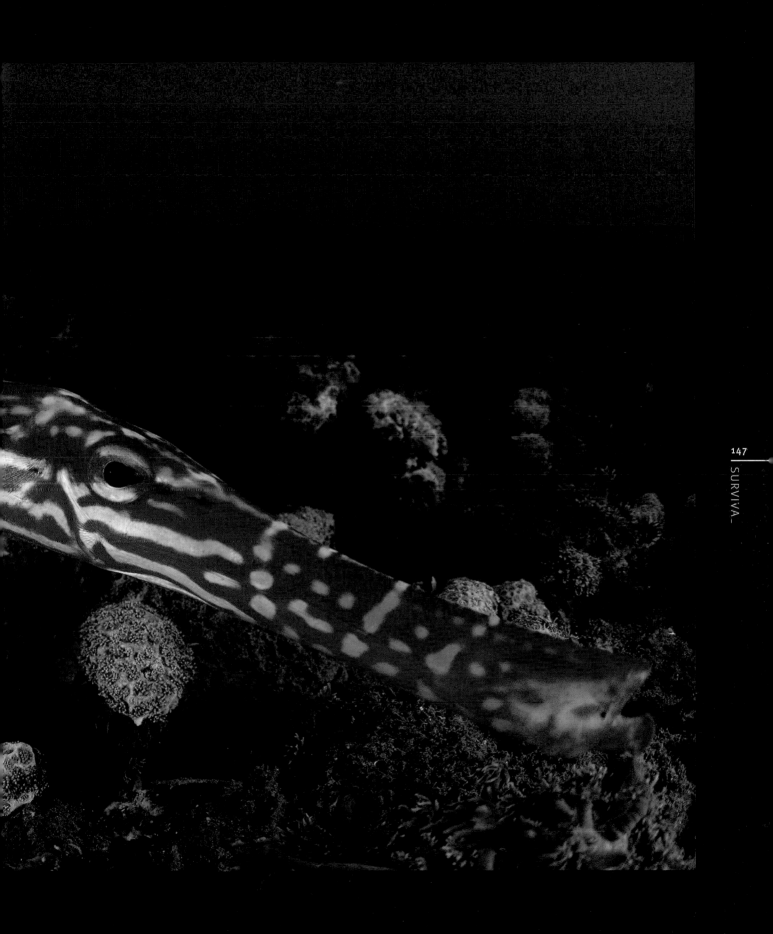

> I had already surfaced after a long, frustrating dive trying to locate a new species of pygmy sea horse, when a sea snake popped up beside me to breathe. For the next hour, the chase was on as I tried to keep up with the sleek predator in the currents, striving to get a shot as it hunted across the shallow reefs. 🔲

▷ The banded sea krait (*Laticauda colubrina*) has a flattened, rudderlike tail to aid its propulsion through the water. Raja Ampat Islands, West Papua, Indonesia.

△ Like terrestrial snakes, the elephant-trunk sea snake (*Acrochordus javanicus*) relies on receptors on its forked tongue to detect its prey. Manado, Sulawesi, Indonesia.

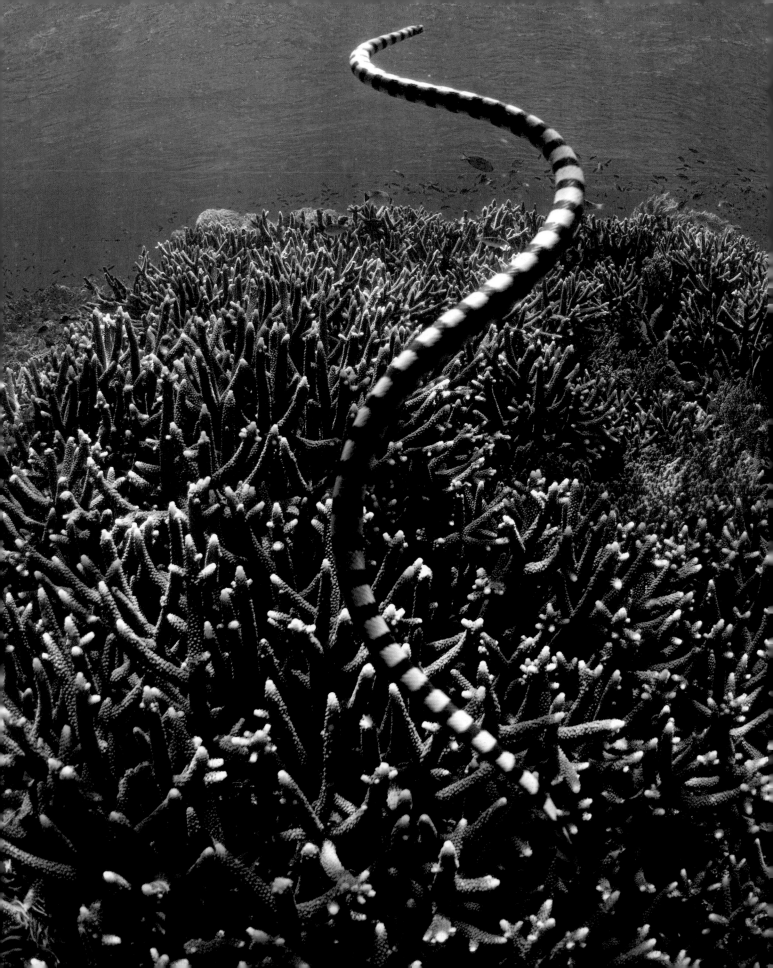

Blue groper live for many years and can become extremely tame and approachable. This particular individual lived in an area well-known for its crayfish and was used to seeing lots of divers. During the dives I spent in his territory he would investigate whatever I was doing, swimming to within inches of my face and even mouthing the dome of my camera housing. I suspect that he had been fed by divers in the past and was expecting a free handout of abalone or even a cray. 🔲🔲

▷ Despite its name, the blue groper (*Achoerodus gouldii*) is in fact a species of wrasse. It has evolved thick, rubbery lips and peglike teeth to deal with its robust diet of mussels, crabs, and urchins. Kangaroo Island, Australia.

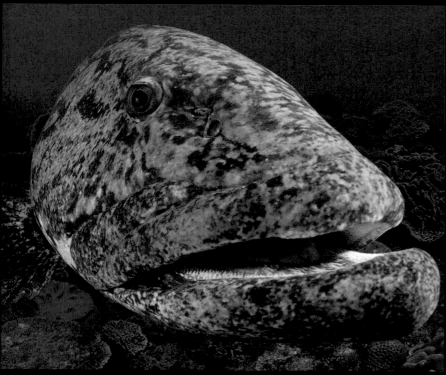

△ The strong jaws of the potato bass (*Epinephelus tukula*) have evolved to cope with a diet of crustaceans and fish. Sodwana Bay, South Africa.

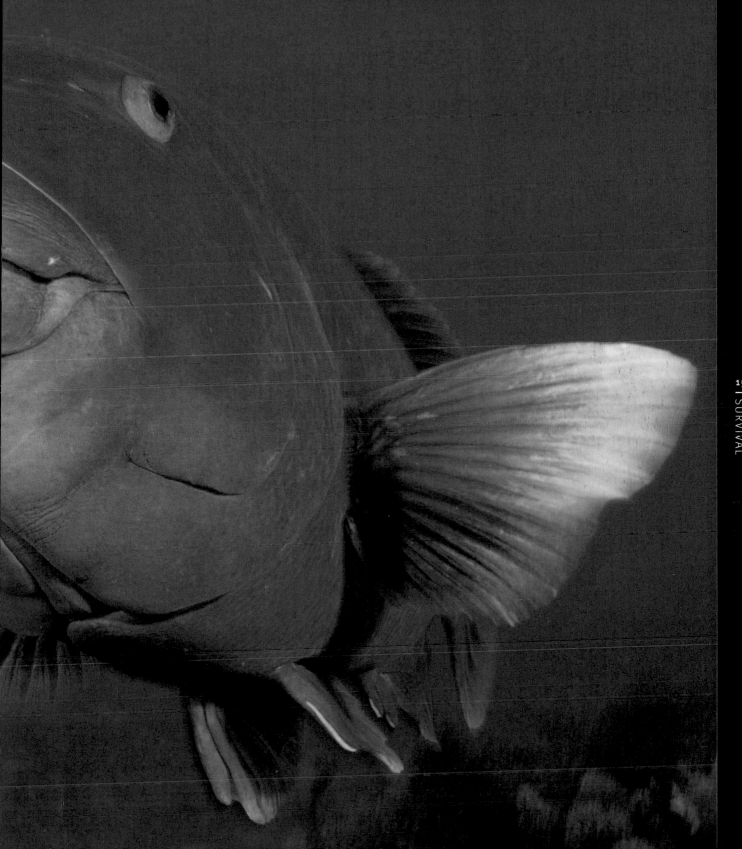

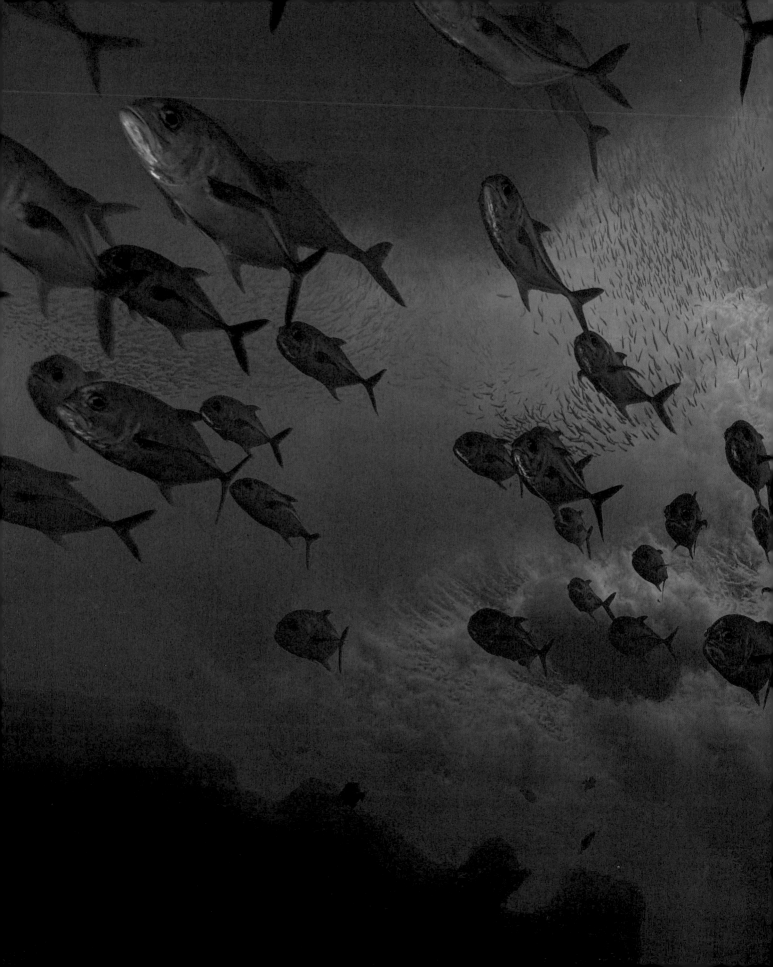

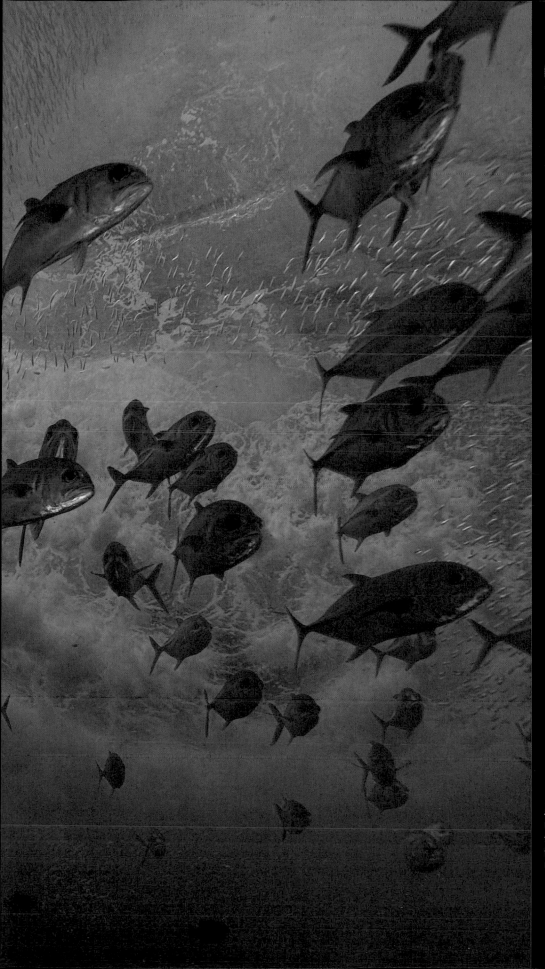

> Watching trevallies as they attacked huge clouds of baitfish was simply mesmerizing. The schools of sardines would literally burst apart in waves of motion as the packs of hunting predators charged through them. To add to the spectacle, a steady rain of tiny, silver scales would drift down from the sardines after each successful attack—all that remained of the unlucky few.

◁ Bigeye trevally (*Caranx sexfasciatus*) hunt in large packs, relying on speed and their ability to separate small groups of prey fish from the main school. Fernando de Noronha, Brazil.

Marbled or black-blotched stingrays are a common sight in the Maldives and it's not unusual to spot one every day. Catching one of these rays in the process of feeding, however, is another matter altogether. We were lucky enough to follow this big ray as it moved across the sea floor, digging up food from beneath the rubble. Whenever it found something that required a little extra effort to remove the overlying sand, it would arch its broad back and pump water beneath its body—a remarkable sight to witness. 』』

▽ The marbled stingray (*Taeniura meyeni*), along with the majority of stingrays, feeds on the sea floor. The ray uses smell to locate its prey, which it crushes with large, flat, plate-like teeth. Felidhoo Atoll, Maldives.

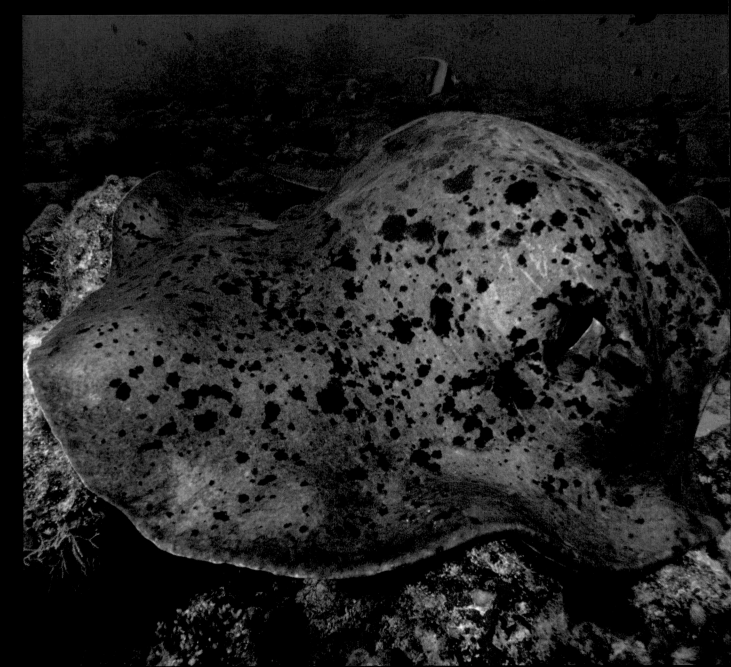

▽ Rather than feeding on the seabed like stingrays, manta rays (*Manta birostris*) feed exclusively on plankton in open water—straining out their food through sievelike gills. Sangalaki, Kalimantan, Indonesia.

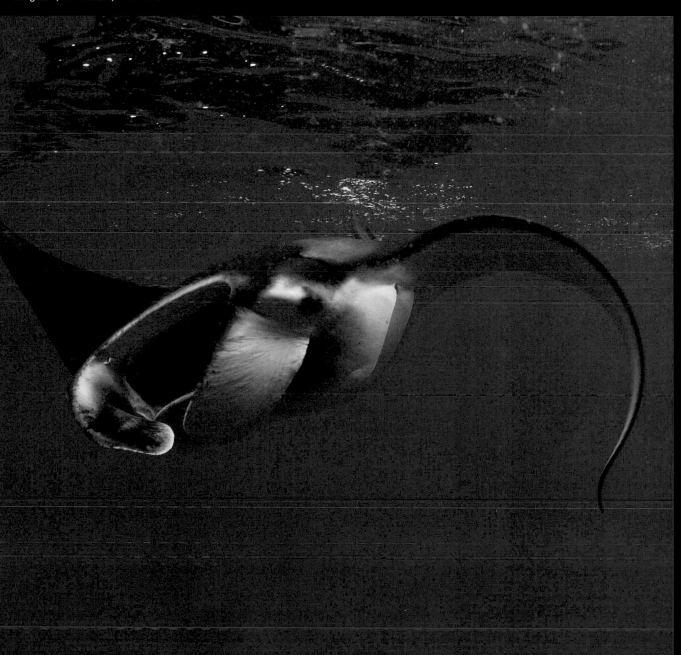

" Tigers are notorious sharks with a well-earned reputation for being extremely dangerous. They can feed on almost anything and, with their strong jaws and sharp teeth, even an investigative bite can cause some serious damage. In Aliwal, where this shot was taken, several big female tigers liked to check out cameras— and photographers. With safety divers in the water, we weren't in any danger, but being bumped by a 13-ft (4-m) tiger shark certainly gets the adrenaline flowing. "

▷ The tiger shark (*Galeocerdo cuvier*) has broad tastes and will feed on anything from birds, turtles, and mammals to fish, lobsters, and even other sharks. With a huge jaw, large nostrils, and lines of electro-sensitive pits, this shark is a very capable predator. Aliwal Shoals, South Africa.

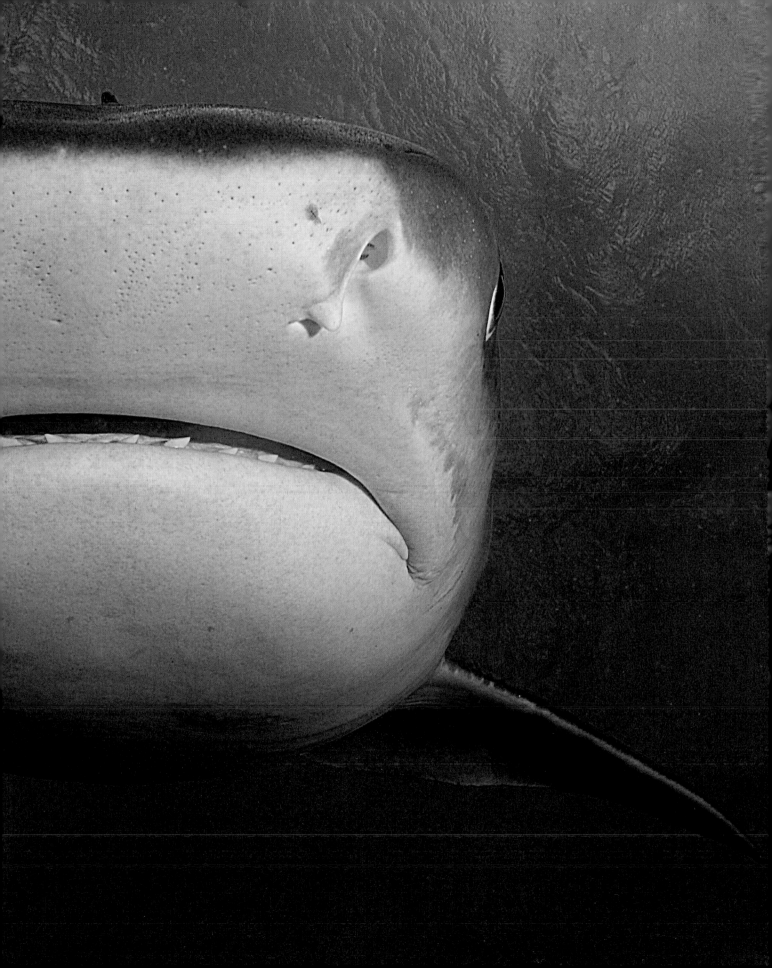

❝ I've been fortunate enough to dive with many different species of sharks right across the globe, and I'm always amazed by the power and beauty of these stunning predators. Yes, they can be dangerous, and yes, you have to give them a great deal of respect, but I never turn down an opportunity to film or photograph sharks—and I always try to capture a sense of the grace and authority of these predators. Sharks are amazing creatures that should be appreciated for what they really are, and by conveying their true nature I hope to play my part in their conservation before they disappear from our reefs. **❞**

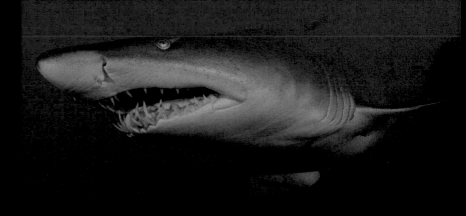

△ Sand-tiger or gray nurse sharks (*Carcharias taurus*) use their many teeth to snag small fish and cephalopods while hunting at night. Sodwana Bay, South Africa.

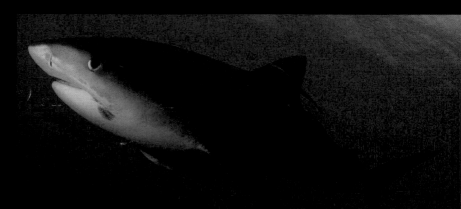

△ Most tiger sharks (*Galeocerdo cuvier*) are excellent opportunist predators, equipped with teeth sharp enough to cut through the tough carapace of a sea turtle. Aliwal Shoals, South Africa.

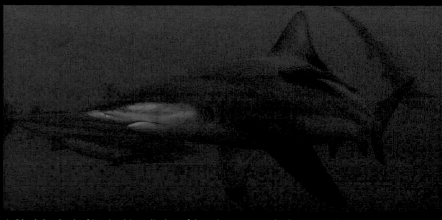

△ Blacktip sharks (*Carcharhinus limbatus*) hunt in groups and rely on speed and confusion to catch their prey. Aliwal Shoals, South Africa.

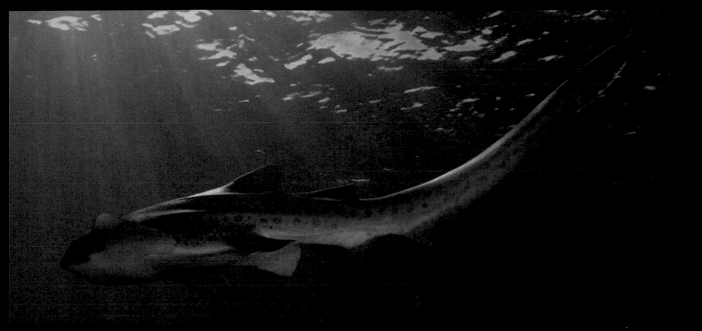

△ Zebra or leopard sharks (*Stegostoma fasciatum*) feed on shellfish and crustaceans, which are crushed in their powerful jaws. Sipadan, Sabah, Malaysia.

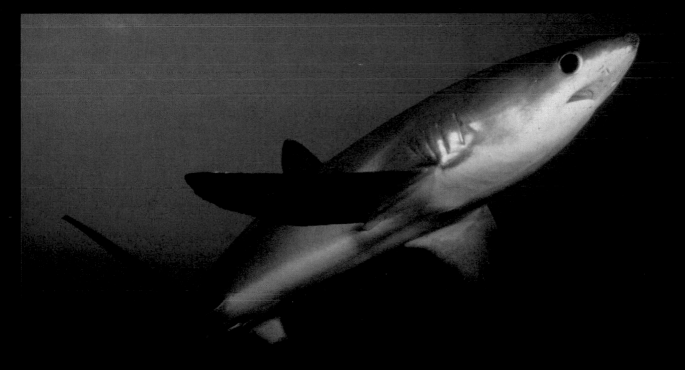

△ Pelagic thresher sharks (*Aloplus pelaglcus*) are deep-water sharks that use their incredible tails to stun small fish. Monad Shoals, Malapascua, Philippines.

Arms and armor

The reef hosts an evolutionary arms race between predator and prey, with ever more specialized weapons and defenses being deployed.

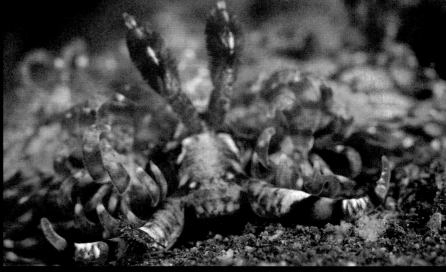

For prey, survival means avoiding being eaten. Escape is the easiest way to dodge this fate, and most fish are capable of bursts of high speed. Those not able to flee must employ other defenses. Toxins are used by flatworms, nudibranchs, and fish, who advertise their inedibility with bright colors and patterns. Others exploit these warnings through mimicry, without having to produce any toxins themselves. Another way to keep predators at bay is to appropriate

toxic neighbors—boxer crabs, for instance, brandish poisonous anemones in their front claws like tiny pugilists. If an attack is unavoidable, the next-best option is to survive it—sea horses have bony plates of armor, lionfish flaunt poisonous spines, and stingrays have venomous barbs in their tails.

For predators, survival means overcoming these defenses. Speed, stealth, and highly tuned senses are vital, but individual species have their

△ A predatory nudibranch (*Pteraeolidia ianthina*) displays its oral tentacles.
▷ A small spotfin lionfish (*Pterois antennata*) rests securely within its sheltering spines.

own ways of killing. Octopuses have sharp beaks and strong toxins of their own, some moray eels have an extra row of teeth, and sea snakes possess the most potent venom of any snake. Even the lowly cone shell has a venomous barb that's lethal to humans, let alone fish.

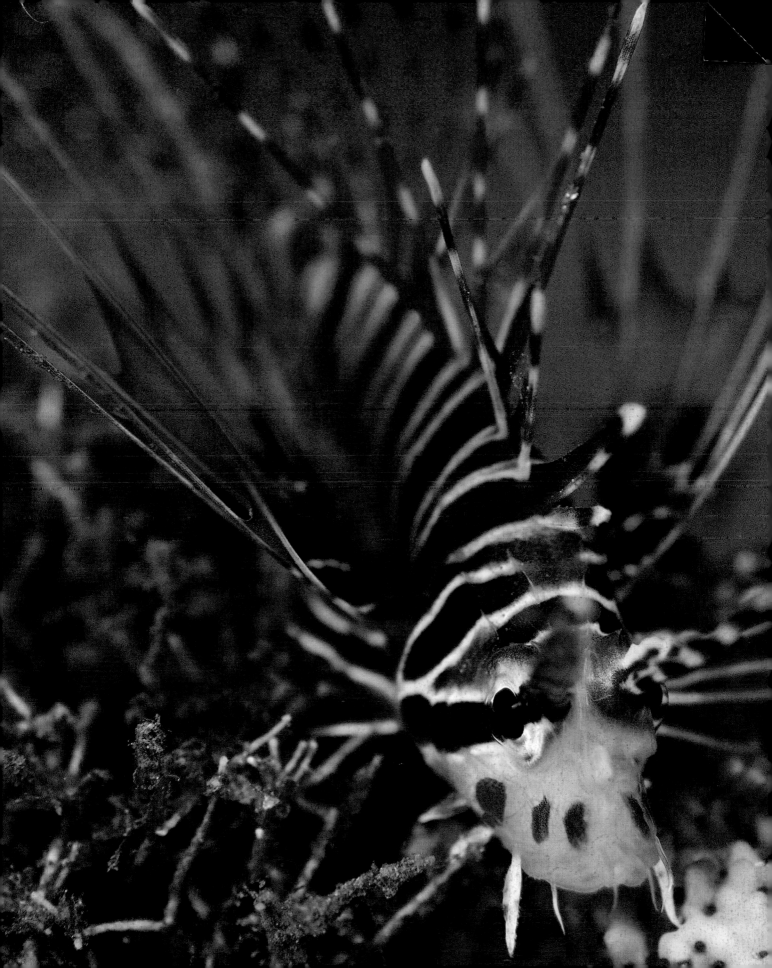

Harlequin shrimp (*Hymenocera elegans*) live in territorial pairs and hunt starfish together. Only 1 in (2 cm) across, it is thought that their decorative markings and armor are used to signal between the pair. Lembeh Straits, Sulawesi, Indonesia.

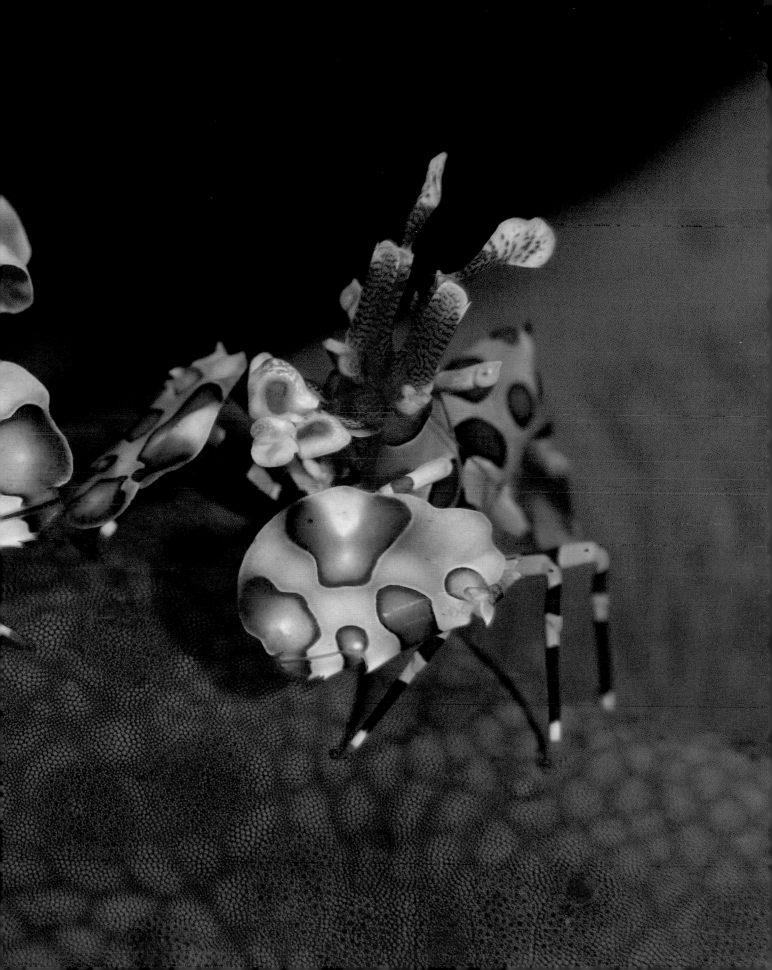

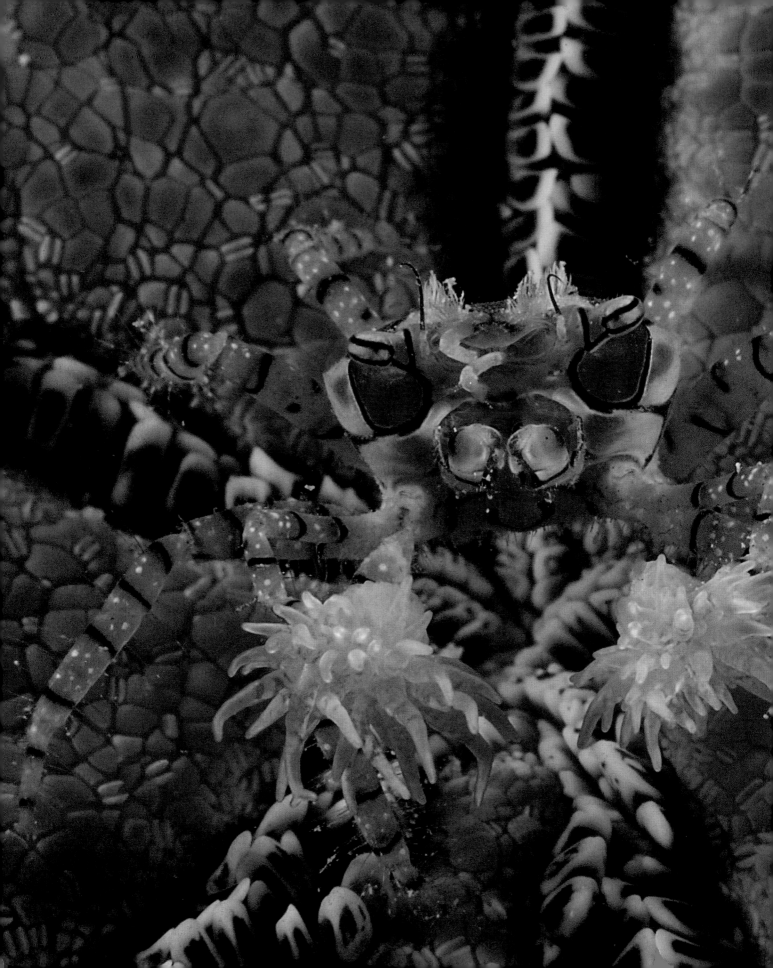

PERSONAL PROTECTION

The simplest way for an animal to protect its body is to grow a tough casing. This form of defense has been used by crustaceans for millions of years—all types have a thick carbonate carapace to resist the blows and bites of their foes. Some fish, such as sea horses and boxfish, have also evolved body armor, in the shape of bony scales. However, predators are constantly honing their methods of attack, and tough carapaces or scales are not always enough. Hermit crabs employ discarded gastropod shells to protect their soft body parts, while sponge and decorator crabs cover themselves in sponges and other materials for camouflage and protection. Some species make use of other animals on the reef, hiding in the shelter of urchins, for example, or carrying them on their backs. The boxer crab (pictured) even grasps stinging anemones in its claws and brandishes them at potential threats. But it is the cephalopods that are the most innovative: veined octopuses have taken advantage of the human presence on the reef and can be seen hiding in jettisoned bottles, split coconut shells, and plastic containers.

◁▽ Barely larger than a thumbnail, boxer crabs (*Lybia tesselata*) are surprisingly pugnacious. They stand their ground against even the largest of predators, waving a pair of anemones held in their claws like miniature boxing gloves. Mabul, Sabah, Malaysia.

We had been stuck in Manokwari Harbor in West Papua for some days, waiting for repairs to the boat's propeller after we'd hit a log while sailing at night. There were plenty of wrecks in the harbor, most of them sunk during World War II, but it was the night-diving in a shallow bay that really caught our attention. There were incredible numbers of large crabs trundling around on the sandy sea bottom and across the reef, all covered in anemones, pieces of sponge, and even squared-off lengths of wood. It was fascinating just to sit in the sand and watch the crustaceans of the reef going about their business, camouflaged and protected in so many different ways.

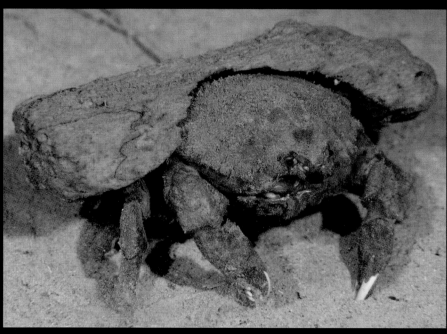

△ Rather than using a piece of sponge, this sponge crab (*Dromia dormia*) holds a piece of wood on its back for camouflage and protection. Manokwari, West Papua, Indonesia.

▷ Hermit crabs (*Dardanus pedunculatus*) sometimes cover their carapace with small anemones for extra protection and camouflage. In return, the anemones can feed in various locations as the crab moves across the reef. Manokwari, West Papua, Indonesia.

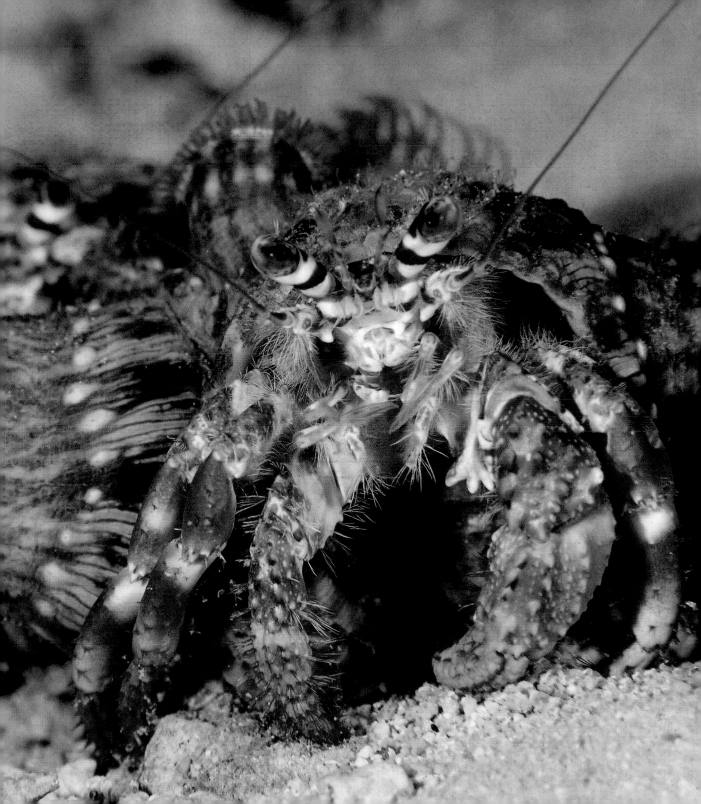

I was hunting around for frogfish in the Lembeh Straits when I came across a large group of sea urchins. As I approached, one of them promptly got up off the sand and began to walk away. On closer inspection, I saw that this particular urchin was in fact being carried on the back of a crab, who was using it for protection. Intrigued, I moved closer and found a pair of zebra crabs, several shrimp, and even a couple of juvenile fish, all hiding in the urchin's spines and using its defenses for their own protection. �”

▷ The zebra crab (*Zebrida adamsii*) is small enough to live among the spines of an urchin, and has evolved hooks on its legs to secure its grip. Lembeh Straits, Sulawesi, Indonesia.

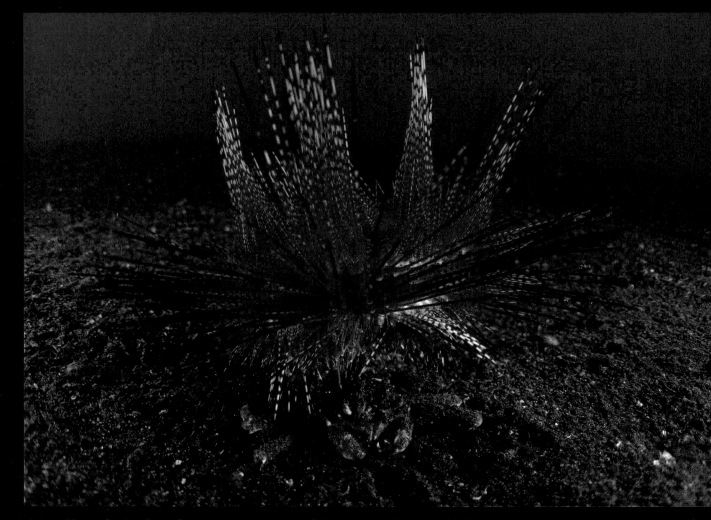

△ An urchin crab (*Dorippe frascone*) picks up and carries a beautiful but extremely sharp sea urchin for its own protection—a form of defense few predators can breach. Lembeh Straits, Sulawesi, Indonesia.

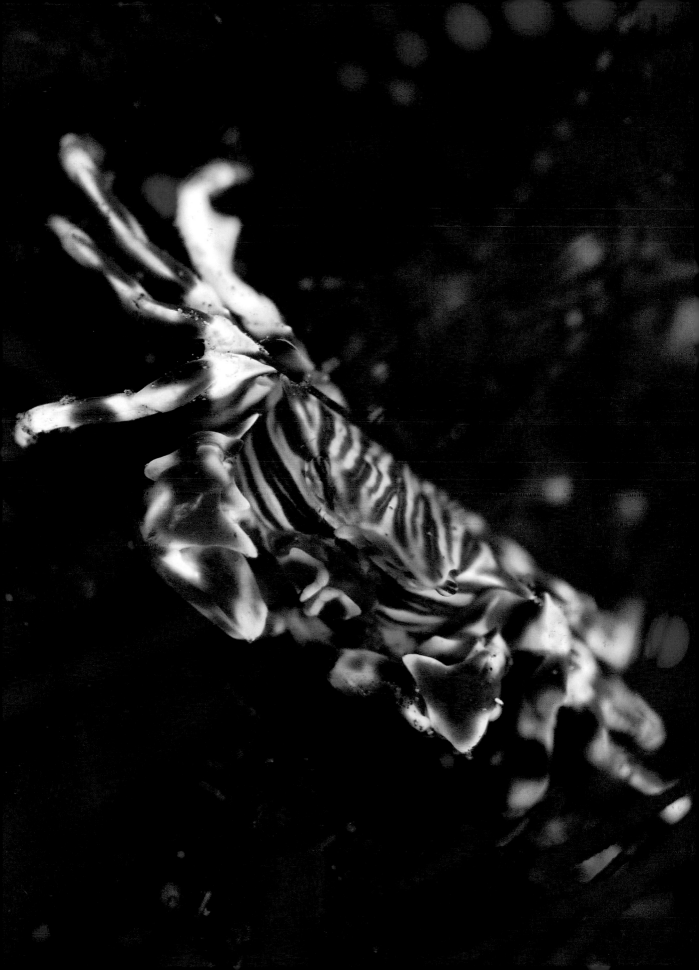

❝ The incredible color and detail of sea urchins make them one of my favorite subjects for macrophotography. When lit by strobes, the vivid colors— electric blues, deep saturated reds, and sometimes even bright yellows—make a perfect backdrop. It only needs a tiny juvenile fish, such as a banggai cardinal, to really set the picture off. **❞**

▷ Banggai cardinalfish (*Pterapogon kauderni*) spend their entire lives around sea urchins. Juveniles, such as the one pictured, are small enough to shelter in the shorter spines of vivid *Astropyga sp.* urchins, while adults prefer the black *Diadema spp.*, with its long, needlelike spines. Lembeh Straits, Sulawesi, Indonesia.

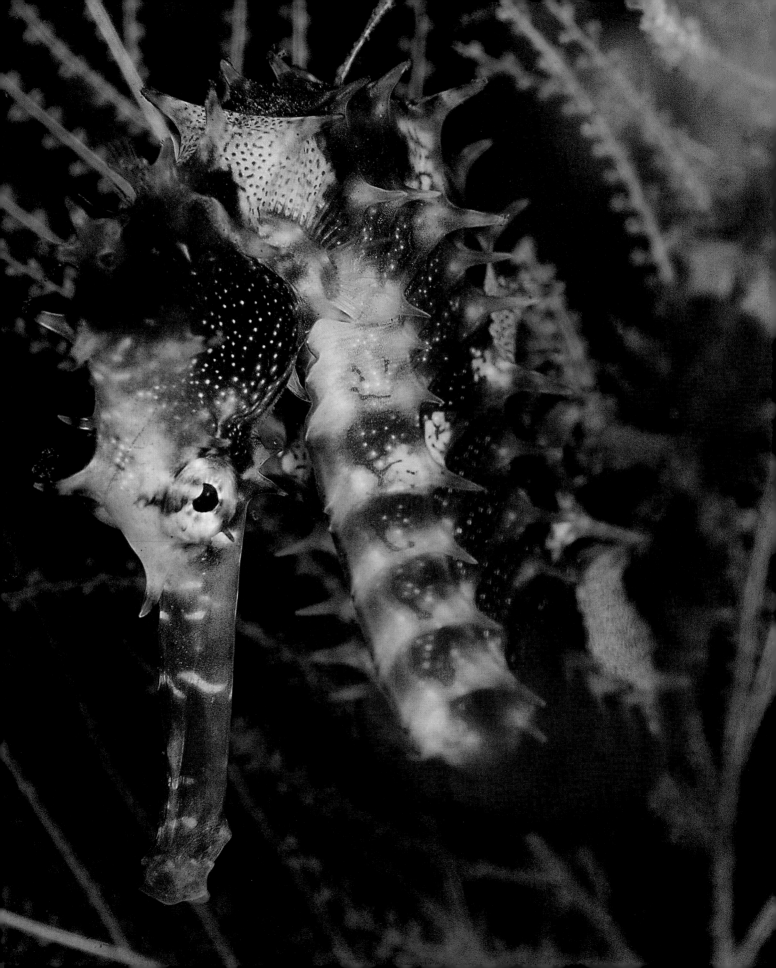

" While filming in Sulawesi, I was lucky enough to witness the true effectiveness of the armor of these small fish. As the sea horse drifted over the sand, it was suddenly hit and carried sideways by a large flounder lying buried in the sand. The predator immediately swallowed its prey but, within seconds, spat it out again. The sea horse promptly swam off, apparently unhurt and without even a scratch on its skin. It seemed that the combination of tough armor and small spines was enough to dissuade the predator from making a meal of the sea horse. "

◁ Like all sea horses, the thorny sea horse (*Hippocampus histrix*) has tough armor made up of dense, bony segments that encircle its body. Seraya, Bali, Indonesia.

△ Despite its tough body armor, the thorny sea horse (*Hippocampus histrix*) also relies on a degree of camouflage for protection. Mabul, Sabah, Malaysia.

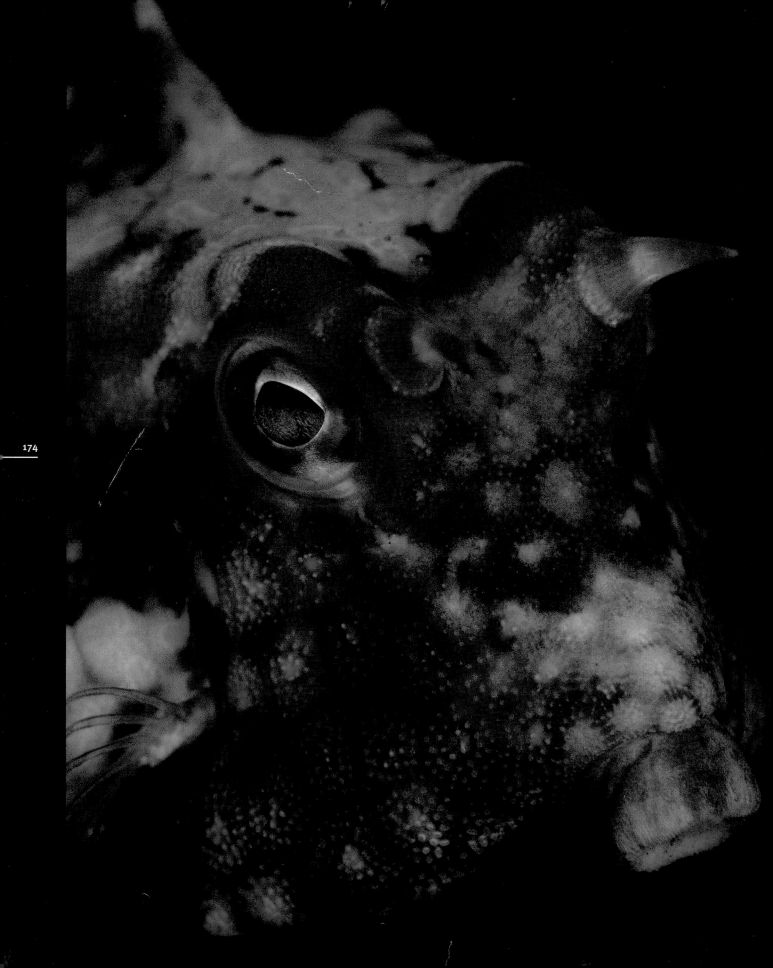

◁ A thornback cowfish (*Lactoria fornasini*), like all boxfish and cowfish, has a whole host of defenses based around modifications of its skin and scales—the first line of defense after signals and warnings have failed. Lembeh Straits, Sulawesi, Indonesia.

" With their ungainly swimming style, cowfish and boxfish appear quite comical underwater. Their armored bodies seem to lack any of the sinuous, graceful movements of most other fish. Sadly, their coats of armor have another, far less desirable side-effect—they maintain their shape when the fish is dried, making them sought-after as tourist souvenirs. It's not uncommon to see stalls selling cowfish, stacked alongside the shells and bleached corals, in markets throughout Southeast Asia and beyond. Lying on a table, surrounded by other dead marine animals, these fish appear more tragic than comic. "

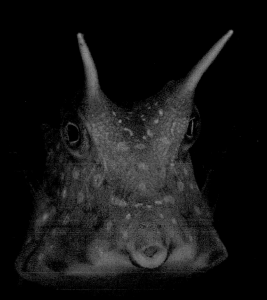

△ The longhorn cowfish (*Lactoria cornuta*) sports horns—like its terrestrial namesake. Lembeh Straits, Sulawesi, Indonesia.

△ The juvenile longhorn cowfish (*Lactoria cornuta*) only settles on the reef after its armor is fully formed. Lembeh Straits, Sulawesi, Indonesia.

△ The juvenile cube boxfish (*Ostracion cubicus*) has a coating of toxic mucus as well as a coat of armor. Lembeh Straits, Sulawesi, Indonesia.

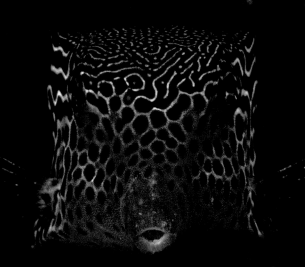

△ Only the mouth, fins, and eyes protrude beyond the armor of this juvenile Solor boxfish (*Ostracion solorensis*). Mabul, Sabah, Malaysia.

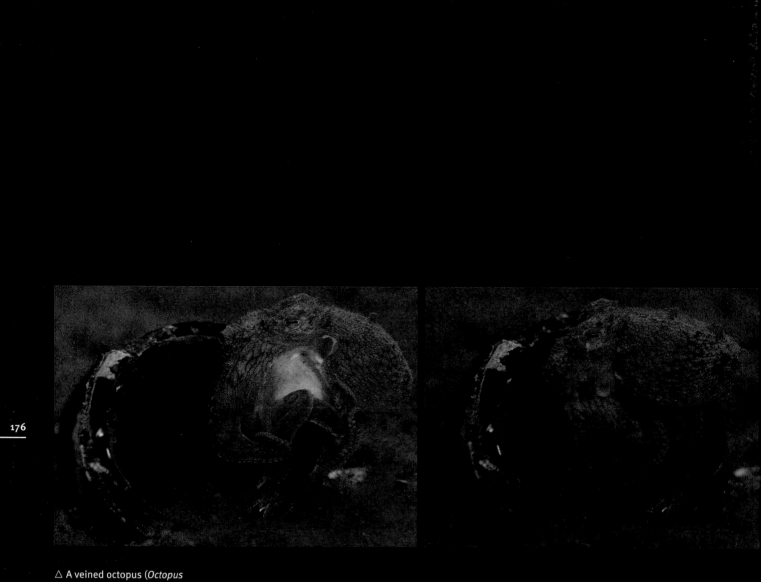

△ A veined octopus (*Octopus marginatus*) seeks temporary shelter inside a broken bottle. Octopuses show a high degree of intelligence and can easily adapt to changes in their environment. Lembeh Straits, Sulawesi, Indonesia.

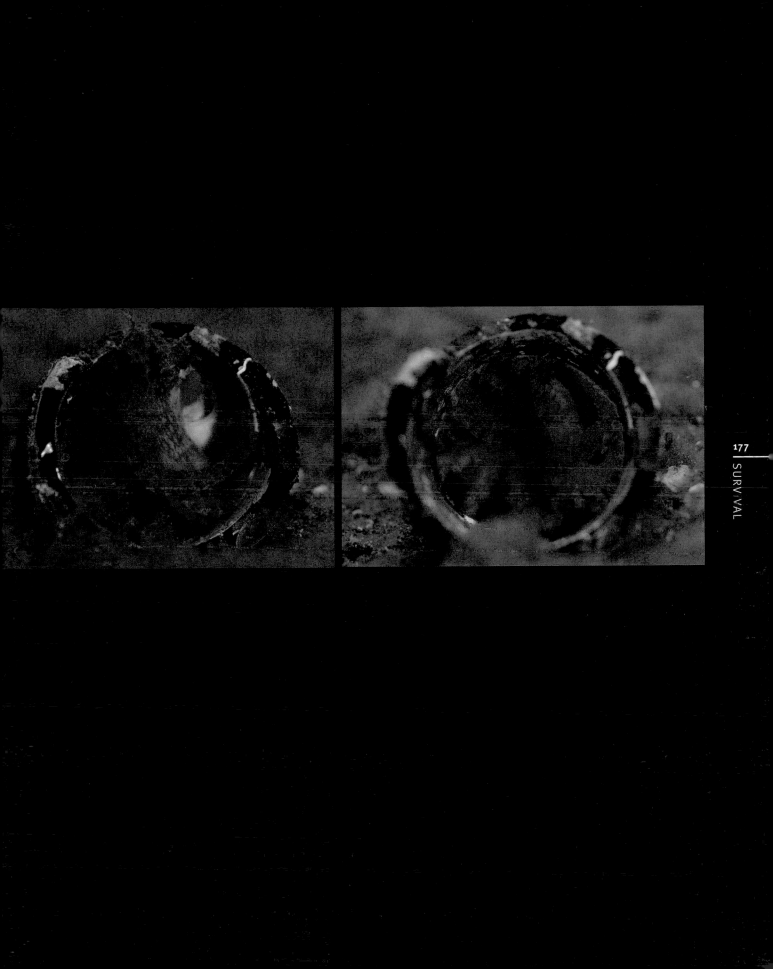

Superb camouflage and the shelter of a discarded bottle are ample protection for a veined octopus (*Octopus marginatus*) on the exposed sand flats. Lembeh Straits, Sulawesi, Indonesia.

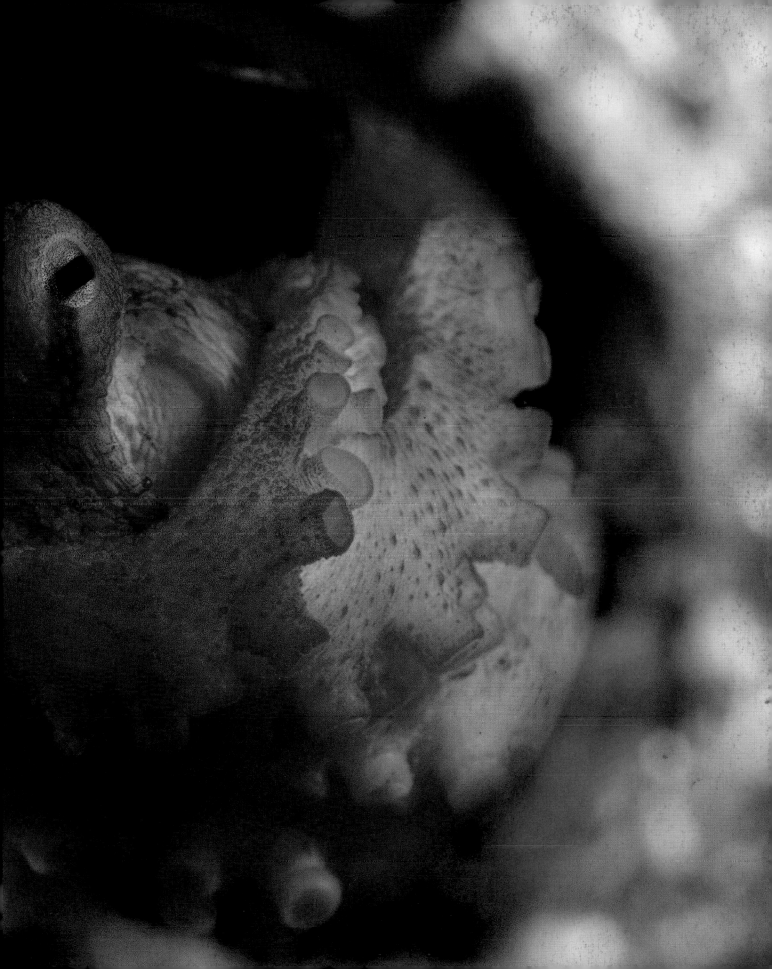

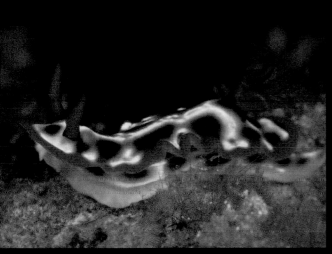

◁ Nudibranchs, such as the *Hypselodoris bullockii*, are chemical warfare experts. Some are merely noxious or distasteful while others have toxins powerful enough to kill even fish and crustaceans. Mabul, Sabah, Malaysia.

CHEMICAL WARFARE

Toxins are poisonous or distasteful chemicals in the tissues of an animal's body. They can be either manufactured by the animal or ingested as part of its diet, but their main purpose is always to discourage attack. Most animals are eager to advertise their toxicity—warning off predators with obvious, colorful markings—and the smaller animals on the reef illustrate this particularly well. The toxic flatworms and nudibranchs found throughout the world, for example, come in every color and pattern, all sending the message "toxic—do not touch."

The range of chemicals in use on the reef is huge. Many are simply foul-tasting, extremely bitter or strong-smelling, and are excreted in the mucus that covers the body. Some types of dragonet, for example, are known as "stinkfish" because of this powerful mucus. Other types of chemicals are more powerful poisons located in tissues throughout the body, not just the mucus. The internal organs of pufferfish, for example, contain one of the strongest toxins in the animal kingdom and, every year in Japan, several people die as a result of eating badly prepared pufferfish.

△ The nudibranch *Hypselodoris purpureomaculosa*.
Mantanani, Sabah, Malaysia.

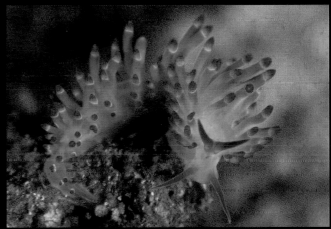

△ The nudibranch *Flabellina exoptata*.
Mantanani, Sabah, Malaysia.

△ The nudibranch *Nembrotha kubaryana*.
Lembeh Straits, Sulawesi, Indonesia.

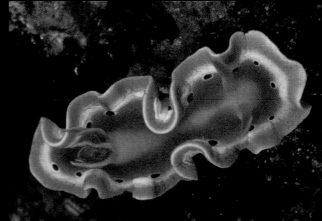

△ The nudibranch *Glossodoris cruentus*.
Mantanani, Sabah, Malaysia.

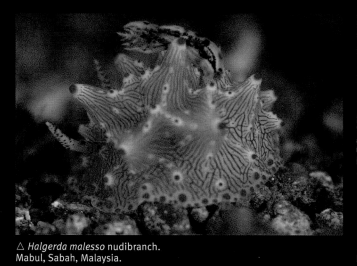

△ *Halgerda malesso* nudibranch.
Mabul, Sabah, Malaysia.

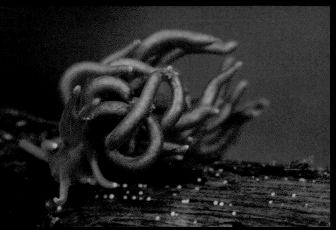

△ *Phyllodesmium briareum* nudibranch.
Lembeh Straits, Indonesia.

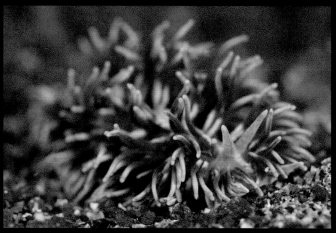

△ *Phyllodesmium sp.* nudibranch.
Lembeh Straits, Indonesia.

△ *Hypselodoris bullockii* nudibranch.
Lembeh Straits, Indonesia.

△ *Ceratosoma tenue* nudibranch.
Lembeh Straits, Indonesia.

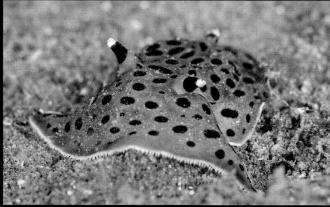

△ *Euselenops luniceps* nudibranch.
Lembeh Straits, Indonesia.

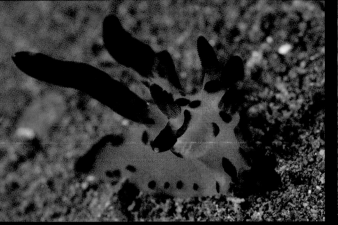

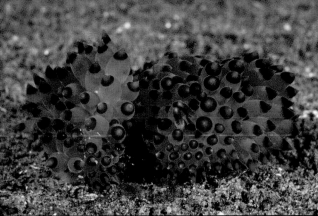

△ *Thecacera sp. 2* nudibranch.
Seraya, Bali, Indonesia.

△ *Janolus sp.* nudibranch.
Lembeh Straits, Indonesia.

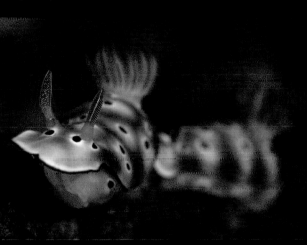

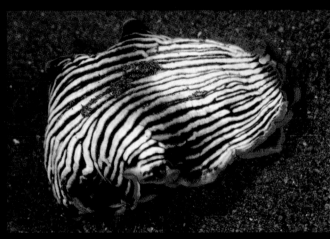

△ *Risbecia tryoni* nudibranch.
Lembeh Straits, Indonesia.

△ *Armina sp. 1* nudibranch.
Seraya, Bali, Indonesia.

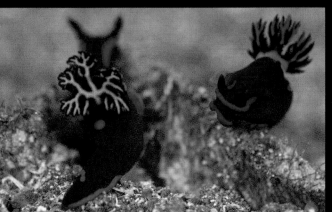

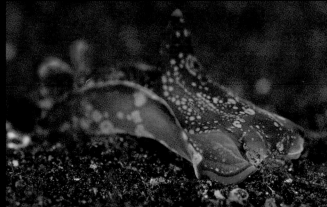

△ *Tambja morosa* nudibranch.
Lembeh Straits, Indonesia.

△ *Philinopsis cyanea* nudibranch.
Lembeh Straits, Indonesia.

The *Spurilla australis* nudibranch has bright, waving branches called cerata on its back. The tips contain stinging cells to dissuade attacking predators. Lembeh Straits, Sulawesi, Indonesia.

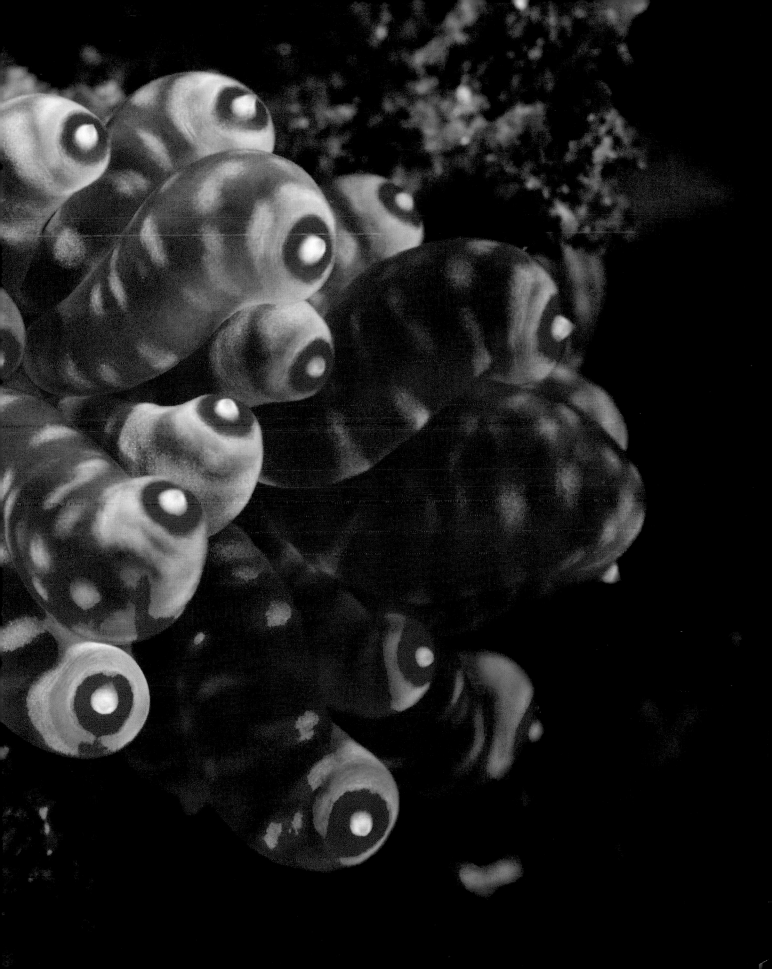

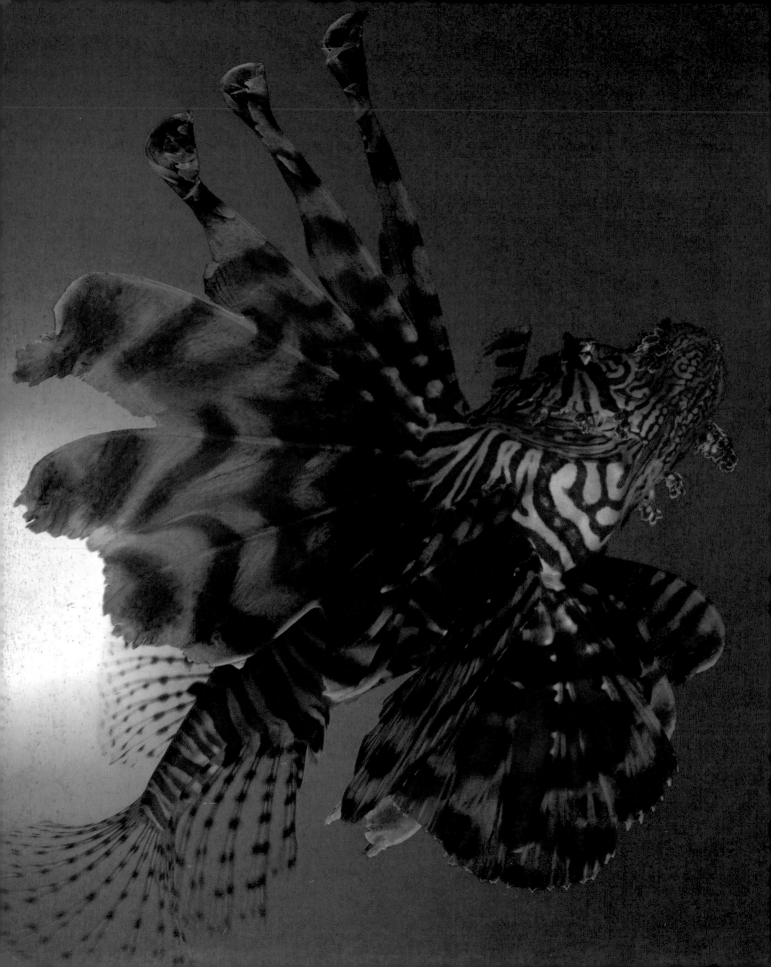

BITES, BRISTLES, AND BARBS

Venoms differ from toxins in that they are actively injected into another animal—venomous species have to rely on teeth and spines to break the surface of the skin, after which the poisonous chemicals can be pumped in. For most animals, this is a defensive measure—the spines are arrayed around the body or across the back so that a predator's bite is met with a mouthful of venomous barbs. Animals such as stonefish employ incredibly powerful venom, capable of causing tissue death and intense pain. Their cousins, scorpionfish and lionfish, openly advertise the fact that they carry venom— lionfish have evolved bright, banded markings on their spines, while devil scorpionfish use flashy threat displays on the undersides of their pectoral fins. Predators on the reef use venom for hunting and have evolved potent, fast-acting chemicals designed to immobilize their prey before they can swim away. Both sea snakes and blue-ringed octopuses have some of the most powerful venoms in the natural world—essential for hunting the small, fast-moving fish that must be stopped in their tracks before they can be eaten.

◁ The common lionfish (*Pterois volitans*) has long, flamboyant spines decorated with bright tassels and flags. Despite its beauty, these decorations act as advertisments for its venomous nature. Mabul, Sabah, Malaysia.

△ A lionfish's spines have a gland at their base that excretes a venom painful enough to keep all animals away from this confident predator. Mabul, Sabah, Malaysia.

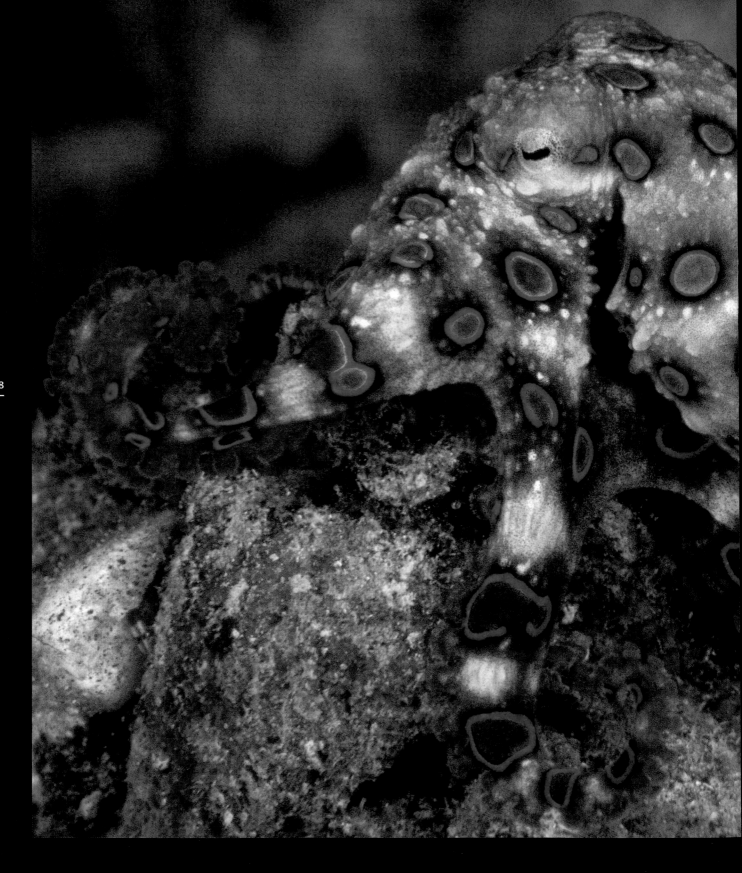

Blue-ringed octopuses are quite difficult to find because of their small size and the camouflage they use when hunting or resting. However, sometimes they are discovered under the strangest of circumstances. On Mabul, one of the young boatmen walked into the restaurant where we were eating, cupping something in his hands and shouting, "Look what I found!" He had seen a blue-ringed octopus while cleaning the bottom of the boat and, not knowing what it was, had decided to catch it and ask someone. Luckily, we persuaded him to return the highly venomous octopus to the water as fast as he could, and both boatman and octopus were unharmed. 〞

◁△ The vivid markings of a blue-ringed octopus (*Hapalochlaena lunulata*) are a clear indication of its venomous nature. Predators that ignore this warning must contend with one of the natural world's strongest venoms, capable of suffocating a human as the poison shuts down the muscles of its victim. Mabul, Sabah, Malaysia.

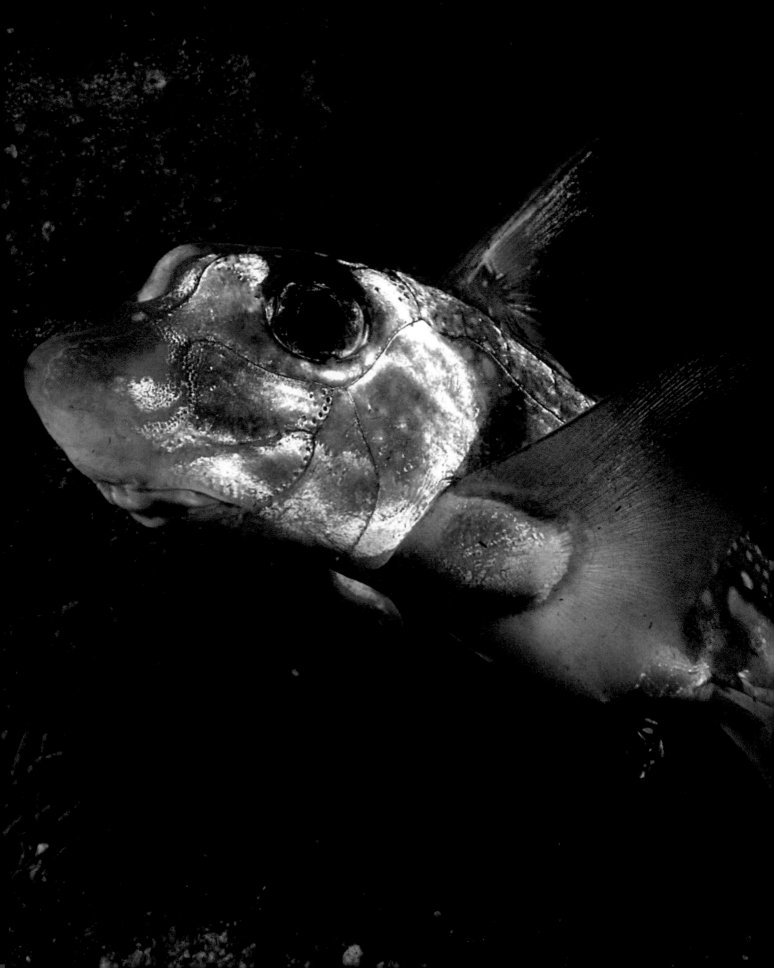

SURVIVAL

◁ The chimaera or spotted ratfish (*Hydrolagus colliei*) has a cartilaginous skeleton and is closely related to sharks. For defense it is equipped with a venomous spine at the front of its dorsal fin. Victoria Island, British Columbia, Canada.

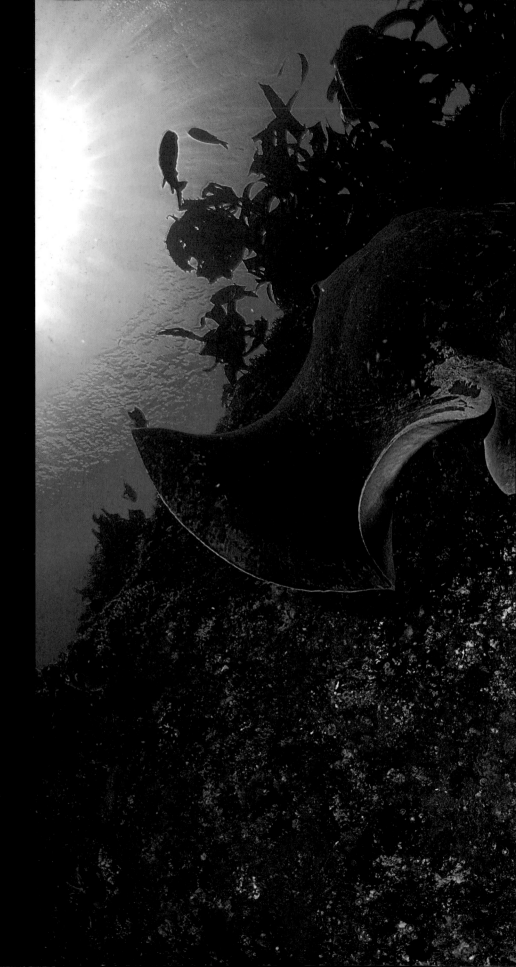

An encounter with a big stingray can be a dramatic experience. As a photographer, you are always trying to get as close as possible to your subject to ensure that the animal fills the frame. However, you have to be careful not to get too confident. Wide-angle lenses tend to make things look farther away than they really are and, on several occasions, I have looked away from the viewfinder and come face-to-face with a ray's venomous barbs.

▷ Like all stingrays, the short-tail stingray or bull ray (*Dasyatis brevicaudata*) has venomous barbs at the base of its tail. Even the largest stingrays can bend their tail up and over their body to defend themselves against attack from any angle. Poor Knights Islands, New Zealand.

SHOCK TACTICS

A variety of animals use electricity underwater. For most, it is a passive skill—they can detect electrical fields and use this information to hunt, but are unable to generate their own electric charge. Sharks are the best-known electroreceptive animals, capable of detecting the electrical fields of their prey by using a series of pits on their faces and the sides of their bodies. Other species, however, have evolved the ability to generate their own electrical fields, which are produced in stacks of tissue derived from muscle or nerve cells. Weakly electric fish, such as elephantnose fish, use electricity for navigation and communication in the murky waters in which they live. Strongly electric fish, such as torpedo rays and electric eels, on the other hand, can produce powerful bursts of electricity that are strong enough to stun or kill their prey—and warn off large predators. Some fish can even deliver shocks at over 500 volts, with a current of up to one ampere. That's enough to hurt and even kill a human—although there are no recorded deaths associated with these unusual animals.

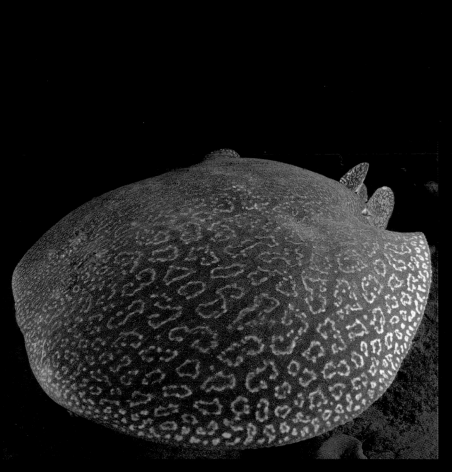

◁△ The variable torpedo ray (*Torpedo sinuspersici*) can stun or kill its prey with a 200-volt charge, produced in two kidney-shaped organs on each side of its head. Sodwana Bay, South Africa.

Deception

For both predator and prey, an ability to blend into the background, or deceive and confuse adversaries, is paramount for survival.

The simplest way to lure your prey within striking distance, or deceive your enemy and escape, is to use the reef itself. Many species bury themselves in sandy seabeds, leaving only their eyes and mouths exposed. The bobtail squid even has a coating of mucus to help grains of sand stick to its body. Others use camouflage. Stonefish are identical to stones, wobbegong and crocodilefish virtually disappear against the sand, and ghost pipefish perfectly resemble sea fans

and sea grass. Cuttlefish and octopuses can change the color and texture of their skin depending on where they happen to be, while the decorator crab gets inventive with sponges and hydroids, employing them to cover its carapace.

Deception, though, is about more than camouflage. The stargazer has a worm-like appendage for bait, which wriggles inside its mouth. Like butterflies above the surface, some species of animals use eyespots to trick predators into thinking

△ A minute diamond filefish (*Rudarius excelsus*) hides among plants in a sea-grass bed.
▷ A clown or warty frogfish (*Antennarius maculatus*) perfectly mimics a sponge.

they are larger than they really are. However, the undisputed master of deception is the mimic octopus. Only recently discovered, this stunning animal uses its long arms and bold markings to impersonate far more threatening creatures, such as sea snakes and lionfish.

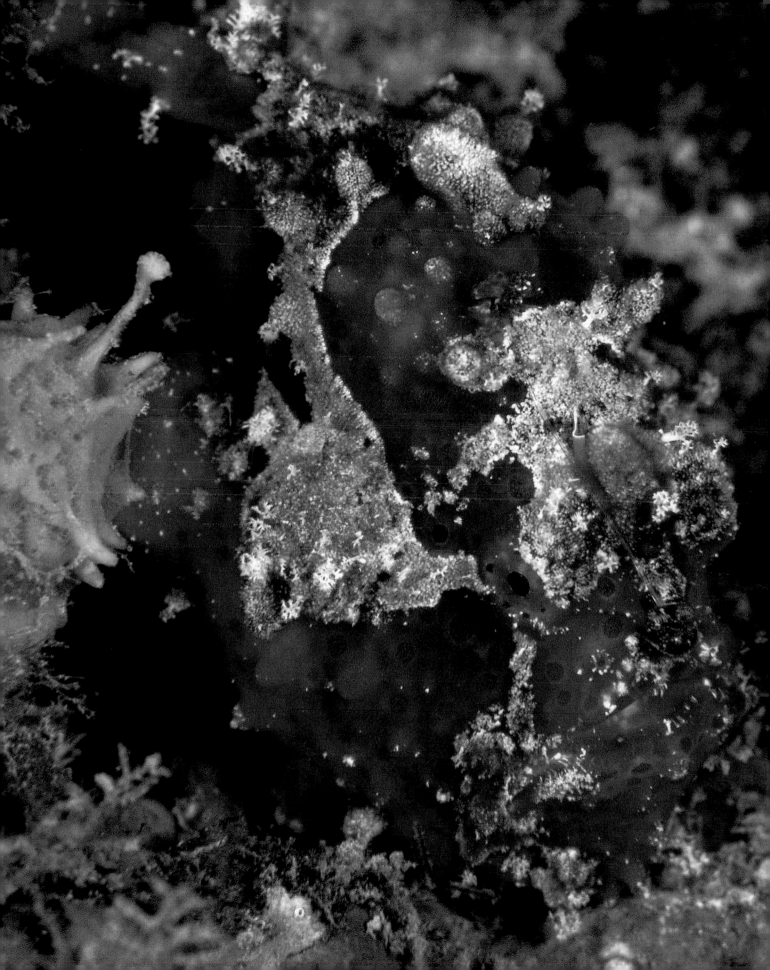

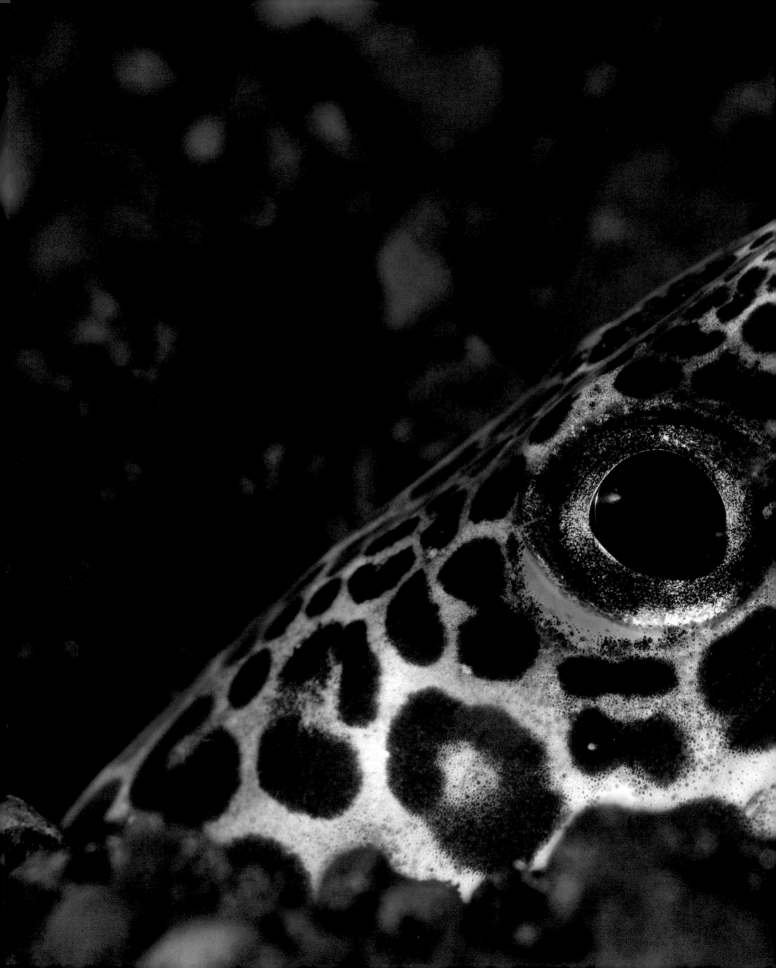

LYING LOW

The sand plains of the reef are exposed and dangerous places. For the animals that live here, often the only way to find safety is to hide away in the sandy bottom. Some animals, such as stingrays and bobtail squid, flick sand over their bodies to conceal themselves, while others force their way into the seabed—sand divers, snake eels and blue razorfish, for example, rely on their strength and body shape to drive themselves deep into the sand and disappear from sight. Gobies and mantis shrimp even build permanent homes in the sand, reinforcing the walls of their burrows with pieces of shell and rubble to help prevent collapse.

◁ Along with some other types of snake eels, the barred sand conger (*Poeciloconger fasciatus*) relies on a simple form of deception—burying its long, sinuous body in the sand, leaving only its mouth exposed. This snakelike fish can occasionally be seen out of its burrow, hunting small fish and invertebrates across the sand plains. Seraya, Bali, Indonesia.

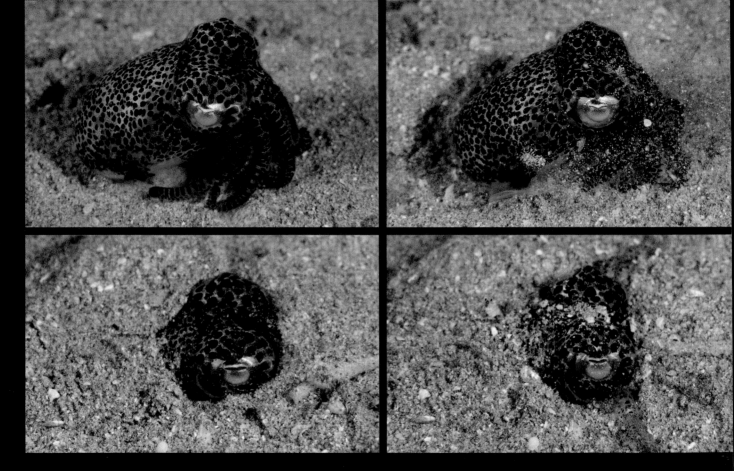

△ A tiny bobtail squid (*Euprymna
berryi*) buries itself beneath the
sand for safety. Once most of its
body is concealed, this cephalopod
flicks grains of sand over its eyes
and the sticky mucus that covers
the top of its body, ensuring that
it won't be exposed by the strong

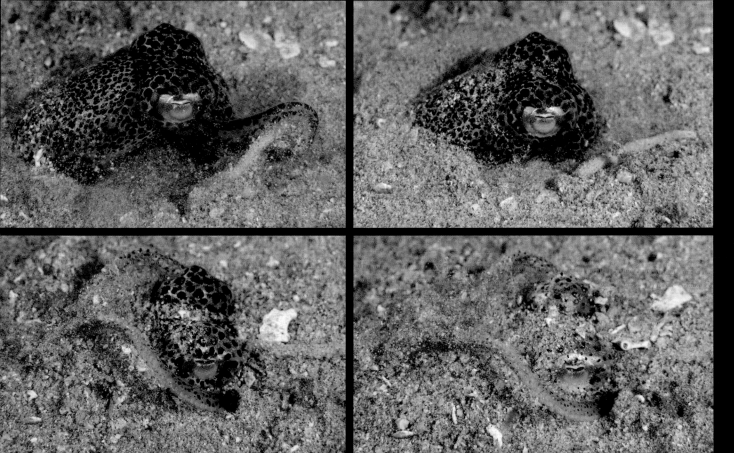

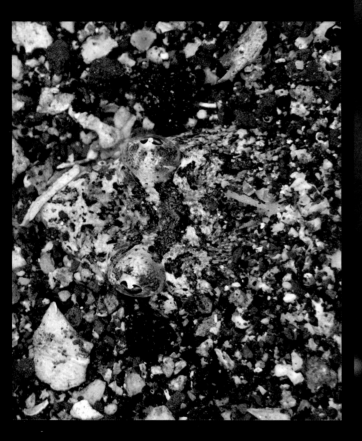

△▷ The grinner, which is similar to the lizardfish, is an ambush predator that relies on its camouflage and burying skills to avoid being detected by the small fish that make up its diet. As demonstrated by this slender grinner (*Saurida gracilis*), the only parts of its body normally visible are a pair of large eyes and the jagged line of its powerful jaws. Lembeh Straits, Sulawesi, Indonesia.

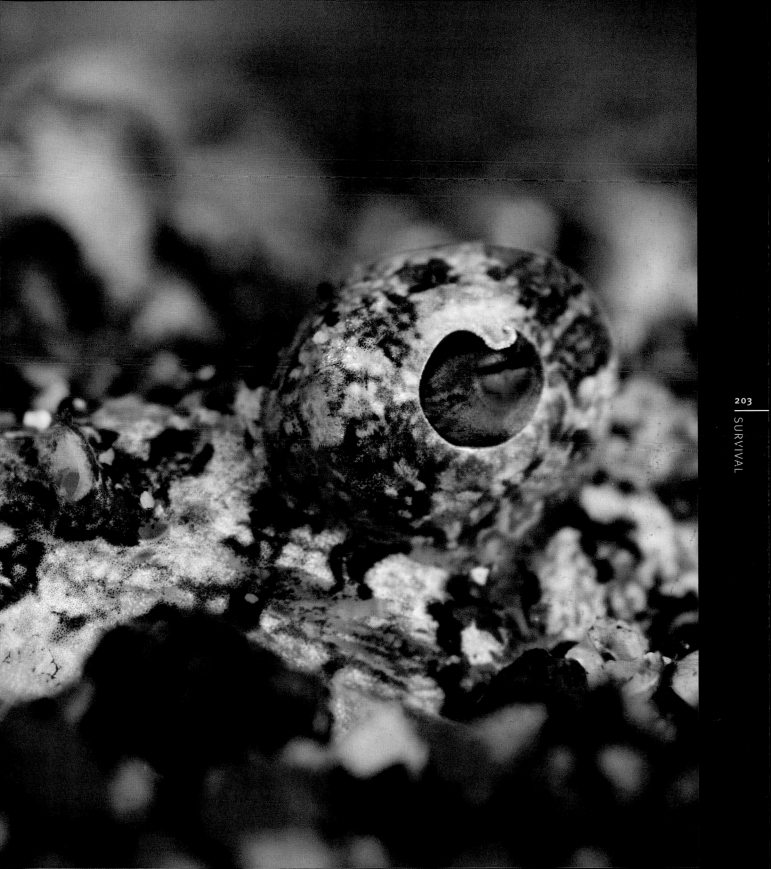

▽ ▷ The whitemargin stargazer (*Uranoscopus sulphureus*) is one of the ultimate ambush predators, hiding in the sand with only the tooth-lined slit of its huge mouth visible. With a wriggling, wormlike lure, it attracts passing fish—which are engulfed in a fraction of a second. Mabul, Sabah, Malaysia.

The first time you spot the dark crack of a stargazer's mouth and gently wave away its cloak of sand, you can't help but be amazed by this truly ugly but incredibly well-adapted fish. Everything about this species says "ambush predator"—from its camouflage, upturned head, and array of sharp teeth, to the tiny lure it uses to bring its prey within striking distance.

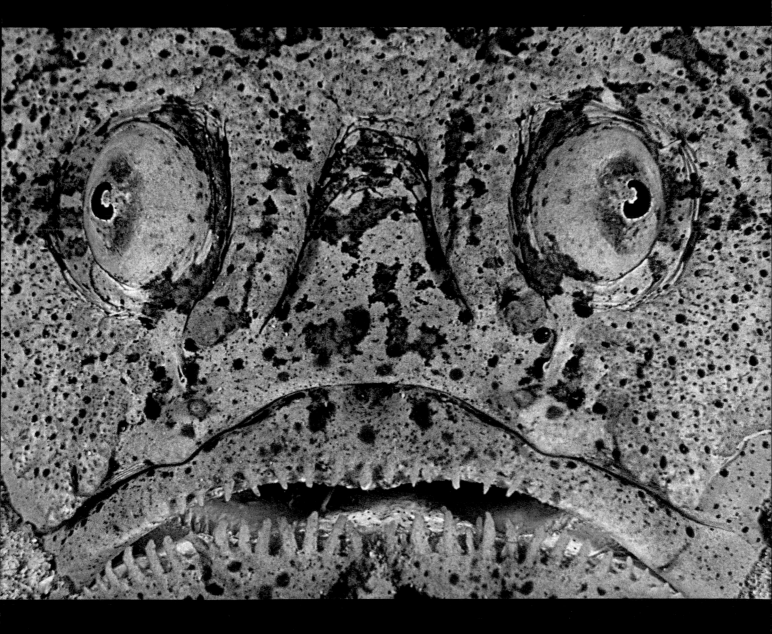

△ Common lionfish (*Pterois volitans*).

△ Scrawled filefish (*Aluterus scriptus*).

△ Epaulette shark (*Hemiscyllium ocellatum*).

△ Bobtail squid (*Euprymna berryi*).

△ Allied cowrie (*Pseudosimnia sp.*).

△ Tasseled wobbegong (*Eucrossorhinus dasypogon*).

△ Dwarf lionfish (*Dendrochirus brachypterus*).

△ Emperor angelfish (*Pomacanthus imperator*).

△ Barred sand conger (*Poeciloconger fasciatus*).

△ Tasseled wobbegong (*Eucrossorhinus dasypogon*).

❝ Just like the different eyes of the reef, the huge range of skin markings, colors, and textures demonstrates the great diversity of lifestyles in the underwater world—and reflects the many niches exploited by marine life. No two species are the same, but surprisingly different animals have evolved very similar ways of dealing with comparable problems. For all the residents of the reef, however, camouflage is of vital importance, and signals between mates and competitors, as well as body armor and vivid warnings, have all influenced how each and every animal's skin has evolved. ❞

△ Leaf scorpionfish (*Taenianotus triacanthus*).

△ Tiger cowrie (*Cypraea tigris*).

△ Stargazer (*Uranoscopus sulphureus*).

△ Reef stonefish (*Synanceia verrucosa*).

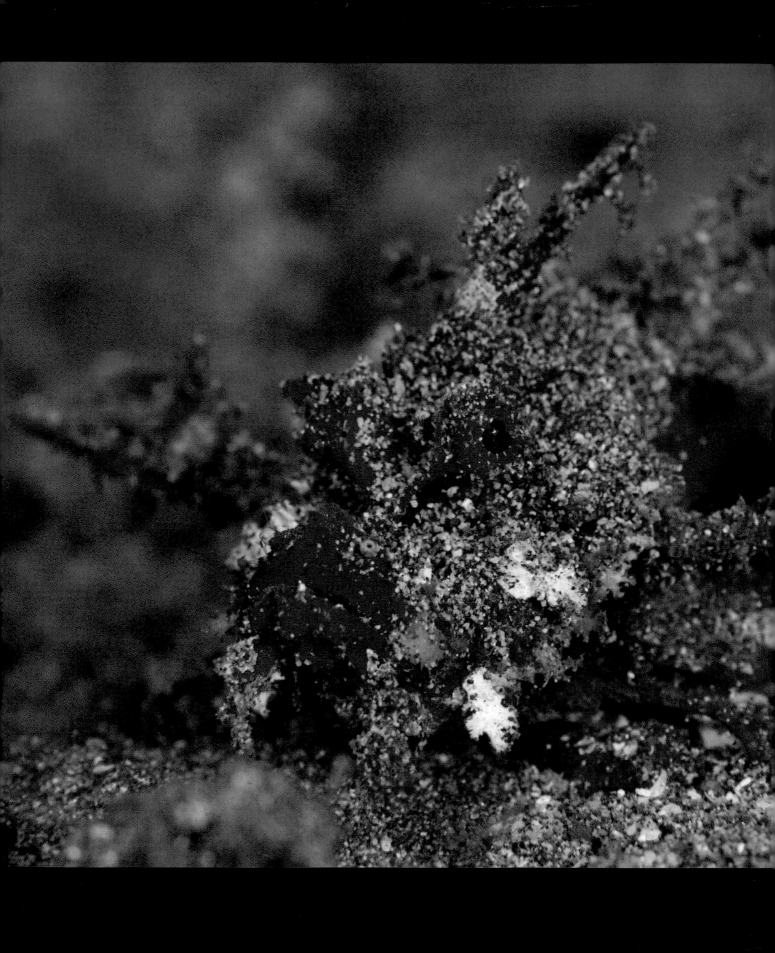

THE PERFECT DISGUISE

For the animals on the reef, camouflage allows them to blend into the background or break up the outline of their body to remain undetected. Many different species rely on camouflage to survive and all have evolved to match their natural environment. Animals on the empty plains, for example, resemble nothing more than a patch of sand or the pieces of coral rubble that dot their home. Minute crabs and gobies, on the other hand, have transparent bodies or are colored and patterned to accurately match the soft corals in which they live. Sea dragons and kelpfish that live among fields of algae have so honed their camouflage that they are difficult to spot in the waving fronds. For most species, camouflage is fixed from birth, tying them to a particular location—although the ornate ghost pipefish and giant frogfish develop their coloration according to where they settle. The undisputed masters of camouflage, however, are cephalopods: octopuses, cuttlefish, and squid can change the color and texture of their skin at will to match the reef—even as they move across it.

◁▽ The devil scorpionfish (*Inimicus didactylus*) uses camouflage to move stealthily across the seabed. If it finds a patch of coral with fish nearby, this venomous predator buries itself and waits for its prey to approach—before striking and sucking the fish into its mouth. Lembeh Straits, Sulawesi, Indonesia.

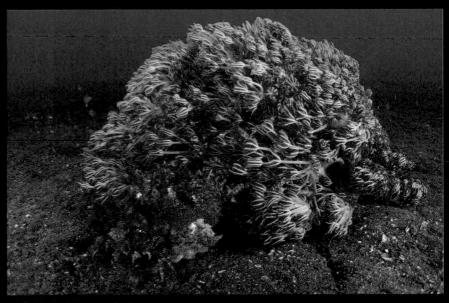

The crocodilefish (*Cymbacephalus beauforti*) is a visual hunter with acute eyesight. Its large eyes are camouflaged by a frill of skin. Mabul, Sabah, Malaysia.

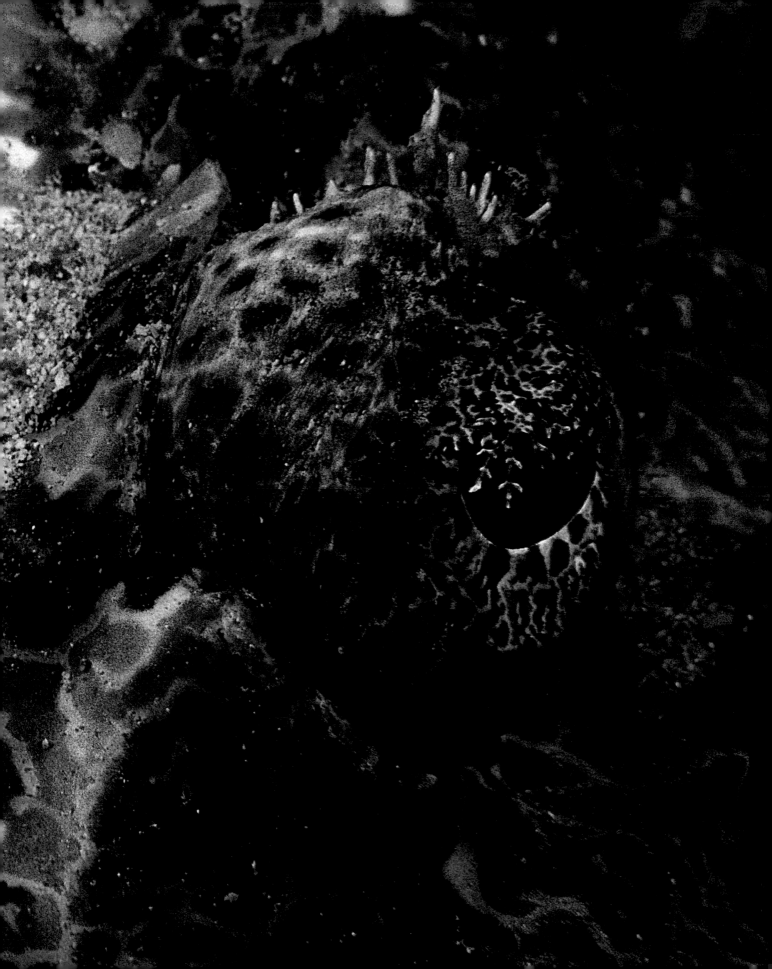

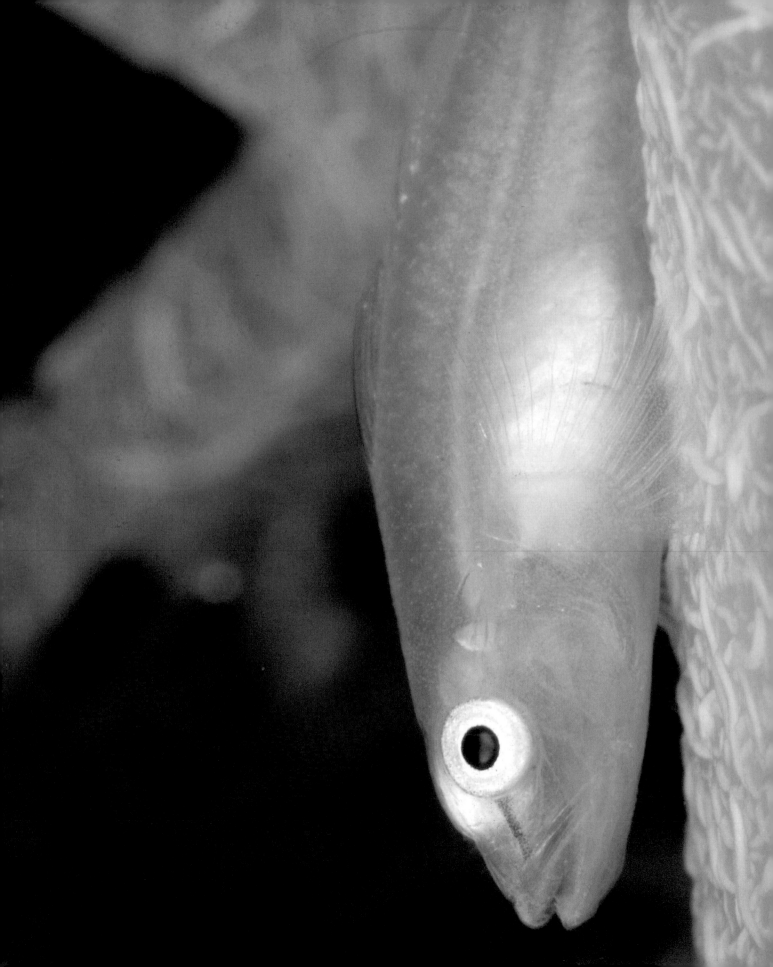

" Soft corals are a complete ecosystem in their own right, and it's possible to spend entire dives hunting for the minute fish, crabs, and shrimp that make their home among the intricate branches of these plantlike animals. The creatures here are all remarkably well camouflaged with transparent bodies, decorated shells, and delicate colors—sometimes even matching the elaborate patterns of polyps on the surface of the soft coral or the tough spicules that make up its skeleton. "

◁ The soft-coral ghost goby (*Pleurosicya boldinghi*) has an almost transparent body and colors to match that of its host soft coral, allowing it to blend into the background as it hides from predators. Raja Ampat Islands, West Papua, Indonesia.

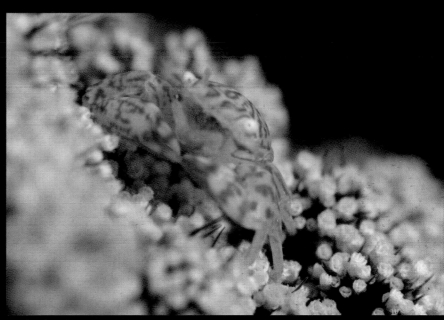

△ The porcelain crab (*Porcellanella picta*) can be found on a variety of hosts. Different species live on particular types of soft coral and have beautiful markings to match their colorful hosts. Lembeh Straits, Sulawesi, Indonesia.

A many-host goby (*Pleurosicya mossambica*) hides in its forest of polyps, only exposing itself to predators when darting out to grab particles of food. Raja Ampat Islands, West Papua, Indonesia.

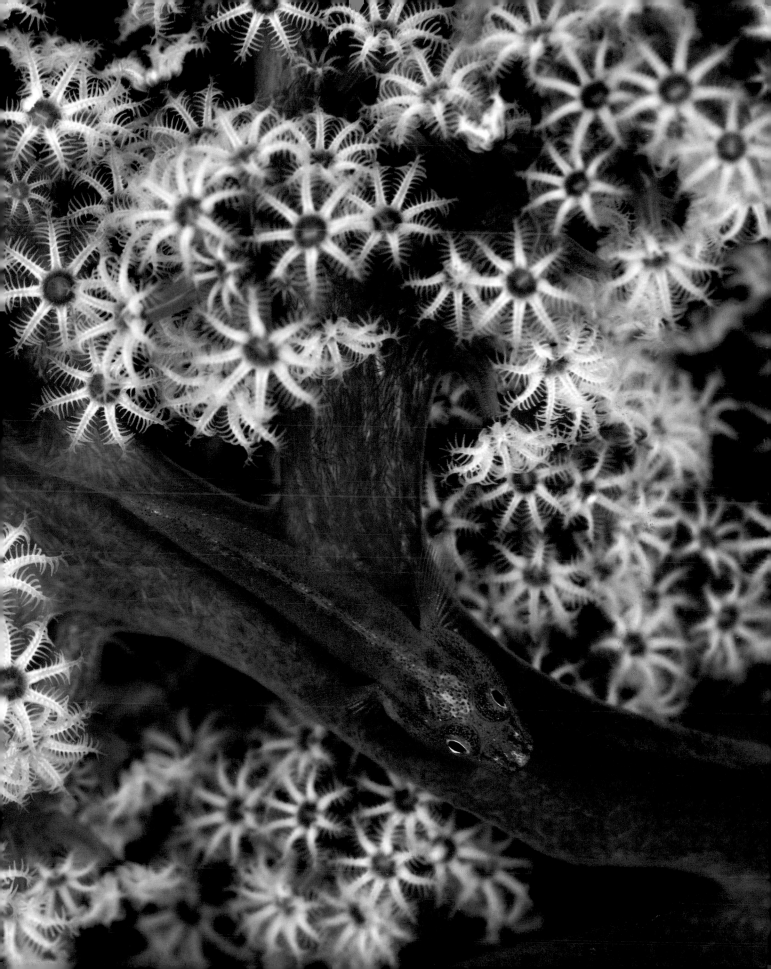

▷ The leafy sea dragon (*Phycodurus eques*) is a rare and stunning animal named after the leaflike projections that cover its body. This remarkable camouflage means it has no natural enemies, although the leafy sea dragon is now endangered because of human activities. Kangaroo Island, Australia.

▽ The camouflage of the weedy sea dragon (*Phyllopteryx taeniolatus*) allows it to disappear against the brown stalks and waving green fronds of its home. Kangaroo Island, Australia.

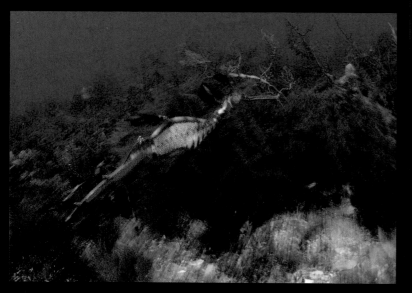

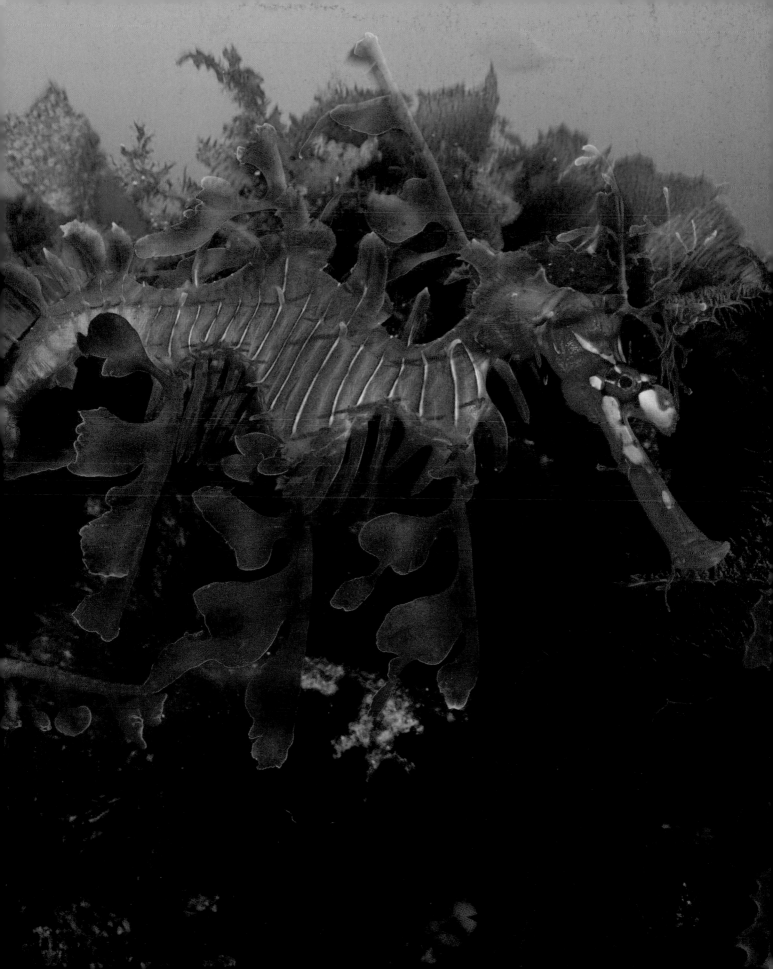

With so much diversity found at a minute scale, the macro-world of the reef is always full of surprises. On a recent trip to the Raja Ampat Islands we discovered that rather than there being three or four types of pygmy sea horses, as we expected, there were actually around seven. Most have yet to be scientifically described and might turn out to be just color variations, or even types of closely related pipe horses or pipefish. However, our experience clearly demonstrates how diverse places such as West Papua are—and how little we know about these habitats so far. Who knows how many other species are out there, just waiting to be discovered?

△ *Hippocampus denise.* Lembeh Straits, Sulawesi, Indonesia.

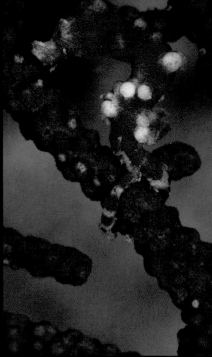

△ *Hippocampus denise var.* Raja Ampat Islands, West Papua, Indonesia.

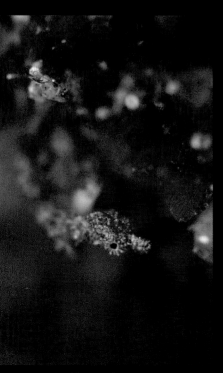

△ As yet unclassified species of pygmy pipehorse. Lembeh Straits, Sulawesi, Indonesia.

△ *Hippocampus pontohi.* Raja Ampat Islands, West Papua, Indonesia.

△ *Hippocampus bargibanti var.* Raja Ampat Islands, West Papua, Indonesia.

This pygmy sea horse (*Hippocampus bargibanti*) is no bigger than a little fingernail. Most species have yet to be scientifically described, and it's likely that more are just waiting to be found. Kapalai, Sabah, Malaysia.

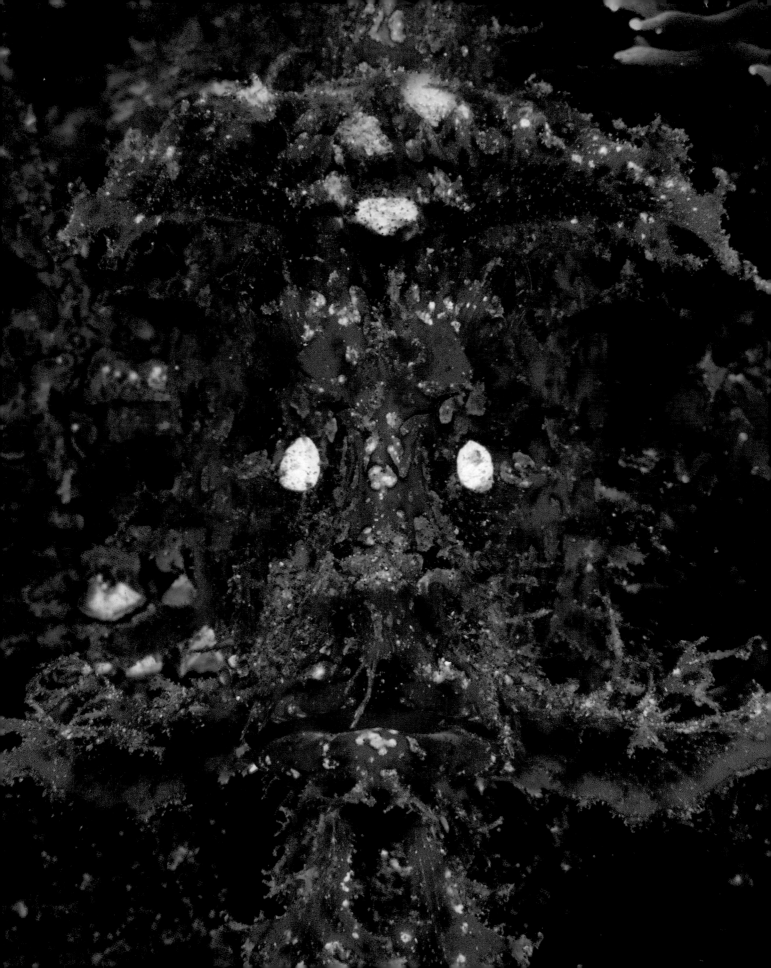

◁▽ As well as having excellent camouflage, the weedy scorpionfish (*Rhinopias frondosa*) has false eyespots. This further confuses its prey, and makes it appear larger than it really is. Lembeh Straits, Sulawesi, Indonesia.

different ways of camouflaging themselves according to the environments in which they live and hunt. Ambon and weedy scorpionfish are closely related, but ambon scorpionfish have evolved to match the algae and debris that drift across their homes, while weedy scorpionfish are thought to match the soft corals and weeds that make up the patch reefs where they live. **"**

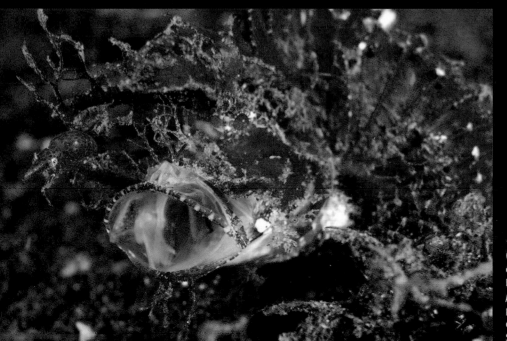

◁ The ambon scorpionfish (*Pteroidichthys amboinensis*) has convincing camouflage, as shown by the pygmy squid (*Idiosepius pygmaeus*) on the left of this picture, taking refuge perilously close to the predator. Lembeh Straits, Sulawesi, Indonesia.

I first developed a peculiar fascination for crustaceans after discovering just how many different species of animals choose to live on feather stars. Commensal shrimp, snapping shrimp, squat lobsters, and even a species of fish can all be found on a single crinoid. Then, if you explore the next crinoid along, there are several more species just waiting to be discovered. Such a profusion of life, however, doesn't make photographing them any easier—these animals are incredibly well-camouflaged.

▷ The crinoid squat lobster (*Allogalathea elegans*), which is no bigger than a postage stamp, has an elongated body with stripes and patterns that perfectly match the feather star on which it lives. Lembeh Straits, Sulawesi, Indonesia.

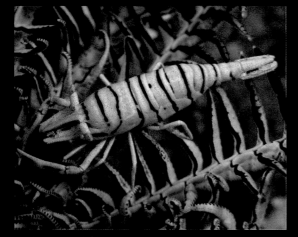

△ The stripes of this crinoid shrimp (*Periclimenes cornutus*) perfectly match its host. Lembeh Straits, Sulawesi, Indonesia.

△ A crinoid shrimp (*Periclimenes cornutus*) blends in well with its feather-star home. Lembeh Straits, Sulawesi, Indonesia.

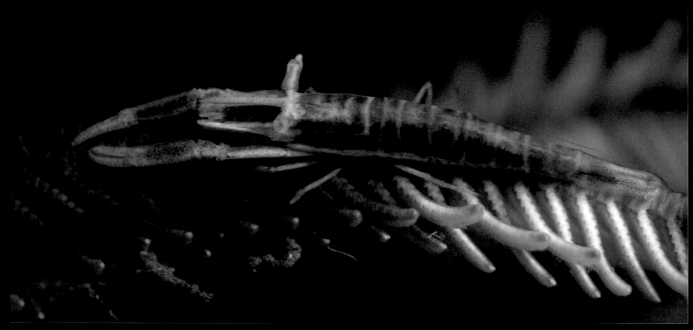

△ This crinoid shrimp (*Periclimenes amboinensis*) is perfectly camouflaged against a feather star. Lembeh Straits, Sulawesi, Indonesia.

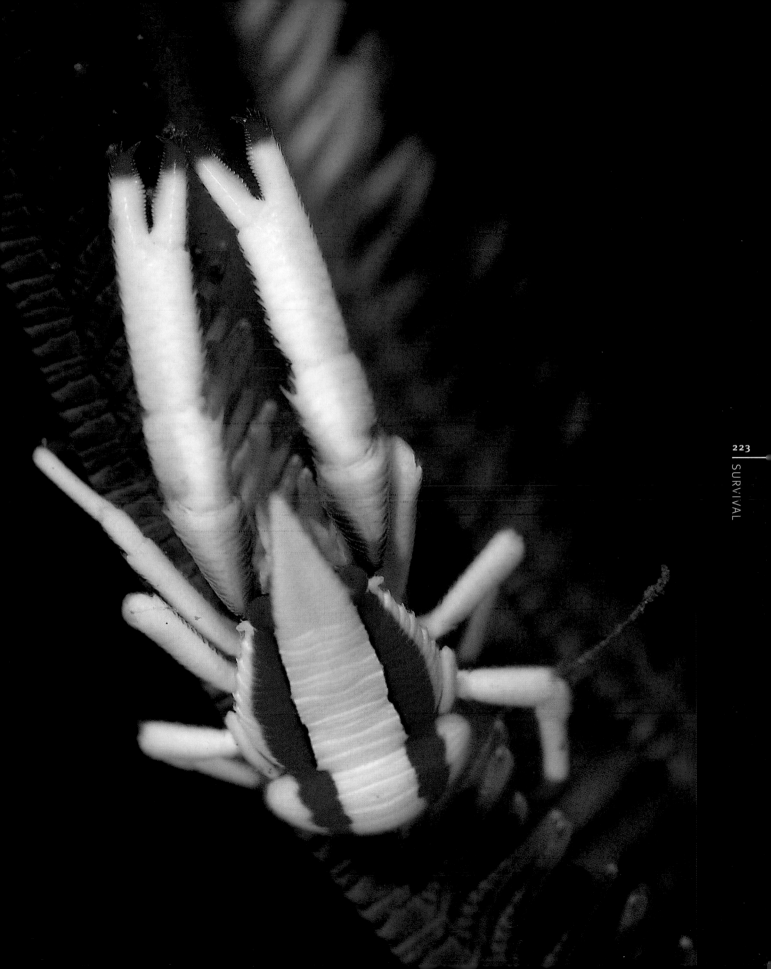

Cowries are elusive animals and are very difficult to find among the coral polyps in which they spend their entire lives. Once located, they can also be extremely difficult to identify. However, humans have had a long relationship with these stunning animals—money cowrie shells were used as currency for centuries, and have even turned up in Viking burial mounds, hundreds of miles away from their tropical home.

▽ The cowrie (*Calpurnus verrucosus*), along with its cousin the allied cowrie, has a mantle of tissue that it extends over its shell. This is decorated and patterned to match the polyps of the sea fan or leather coral in which it lives and feeds. Mabul, Sabah, Malaysia.

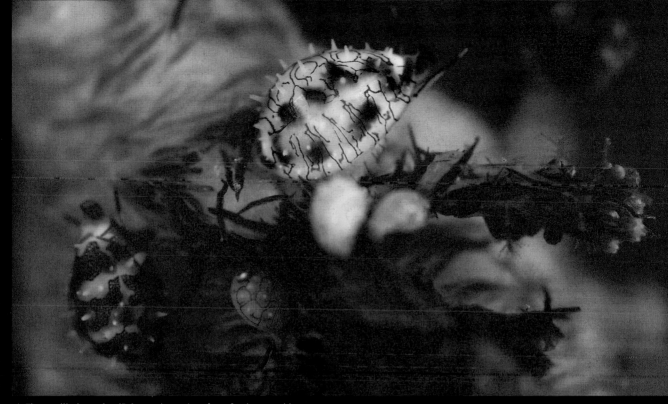

△ These allied cowries (*Prionovola aenigma*) perfectly resemble their soft-coral host. Lembeh Straits, Sulawesi, Indonesia.

△ A *Pseudosimnia globuvula* allied cowrie camouflages itself against the coral polyps. Mabul, Sabah, Malaysia.

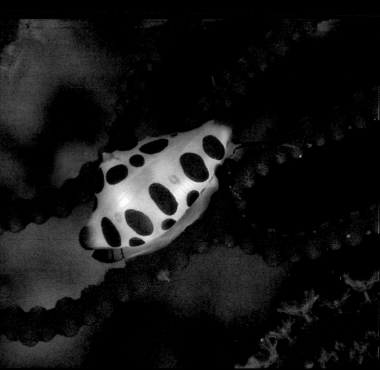

△ This allied cowrie (*Pseudosimnia sp.*) hides among the soft coral. Lembeh Straits, Sulawesi, Indonesia.

△ A *Primovula platysia* allied cowrie feeds on debris on the surface of a gorgonian sea fan. Mabul, Sabah, Malaysia.

" Determined to get a shot of an ornate ghost pipefish giving birth, I was lucky enough to have found a beautiful pregnant female on Sipadan. These fish are supposed to give birth at dawn, so I would dive down at daybreak and wait by the crinoid in which she was living. For six days I waited— and waited. For six days I was only able to capture her feeding on tiny mysid shrimp in the coral rubble. Then, on the seventh day, I dived down and discovered she was gone. I did, however, find her smaller partner several yards away, looking a little ragged, as if he had survived an attack by a predator. Despite failing to get the shot I wanted, I secretly hoped that my female had escaped safely and was giving birth to the next generation of beautiful ghost pipefish. "

▷ Young ornate ghost pipefish (*Solenostomus paradoxus*) are transparent and only develop their colorful markings later. Their adult colors are determined by the environment in which they finally settle, be it a red sea fan or a yellow crinoid. Kapalai, Sabah, Malaysia.

△ A mature female ornate ghost pipefish (*Solenostomus paradoxus*) in a sea fan. Mabul, Sabah, Malaysia.

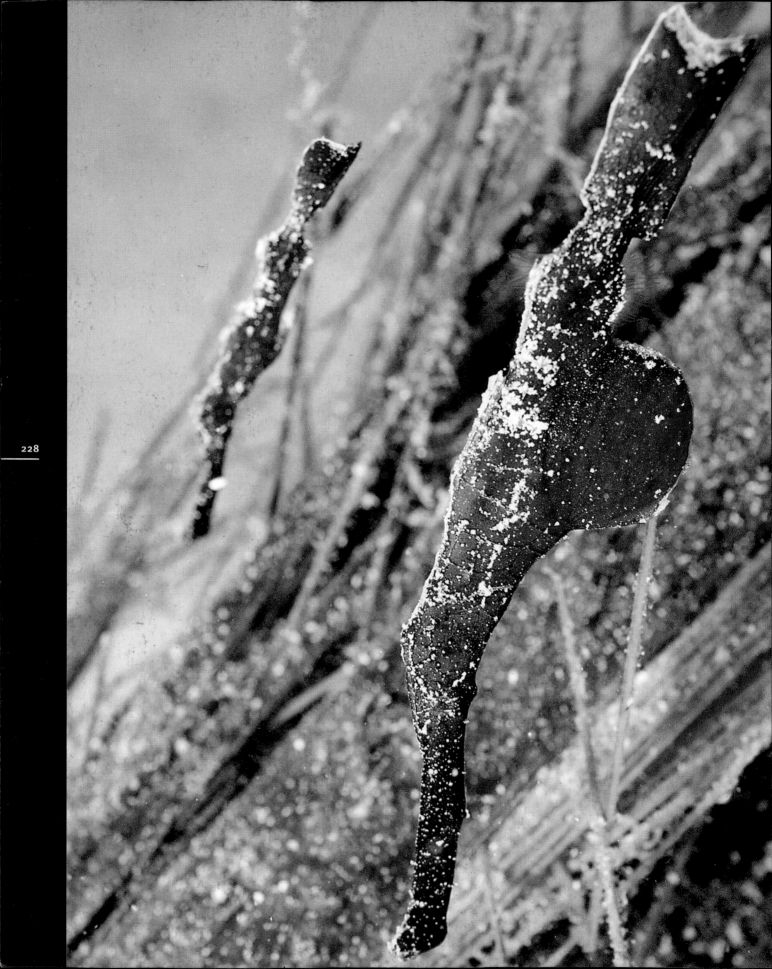

△ A juvenile robust ghost pipefish (*Solenostomus cyanopterus*) mimics dead algae. Lembeh Straits, Sulawesi, Indonesia.

△ A halimeda ghost pipefish (*Solenostomus halimeda*) mimicking halimeda algae. Kapalai, Sabah, Malaysia.

△ A male and female robust ghost pipefish (*Solenostomus cyanopterus*) mimic living seagrass. Mabul, Sabah, Malaysia.

◁ Robust ghost pipefish (*Solenostomus cyanopterus*) mimicking dead seagrass. Kapalai, Sabah, Malaysia.

Tracking down hairy frogfish and watching them feed proved to be more straightforward than I had expected. Although they are extremely well camouflaged, there are many locations in the Lembeh Straits where these voracious predators can be found. Sure enough, we discovered some fine specimens, all perfectly resembling the soft corals that grow in the seas here. As we watched, the frogfish were constantly striking out at the schools of small cardinalfish that sheltered among the corals. The deception of the frogfish seemed almost complete—only on a few occasions did a cardinalfish spot its adversary in time and escape.

▽▷ The huge mouth of the hairy frogfish (*Antennarius striatus*) is only revealed when it "yawns", a threat display used when its hiding place among the soft corals is disturbed. Lembeh Straits, Sulawesi, Indonesia.

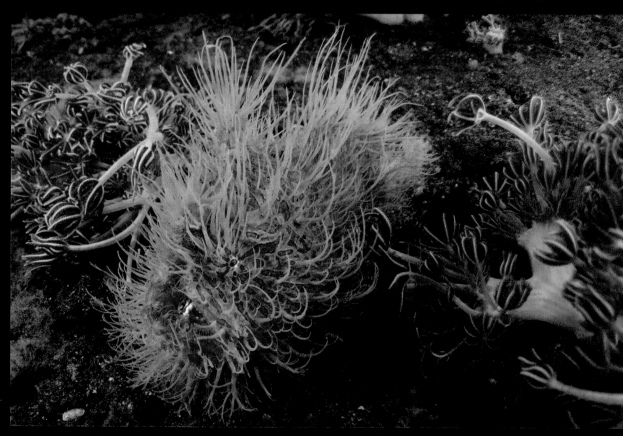

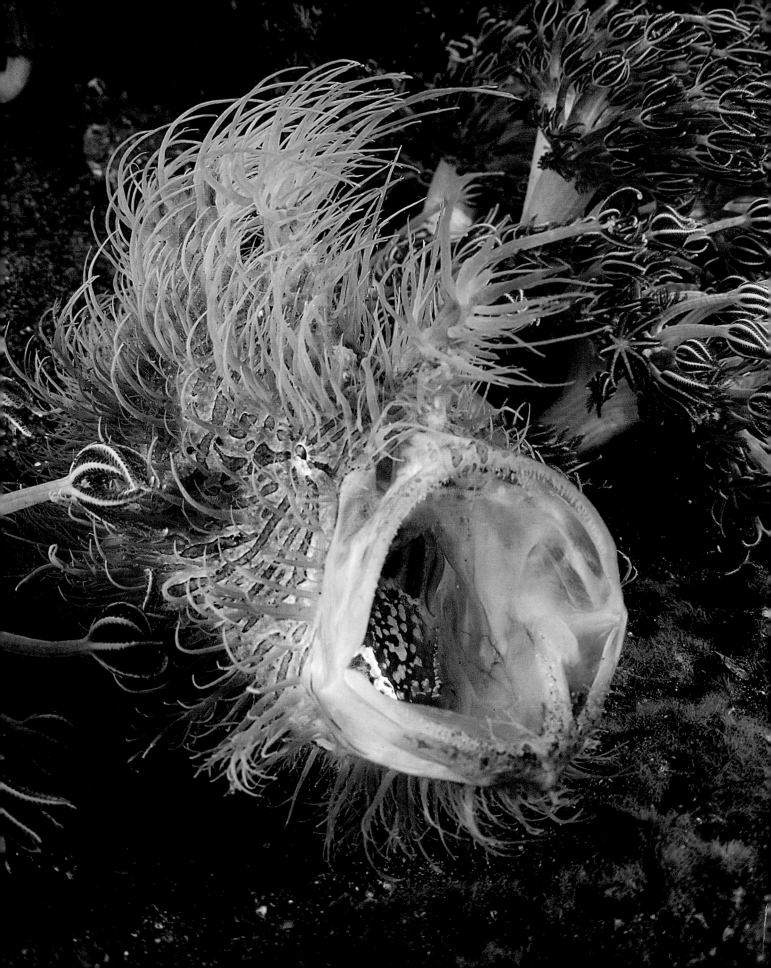

ULTIMATE DECEPTION

Only discovered in 1998, the mimic octopus is thought to represent the pinnacle of deceptive behavior on the reef. Unlike many other species of octopus, the mimic hunts across the exposed sand plains during the day and, to survive in this dangerous environment, has evolved an ability to dynamically mimic other animals—particularly venomous sea snakes and lionfish. By copying their markings, and using its tentacles to imitate their body shape, the mimic can warn off any predators. It has been argued that this behavior is actually just a vivid threat display, only seen as mimicry through our own eyes. But whatever the explanation, the mimic is undoubtedly one of the most remarkable creatures ever to be found on the reef.

▽ The mimic octopus (*Thaumoctopus mimicus*) is possibly the only species of animal that can dynamically mimic a range of subjects. Sulawesi, Indonesia.

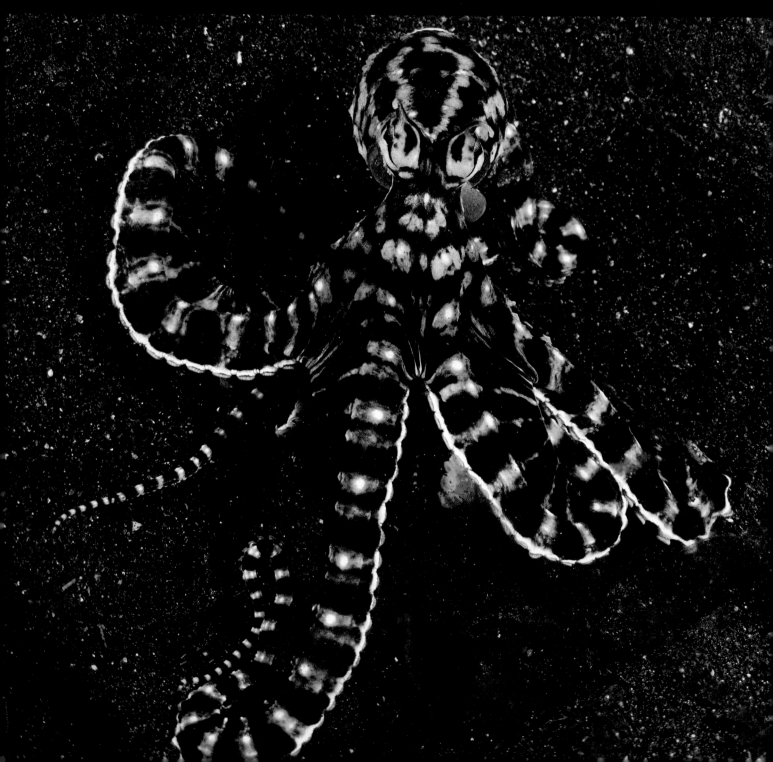

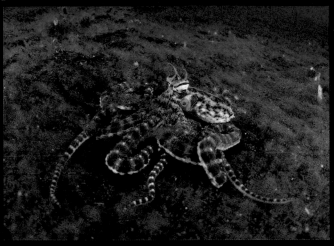

△ When undisturbed, the muted colors of the mimic octopus allow it to blend in well with the sand and algae on the sea floor.

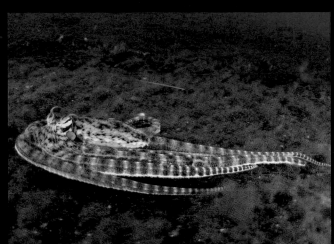

△ If exposed by a predator, this octopus moves off, mimicking nonvenomous species such as flatfish.

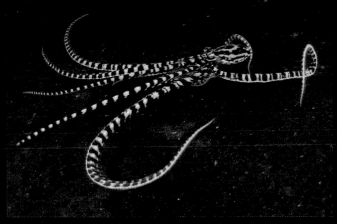

△ If threatened further, the mimic displays the dramatic markings typical of venomous predators like sea snakes or lionfish.

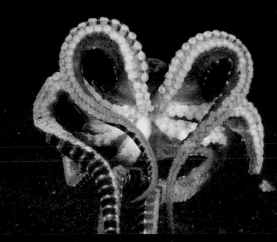

△ If mimicry fails, the octopus can deploy its speed to avoid a predator, using jet propulsion to escape.

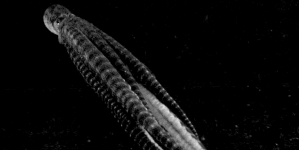

△ Moving at high speed, the mimic either hunts for a suitable hole or heads to the surface.

△ As the mimic drops back down to the seabed, it spreads its arms, perhaps resembling an inedible crinoid.

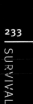

Schooling

The open water is a dangerous place, but it's here that many fish must feed, find a mate, and spawn. Safety in numbers is crucial for survival.

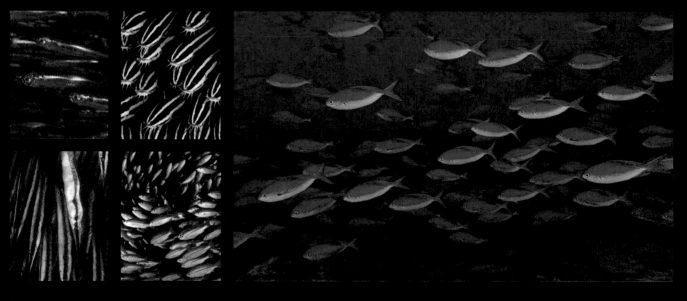

Schooling is one of the best ways to survive an attack by a predator when there are no mangrove roots or coral branches in which to hide. Some schools are loose and temporary, with many different species congregating in current-swept areas to feed. Others are more permanent, consisting of a single species. Both, however, rely on the fact that individual fish are less likely to be targeted when surrounded by masses of others. Reflective scales and bright colors or patterns further help each fish merge into the school. As with zebras on the plains of Africa, stripes of color add to the confusion when an attacking predator sends the fish into frenzied motion. A school can pulse into remarkable shapes and sizes, with ripples of movement racing throughout, as each fish responds to the changes in water pressure caused by the actions of its neighbor, an attacking predator, or the bubbles of an inquisitive diver.

△ Yellowtail fusiliers (*Caesio teres*) schooling for safety as they feed above the reef.
▷ Chevron barracudas (*Sphyraena quenie*) can create spiral formations as they school.

Schooling has further benefits for a sociable animal—finding a mate is simpler when surrounded by your own species. Many fish use color displays to advertise their willingness to mate, and can turn them on and off at will should a predator emerge from the blue.

Schooling is common behavior for both temperate and tropical fish. For safety, these snappers (*Lutjanus sp.*) form large schools during the day, dispersing at night to feed on small fish. Sodwana Bay, South Africa.

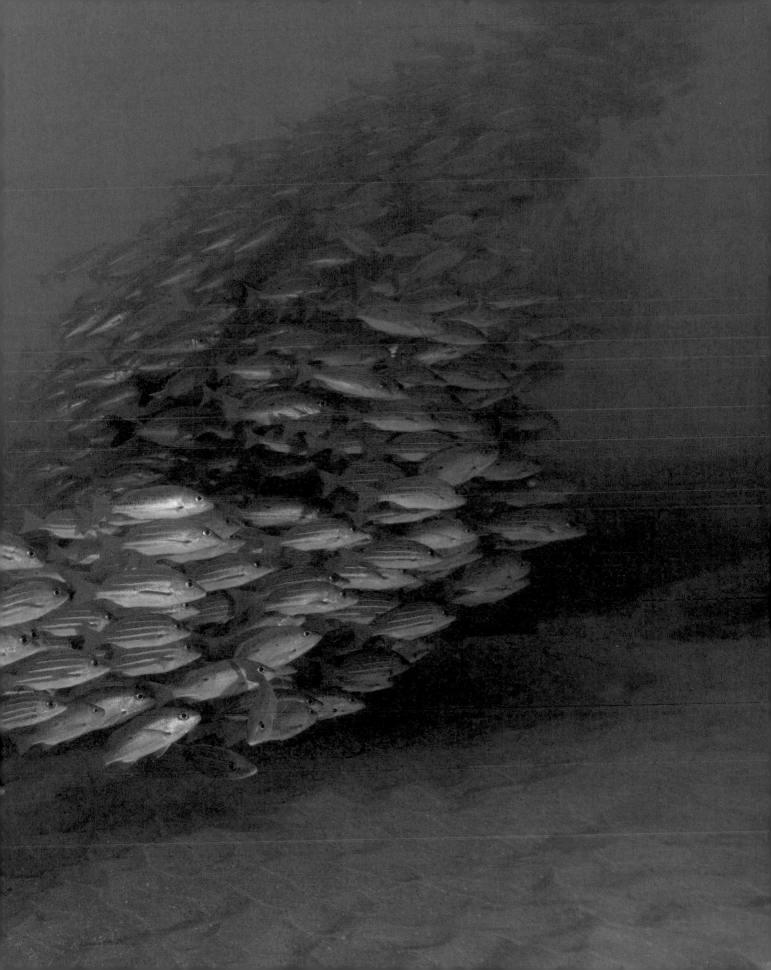

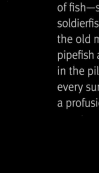

" Off the northeast coast of Borneo lies an old oil-rig platform that has been transformed into a diving resort. During the conversion, metal was removed from the interior of the rig, cleaned up, and piled on the sandy seabed to create a series of artificial reefs. These reefs now harbor an incredible amount of marine life. Schools of fish—such as these whitetip soldierfish—take shelter among the old metal frames, ghost pipefish and frogfish lie hidden in the piles of wreckage, and every surface is covered in a profusion of life. "

▷ Whitetip soldierfish (*Myripristis vittata*) prefer to hide in caves or deep overhangs, but are equally happy to shelter in a wreck. Their red coloration only shows up in the flash of a camera's strobe—under natural light they appear completely colorless, blending into the muted colors of their surroundings. Mabul, Sabah, Malaysia.

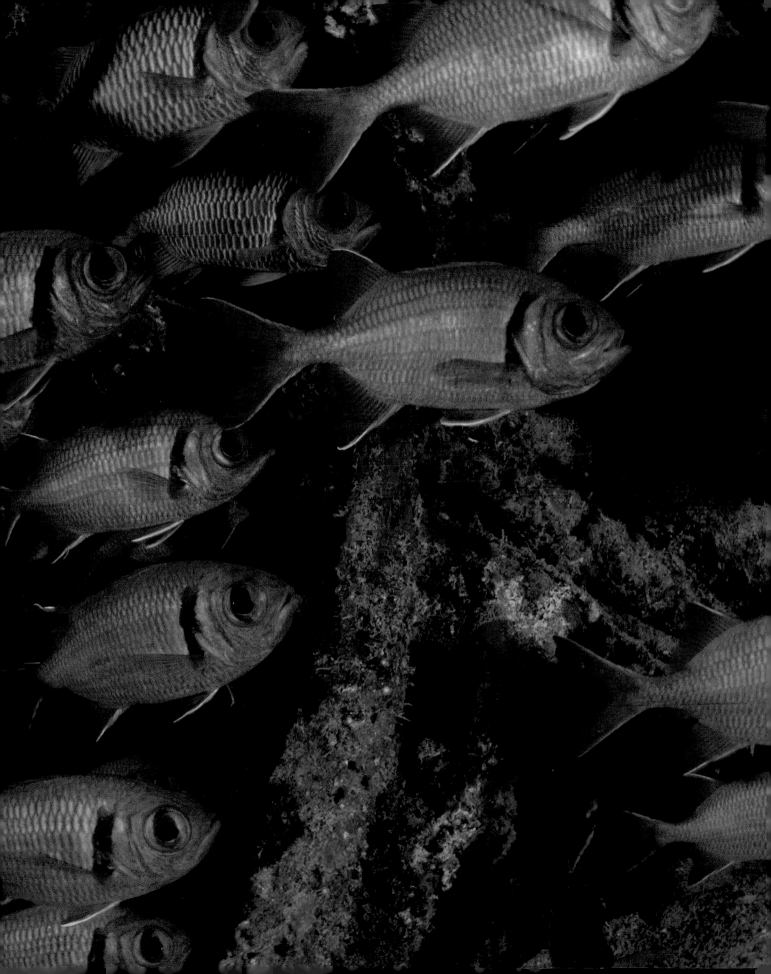

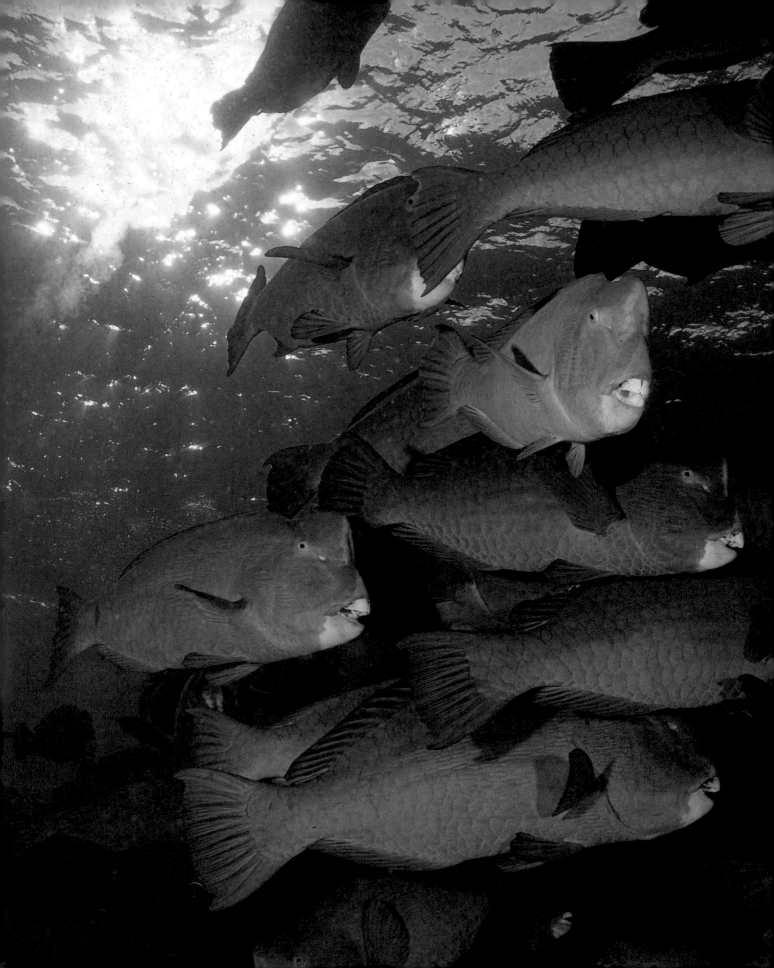

" Every morning, just as the sun breaks the horizon, a group of bumphead parrotfish gather at Barracuda Point on Sipadan, Malaysia. I have been fortunate enough to dive with these animals many times, watching them as they mill around, make use of the cleaning stations in the shallows, and prepare themselves for the day ahead. By the time any other divers have entered the water, the school is ready to move off to feed, moving like a herd of buffalo grazing over the sunlit reefs. "

◁ Bumphead parrotfish (*Bolbometopon muricatum*) moving slowly over the reef. During the few days on either side of the full moon, male bumpheads display to the females, eventually chasing them toward the surface, where they spawn. Sipadan, Sabah, Malaysia.

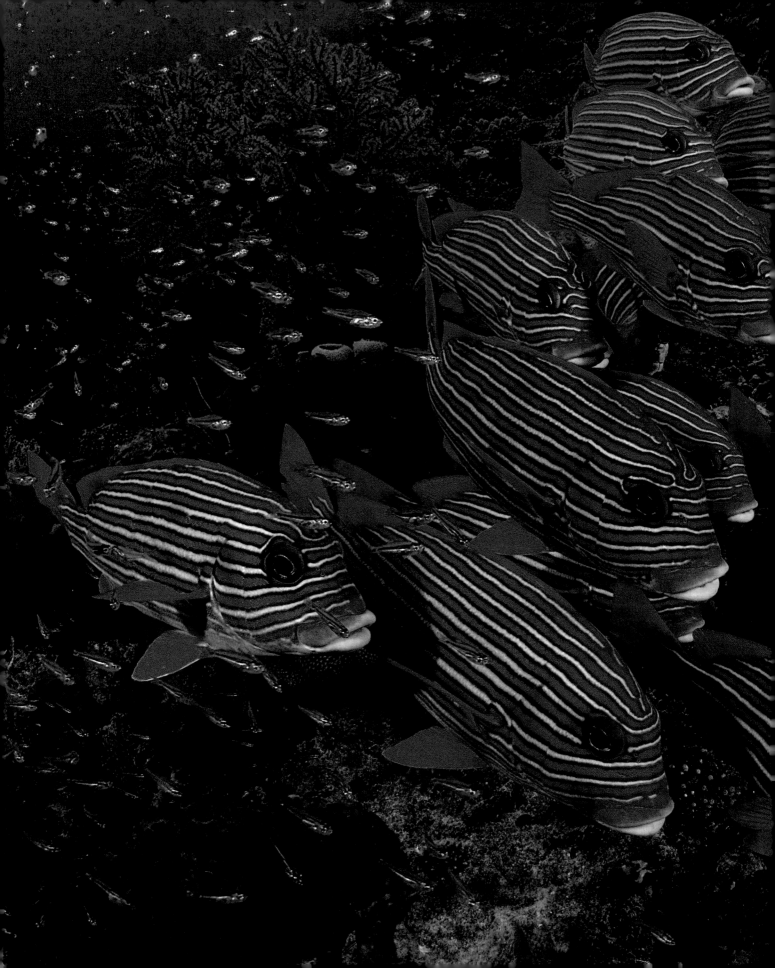

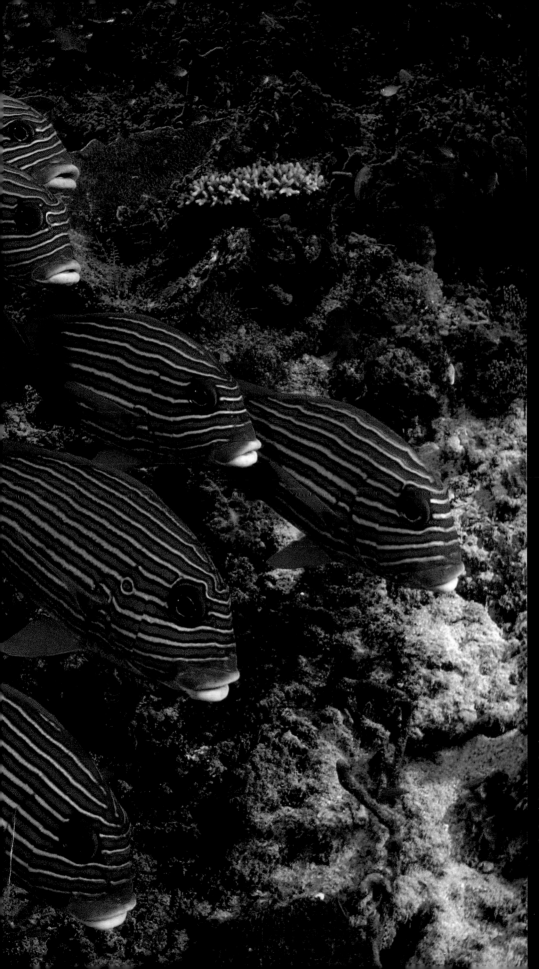

" Despite being a relatively common sight on the reef, sweetlips are one of my favorite photographic subjects. Small schools of these vivid-looking fish take up residence around coral bommies or black coral bushes and, as long as you are slow and quiet, can be very easy to approach. Their huge lips and bright eyes lend them a good deal of character, perfect for portraits. "

▷ Yellow-ribbon sweetlips (*Plectorhinchus polytaenia*) use their bright markings to identify other members of their species, helping them stay together in a school among the other brightly colored fish on tropical reefs. Their stripes also break up the outline of each animal, making it difficult for a predator to identify individuals to attack. Raja Ampat Islands, West Papua, Indonesia.

Yellowtail fusiliers (*Caesio teres*) schooling in the open water. When threatened, they form a tight mass of color, making it difficult for a predator to pick out individual fish. West Papua, Indonesia.

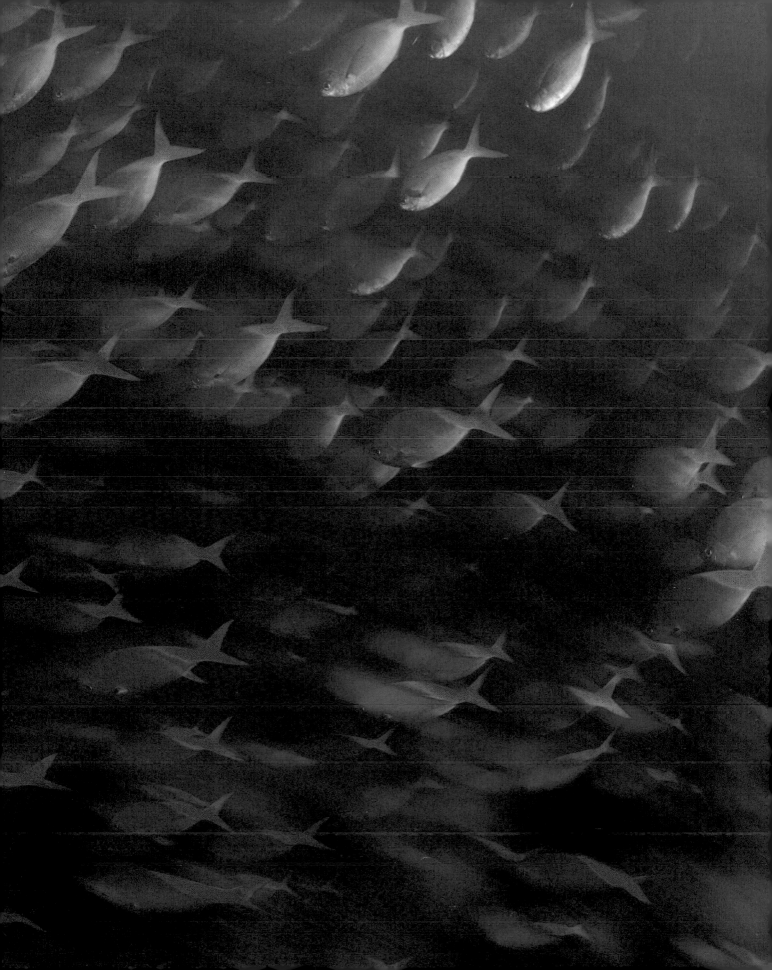

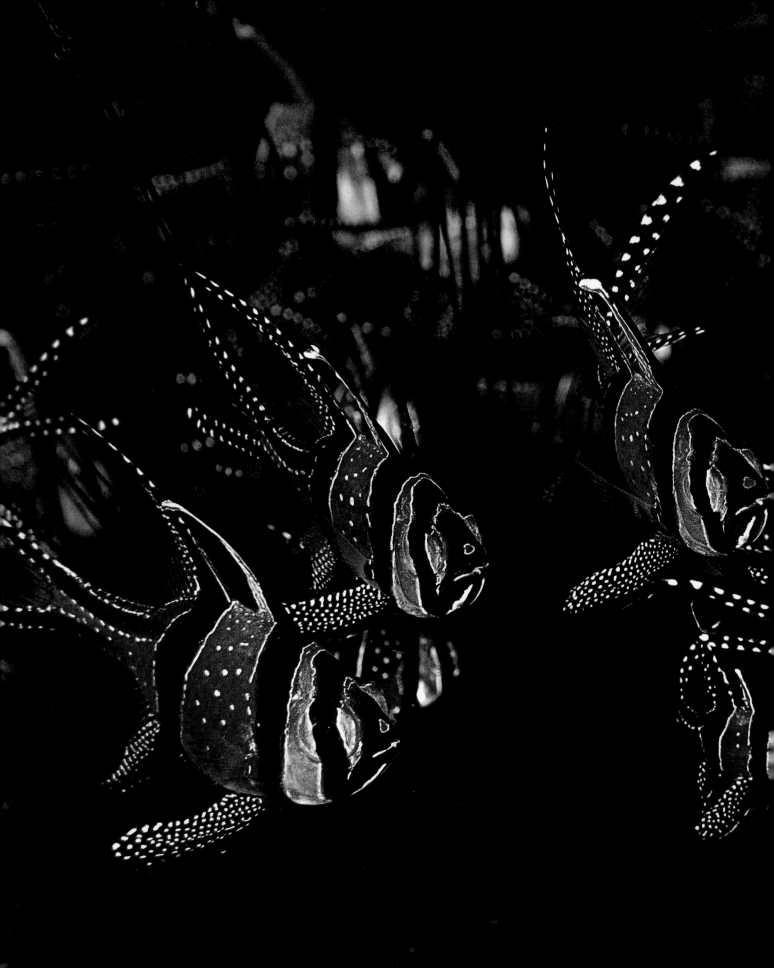

SURVIVAL

> " These stunning fish originate from a tiny group of islands on Sulawesi's east coast, but can now be found in several other locations—it's thought that they were spread by the fishermen who catch them live for the aquarium trade. Worldwide demand for these fish means they are now facing extinction. "

◁ Banggai cardinalfish (*Pterapogon kauderni*) form tight schools in the shelter of sea urchins. Their stunning markings may appear bold and obvious to us, but they help each fish blend in both with the school and with their spiny home. Lembeh Straits, Sulawesi, Indonesia.

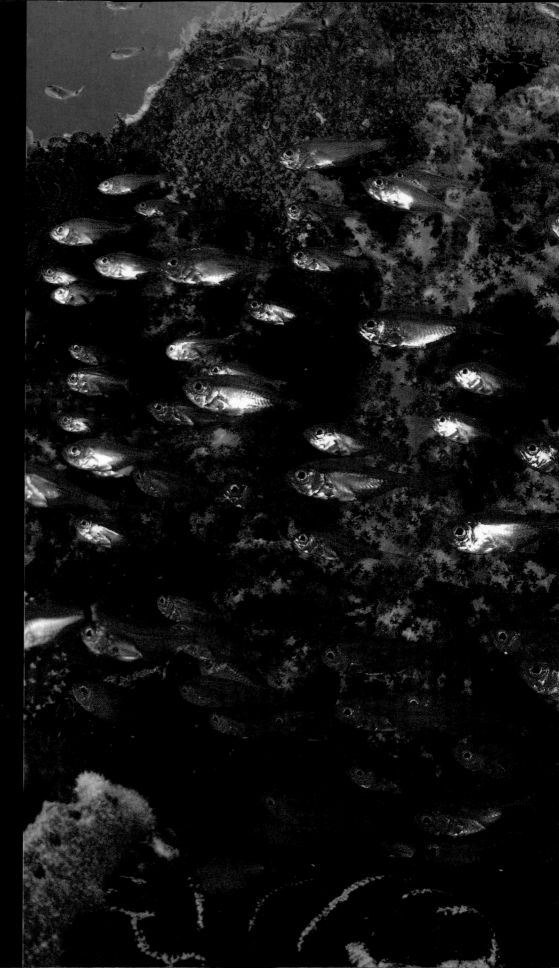

" While diving on the untouched reefs of the Raja Ampat Islands, we would often come across huge clouds of these beautiful fish, surrounding large coral heads or sea fans. Watching them as they reacted in unison to approaching predators became almost hypnotic, as the pulsing movement of the schools seemed to synchronize perfectly with the rhythms of the currents and swell. "

248

▷ Like many small fish, golden sweepers (*Parapriacanthus ransonneti*) prefer the shelter of the reef to open water. Their reflective scales help confuse attacking predators. Raja Ampat Islands, West Papua, Indonesia.

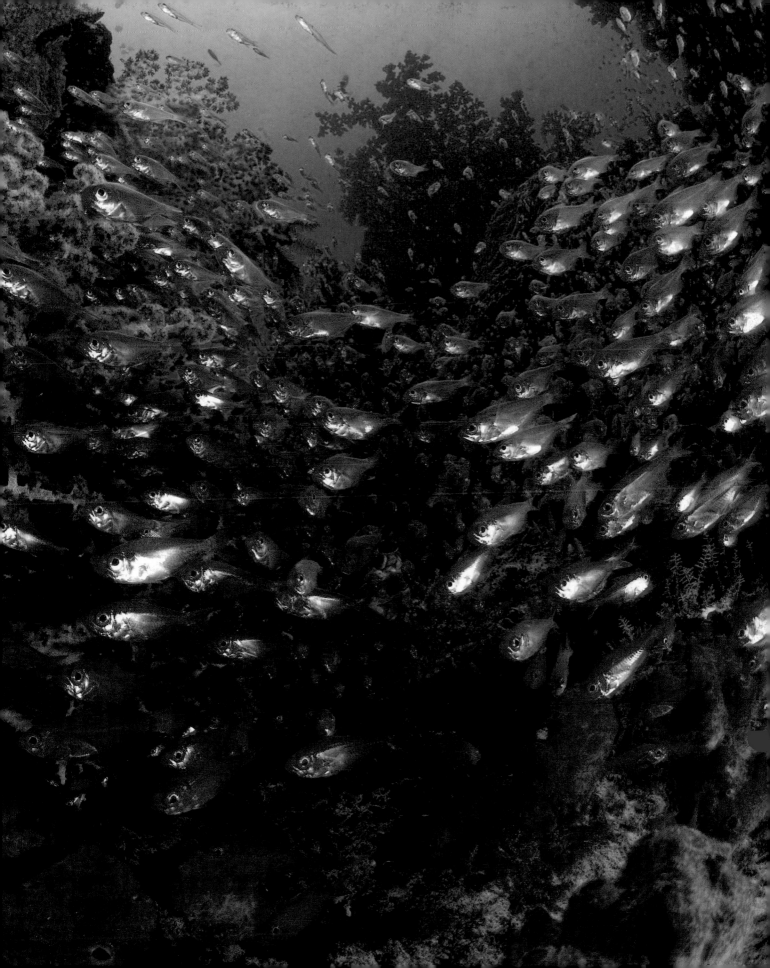

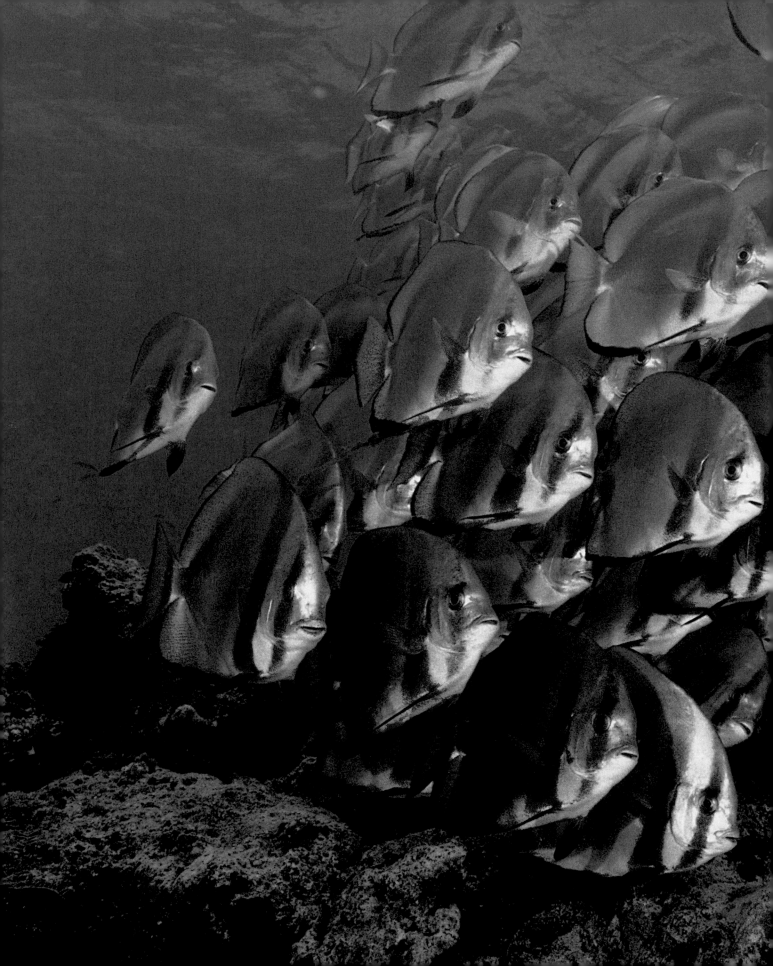

" Large schools of batfish are often one of the first sights to greet you as you descend onto a healthy reef. They hover en masse around cleaning stations, opening up their gills and allowing cleaner wrasse to go about their work, or form loose groups out in the blue as they feed. Batfish can rapidly change the bars that mark their bodies, darkening them when they feel threatened, and then bunching together to present a confusing mass of stripes. **"**

◁ The black bars on batfish (*Platax boersii*) are thought to disguise their large, obvious eyes and break up the outline of their bodies when they school. Sipadan, Sabah, Malaysia.

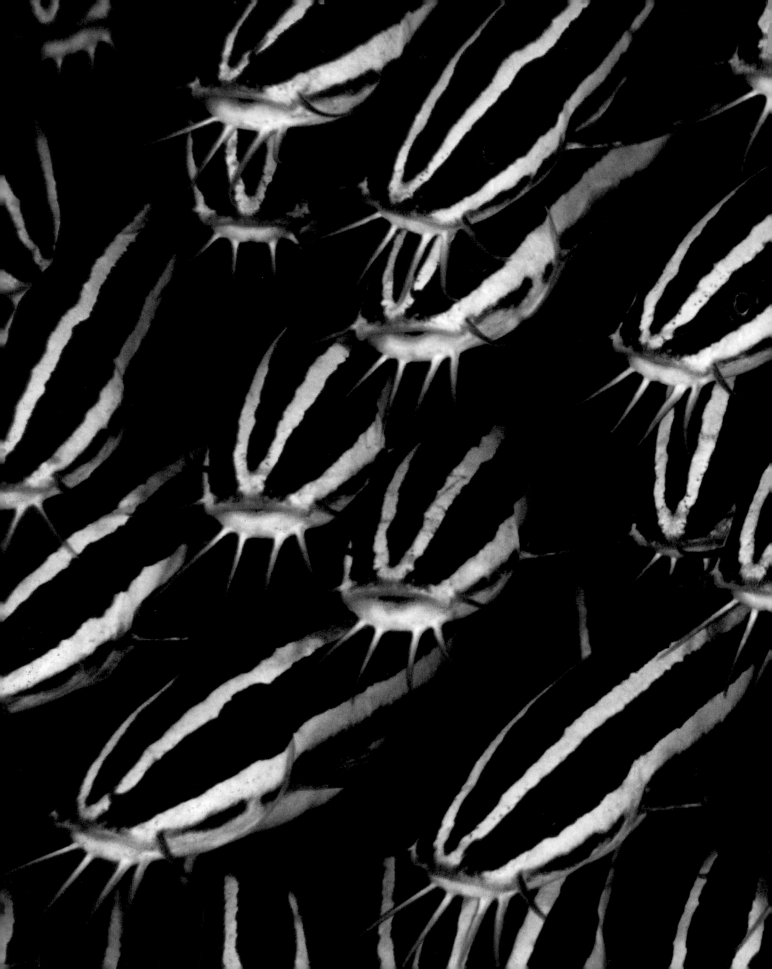

Striped catfish (*Plotosus lineatus*) roam across sand plains in tight ball-shaped formations, darting down to feed on small crustaceans disturbed by their presence. Lembeh Straits, Sulawesi, Indonesia.

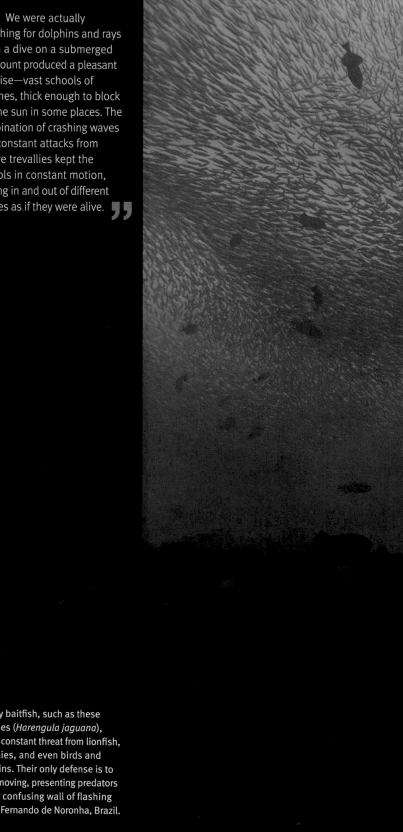

> " We were actually searching for dolphins and rays when a dive on a submerged seamount produced a pleasant surprise—vast schools of sardines, thick enough to block out the sun in some places. The combination of crashing waves and constant attacks from bigeye trevallies kept the schools in constant motion, pulsing in and out of different shapes as if they were alive. "

▷ Tiny baitfish, such as these sardines (*Harengula jaguana*), live in constant threat from lionfish, trevallies, and even birds and dolphins. Their only defense is to keep moving, presenting predators with a confusing wall of flashing silver. Fernando de Noronha, Brazil.

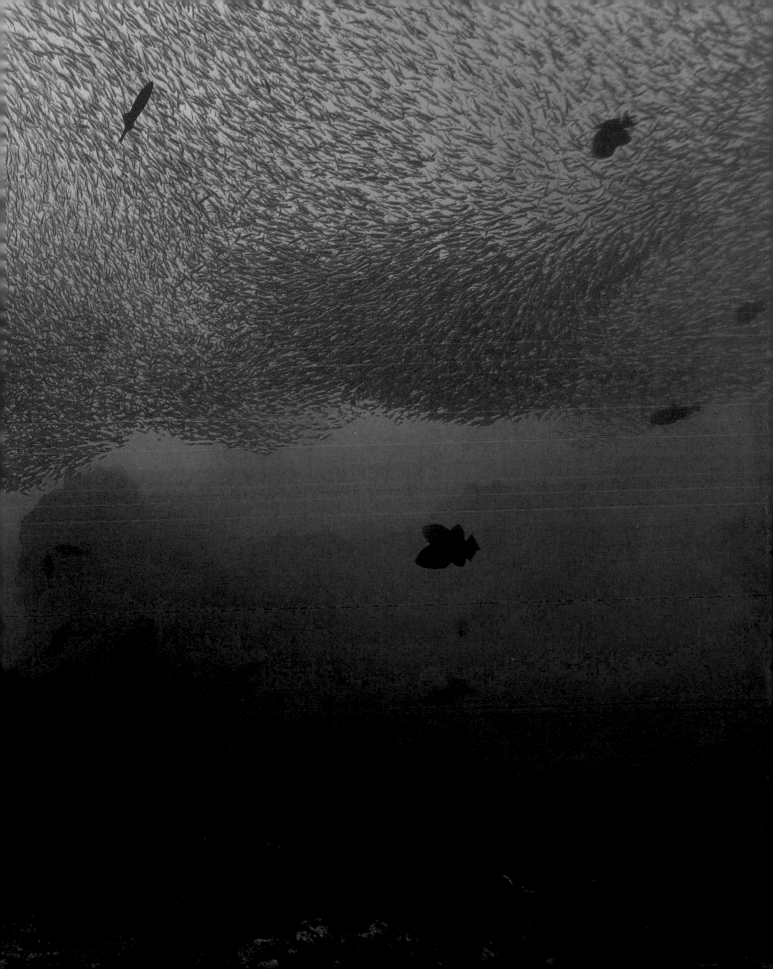

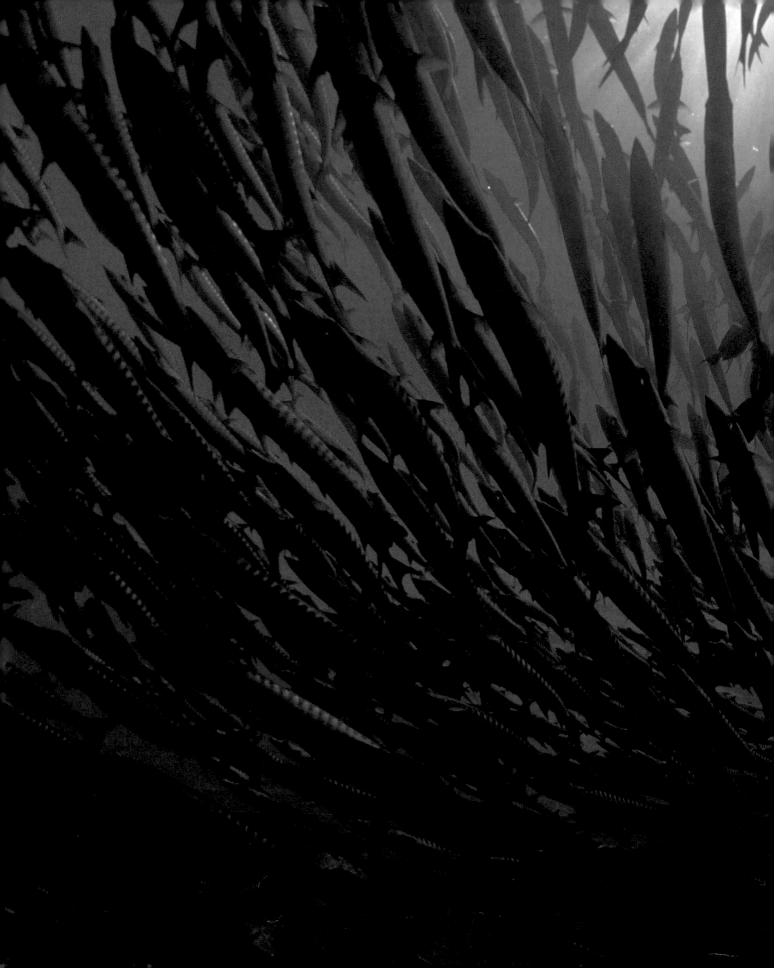

A huge school of chevron barracuda (*Sphyraena quenie*) turning in the water is one of the most remarkable sights on the reef—especially when viewed from the eye of this fishy tornado. Sipadan, Sabah, Malaysia.

" Despite the fact that these snappers were easy to locate, I had a frustrating and difficult time trying to get the head-on shot I really wanted. Every time I thought I had the perfect composition, the fish would suddenly spin away, splitting apart and turning in different directions before coming together again farther off in the distance. It was a perfect illustration of how big schools respond to a threat—be it a shark or a photographer. "

▷ Large schools of humpback snappers (*Lutjanus gibbus*) are commonly seen hovering over the shallow reefs of east Africa. They rely on speed and confusion to keep predators at bay, bursting into frenzied motion if threatened. Sodwana Bay, South Africa.

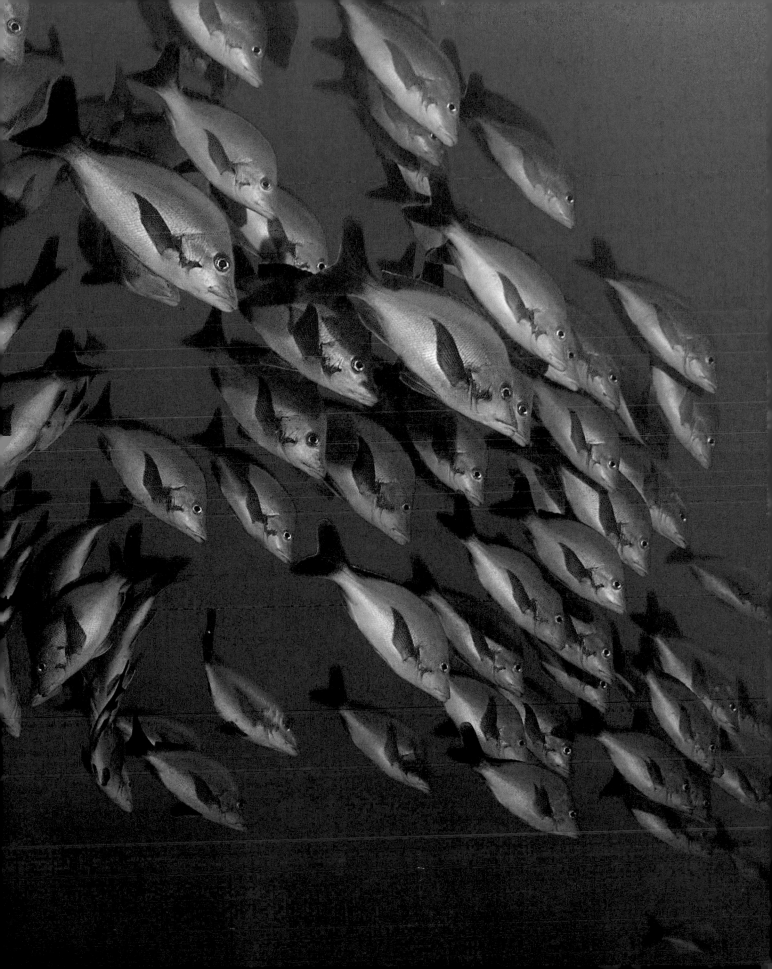

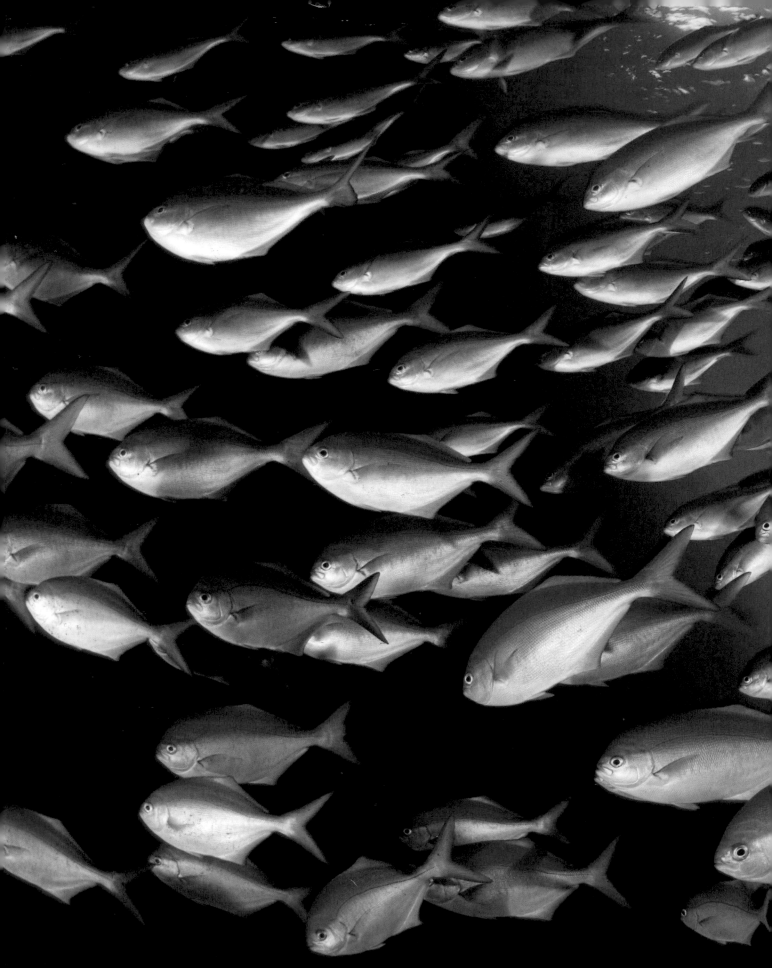

Blue maomao (*Scorpis violaceus*) form dense, colorful schools in areas with plentiful food. Sea arches, which concentrate the plankton-laden currents, provide perfect feeding conditions. Poor Knights Islands, New Zealand.

" In the South China Sea there are several atolls with resident schools of scalloped hammerhead sharks. Despite their size, these schools are difficult to approach because, surprisingly enough, hammerheads are extremely shy—the bubbles from a diver are enough to scare them off. The only way I managed to get this shot was to hide behind a sea fan on the reef wall and hold my breath, waiting for the sharks to get close enough before swimming out and shooting a couple of frames. "

◁ In the deep waters of tropical reefs, where the temperature is cooler than at the surface, scalloped hammerhead sharks (*Sphyrna lewini*) spend the day in large, mixed schools consisting of both adults and juveniles. As hammerheads are known to hunt alone, it's thought they school for social reasons, such as to find a mate in the dark waters. Layang Layang, Sabah, Malaysia.

264

▷ Spinner dolphins (*Stenella longirostris*) are among the most sociable animals in the sea, spending their lives in large pods. They hunt, play, and travel together, communicating using a complex language of sonar squeaks and clicks. Fernando de Noronha, Brazil.

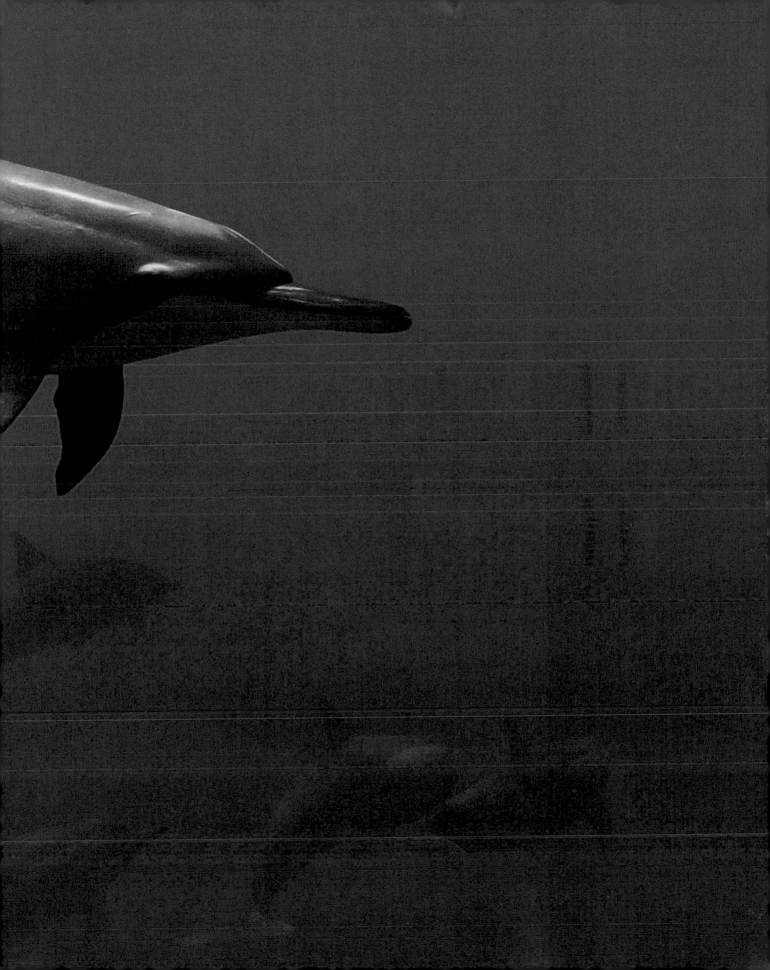

" I had been diving around a small rocky outcrop, home to a group of juvenile male sea lions and a few females. Most would play together on the surface or simply lounge in the sun, occasionally allowing me to get close enough to shoot. However, one young male seemed to want to involve me in the life of the small group, presenting me with mouthfuls of seaweed ripped from the rocks. "

▷ Australian sea lions (*Neophoca cinerea*) live and breed along the south coast of Australia, where they feed on fish and squid in the cool ocean currents. During the breeding season, the males fight for control of small territories used by the females to give birth on dry land. Kangaroo Island, Australia.

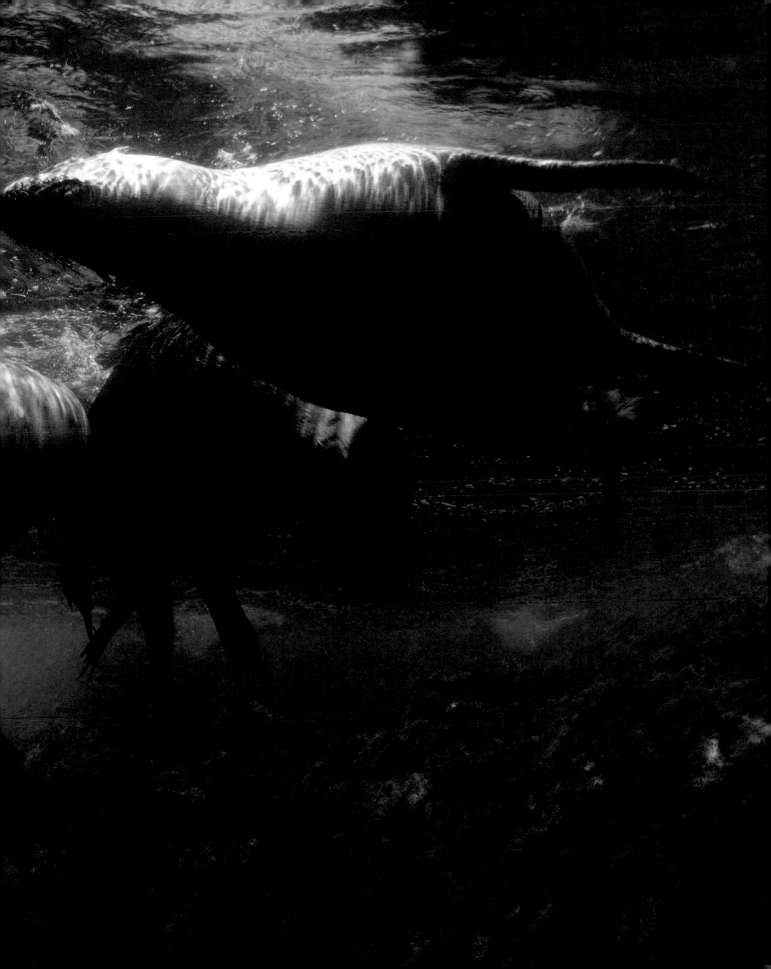

Symbiosis

The simple arrangement of predator and prey is not the only bond on the reef—some remarkable interdependent relationships have also evolved.

Intense competition for light, space, and food has resulted in some unusual underwater partnerships. For tiny crustaceans, hydroids, and even fish, the body surface of a large animal is the perfect place to grow, feed, and mate. Other fish, such as angelfish and wrasse, might gather around a foraging hawksbill turtle, hoping to benefit from the bounty of food exposed as it rips up corals in search of sponges. A pearlfish seeks protection from predators by living inside a large sea cucumber, although it offers its host nothing in return. These one-sided partnerships are known as commensalism, with the host neither gaining nor losing.

Mutually beneficial partnerships include the cleaner wrasse and shrimp that service both the smallest and largest inhabitants of the reef by eating their dead skin and parasites. Certain species of branching corals provide shelter for minute crabs, which, in return, defend

△ A tiny western cleaner-clingfish (*Cochleoceps bicolor*) on a harlequin fish (*Othos dentex*).
▷ A big-eye bream (*Monotaxis grandoculis*) and cleaner wrasse (*Labroides dimidiatus*).

their host and home by biting the feet of attacking crown-of-thorns starfish.

Symbioses reach their ultimate expression with species that can't live without the presence of another. Most famously, beautiful anemonefish can only survive hidden in the arms of anemones.

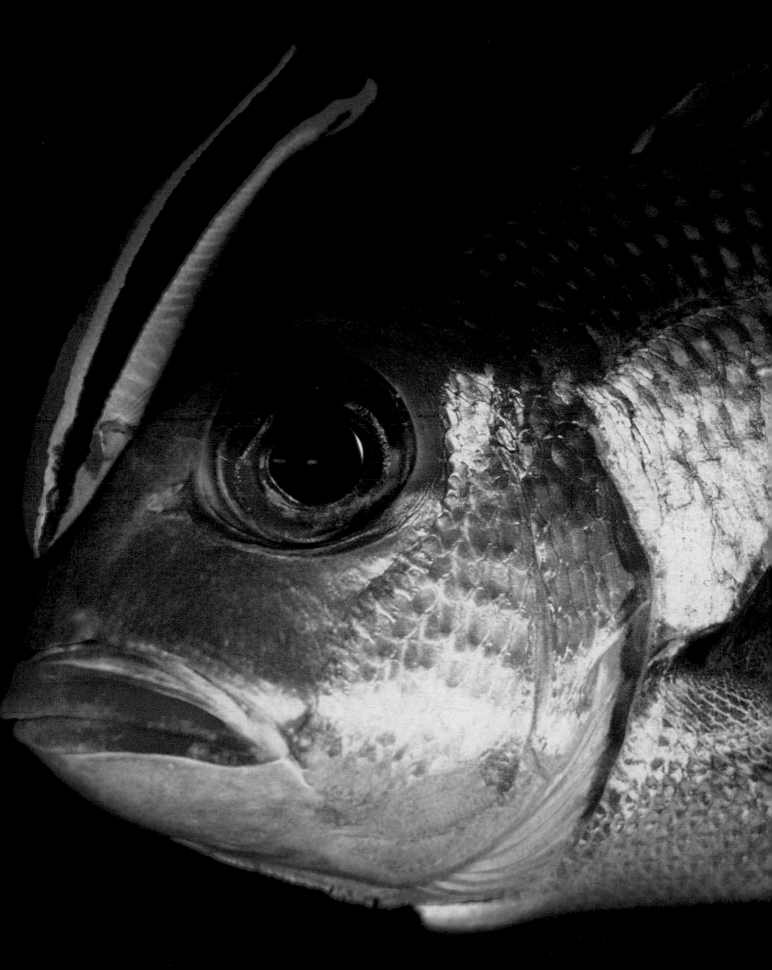

ONE-SIDED RELATIONSHIPS

Symbioses, or relationships between animals, are categorized according to how each partner benefits from the relationship. On the reef, most relationships are one-sided, with only one partner benefiting. Known as commensal symbioses, some of these partnerships have evolved simply because the surface of a large animal provides a perfect home for another. Tiny shrimp, crabs, and fish all make use of larger hosts, gaining from the protection provided by their partner. Other relationships are more temporary, with one animal using another to help it feed. Jackfish, trumpetfish, and cobia, for instance, all follow behind larger predators, using them as cover and waiting for the chance to pounce on any small fish or crustaceans disturbed by the presence of the larger animal. The distinction between the different forms of symbiosis can, however, be difficult to determine. Turtles have a variety of relationships with different animals—from the remora fish that get a free ride from the turtle, to the cleaner wrasse that offer something in return by eating parasites from the turtle's carapace and skin.

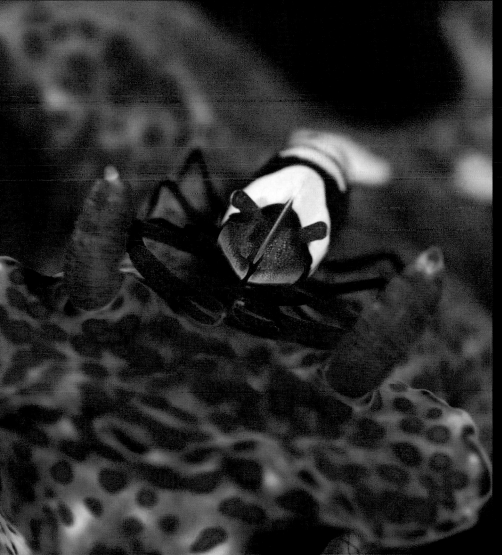

◁△ The imperial shrimp
(*Periclimenes imperator*)—
as small as a fingertip—is a
perfect example of a commensal
partner, living on a range of
different hosts. Here, it benefits
from the protection offered by
a toxic nudibranch (*Ceratosoma
tenue*), but does nothing to help
its host. Lembeh Straits,
Sulawesi, Indonesia.

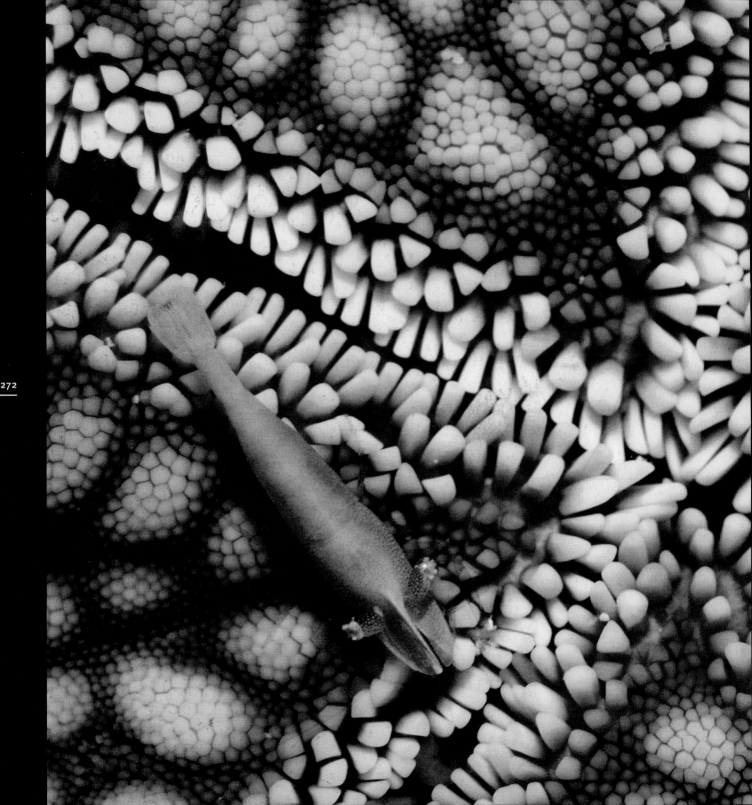

> During a dive, I can often be found paying particularly close attention to cushion stars and starfish, hunting for the tiny shrimp that normally make their homes on these animals. The shrimp hide in the protection of their host's defenses and feed on debris stuck to the surface of the sea star. On the underside of a starfish, around the mouth, you can find some beautiful colors and radial patterns, perfect for macro-photography. Not only are starfish stunning in their own right, but they also provide an excellent backdrop for shooting the commensal shrimp themselves. **"**

◁ A cushion starfish (*Culcita novaguineae*) plays host to a minute partner shrimp (*Periclimenes soror*) no longer than the width of a pencil. If threatened by a predator, the shrimp darts beneath its mobile home for safety. Mabul, Sabah, Malaysia.

△ A partner shrimp (*Periclimenes soror*) hides against a cushion starfish (*Culcita novaguineae*). Mabul, Sabah, Malaysia.

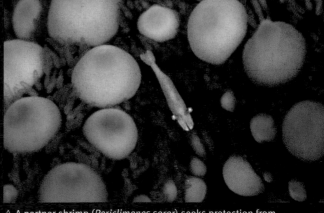

△ A partner shrimp (*Periclimenes soror*) seeks protection from a warty starfish (*Nardoa frianti*). Kapalai Islands, Sabah, Malaysia.

" Hermit crabs are not something I normally take a close look at— they are so common on the reef that I usually swim past without a second glance. However, I spotted this tiny goby sitting at the entrance to the shell, right next to the crab. I had never seen this behavior before and it made me wonder just how many other gobies I had been missing. Nowadays, I give every hermit crab a quick once-over in case any unexpected partners are lurking inside. "

◁ Reefs and sand flats are dangerous places, so hermit crabs (*Dardanus lagapodes*) seek protection and concealment in the cast-off shells of mollusks. Occasionally, a small goby (*Priolepis sp.*) will take up residence alongside the crab, relying on its partner and shell for defense, but offering nothing in return. Mantanani, Sabah, Malaysia.

A cobia (*Rachycentron canadum*)
uses the cover of a marbled stingray
(*Taeniura meyeni*) as it hunts at night,
pouncing on any creatures disturbed
by the presence of the large ray.
Lankayan, Sabah, Malaysia.

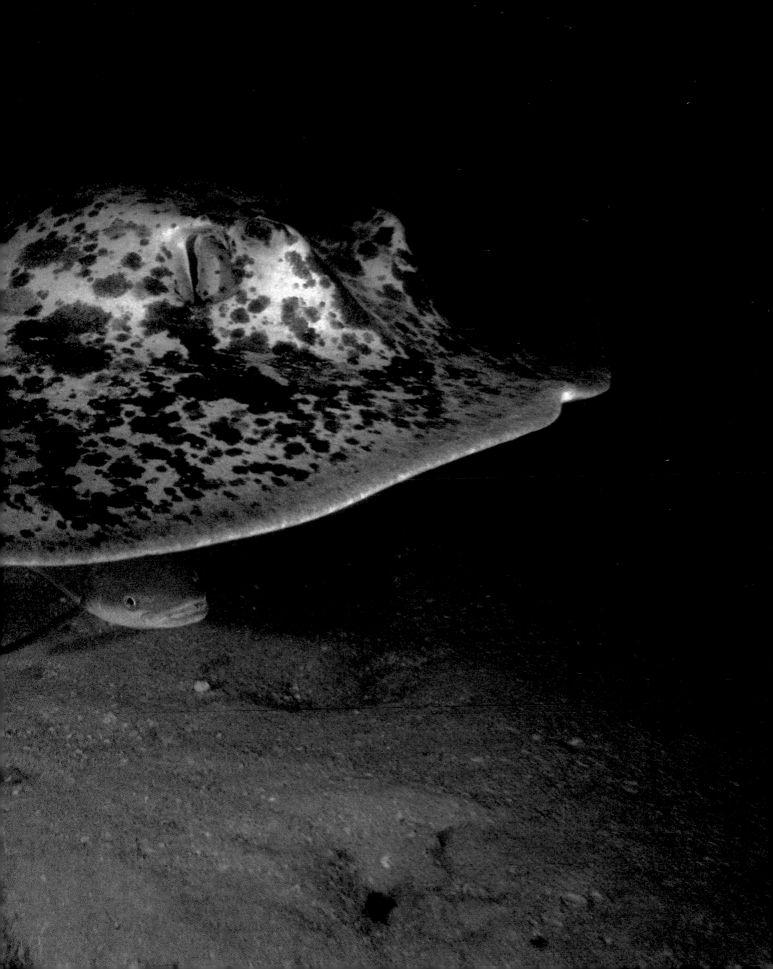

To many fish, a green turtle (*Chelonia mydas*) is a living ecosystem—Boers batfish (*Platax boersii*) even fight for the right to follow an individual and feed on its feces. Sipadan, Sabah, Malaysia.

Diving around Sipadan in Sabah and watching its large population of turtles gives you an excellent indication of how important other species are to turtles—and how big a role the turtles themselves play in the lives of other animals. As well as their more visible relationships with cleaner wrasse and batfish, for example, turtles may also benefit the health of the reef itself, turning over areas of rubble as they feed and exposing new sites for colonization by juvenile coral polyps. 🙶

▷ At a cleaning station, a two-spot bristletooth (*Ctenochaetus binotatus*) scrapes algae off the carapace of a green turtle (*Chelonia mydas*). Sipadan, Sabah, Malaysia.

▷ A remora (*Echeneis naucrates*) hitches a free ride on a green turtle (*Chelonia mydas*) using a "sucker," and will feed on any scraps whenever it has the chance. Sipadan, Sabah, Malaysia.

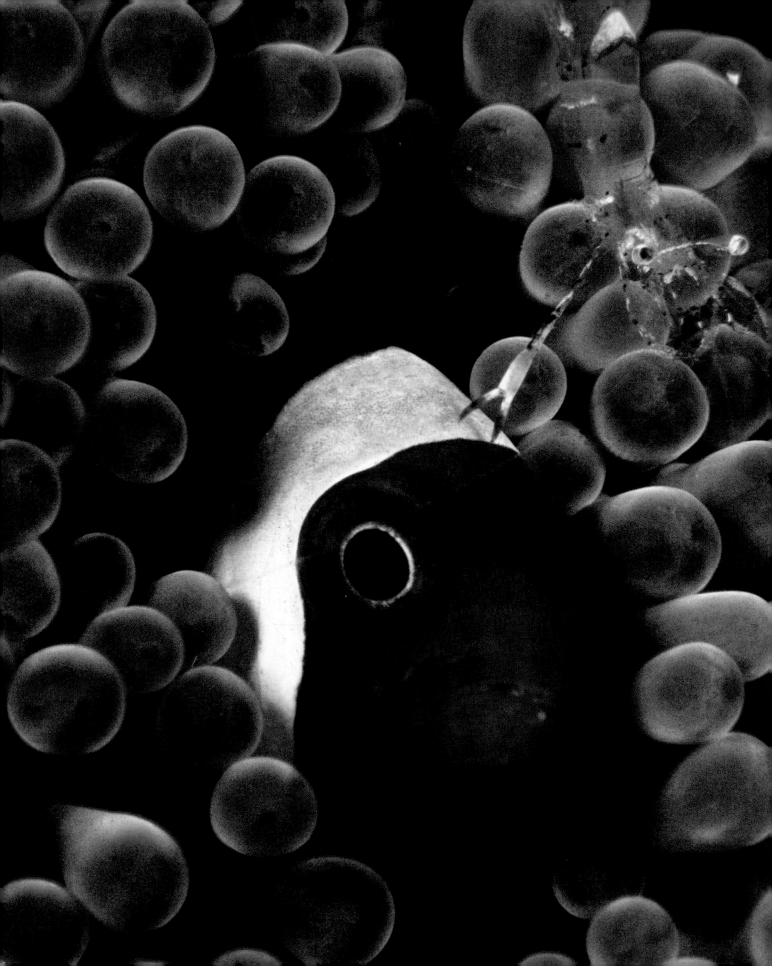

benefit from the relationship. These close partnerships are common on the reef, and the most visible examples are those between the cleaner wrasse or shrimp and their "customers." By offering its services, the cleaner can feed on dead skin, parasites, and debris, while the recipient the condition of its scales. The ultimate mutual symbiosis, however, is at the heart of life on tropical reefs. Hard corals have algae living in their tissues, and in return for shelter, these algal cells provide food via photosynthesis, allowing the corals to thrive in the nutrient-poor, sunlit seas.

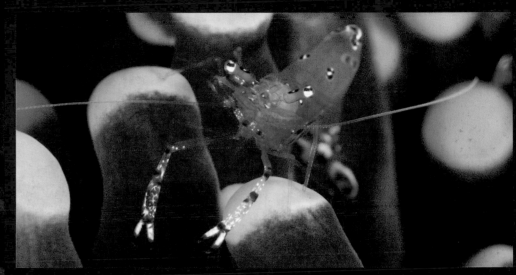

△ Anemones play host to a variety of animals, such as this commensal shrimp (*Periclimenes venustus*). Mantanani, Sabah, Malaysia.

◁△ A commensal shrimp (*Periclimenes cf. magnifica*) cleans a saddleback anemonefish (*Amphiprion polymnus*), whose white stripes have turned reddish in color—its night-time camouflage. Mantanani, Sabah, Malaysia.

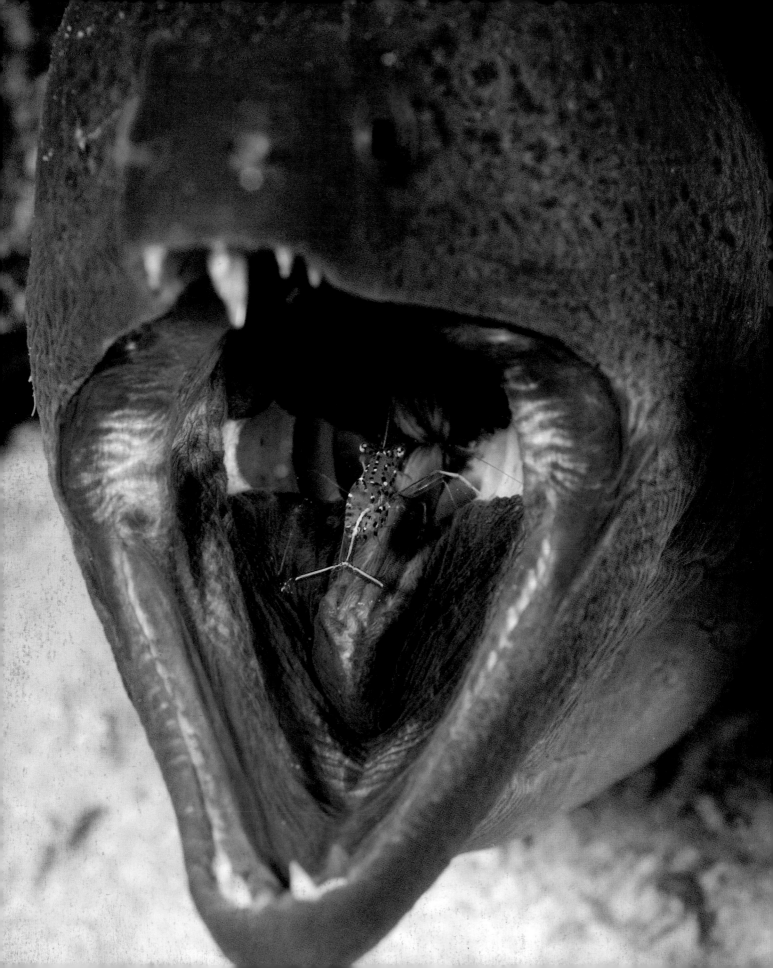

The strength of the relationships and signals between different species never ceases to amaze me. A moray eel doesn't normally eat tiny shrimp, but when one is already in its mouth, the temptation to grab a free meal must be huge. However, millions of years of evolution have ensured that the moray instinctively recognizes the markings and stripes of the shrimp as belonging to something that is not to be eaten. Equally, the shrimp sees the moray's wide-open mouth as a perfectly benign invitation. **"**

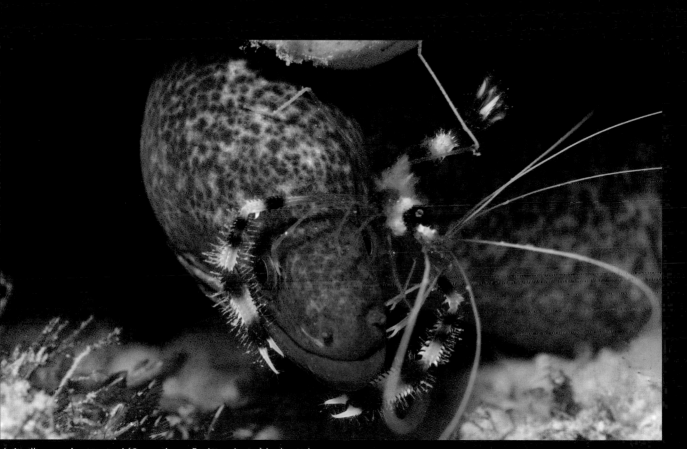

△ A yellowmargin moray eel (*Gymnothorax flavimarginatus*) is cleaned by a banded boxer shrimp (*Stenopus hispidus*). Mabul, Sabah, Malaysia.

◁ A giant moray eel (*Gymnothorax javanicus*) allows a cleaner shrimp (*Urocaridella antonbrunii*) to pick parasites from its teeth and gills. Mabul, Sabah, Malaysia.

△ The white-banded cleaner shrimp (*Lysmata amboinensis*) has evolved bright markings to advertise its services, while the tomato rockcod (*Cephalopholis sonnerati*) uses color changes and postures to signal its intentions. These messages allow the shrimp to safely enter the mouth of the normally voracious predator. Mabul, Sabah, Malaysia.

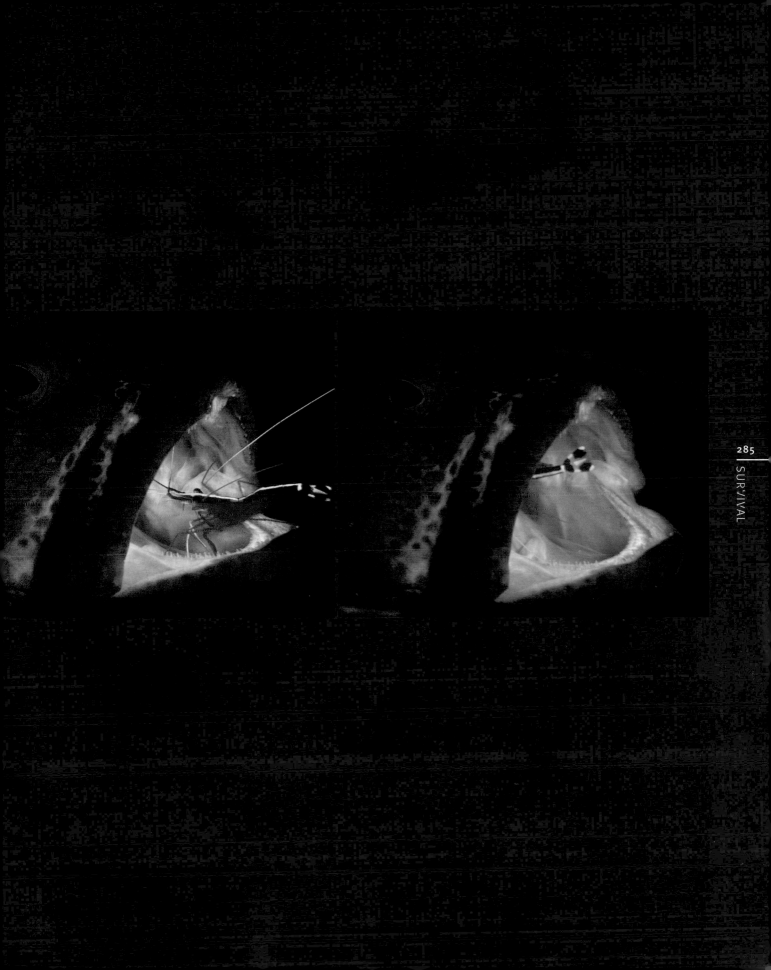

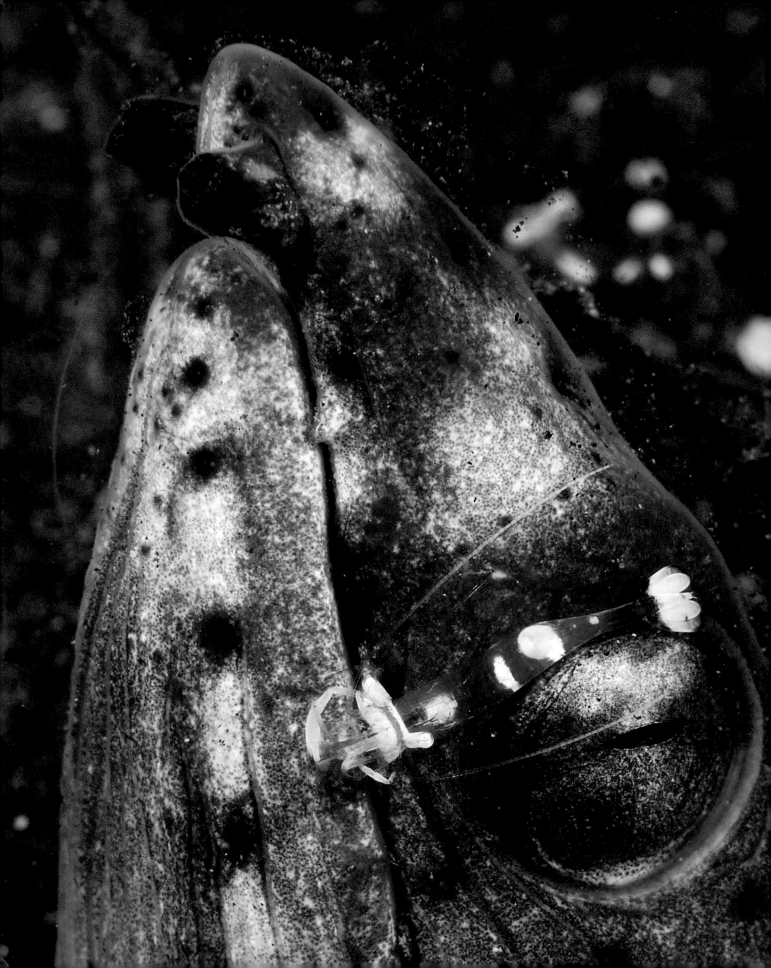

" We've been lucky enough to explore many new places—and spend a lot of time diving at our favorite sites. The hours put in underwater are especially worthwhile when we capture slightly more unusual animal behavior. While searching for snake eels, I noticed that some appeared to have periclimenes shrimp living with them in their burrows, acting as cleaners when the eel was resting. It was a unique experience to see these shrimp living in such close proximity to their "clients," since they are normally only found on anemones or in the shelter of rocks. "

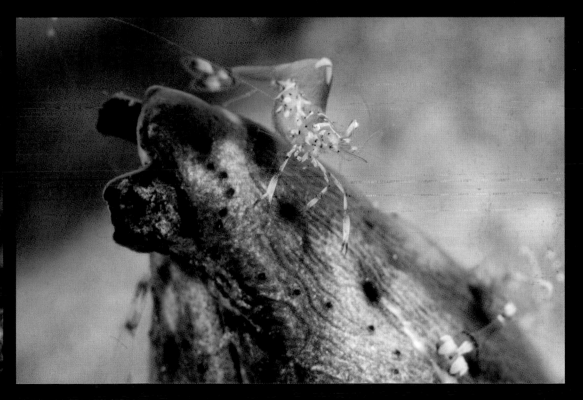

◁△ A periclimenes shrimp (*Periclimenes magnificus*) picks off dead skin from a black-pitted snake eel (*Pisonophis cancrivorus*). Lembeh Straits, Sulawesi, Indonesia.

Despite the fact that animals are fairly easy to approach at cleaning stations, it can be frustrating getting a suitable shot. The wrasse are constantly darting around, and trying to get two or three of these fish in the frame, in focus, and actually doing something—all at the same time—is virtually impossible. It doesn't help that cleaning stations are usually very busy places—I've had so many good shots ruined by a small cardinalfish or damsel completely out of focus in the foreground.

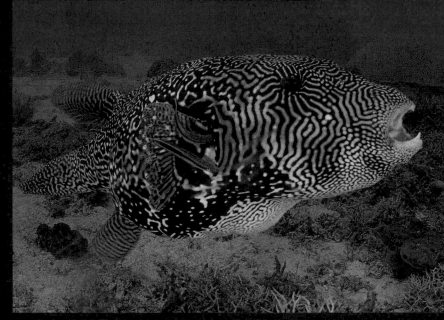

△ A map pufferfish (*Arothron mappa*) allows a pair of bluestreak cleaner wrasse (*Labroides dimidiatus*) to clean its delicate gills. Sangalaki, Kalimantan, Indonesia.

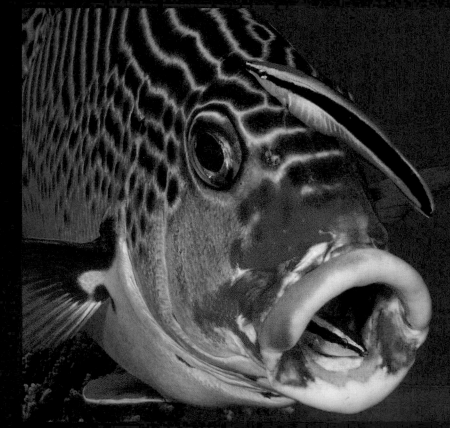

△ A wrasse (*Labroides dimidiatus*) ventures inside the mouth of an oblique-lined sweetlips (*Plectorhinchus lineatus*), while a second cleans the outer skin. Kalimantan, Indonesia.

A tallfin batfish (*Platax teira*) allows a bluestreak cleaner wrasse (*Labroides dimidiatus*) to go about its work, seemingly unperturbed by the presence of the cameraman. Kapalai, Sabah, Malaysia.

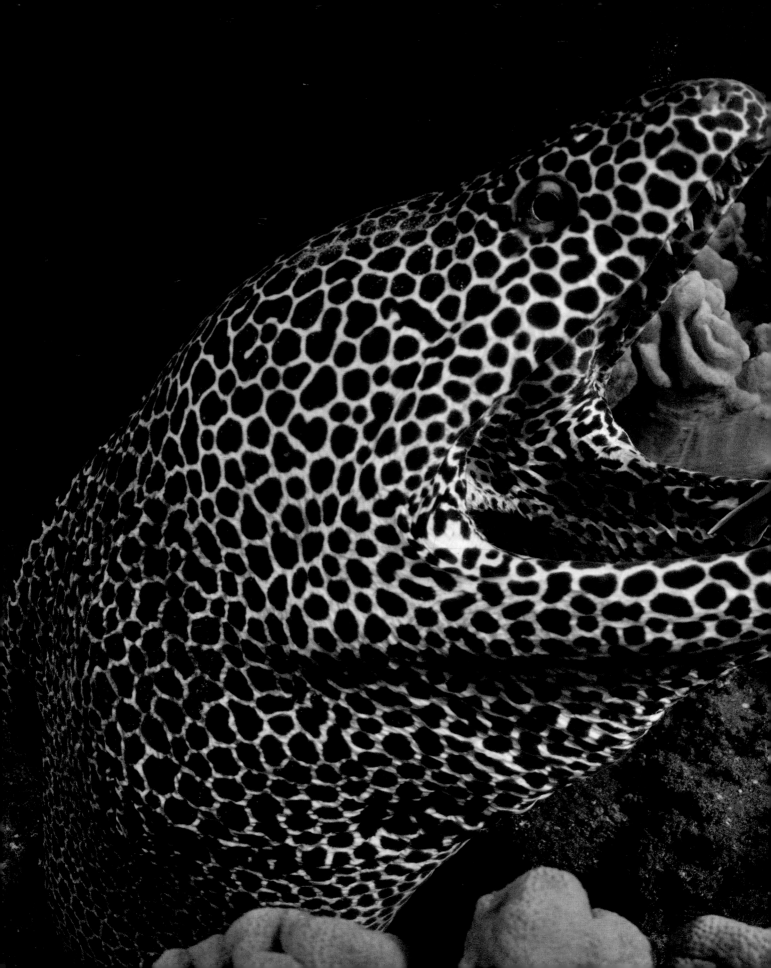

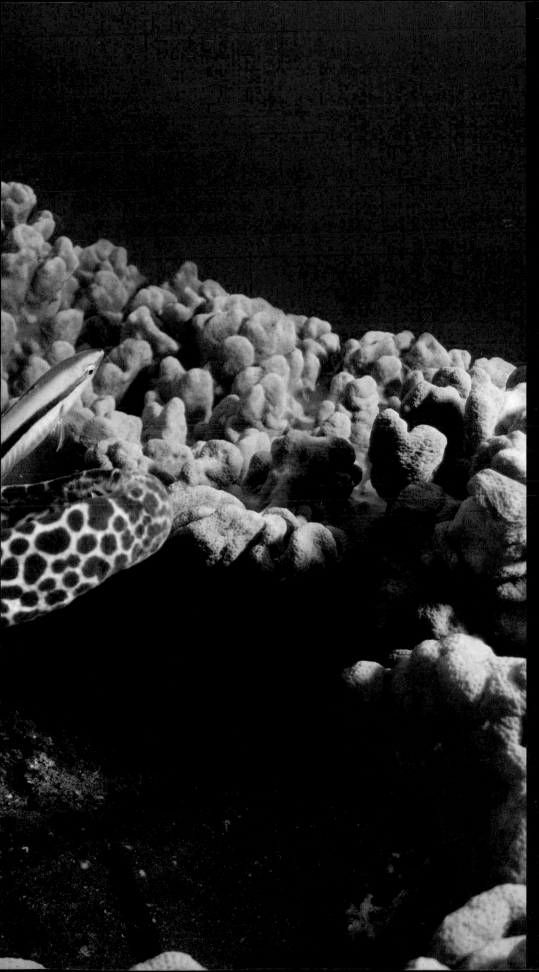

❝ A cleaning station is the perfect place to get close to big animals, or ones that are otherwise quite shy. These areas seem to be neutral territories where prey can mix safely with predators, big animals can join small ones, and divers can swim with the countless different species on the reef. Whenever I dive at a new site, I'll always try to find out as much as possible about any good cleaning stations, and Sodwana has some amazing examples—with big morays, grouper, and the occasional shark dropping by. ❞

◁ Cleaner wrasse (*Labroides dimidiatus*) are employed by most fish, from the smallest damsel to some of the largest predators on the reef, such as this honeycomb moray eel (*Gymnothorax favagineus*). Sodwana Bay, South Africa.

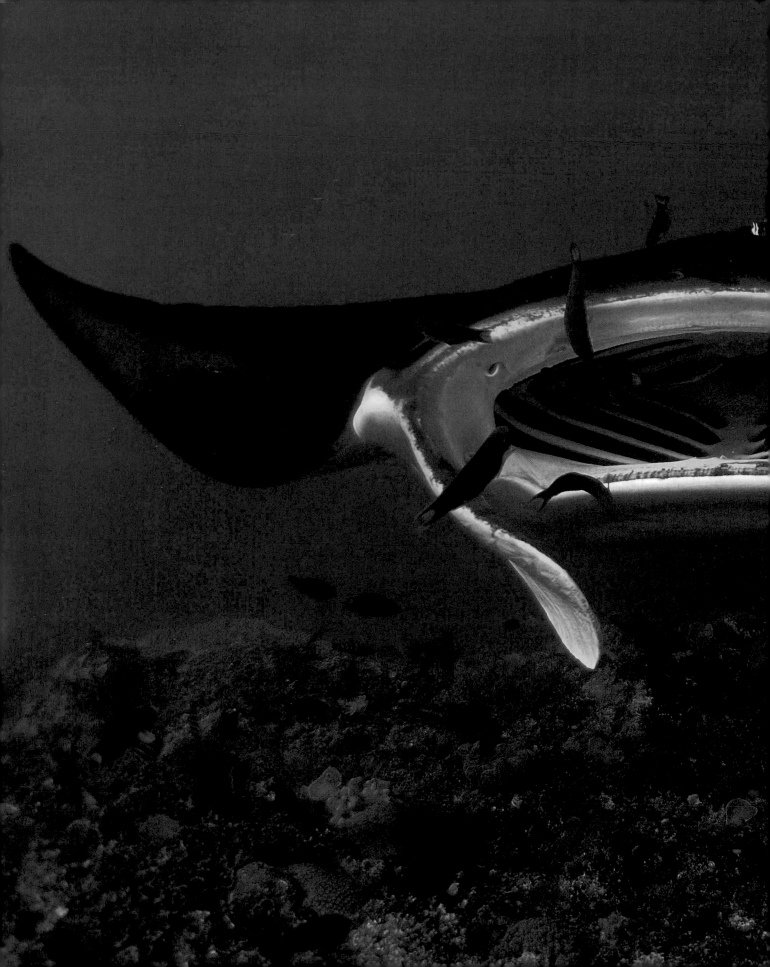

A manta ray (*Manta birostris*)
exposes its delicate gills, trusting
the masses of crescent wrasse
(*Thalassoma lunare*) to safely
remove any parasites. Raja Ampat
Islands, West Papua, Indonesia.

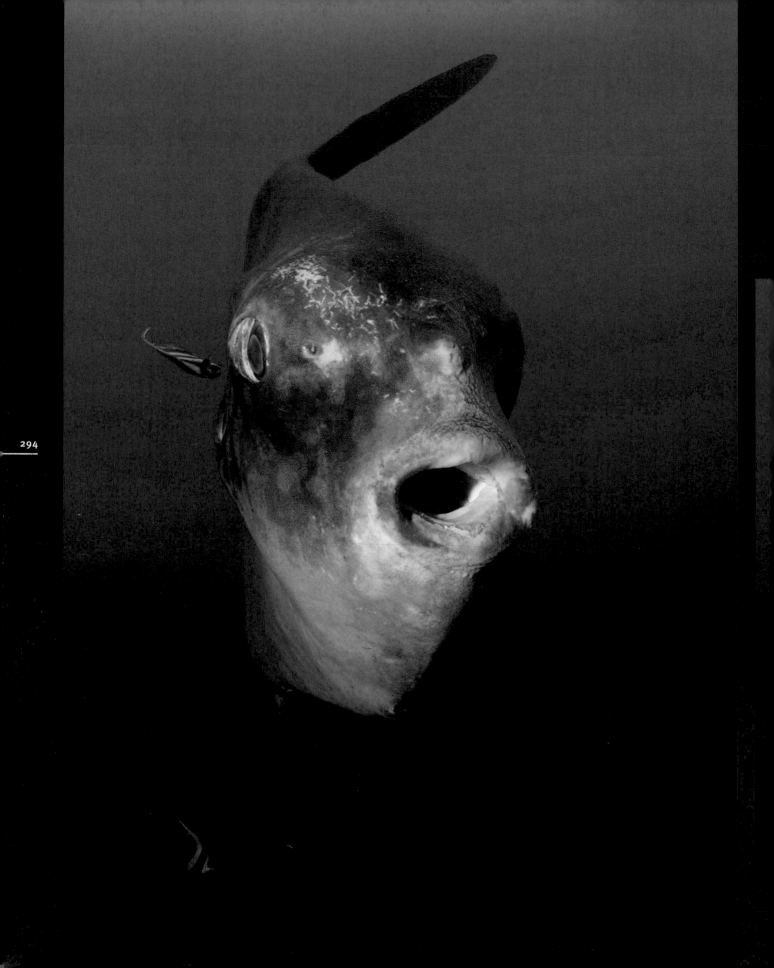

" I had traveled to Bali for one reason: to try to capture images of the mola mola fish, probably the most unusual-looking fish to be found on the reefs. These huge animals visit cleaning stations in deep water, not far from Bali's beaches, to be picked clean by schools of bannerfish. Diving down into the cold currents to witness groups of these fish aligning themselves along the reef and lining up to be cleaned was one of the most incredible experiences of my diving career. "

△ A schooling bannerfish (*Heniochus diphreutes*) on cleaning duty. Lembongon, Bali, Indonesia.

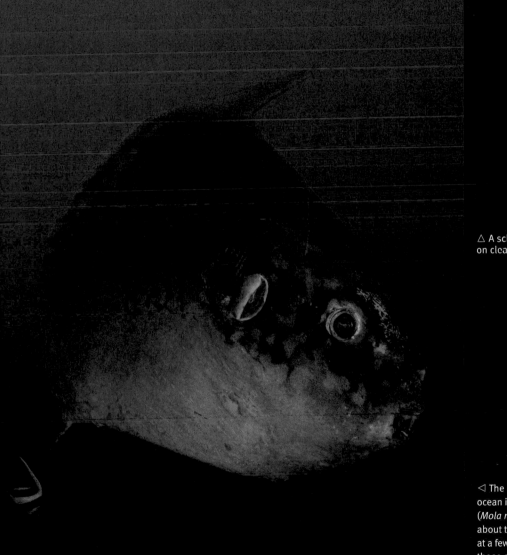

◁ The largest bony fish in the ocean is the mola mola or sunfish (*Mola mola*). What little is known about this fish has been garnered at a few cleaning stations, such as those off the southeast coast of Bali. Lembongon, Bali, Indonesia.

UNBREAKABLE BONDS

Most animals can benefit from symbiotic relationships with other species but are able to survive perfectly well on their own. For a few species, however, the presence of another animal determines whether they live or die. Of all these obligate symbionts, the best-known, and possibly the most beautiful, are the anemonefish. These stunning fish live in permanent harems sheltered by their host anemone, feeding, fighting, and even raising their eggs among its stinging arms. In return for this much-needed shelter, the anemonefish attack and drive off any predator willing to risk an attack on a venom-laden anemone. However, if the anemone is taken out of the equation, these vivid animals can no longer survive among the corals.

▷ A western clown anemonefish (*Amphiprion ocellaris*) hides among the protective arms of a magnificent anemone (*Heteractis magnifica*). Sangalaki, Kalimantan, Indonesia.

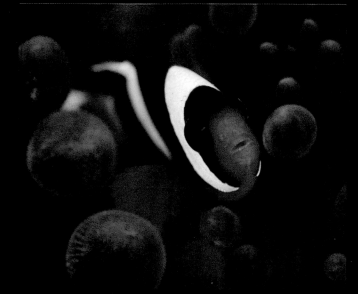

△ A Clark's anemonefish (*Amphiprion clarkii*) seeks shelter in the arms of an anemone. Mabul, Sabah, Malaysia.

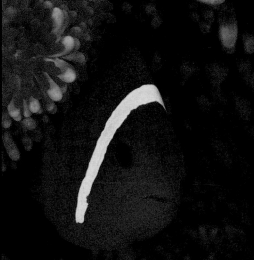

△ A Maldives anemonefish (*Amphiprion nigripes*) is protected by its host anemone. Male Atoll, Maldives.

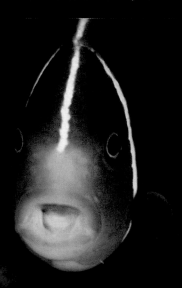

△ A pink anemonefish (*Amphiprion perideraion*) finds refuge within the arms of an anemone. Mabul, Sabah, Malaysia.

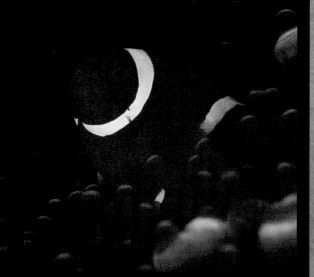

△ A spinecheek anemonefish (*Premnas biaculeatus*) finds cover in an anemone. Kapalai, Sabah, Malaysia.

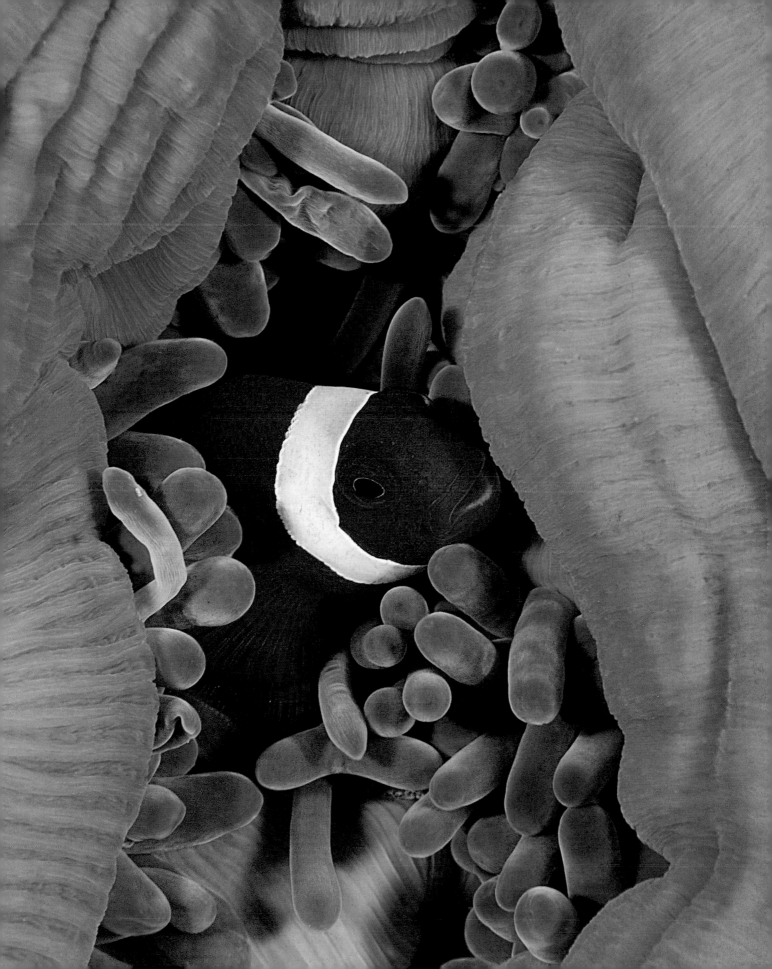

“ Obligate symbioses are at the heart of life on tropical reefs. The anemonefish's reliance on its host anemone is one clear example, but the anemone itself relies on symbiotic algae living within its tissues. This algae, which also lives in the tissues of hard corals, photosynthesizes the sun's energy—producing nutrients for its host and forming the basis of the whole food chain. Occasionally, when water temperatures rise above a critical level, anemones and corals eject their algal partners, resulting in bleaching events. Living in the arms of a bleached anemone hasn't directly affected this anemonefish, but bleaching can ultimately lead to the death of entire stretches of reef. ”

▷ A western clown anemonefish (*Amphiprion ocellaris*) seeks protection in the stinging arms of a bleached magnificent anemone (*Heteractis magnifica*). Kapalai, Sabah, Malaysia.

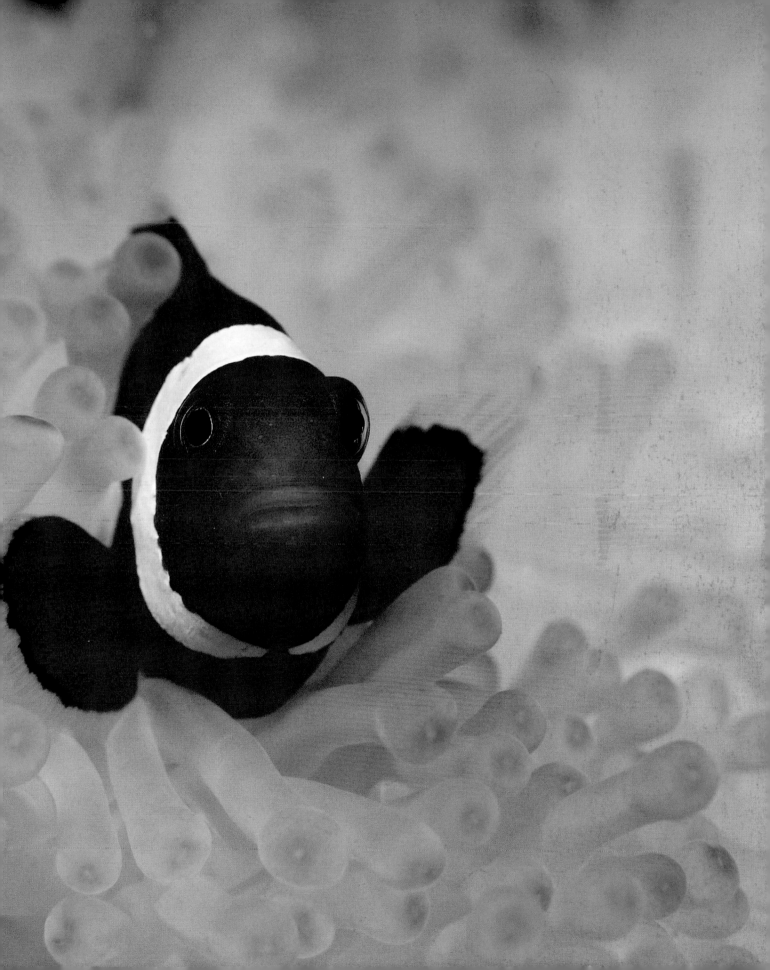

Life cycles

The need to reproduce is the driving force behind all life on the reef, with the success of a species being judged on its ability to pass on its genes.

For species such as hard corals, sex is a straightforward affair—most simply release their sperm and eggs into the currents and leave fertilization to fate. To maximize their chances of success, corals on the same reef synchronize the release of their reproductive cells —often on a single night of the year, turning the sea soupy in the process.

Most species of wrasse and parrotfish have more complex sex lives. A harem of females is led by a mature male, who uses his flashy displays to communicate to them. Unfortunately, this behavior also exposes him to attack and, if killed, he is soon replaced by the dominant female, who then changes her sex.

Hermaphrodites, such as nudibranchs, can mate whenever they meet another member of their species, simply swapping packets of sperm. For others it's not so easy, and they must advertise their intention to mate and fight off competitors at the same time.

△ Weber's chromis (*Chromis weberi*) fish "kiss" as they fight over territory or mates.
▷ A female peacock mantis shrimp (*Odontodactylus scyllarus*) guards her eggs.

When it comes to tending their eggs, some species go to extraordinary lengths. The female giant octopus, for example, even starves herself, dedicating her time to guarding the developing eggs during the long gestation period necessary in the frigid waters.

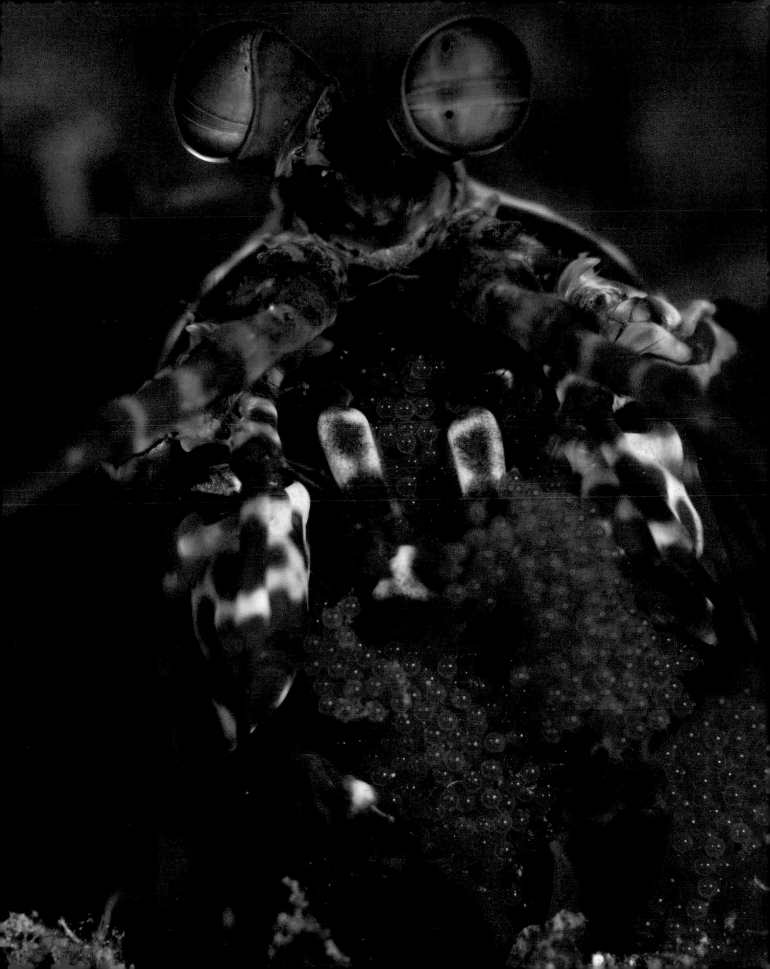

COURTING RITUALS AND DISPLAYS

Displays and rituals are common underwater; they allow an animal to find a member of its own species among many others, as well as locate a member of the opposite sex within a school. Between competing males, displays are used to demonstrate dominance without having to resort to fighting, and are necessary to persuade a partner that they are a worthy mate. These signals, however, draw attention from predators as well as potential mates and, as a result, are usually only temporary and can be turned on and off at will. Bottom-dwelling fish, or those that rely on camouflage, flash bright colors on the underside of their fins, or briefly change the colors and markings of their bodies. Small fish such as jawfish, gobies, and dragonets, on the other hand, use jumping movements or display dorsal fins that are normally kept hidden from view. Many species use sound or movement as part of their courtship rituals, drumming out a love ballad or shivering and waving as they approach a receptive partner. A good courtship ritual can even save an animal's life—it's not unusual, for example, for a female octopus to eat a male if he doesn't display correctly.

▽▷ Strapweed filefish (*Pseudomonacanthus macrurus*) live in loose, male-controlled territories. The male displays to and mates with the females, but if he is not deemed worthy, the female will visit another male nearby. Lembeh Straits, Sulawesi, Indonesia.

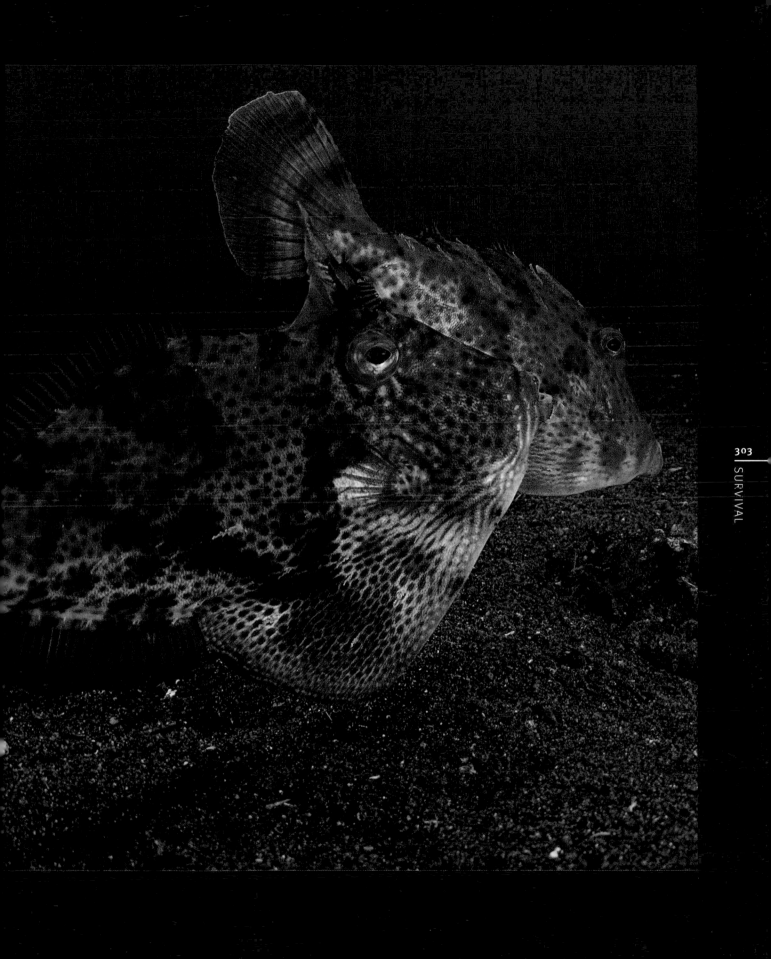

“ I was lucky enough to catch a group of rare circled dragonets as they went through their courting rituals during one of my many sunset dives off Sipadan. The male slowly circled the different females, flashing his dorsal fin and gently vibrating his body in an attempt to persuade one of them to mate. The fish were completely preoccupied with mating and didn't appear to even notice my presence. ”

▽ The rare circled dragonet (*Synchiropus circularis*) has only been observed off isolated oceanic islands, including Sipadan. Like other dragonets, it has elaborate courtship rituals that culminate in the pair's spawning above the reef. Sipadan, Sabah, Malaysia.

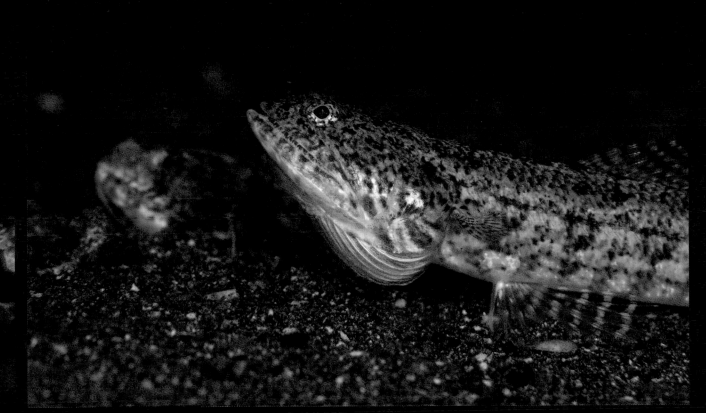

△ A clearfin lizardfish (*Synodus dermatogenys*) inflates its throat and vibrates its head to attract a mate. Lembeh Straits, Sulawesi, Indonesia.

△ A jawfish (*Opistognathus sp.*) jumps clear of its burrow to display its bright markings. Mabul, Sabah, Malaysia.

△ A yellow shrimp goby (*Cryptocentrus cinctus*) flaunts its vivid colors. Mabul, Sabah, Malaysia.

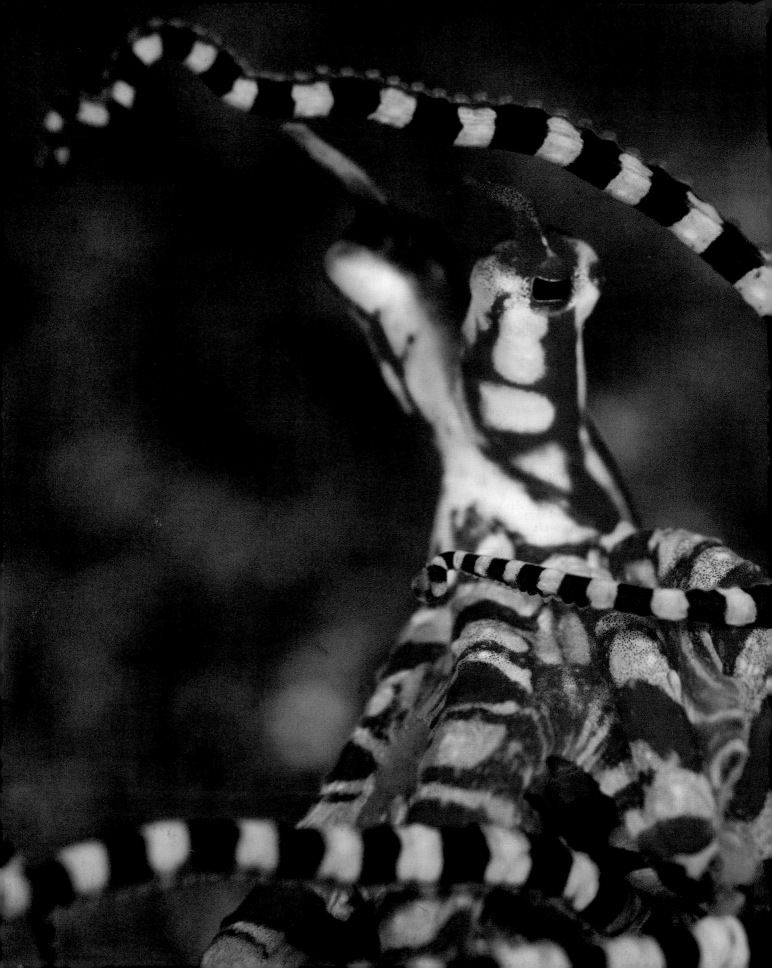

" I had been following a wonderpus for some time and, as it seemed to have grown used to my presence, I decided to move in and get some tight, portrait shots. Concentrating on getting the eyes in sharp focus, I didn't notice anything out of the ordinary until I double-checked my camera's LCD screen—there were in fact two animals, with the small male almost completely entwined with the much larger female. I hadn't even realized that I had disturbed the pair in the act of mating, but they seemed not to mind, simply going their separate ways after they had finished. "

◁▽ Most female octopuses are larger than males, and the male's courtship rituals discourage her from eating him. Little is known about the wonderpus (*Wonderpus photogenicus*), but it is thought that this species' courtship rituals may simply establish the desire to mate between the pair. Lembeh Straits, Sulawesi, Indonesia

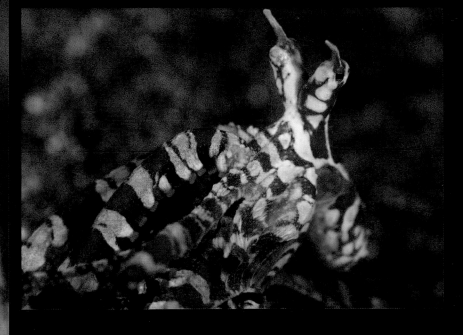

PRIMAL URGES

Every animal and plant on the reef has just one purpose in life: to reproduce and pass on its genes to the next generation. Most species of corals and anemones reproduce asexually, "budding" off copies of themselves to form the colonies that make up the structure of tropical reefs. While asexual reproduction is relatively simple, all the offspring are genetically identical to the parent and populations are vulnerable to changing conditions and disease. Sexual reproduction, on the other hand, requires the swapping of genetic material between partners and does result in variation in the offspring— a strategy employed by most animals on the reef. Corals are actually capable of both types of reproduction and, when conditions are right, release their eggs and sperm into the water to fertilize outside their bodies—a process known as spawning. Some wrasse, parrotfish, and damsels indulge in frenzies of mass spawning, while tiny mandarinfish are more initimate, spawning in pairs above the corals. Other species, such as nudibranchs, sharks, and turtles, mate and fertilize their eggs inside their bodies.

▷ To ensure that fertilized eggs are dispersed into the currents, male mandarinfish (*Synchiropus splendidus*) take their partners for a mating dance away from the reef, before darting back to safety. Maratua, Kalimantan, Indonesia.

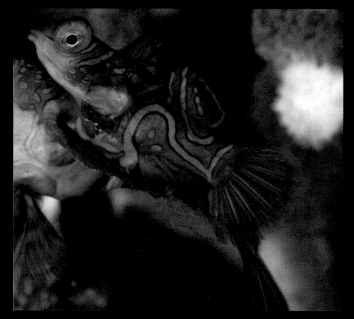

△ The eggs of the female mandarinfish (*Synchiropus splendidus*) remain close to her body so the male can fertilize them. Kalimantan, Indonesia.

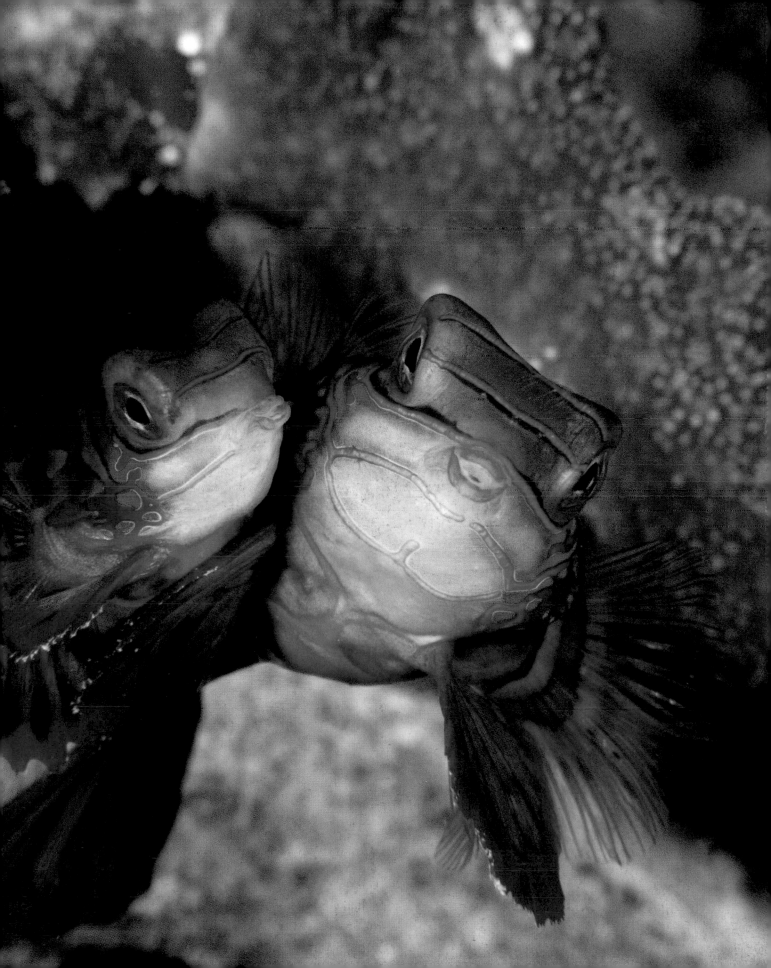

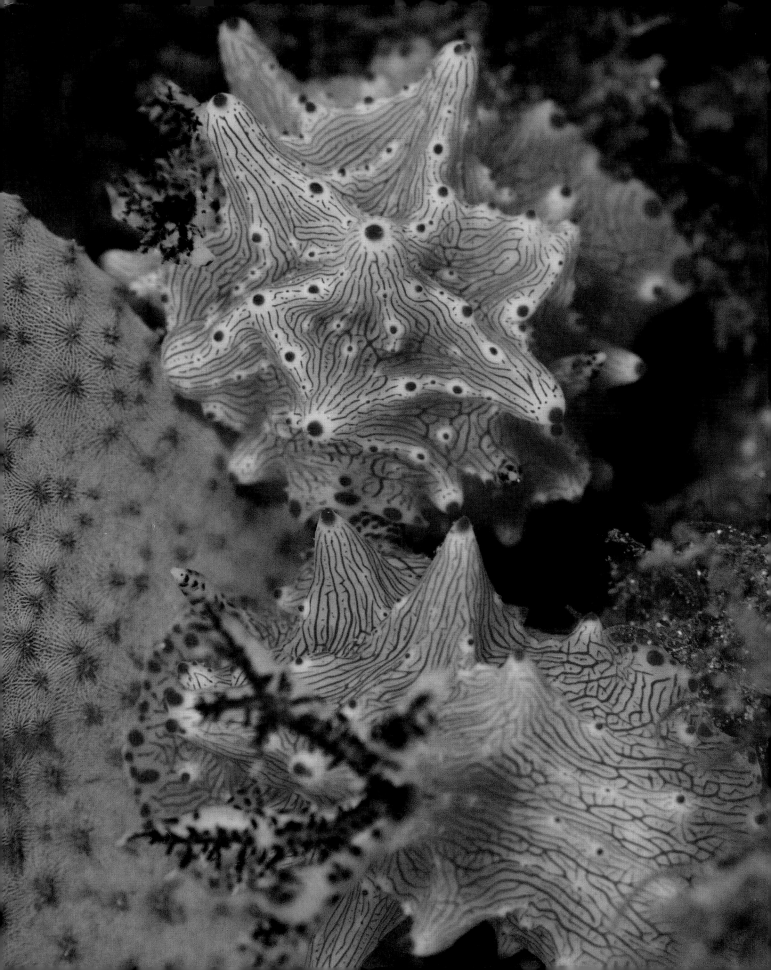

◁ Nudibranchs, such as *Halgerda malesso*, are hermaphrodites with both male and female reproductive organs. Mating involves simply swapping packets of sperm, and most nudibranchs mate whenever they come across a member of their own species. Mabul, Sabah, Malaysia.

△ *Mexichromis multituberculata* nudibranchs line up head-to-tail in preparation for swapping packets of sperm. Seraya, Bali, Indonesia.

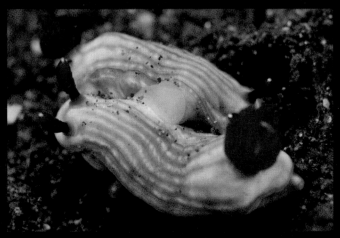

△ *Hypselodoris whitei* nudibranchs extending their sperm ducts to mate. Lembeh Straits, Sulawesi, Indonesia.

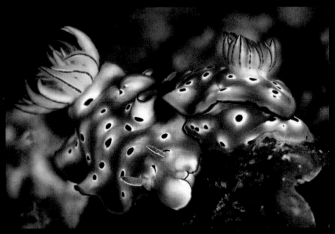

△ Like all nudibranchs, *Risbecia tryoni* keep their male and female reproductive systems apart to avoid self-fertilization. Sabah, Malaysia.

▷ The nudibranch *Hypselodoris bullockii* stores up packets of sperm from its partner before eventually laying its fertilized eggs in a spiraling, ribbonlike mass. Mabul, Sabah, Malaysia.

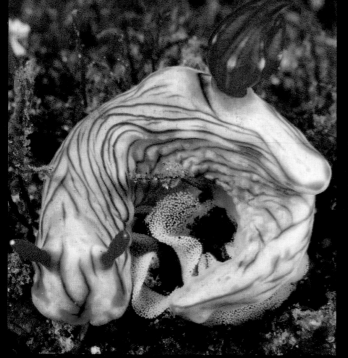

△ The nudibranch *Hypselodoris nigrostriata* laying its fertilized eggs. Seraya, Bali, Malaysia.

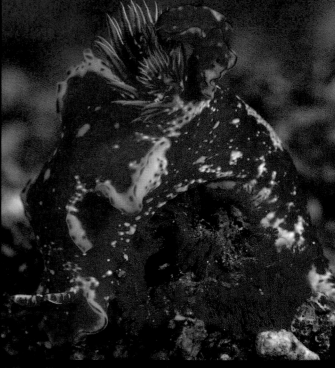

△ The nudibranch *Ceratosoma tenue* lays eggs that are camouflaged against the reef. Sulawesi, Indonesia.

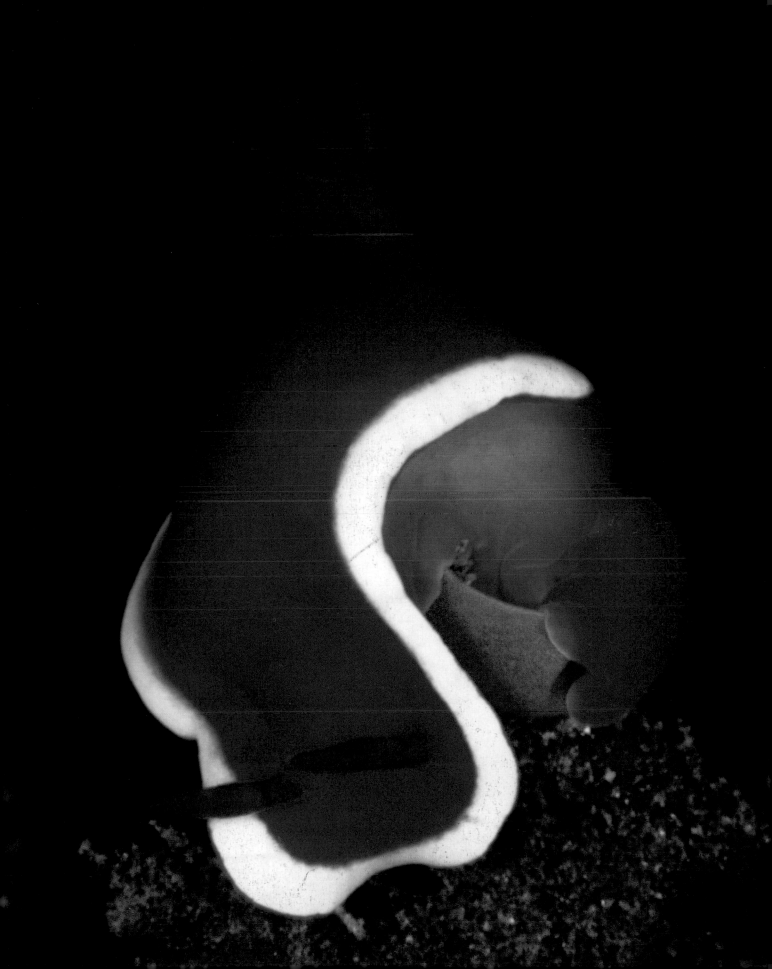

" I was at the end of a long night dive, looking for shrimp and crabs on the sand flats, when I noticed small puffs and strands of what looked like smoke coming from a few corals at the edge of the reef. The visibility dropped considerably and I realized that I was witnessing the end of a mass spawning, something I had never seen before—and had very nearly missed again. The surface of the water had turned soupy and was covered in eggs and sperm—ample demonstration of the scale of the event. Many species of coral spawn simultaneously in the same location when conditions are perfect for the distribution of the next generation. This is usually on a single night of the year, when the corals take their cue from the cycles of the moon and tides. "

▽ ▷ Hard corals (*Lobophyllia sp.*) on the same reef synchronize their spawning and release vast numbers of eggs and sperm into the currents. Sangalaki, Kalimantan, Indonesia.

" I will never forget the first time I saw green turtles mating. I was diving on Sipadan when I saw several males following each other out into the blue. Heading after them, I ran into a group of seven males, all frantically biting one another and trying to mount the lone female in the chaos. Green turtles are normally quite sedate and gentle animals but, when it comes to mating, they turn into completely different creatures—I'd never seen them as energetic and determined as this before. "

▽ During mating, the male green turtle (*Chelonia mydas*) grasps the carapace of the female using claws on his front flippers. The other males attempt to pull him off so that they can have a chance to mate. Sipadan, Sabah, Malaysia.

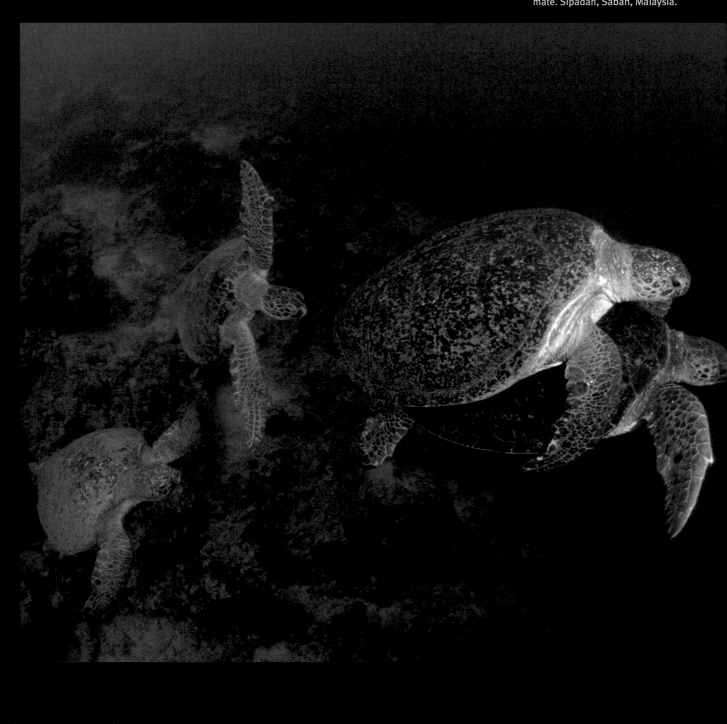

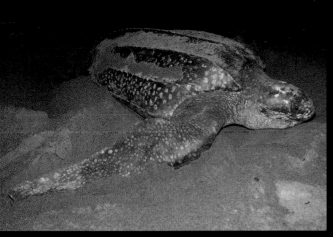

△ A female leatherback turtle (*Dermochelys coriacea*) coming onto a nesting beach at night. Kamiali, Papua New Guinea.

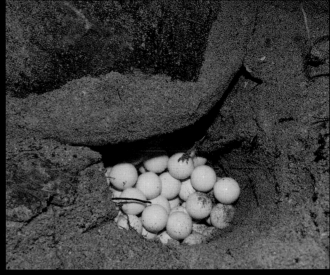

△ A female hawksbill turtle (*Fretmochelys imbricata*) buries her eggs to prevent scavengers from eating them. Gulisan, Sabah, Malaysia.

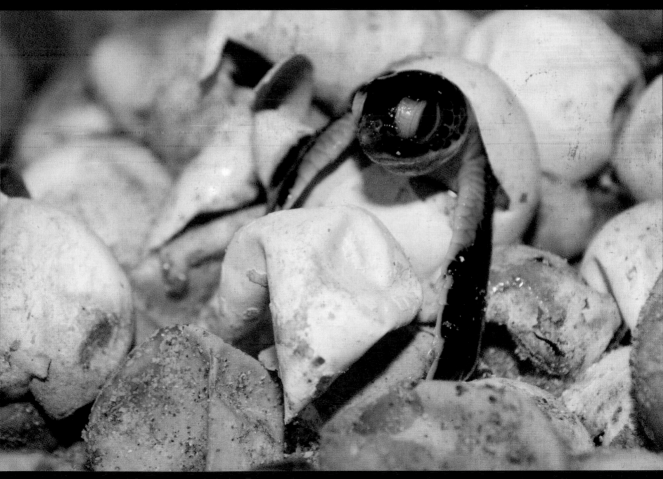

△ The eggs of a green turtle (*Chelonia mydas*) hatch after about 60 days, after which the young head out to the open ocean. Selingan, Sabah, Malaysia.

A pair of rare leatherback turtle hatchlings (*Dermochelys coriacea*) head out to sea. It is thought that only one in 1,000 turtles make it to adulthood and breeding age. Kamiali, Papua New Guinea.

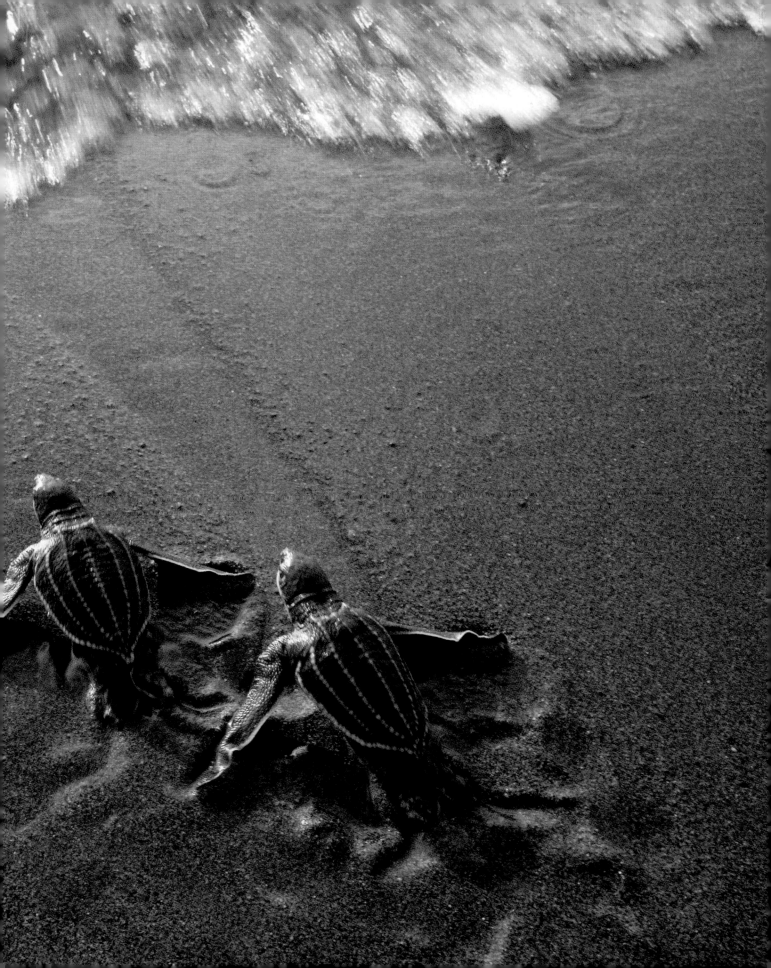

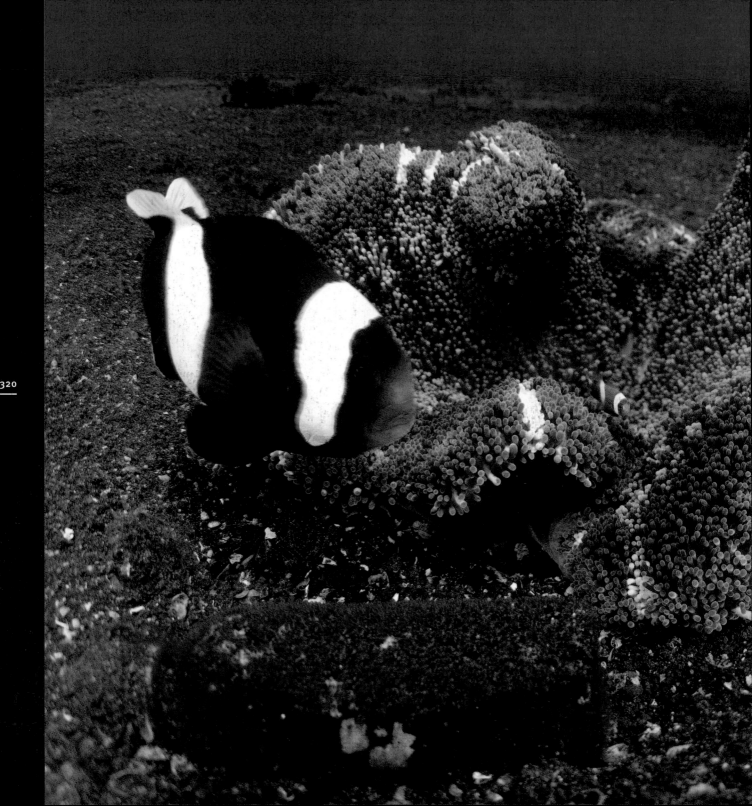

CARING FOR THE BROOD

Broadcast spawners rely on fate—and the huge amount of eggs and sperm they produce—to ensure that the next generation of fish returns to populate the reefs. Other species employ a different strategy—tending their eggs and investing time in caring for their young so that they have the best possible start in life. For them, only a small number of eggs are produced, each one equipped with a yolk sac to feed the developing embryo. The eggs are then laid on a patch of rock or coral. Many-host gobies lay eggs directly on the sea squirts on which they live, while sea horse males have evolved specialized pouches into which the eggs are deposited after they are fertilized—the "pregnant" males then care for the eggs until they hatch. Cardinalfish and jawfish males take their role as protectors one stage further, keeping the newly fertilized eggs safe and clean in their mouths, starving themselves throughout the gestation period to protect their eggs from predators. Some species of cardinalfish have even been known to mouth-brood hatched juveniles for up to three months.

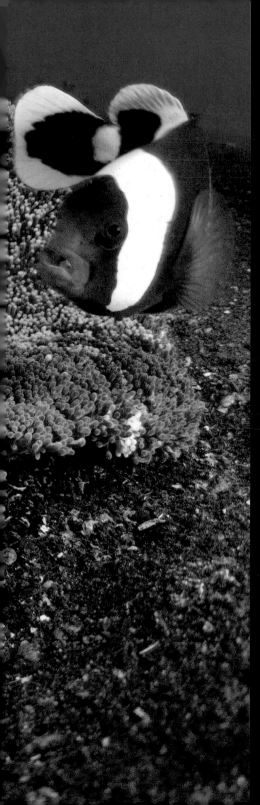

◁ Saddleback anemonefish (*Amphiprion polymnus*) guard their eggs—which they have laid on an old bottle. The fish have dragged the bottle close to their host anemone (*Stichodactyla haddoni*), where they will keep the eggs free from algae or parasites. Lembeh Straits, Sulawesi, Indonesia.

△ A host of eyes develop inside the eggs of a saddleback anemonefish (*Amphiprion polymnus*). Mabul, Sabah, Malaysia.

▽▷ Female golden damselfish (*Amblyglyphidodon aureus*) lay their eggs on the branches of dead sea whips. The male follows closely behind her to fertilize the eggs, and then takes full responsibility for the clutch. Mabul, Sabah, Malaysia

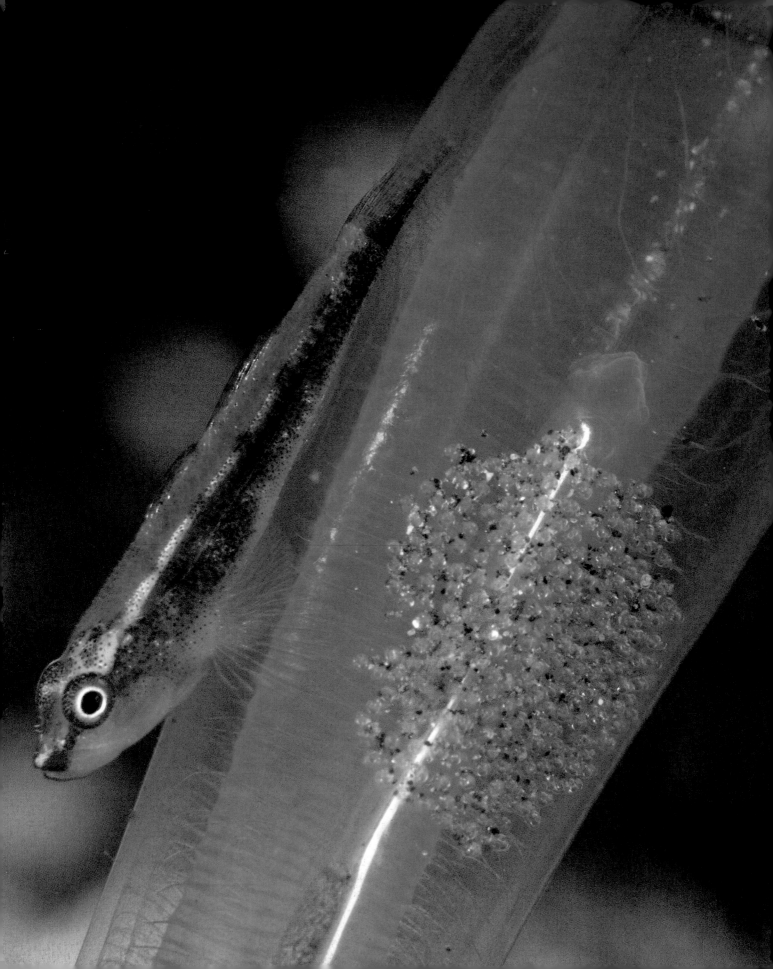

" It takes a lot of searching to find the eggs of these tiny fish. Until the eyes of the juveniles develop, the eggs are almost completely transparent and virtually impossible to spot. However, once you've found a clutch, you have a perfect opportunity to get some beautiful shots illustrating parental care among fish. The goby will dart out into the currents to feed, or hide briefly if threatened by a predator or even the photographer– but it never fails to return to its clutch, time and time again. "

◁ The many-host goby (*Pleurosicya mossambica*) normally lays its eggs on a sea squirt (*Rhopalaea sp.*) so it can remain with the eggs as they develop, and feed in the currents flowing past its perch. Seraya, Bali, Indonesia.

△ A many-host goby (*Pleurosicya mossambica*) guards its clutch on a sea squirt (*Rhopalaea sp.*). Mabul, Sabah, Malaysia.

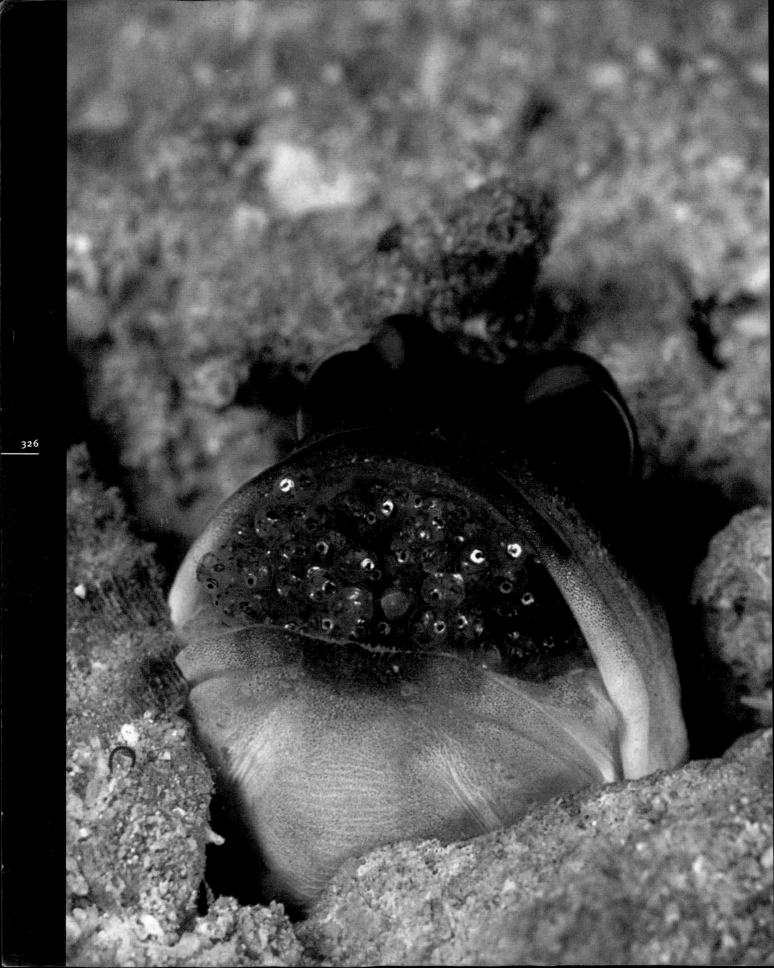

◁ After mating, the female goldspecs jawfish (*Opistognathus sp.*) deposits her eggs in the mouth of the male, where they remain until they hatch about a week later. Throughout this period, the male rolls the eggs around his mouth to ensure that all receive an adequate supply of oxygen. Mabul, Sabah, Malaysia.

" The jawfish is aptly named—its most obvious feature is its huge, extensible mouth. These interesting fish use their jaws for a variety of purposes and can be fascinating to watch while underwater. They maintain their burrows by using their mouths to shovel out any sand and rubble; they jump up into the water, spreading their mouths wide to display to potential mates or to competitors; and the male even tends his partner's eggs in his mouth, keeping them safe until they hatch. "

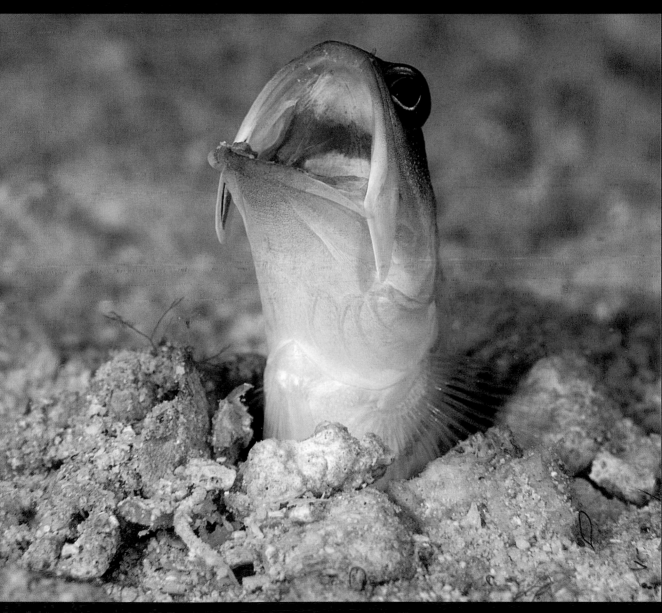

△ Jawfish (*Opistognathus sp.*) are common at the base of reefs but—unless displaying like this individual—only their heads are visible at the entrance of their burrows. Mabul, Sabah, Malaysia.

▽ Unlike many other species on the reef, juvenile flamboyant cuttlefish (*Metasepia pfefferi*) do not spend any time in the plankton. Instead, they hatch as miniature adults, ready to start hunting across the sand plains. Lembeh Straits, Sulawesi, Indonesia.

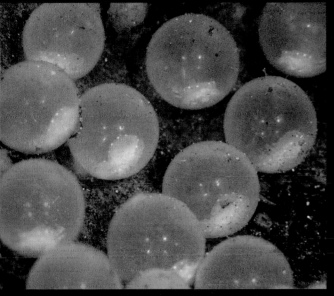

△ Batches of eggs are laid together on a solid surface, safely hidden from predators. Lembeh Straits, Sulawesi, Indonesia.

△ The egg case protects the developing cuttlefish from changing sea conditions, parasites, and predators. Lembeh Straits, Sulawesi, Indonesia.

△ Juvenile flamboyant cuttlefish are capable of rapid changes of color immediately after hatching. Lembeh Straits, Sulawesi, Indonesia.

△ A juvenile, no bigger than a fingernail, is as capable a predator, and as beautiful, as a full-grown adult. Lembeh Straits, Sulawesi, Indonesia.

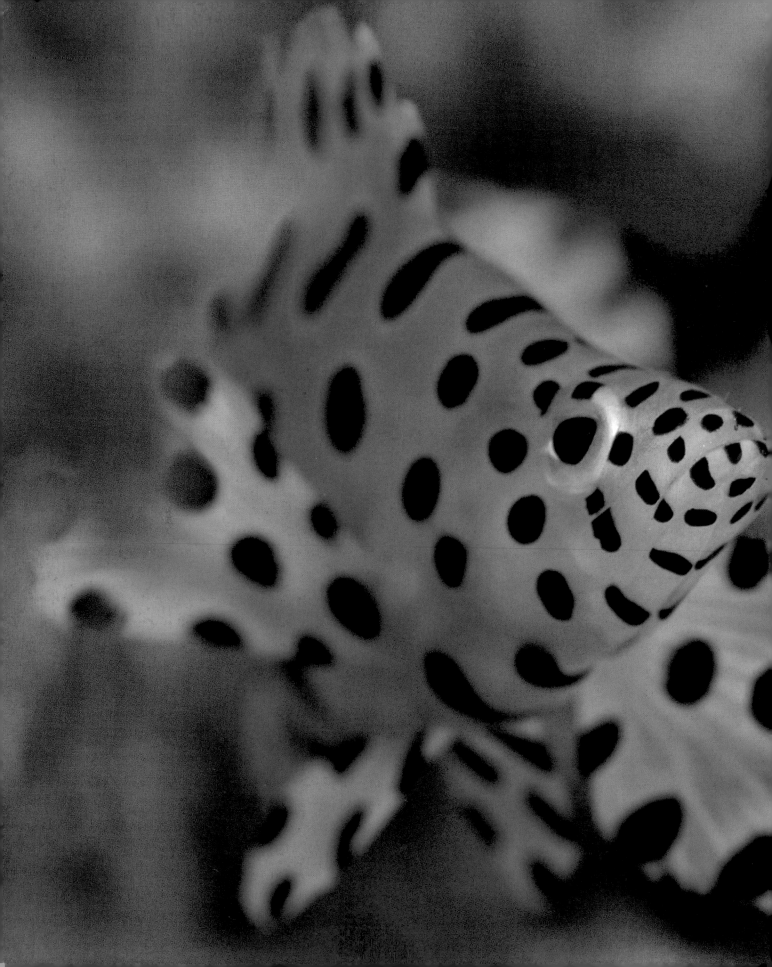

cowfish are tiny versions of their parents and have the same defenses and adaptations for survival, while other species have evolved their own copy the dancelike swimming style of flatworms. Despite their small size, however, most juveniles are capable of fooling the largest of predators.

△ An emperor angelfish (*Pomocanthus imperator*) wards off danger with bright colors. Bali, Indonesia.

△ The broadclub cuttlefish (*Sepia latimanus*) is camouflaged from birth. Sulawesi, Indonesia.

△ A pinnate batfish (*Platax pinnatus*) echoes the colors of toxic flatworms. Sulawesi, Indonesia.

△ A sponge filefish (*Brachaluteres ulvarum*) hides in soft corals or hydroids. Sulawesi, Indonesia.

△ A yellow boxfish (*Ostracion cubicus*) is born with its tough scales. Sulawesi, Indonesia.

◁ The juvenile barramundi cod (*Cromileptes altivelis*) is thought to mimic toxic flatworms. Lembeh Straits, Sulawesi, Indonesia.

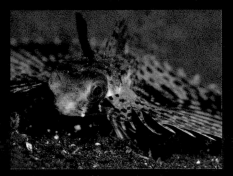

△ A flying gurnard (*Dactyloptena orientalis*) scares off predators with its fins. Sulawesi, Indonesia.

conserving reefs

The human race has long had a negative effect on the marine world, but only now are we approaching a turning point from which the oceans and reefs may never recover. We must act quickly to secure their future.

Humankind has always considered the resources provided by the oceans and reefs to be limitless—the fish have always been plentiful and the waves have carried away our garbage and waste, leaving the shores clean once again. Given the vast size of the oceans and our relative lack of knowledge about what lies beneath the surface, it is easy to understand this position and excuse our lack of control. However, as human populations have grown to the sizes we see today, our behavior has taken its toll on the environment, and the habitats that we have relied on for so long have begun to suffer.

The reefs of the world currently face many serious problems. One of the main threats to our reefs is overfishing—every day, millions of people around the world rely on reefs to provide them with food, and every day, thousands of fishing vessels set out to meet this demand. Huge nets scour the seabed, long-lines are set out across the oceans, and sharks are slaughtered by the millions to feed the demand for shark-fin soup. In fact, many populations of fish around the world have now collapsed to the point that they are unlikely to recover

in the future. Coral reefs in parts of the tropics are being destroyed at an alarming rate by blast-fishermen intent on a quick catch, and by the use of cyanide to supply the trade in live fish for restaurants and aquariums. Tropical mangroves are demolished to make way for coastal developments or are burned for charcoal, while temperate kelp forests are harvested around the world. Other, less direct effects are also taking their toll. Populations of kelp-grazing urchins have boomed after their predators have been overfished, for example, making the regrowth of these magnificent underwater forests more difficult. Plastics dumped into the sea last for decades, clogging the stomachs of turtles and sea birds, while long-abandoned fishing gear drifts for years, drowning dolphins and sharks as they travel the oceans. Oil spills and waste from shipping also threaten the world's marine environments, while runoff from the land—in the form of pollution, sediments, and nitrogen-laden water—smother both inshore reefs and rocky, seaweed-clad shores. All human activities, whether at sea or on land, ultimately have some effect on the reefs of our planet.

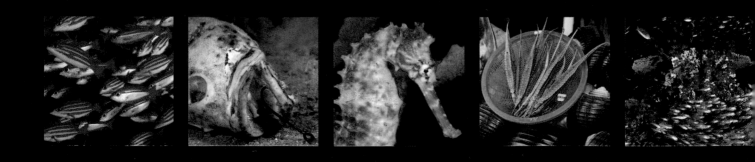

Only recently has humankind begun to understand the importance of diversity to the ecosystems of the world. With the destruction of entire reefs, mangrove swamps, and kelp forests, we are now responsible for the permanent loss of a disturbingly large amount of diversity, and face the very real possibility of the collapse of entire ecosystems. Humans and reefs have always had an intimate relationship, but only in modern times has this partnership been tipped in the wrong direction. It is now up to us to save these beautiful habitats, to study them and learn their limits, and to recognize that we must control our own short-time desires for the sake of the long-term health of not only individual habitats, but also the global ecosystem as a whole.

It is not too late for change. Sustainable fishing practices, such as establishing and enforcing catch quotas and setting up "no-take" zones, have succeeded in maintaining large-scale commercial fisheries, as well as subsistence fishermen on isolated reefs and islands. New aquaculture techniques that farm salmon and shrimp, for example, may take the pressure off wild populations without harming the environment. Also, corals and clams can be grown in tanks and transplanted onto damaged reefs, allowing them to flourish once again. Improvements in shipping controls, and the slow realization that what we do on land has a long-lasting effect on our seas, have led to a reduction in pollution in many parts of the world—but there is a long way to go. Today, the single most important step forward is education. It is crucial that we are aware of the negative effects of overpopulation and consumerism on the world's habitats. Now is the time for us to revive our relationship with the ecosystems of the underwater world before they are damaged beyond repair.

> " It is imperative that we control our short-term desires for the sake of the long-term health of the world's reefs. "

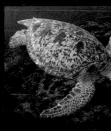

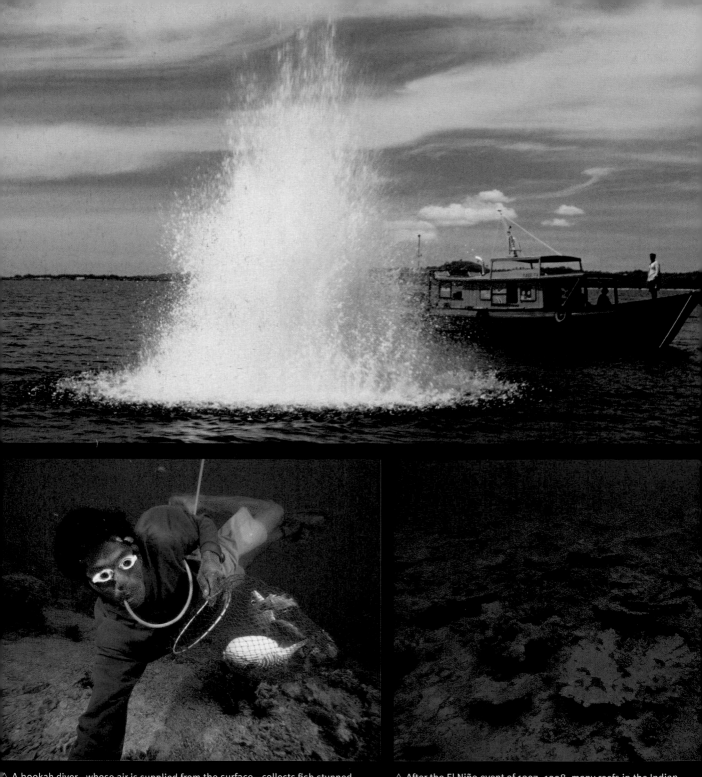

△ A hookah diver—whose air is supplied from the surface—collects fish stunned by sodium cyanide, a chemical that also kills the corals. Southeast Asia

△ After the El Niño event of 1997–1998, many reefs in the Indian and Pacific Oceans were killed or damaged. Indian Ocean

Nowadays, tropical coastal habitats are threatened not just by the huge demand for food, but also by the destructive methods that have become so commonly used. Fishing practices such as bottom-trawling and blast- and cyanide-fishing may produce a large catch, but they also destroy the very reefs and habitats that support the fish populations in the first place. Also, with the possibility of more widespread problems such as global warming and El Niño events, already damaged areas may be pushed beyond the point from which they can recover. Unless something is done quickly, tropical coastal habitats like reefs will be damaged beyond repair, and millions of people will have to look elsewhere for their food. **"**

◁ Blast-fishing is a quick and easy method of making a catch, but is highly destructive to the reef itself—as well as being extremely wasteful. Southeast Asia.

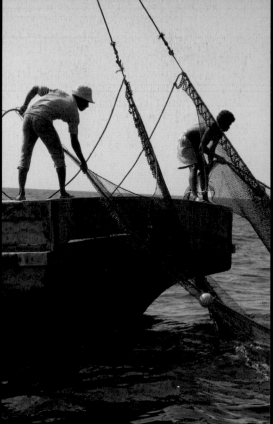

△ Fishermen hauling in their nets—these small-scale operators target a wide range of species. Southeast Asia.

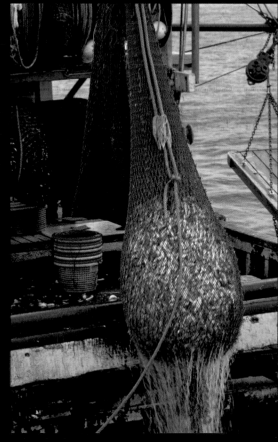

△ Shrimp-trawling in the tropics has one of the highest bycatch rates of any fishery. Southeast Asia.

Sharks are in a lot of trouble. Far too many of these apex predators are killed every year, and what many people don't realize is that these animals play a vital role in the marine ecosystem. By feeding on prey species, they control entire populations of other animals—culling the weak, the slow, and the unlucky. Some studies show that sharks may be a keystone species—take away the keystone and the arch falls down; take away the sharks and entire marine ecosystems could collapse. 💬

▷ There has always been a demand for shark products. In recent years, however, shark-fin soup has become hugely popular, and it is estimated that 100 million sharks are killed every year—primarily for their fins. It is thought that many shark species will be extinct within decades. Images from across Southeast Asia.

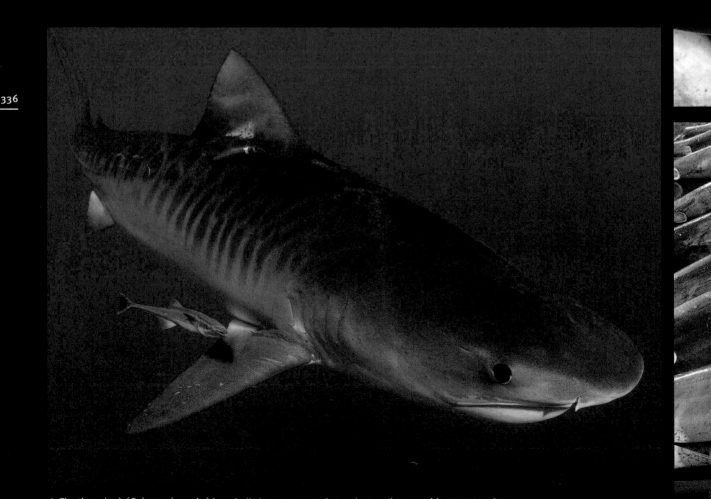

△ The tiger shark (*Galeocerdo cuvier*) is a vitally important species and yet, only now, with recent tagging studies, have we begun to understand their populations and movements. Aliwal Shoals, South Africa.

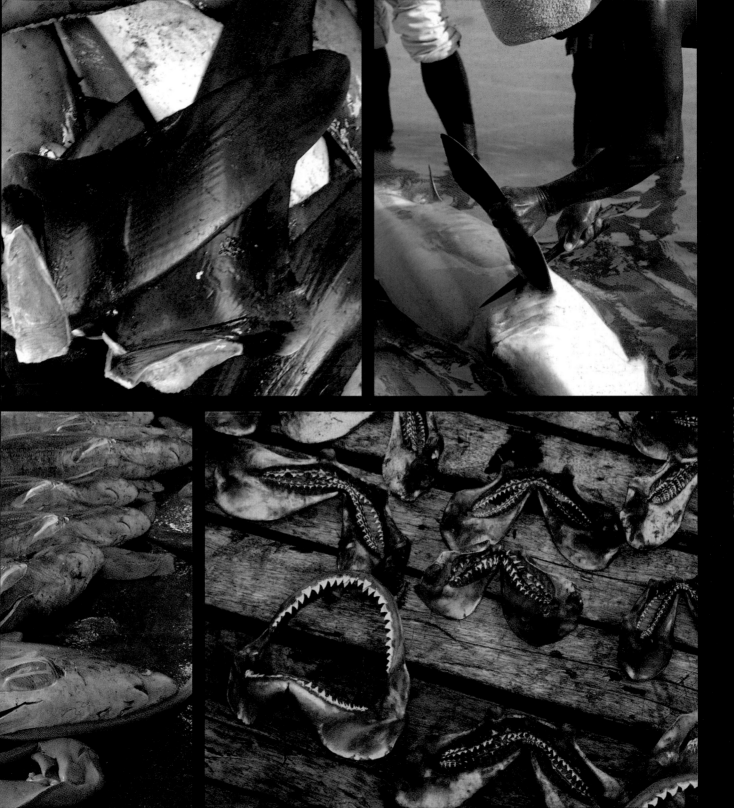

"I saw my first turtle coming up to lay eggs on Sipadan in Sabah, Malaysia. While you can no longer stay overnight on this island, there are other, carefully managed nesting beaches in northern Borneo where you can pay to have the opportunity to watch these animals as they haul themselves up the beaches to nest at night. The income generated by a healthy population of turtles far outweighs that from the sale of eggs or turtle shells—turtles are more valuable alive than dead. However, education is crucial in helping local populations see that their traditional patterns of exploiting turtles are not only less lucrative than modern conservation-based tourism, but are actually killing off the turtles."

▷ Turtles play an important role in the ecosystem of the reef, but these ancient mariners could now be facing extinction as their eggs are collected and sold in markets, adults drown in trawl nets, and nesting beaches are turned into resorts. Southeast Asia.

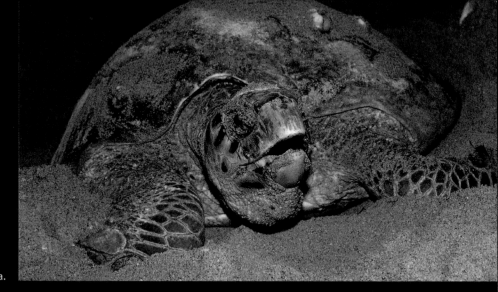

▷ After hauling herself up the beach on a dark, moonless night, a female hawksbill turtle (*Eretmochelys imbricata*) lays her eggs in a nest dug above the high-tide mark. Gulisan, Sabah, Malaysia.

△ Rangers from the wildlife department watch over a green turtle (*Chelonia mydas*) as she lays her eggs. Selingan, Sabah, Malaysia.

coral reefs of the world

Coral reefs are found throughout the warm, shallow, sun-dappled waters of the tropics. They are solid structures built predominantly from the skeletal remains of hard or stony corals—small, colony-forming organisms.

There are three main types of coral reefs: fringing reefs, barrier reefs, and atolls. Fringing reefs are the most common and occur adjacent to land, with little or no separation from the shore. They develop through upward growth of reef-forming corals on an area of continental shelf. Barrier reefs are broader and separated from the land by a stretch of water—called a lagoon—which can be extremely wide and deep. Atolls are large, ring-shaped reefs that enclose a central lagoon; most atolls are found well away from large landmasses, such as in the South Pacific. Parts of the reef structure in both atolls and barrier reefs often protrude above sea level as low-lying coral islands, which develop from wave action depositing coral fragments broken off from the reef itself.

The reef-building hard corals can grow only in clear, sunlit, shallow water where the temperature is at least 64°F (18°C) but ideally 77–84° F (25–29°C).

Hard corals grow best when the average salinity of the water is 36 parts per thousand and where there is little wave action or sedimentation from river runoff. These conditions occur only in some tropical and subtropical areas of the world. The highest concentration of coral reefs is found in the Indo-Pacific region, which stretches from the Red Sea to the central Pacific Ocean. A smaller concentration of reefs also occurs around the Caribbean Sea.

1 LIGHTHOUSE REEF

LOCATION 50 mi (80 km) east of central Belize

TOTAL AREA 120 sq mi (300 sq km)

WATER TEMPERATURE 75–82°F (24–28°C)

Lighthouse Reef is an atoll lying 35 miles (55 km) east of the huge Belize barrier reef. Like all atolls, it is bounded by numerous coral formations, many of which break the surface. These corals form a natural barrier against the sea and surround a lagoon, which sits on top of a mass of limestone. At its center is Lighthouse Reef's most remarkable feature—a large, almost circular sinkhole in the limestone known as the Great Blue Hole. Approximately 480 ft (145 m) deep and containing the entrance to a system of caves, the Great Blue Hole is one of the world's best dive sites.

KEY SPECIES Queen angelfish
(*Holacanthus ciliaris*)

2 GREAT BARRIER REEF

LOCATION Queensland coast, northeastern Australia

TOTAL AREA 14,300 sq mi (37,000 sq km)

WATER TEMPERATURE 75–80°F (24–27°C)

Australia's Great Barrier Reef is the world's largest coral reef system and stretches over 1,250 miles (2,000 km) along the coast of Queensland. In 1975, the Great Barrier Reef Marine Park was established and, in 1981, the region was declared a UNESCO World Heritage Site. The Great Barrier Reef consists of about 3,000 individual reefs and small coral islands, and is home to a staggering diversity of species—there are approximately 4,000 species of mollusks, 1,500 species of fish, 500 species of algae, and 20 species of sea snakes.

KEY SPECIES Giant potato bass
(*Epinephelus tukula*)

mangroves of the world

Located on coastlines throughout the tropics and subtropics, mangrove swamps are a collection of salt-tolerant evergreen trees that thrive in the intertidal environment between the high- and low-water marks.

Mangrove swamps line approximately eight percent of the world's coastlines, where they filter pollutants from rivers and help protect the shore from erosion. Mangroves thrive in coastal areas that are protected from direct wave action and where there is fine mud or sandy sediment in which the roots can take hold. As the lower parts of the roots develop in this sediment, aerial roots form a tangled network above, which traps silt and other material carried there by rivers and tides, and acts as a filter system that helps protect the coral reefs farther offshore.

Some 54 species of trees and shrubs are classified as true mangroves, and each has evolved adaptations for life in the intertidal environment. The ability to grow in salty water is essential for survival, and some species have evolved to excrete salt through their leaves.

As a habitat, mangrove swamps are rich centers of biodiversity. Their complex root systems provide a safe haven for developing fish, for example, offering ideal hiding places. Mangrove leaf litter is also food for animals such as crabs, although most is broken down by bacteria and fungi, which then turn it into food for fish and shrimp. Above the waterline, mangroves are also home to a vast range of birds, insects, and mammals.

1 EVERGLADES

LOCATION Southwestern Florida

TOTAL AREA 600 sq mi (1,500 sq km) of mangroves

WATER TEMPERATURE 70–84°F (21–29°C)

Mangroves occupy a large, roughly triangular area at the southwestern tip of southern Florida—the largest area of mangrove swamps in North America. The dominant mangrove species along the edges of the delta and the numerous channels is the red mangrove, and water within the channels is normally stained brown from tannin contained in the leaves of this species. Red mangroves are crucial to the Everglades ecosystem, acting as a nursery for many species of fish, shrimp, sponges, crabs, and other invertebrates.

KEY SPECIES The rare and endangered American crocodile (*Crocodylus acutus*)

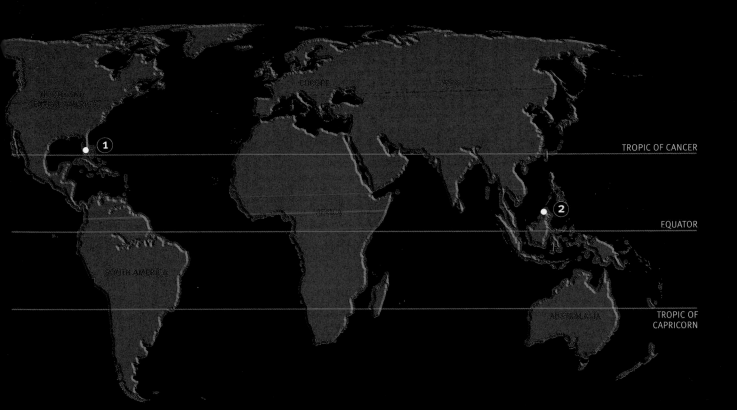

2 KINABATANGAN

LOCATION Southeast of Kota Kinabalu, eastern Sabah, Malaysia

TOTAL AREA 400 sq mi (1,000 sq km)

WATER TEMPERATURE 75–82°F (24–28°C)

The mangrove swamps in this region form a complex mosaic with other types of lowland forest and open reed marsh. They are home to dozens of species of saltwater fish, invertebrates, otters, and some 200 species of birds. Irrawaddy dolphins are occasionally spotted, as is Borneo's indigenous proboscis monkey and the saltwater crocodile. Over the past 30 years, there has been extensive clearance of mangroves in the Kinabatangan delta but, in recent years, the government of Sabah has been engaged in a large-scale mangrove replanting operation.

KEY SPECIES Monitor lizard (*Varanus salvator*)

seagrass beds of the world

Seagrasses, which are mostly found in tropical and subtropical waters, are the only fully marine flowering plants. They thrive in shallow, sandy lagoons or enclosed bays, where the clear water allows sunlight to penetrate.

Seagrass beds are some of the most productive marine habitats in the ocean. Unlike seaweeds and kelps, seagrasses have roots that enable them to absorb nutrients from within the sediments of the sea floor. In doing so, they bring nutrients into the food chain that would otherwise be locked up beneath the substrate. The intertwined roots and buried stems, or rhizomes, of seagrass plants help to stabilize the sand and

protect shallow seabeds from erosion, and the leaves help maintain water clarity by trapping fine sediments and particles. Both the leaves and roots of seagrass plants provide food for many species of marine animals, such as green turtles and manatees. The West Indian manatee can consume up to 85 lb (40 kg) of seagrass in one day and, in part, owes its zeppelinlike shape to the large amounts of gas generated as it digests its food.

Seagrass beds also provide important refuges for young fish that must hide from predators until they reach maturity. Many fish that wouldn't normally make their homes in seagrass come to these habitats to spawn, giving their young the best possible chance of survival. The juvenile fish also have a plentiful supply of food in the seagrass meadows as worms, crustaceans, and mollusks can all be found in abundance.

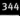
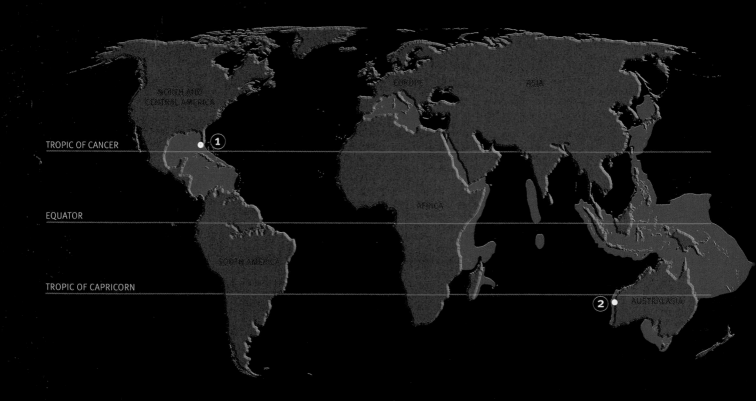

① SOUTH FLORIDA

LOCATION Southern Florida

TOTAL AREA 2,120 sq mi (5,500 sq km)

WATER TEMPERATURE 70–84°F (21–29°C)

The seagrass beds of south Florida are the most extensive in the world, with various species thriving in the protected bays and lagoons. In total, there are seven different species found here, with the most abundant being turtle grass—named after the green turtles that graze on large fields of this plant. Florida's seagrass beds are, however, under constant threat from dredging, pollution, and urbanization.

KEY SPECIES The green turtle
(*Chelonia mydas*)

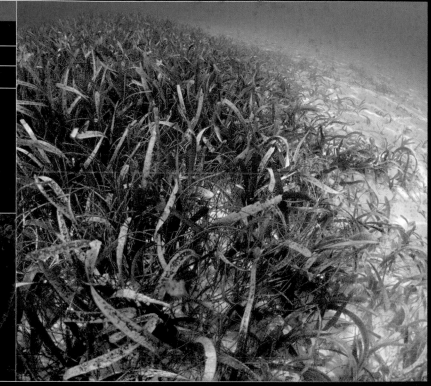

② SHARK BAY

LOCATION North of Perth, Western Australia

TOTAL AREA 1,500 sq mi (4,000 sq km)

WATER TEMPERATURE 75–84°F (24–29°C)

Shark Bay is a UNESCO World Heritage Site, and it contains one of the world's largest and most diverse seagrass beds. Twelve of the 50 species of seagrass in the world are found in Shark Bay, dominating the subtidal zone to depths of about 40 ft (12 m). These vast meadows provide food for one of the world's largest populations of dugongs, and the bay also plays host to dolphins, humpback whales, and turtles.

KEY SPECIES Dugong
(*Dugong dugon*)

kelp forests of the world

Kelps are large seaweeds that grow as dense as forests in the colder waters of the world. They thrive on shallow rocks in the subtidal zone where there is good movement of water, rich in nutrients.

Kelps grow densely on rocky slopes down to a depth of around 30–70 ft (10–20 m), depending on the clarity of the water. In deeper water, where there is less light for photosynthesis, kelps grow more sparsely; in most coastal waters they cannot survive below 80 ft (25 m). Some kelp beds protrude above the surface of the water during low tide, and they can even help protect coasts from severe storms by absorbing wave energy.

Many kelps are treelike in shape, with a branched holdfast or rootlike structure that anchors the plant to the substrate. The long stem often has gas-filled floats that hold the palmlike fronds up to the light and away from grazers. This makes a kelp forest a multilayered environment in which different organisms live at different levels. Small spaces in the holdfast, for example, can protect hundreds

of small animals from predators, while the fronds may become covered in hydroids and tube worms. As with seagrass meadows, kelp forests provide a refuge for many species of young fish until they can join the adult populations. Although kelp habitats support a rich diversity of life, only about 10 percent of kelp plants are eaten directly by animals—the rest enter the food chain as detritus or dissolved organic matter.

1 CATALINA ISLAND

LOCATION Off the coast of California

TOTAL AREA 75 sq mi (194 sq km)

WATER TEMPERATURE 54–68°F (12–20°C)

The California coast is famous for its beds of giant kelp (*Macrocystis pyrifera*)—the largest seaweed in the world. These plants can grow to lengths of over 100 ft (30 m) and form vast, dense forests in the nutrient-rich waters of the California Current. Catalina Island, which lies 22 miles (35 km) off the coast of California, has been a nature reserve since 1974 and has both dramatic scenery above the water and tremendous beauty beneath. As well as kelp, the cold waters are home to eagle rays and California sea lions.

KEY SPECIES Garibaldi fish (*Hypsypops rubicundus*)

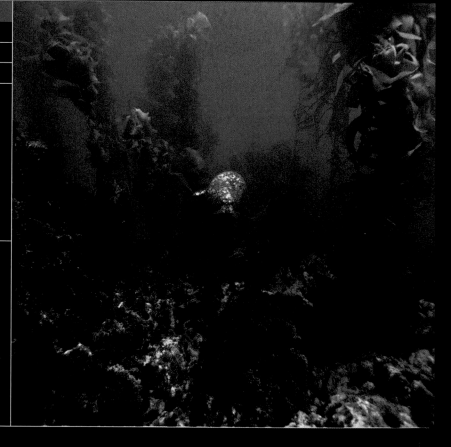

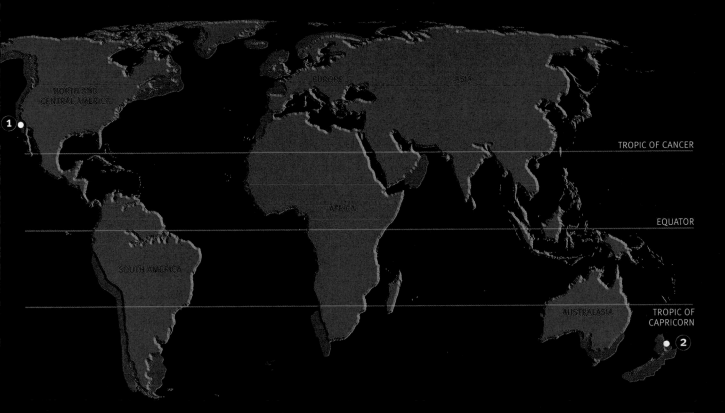

TROPIC OF CANCER

EQUATOR

TROPIC OF
CAPRICORN

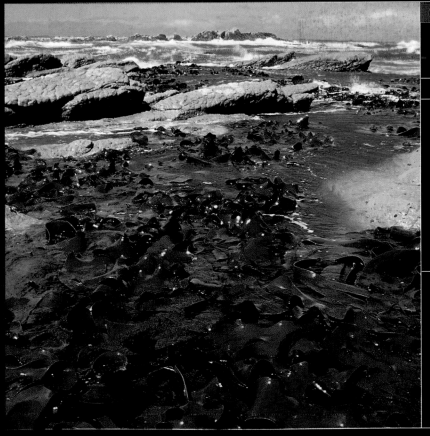

2 POOR KNIGHTS ISLANDS

LOCATION Off the east coast of Northland, North Island, New Zealand

TOTAL AREA Island chain—8½ sq mi (24 sq km)

WATER TEMPERATURE 59–75°F (15–24°C)

The Poor Knights Islands are a group of uninhabited islands that lie 14 miles (23 km) off the coast of North Island in New Zealand. In 1981, a marine reserve was set up around the islands, extending 2,600 ft (800 m) out from the shore. The area is popular with divers for its caves and kelp forests, and is marked with ridges, overhangs, and arches. Approximately 120 fish species inhabit the waters, with vast shoals of blue maomao populating the area. In the most exposed places, *Lessonia variegata* kelp is predominant, while at more sheltered sites *Ecklonia radiata* is more abundant.

KEY SPECIES Yellow moray eel (*Gymnothorax prasinus*)

temperate reefs of the world

The encrusting life at the heart of temperate reefs, and the many other animals that take up residence here, are equally as fascinating as those found in the tropics. Our cold-water shores abound in marine life.

One of the richest of all marine ecosystems, temperate waters are found between the tropics and the poles. Whereas tropical coral reefs are built up from generations of reef-building corals, the base structure of shallow, temperate reefs is the rocky substrate itself. Here, it is the staggering array of invertebrates that highlights the diversity of life on temperate reefs. A host of encrusting sponges, sea squirts, and anemones, for example, cling to the rocks and feed on the drifting plankton —the free-floating animals and plants that form the basis of the food chain.

The fish of temperate reefs may not always be as colorful as their tropical counterparts, but they have evolved just as many fascinating methods of survival. The leafy seadragon, for example, has frondlike formations on its body, which help it evade predators by resembling the seaweeds of its home. The anglerfish, on the other hand, uses camouflage to conceal itself from its prey, luring small fish with a wormlike apendage.

Temperate shores experience seasonal variations and, as a result of the changing conditions, attract a variety of visiting migratory species. Predators, such as sharks and tuna for example, are attracted by the schools of fish that come to feed on the seasonal blooms of plankton.

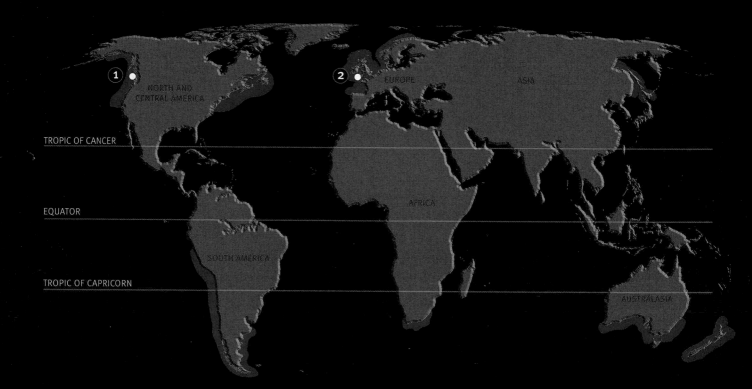

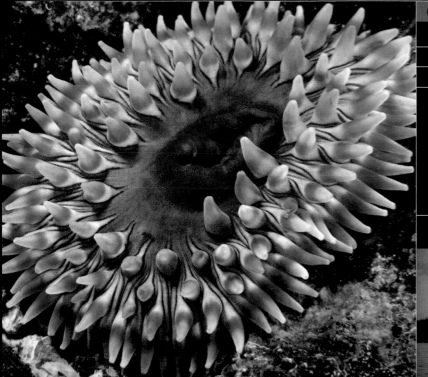

LOCATION British Columbia, Western Canada

TOTAL AREA 12,355 sq mi (32,000 sq km)

WATER TEMPERATURE 48–64°F (9–18°C)

The largest island on the western side of the Americas, Vancouver Island is surrounded by cold waters that abound in marine life. Strong tides and water rich in oxygen and nutrients are an incredible draw for many plants and animals—perhaps the most famous resident of these shores is the inquisitive giant octopus. Other visitors include wolf eels, harbor seals, various whale species, and huge numbers of salmon.

KEY SPECIES Orca or killer whale (*Orcinus orca*)

2 THE MANACLES

LOCATION Off the Lizard, Cornwall, UK

TOTAL AREA Approximately 1 sq mi (2½ sq km)

WATER TEMPERATURE 48–70°F (9–21°C)

Located off the Lizard peninsula—the most southerly point on mainland Great Britain—the Manacles is a popular dive site. An area made famous by its many shipwrecks, the Manacles hosts an array of soft corals, hydroids, and anemones. Some reefs in the network rise 200 ft (60 m) from the seabed and, during the summer months, huge congregations of basking sharks can be spotted in the surrounding waters.

KEY SPECIES Basking shark (*Cetorhinus maximus*)

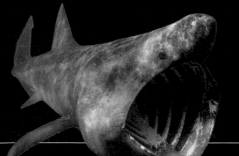

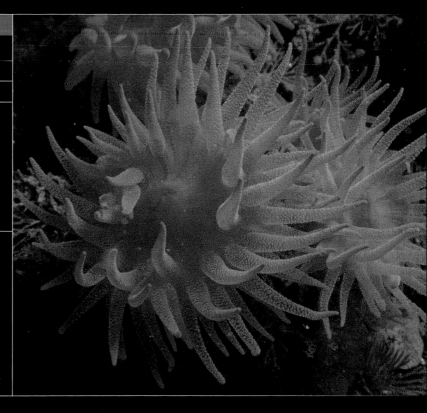

◁ Jason Isley gets close to a tiger
shark (*Galeocerdo cuvier*) while
a blacktip shark (*Carcharhinus
limbatus*) swims beneath them
both. Aliwal Shoals, South Africa.

" Diving and taking photographs is not our job—it's our passion. For all of us in Scubazoo, the chance to jump off a boat and explore a new place, or to photograph and film an animal in a different light, is what we live for. We've been lucky enough to witness many remarkable things during our collective time underwater. However, the ultimate satisfaction comes not from these experiences themselves, but from sharing them with the rest of the world. Telling the whole story of the underwater realm—the good, the bad, and the downright ugly—is what Scubazoo is all about. "

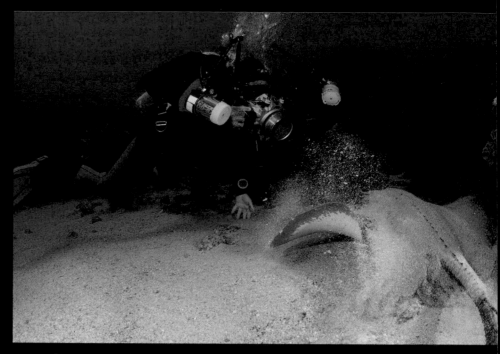

△ Matt Oldfield shooting close-ups of a stingray.
Poor Knights Islands, New Zealand.

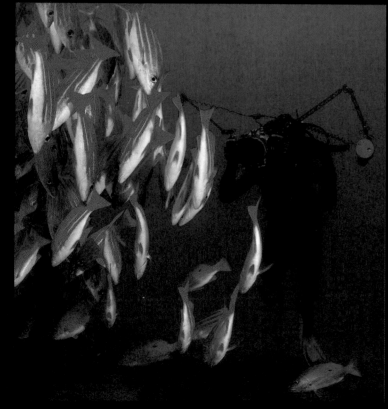

△ Roger Munns in the midst of a school of snappers.
Sodwana Bay, South Africa.

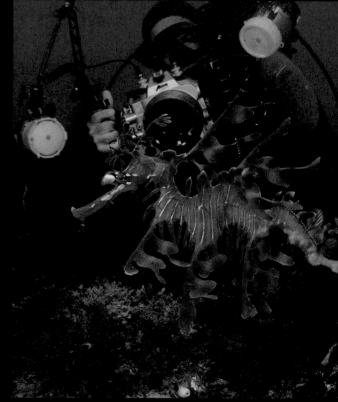

△ Matt Oldfield with a leafy sea dragon.
Kangaroo Island, Australia.

Thanks from Scubazoo

Taking photographs underwater in the wild is ultimately a solo pursuit. However, many people have helped to create the images in this book and, in no particular order, we would like to thank the following for their generous help and support:

Sabah Ministry of Tourism Development, Environment, Science and Technology: Y.B. Tan Sri Datuk Chong Kah Kiat & Datuk Monica Chia; Sabah Tourism Board: Tengku Datuk (Dr) Zainal Adlin & Datuk Irene Benggon Charuruks; ECO Divers Tasik Ria Resort & Kungkungan Bay Resort, North Sulawesi: Jim & Cary Yanny, Steve & Miranda Coverdale; Seaventures Resort, Sabah, Malaysia: Suzette Harris; Blue Wilderness, South Africa: Mark & Gail Addison, Sijmon De Waal & Debbie Millin; Bali Hai Diving Adventures, Indonesia: Michael Cortenbach; Papua Diving, Raja Ampat, Indonesia: Max Ammer; Dive Tutukaka, Poor Knights Dive Centre, New Zealand: Jeroen Jongejans & Kate Malcolm; Aguas Claras, Fernando de Noronha, Brazil: Samuca; Vancouver Island Dive, Canada: John de Boeck; Kangaroo Island Diving Safaris, Australia: Jim & Josie Thiselton; Sipadan Water Village, Sabah, Malaysia: Ken Pan, Leonard Lai & Alex Ho; Malapascua Exotic Island Dive Resort, Philippines: Dik & Cora de Boer and Totong; Four Seasons, Maldives; Sangalaki Dive Resort, Indonesia: Ron Holland; Adventure Journey World, Maratua, Indonesia: Alan Oh; Swanido International, Biak, West Papua, Indonesia: Roger Koh; Layang Layang Island Resort, Sabah, Malaysia: Lawrence Lee; Mantanani Island Resort, Sabah, Malaysia: David Goh; Sipadan Dive Centre, Sabah, Malaysia: Douglas Primas & Gerrard Chin; SMART, Sabah, Malaysia: Robert Lo; Rockfish Divers, Vancouver, Canada: Jonathan Grant; Ocean Optics: Steve Warren; Scubacam Singapore: David Cheung; Anthis/Nexus Japan: Junko Maruoka.

With new species of marine life being found every day, it is a continuous struggle to correctly name each individual creature without scientific taxonomy; therefore we take full responsibility for any errors in species identification and technical detail. We would like to thank the following for their assistance: Liz Wood at the Marine Conservation Society; Markus Ruf at the Marine Research Foundation; Bill Rodman at the Seaslug Forum.

Our comfort underwater is the most important thing when trying to capture images—we need to be able to forget we are diving and focus entirely on the photography of the marine life. Sometimes we are underwater for extremely long periods of time and therefore performance and comfort are the ultimate reasons we use the following equipment: Pinnacle Aquatics: dry suits & wetsuits; Dive Rite: all diving equipment; Seventenths: topside clothing.

www.scubazoo.com

THE SCUBAZOO TEAM

FROM LEFT TO RIGHT: Jason Isley (Co-founder/Managing Director), Simon Christopher (Founder/CEO), Simon Enderby (Operations Director), Matthew Oldfield (Publications Director), Roger Munns (Senior Cameraman).

index

358

Publisher's acknowledgments

In addition to Scubazoo's acknowledgments (see page 357), DK would like to thank the following people for their help in the preparation of this book: Eileen Weckerle and Janine Kraus at the Coral Reef Alliance, Tarda Davison-Aitkins for editorial assistance, Matthew Robbins and Anoushka Jahangiri for design assistance, Andrea Sadler for picture research, and Dr. Laurence Errington for indexing. The world maps were illustrated by Advanced Illustrations Ltd.

The publisher would like to thank the following for their kind permission to reproduce their photographs: **Alamy Images**: Nature Picture Library 349br; WaterFrame 347bl; **Ardea**: Jean Paul Ferrero 345br; Geoff Trinder 343bl; Doc White 346br; **FLPA**: Reinard Dirscherl 345cla; Foto Natura Stock 345br; Flip Nicklin 349cra; Jurgen & Christine Sohns 342bl; **Getty Images**: Georgette Douwma 341cla, 346bl; Stephen Frink 341br; Tim Laman 347br; Panoramic Images 342tr; Norbert Wu 341tr; **naturepl.com**: Alan James 349bl; **Photolibrary**: Dave Fleetham 349tl; **Photoshot / NHPA**: Tom & Therisa Stack 345tr; **Pictures Colour Library**: John Miles 341bl.